DRAWING
ANATOMY

W9-CDL-934

DRAWING
ANATOMY

ARCTURUS

ARCTURUS

This edition published in 2016 by Arcturus Publishing Limited
26/27 Bickels Yard, 151–153 Bermondsey Street,
London SE1 3HA

Copyright © Arcturus Holdings Limited/Barrington Barber

All rights reserved. No part of this publication may be reproduced,
stored in a retrieval system, or transmitted, in any form or by any
means, electronic, mechanical, photocopying, recording or otherwise,
without written permission in accordance with the provisions of the
Copyright Act 1956 (as amended). Any person or persons who do
any unauthorised act in relation to this publication may be liable to
criminal prosecution and civil claims for damages.

ISBN: 978-1-84837-979-4
AD001884UK

Special thanks to the living artists whose work is reproduced in
this book: Louise Gordon, Lucian Freud, Ted Seth Jacobs and
Joseph Sheppard.

Printed in China

CONTENTS

Introduction — 6

Technical Introduction — 8

The Full Figure — 14

The Head — 50

The Torso — 64

The Arms and Hands — 84

The Legs and Feet — 110

The Head in Movement — 136

The Torso in Movement — 166

The Arms and Hands in Movement — 204

The Legs and Feet in Movement — 234

The Moving Body — 270

Life Drawing — 306

Putting it All Together — 318

Index — 352

INTRODUCTION

Anatomy books are essential for figure artists, but many are published for medical purposes and tend to give too much information – for example, the inner organs of the body are interesting to know about, but not relevant for drawing.

What is important for the artist or art student is to learn the structure of the human form, based on the skeleton and the musculature. There have been a number of good and useful books on this subject. Some are a little out of date, not so much in the information that they give but often in the way it has been presented. Other well-produced contemporary books are mainly photographic.

My task has been to produce a comprehensive anatomy book that has all the information necessary for an artist, using drawings and diagrams presented in an easy-to-follow format; and I also wanted to put into it everything that I have found useful in my own drawing practices.

In the first part of this book, I deal with the full figure, followed by a chapter on the anatomy of each major part of the body. Each section shows the skeleton from different viewpoints; then the muscles on top of the bone structure; and finally, the surface form of the human body.

Of course, not all human bodies are perfectly formed and proportions do differ from person to person. Throughout the book I have used well-proportioned, fairly athletic figures. This means that you become acquainted with the shapes of the muscles at their best, although you will probably draw many people who do not have well-toned bodies like these.

In the second part of the book, I examine each part of the body in more detail, concentrating in particular on musculature and how the body moves. Each area of detailed analysis will sometimes repeat what has been shown in the previous chapters: this is necessary because some muscles overlie others, which to a certain extent changes their shape on the surface. So do not be surprised to see the same names cropping up from time to time; it does make them easier to remember, too.

In the technical introduction immediately after this, you will find an explanation of descriptive terms as used in medical circles, followed by a detailed list of Latin terminology. This is worth reading, because understanding anatomical terms will help you to follow the annotations in the book. It may take a little time to memorize all the names you need, but after regular use of these terms you will probably remember enough to describe what you are looking at.

I have omitted any description of the brain, heart, lungs and other viscera because these items are housed within the cranium, the ribcage and the pelvis, and it is the bony parts that dictate the surface shape for figure-drawing purposes. I have also left out details of the male genitalia, because the differences in size and shape are too variable.

Throughout history, artists have looked at our bodies and shown their beauty, power and distortions. I have used the best possible references to draw these pictures, including my own life studies, but have not drawn from dissected corpses as Michelangelo and Leonardo da Vinci did. Artists have contributed much to the study of anatomy, both for artistic and medical purposes. In drawing, the practising artist wants to capture the form of this complex bodily machinery, but first he or she needs to know how it works.

TECHNICAL INTRODUCTION

This section is intended to give you some initial detail about the human anatomy before starting to draw. I have described the properties of bones, muscles, tendons, cartilage, skin, fat and joints, as well as showing diagrams of the different types of joints and muscles. There is also an introduction to anatomical terminology: you will find this useful as certain terms are used throughout the book.

BONES

The skeleton is the solid framework of the body, partly supporting and partly protective. The shape of the skeleton can vary widely. It will affect the build of a person and determine whether they have masses of muscle and fat or not.

Bones are living tissue supplied by blood and nerves. They can become weaker and thinner with lack of use and malnutrition, or heavier and stronger when having to support more weight. They are soft and pliable in the embryo, and only become what we would consider hard and bone-like by the twenty-fifth year of life.

Humans have 206 bones, but a few fuse together with age and it is possible to be born with some bones missing or even having extra ones. We each have a skull, ribcage, pelvis and vertebral column, as well as arm, hand, leg and foot bones. Most bones are symmetrical. The bones of the limbs are cylindrical, thickening towards the ends. The projecting part of a bone is referred to as a ***process*** or an ***eminence.***

Highly mobile areas of the body, such as the wrists, consist of numerous small bones. Other bones, like the scapula (shoulder blade) can move in all directions, controlled by the muscles around it.

The bones of the cranium (skull) differ from all others. They grow from separate plates into one fused vault to house the brain. The mandible (jawbone) is the only movable bone in the head.

The long bones of the arms and legs act like levers, while the flat bones of the skull, the cage-like bones of the ribs and the basin shape of the pelvis protect the more vulnerable organs such as the brain, heart, lungs, liver and the abdominal viscera.

MUSCLES

The combination of bones, muscles and tendons allows both strong, broad movements and delicate, precise ones. Muscles perform our actions by contracting or relaxing. There are long muscles on the limbs and broader muscles on the trunk. The more fixed end of the muscle is called the ***head*** or ***origin***, and the other end – usually farthest from the spine – is the ***insertion***. The thick muscles are powerful, like the biceps; and the ring-shaped muscles (sphincters) surround the openings of the body, such as the eye, mouth and anus. Certain muscles grow together and have two, three or four heads and insertions. Combined muscles also have parts originating in different places.

The fleshy part of a muscle is called the ***meat***, and the fibrous part the ***tendon*** or ***aponeurosis*** (see below).

Striated (voluntary) muscles operate under our conscious control. The 640 voluntary muscles account for up to 50 per cent of the body's weight and form the red flesh. Organized in groups and arranged in several layers, these muscles give the body its familiar form. The following drawings show the various different types of striated muscles, with the tendons at each end. Note the distinctive shape of the sphincter muscle on the far right.

Smooth (involuntary) muscles are confined to the walls of hollow organs, such as intestines and blood vessels. They function beyond our conscious control.

Cardiac (heart) muscles are both striated and involuntary, with a cell structure that ensures synchronic contraction.

TENDONS

The tendons are fibrous structures that attach the ends of the muscles to the bones at protruding points called ***tubercles*** and ***tuberosities***. Some muscles are divided by intervening tendons (see illustration above, second from right). Tendons may be round and cord-like, or flat and band-like, consisting of strong tensile fibres arranged lengthwise. They are inextensible, allowing the muscles to pull hard against them. Many are longer than the muscles that they serve, such as in the forearm.

APONEUROSES

These are broad, flat, sheet-like tendons, a continuation of broad, flat muscles that either attach to the bone or continue into the ***fascia***.

TENDINOUS ARCHES
Fibrous bands connected with the fasciae of muscles.

FASCIAE
Fibrous laminae of various thicknesses, occurring in all parts of the body, enveloping all muscles, blood vessels, nerves, joints, organs and glands. They prevent friction between moving muscles.

LIGAMENTS
Fibrous, elastic bands situated at joints where articulated bones connect, or stretched between two immobile bones.

CARTILAGE
Cartilage is connective tissue composed of collagen (a protein). Fibrous cartilage forms the symphysis pubis (the joint between the pubic bones) and invertebral discs. Elastic cartilage gives shape to the outer flap of the ear. Hyaline cartilage – the most common form – covers the **articular** surface of bones (the ends near the joints); forms the rings of the trachea (windpipe), also the bronchi (airways) of the lungs; and gives shape to the lower ribcage and nose.

SKIN
A tough, self-replenishing membrane about 2 mm thick, which defines the boundary between the internal and the external environments. Human skin is thickest on the upper back, soles of the feet and palms of the hand; it is thinnest on the eyelids. Not only the body's largest sense organ, the skin also protects the body from abrasions, fluid loss and the penetration of harmful substances. And it regulates body temperature, through perspiration and the cooling effect of surface veins.

EPIDERMIS
The skin's top layer with the dermis beneath, a thicker layer of loose connective tissue. Beneath this is the hyperdermis, which is a fine layer of white connective fatty tissue, also called the **superficial fascia.**

FAT
Fat is the body's energy reserve. Its layers soften the contours of the skeletal-muscular frame. It is primarily stored around the buttocks, navel, hips, inner and outer thighs, front and back of knees, beneath the nipples, on the back of the arms, in the cheeks and below the jaw.

JOINTS
Joints form the connections between bones. In fibrous joints, such as sutures in the skull, there is no appreciable movement. There is limited movement in the cartilaginous joints. The most mobile are the synovial joints such as the knees, where the bones are not fixed.

The principal movements of the joints are **flexion**, which means bending to a more acute angle; **extension**, straightening; **adduction**, which means moving towards the body's

midline; **abduction**, moving away from the midline; and **medial** and **lateral rotation** (turning towards and away from the midline).

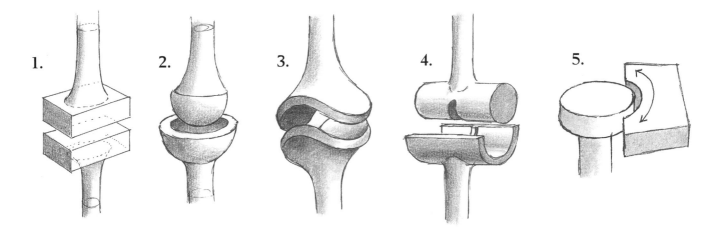

1. PLANE JOINT
Formed by flat or slightly curved surfaces, with little movement, such as the instep.

2. BALL AND SOCKET JOINT
The spherical edge of one bone moves in a spherical excavation of another, like the hip joint.

3. SADDLE OR BIAXIAL JOINT
Allows limited movement in two directions at right angles to each other, like the thumb.

4. HINGE JOINT
Bending and straightening movement is possible on one plane only, such as in the knee, the elbow and the finger.

5. PIVOT JOINT
One bone moves around another on its own axis, such as the radius and the ulna.

UNDERSTANDING ANATOMICAL TERMINOLOGY

To those who have no knowledge of Latin, the Latin names of the muscles and bones may be rather off-putting and hard to grasp. However, once you understand that, for example, an extensor is a muscle involved in the process of extension, that *brevis* is Latin for 'short' and that *pollicis* means 'of the thumb', the position, attachment and function of the *extensor pollicis brevis* muscle become much easier to remember.

But even English anatomical vocabulary may not be familiar to everyone who sets out to draw the human body. For this reason, the main technical terms used in this book, both English and Latin, are explained here.

Some technical terms in English

DEEP	far from the body surface	ANTERIOR	relating to the front surface or part
SUPERFICIAL	near to the body surface		
INFERIOR	lower	POSTERIOR	relating to the back surface or part
SUPERIOR	upper		

11

LATERAL	farther from the inner line of the body
MEDIAL	of or closer to the median line down the centre of the body
DISTAL	farther from the point of attachment to the trunk
PROXIMAL	nearer to the point of attachment to the trunk
PRONE	(of the arm or hand) with the palm facing down
SUPINE	(of the arm or hand) with the palm facing up
RADIAL	on the thumb side of the arm or hand
ULNAR	on the little finger side of the arm or hand
FIBULAR	on the little toe side of leg or foot
TIBIAL	on the big toe side of leg or foot

ALVEOLAR	of the gums or tooth ridge
COSTAL	of the ribs
DORSAL	of the back; of the back of the hand or top of the foot
FRONTAL	of the forehead
HYPOTHENAR	of the mound of muscle on the little-finger side of the palm
LUMBAR	of the loins
MENTAL	of the chin
NUCHAL	of the nape of the neck
OCCIPITAL	of the back of the head
ORBITAL	of the area around the eye
PALATINE	of the roof of the mouth
PALMAR	of the palm of the hand
PLANTAR	of the sole of the foot
SUPRAORBITAL	of the area above the eye
TEMPORAL	of the temple
THENAR	of the ball of the thumb
THORACIC	of the chest

BONES

CALCANEUS	the heel bone
CARPUS	the wrist
CLAVICLE	the collarbone
COCCYX	the four fused vertebrae below the sacrum
CONDYLE	a knob at the end of a bone
COSTAE	the ribs
EPICONDYLE	a knob on or above a condyle
FEMUR	the thigh bone
FIBULA	one of the lower leg bones
HUMERUS	the upper arm bone
ILIUM	one of the hip bones
ISCHIUM	one of the hip bones
MALLEOLUS	a hammer-shaped prominence of a bone (e.g. in the ankle)
MANDIBLE	the lower jawbone
MAXILLA	the upper jawbone
METACARPUS	the bones of the palm of the hand
METATARSUS	the bones of the front part of the foot, except the toes
OLECRANON	the elbow bone

PATELLA	the kneecap
PHALANGES	the finger and toe bones
PROCESS	a projecting part (also EMINENCE)
PUBIS	the pubic bone, part of the hip bone
RADIUS	one of the arm bones
SACRUM	five fused vertebrae near the end of the spine
SCAPULA	the shoulder blade
STERNUM	the breastbone
TARSUS	the ankle, instep and heel bones
TIBIA	one of the lower leg bones
ULNA	one of the arm bones
VERTEBRA	one of the bones of the spine
ZYGOMATIC BONE	the cheekbone

Many bones are named from their shapes: PISIFORM (pea-shaped), CUNEIFORM (wedge-shaped), SCAPHOID (boat-shaped), etc.

MUSCLES

As outlined on pages 10–11, among the movements of the joints are **flexion** (bending to a narrower angle), **extension** (straightening), **abduction** (movement away from the midline of the body) and **adduction** (movement towards the midline). The muscles involved in such movements are FLEXORS, EXTENSORS, ABDUCTORS and ADDUCTORS. There are also ROTATORS.

Other muscles named from their functions are LEVATORS and DEPRESSORS, which respectively raise and lower some part of the body. A TENSOR tightens a part of the body and a DILATOR dilates it. The CORRUGATOR is the muscle that wrinkles the forehead above the nose (think of 'corrugated iron'!).

Muscles come in various sizes and the relative size is often indicated by a Latin adjective:

LONGUS	long	Similarly with regard to position:	
BREVIS	short	INTEROSSEI	between bones
MAGNUS	large	LATERALIS	lateral, of or towards the side
MAJOR	larger	MEDIALIS	medial, of or towards the
MAXIMUS	largest		middle
MEDIUS	middle	ORBICULARIS	round an opening
MINOR	smaller	PROFUNDUS	deep (opposite to SUPERFICIALIS)
MINIMUS	smallest	(For ANTERIOR, POSTERIOR, INFERIOR and	
		SUPERIOR, see the English terms opposite.)	

LATIN FORMS THAT INDICATE 'OF THE …'

ABDOMINIS	of the abdomen	LUMBORUM	of the loins
ANGULI ORIS	of the corner of the mouth	MENTALIS	of the chin
AURICULARIS	of the ear	NARIS	of the nostril
BRACHII	of the arm (also BRACHIALIS)	NASALIS	of the nose (also NASI)
CAPITIS	of the head	NUCHAE	of the nape of the neck
CARPI	of the wrist	OCULI	of the eye
CERVICIS	of the neck	ORIS	of the mouth
DIGITI	of a finger or toe	PALMARIS	of the palm
(DIGITI MINIMI of the little finger or toe;		PATELLAE	of the kneecap
DIGITORUM of the fingers or toes)		PLANTAE	of the sole of the foot
DORSI	of the back	PECTORALIS	of the chest or breast
FASCIAE	of a fascia (see below)	POLLICIS	of the thumb
FEMORIS	of the femur	RADIALIS	of the radius
FRONTALIS	of the forehead	SCAPULAE	of the shoulder blade
HALLUCIS	of the big toe	THORACIS	of the chest
INDICIS	of the forefinger	TIBIALIS	of the tibia
LABII	of the lip	ULNARIS	of the ulna

OTHER PARTS OF THE BODY

FASCIA	a sheet of connective tissue (*pl* FASCIAE)
FOSSA	a pit or hollow (*pl* FOSSAE)

THE FULL FIGURE

In this first section we look at the body as a whole, introducing first the skeletal structure and the major muscles, then the proportions and the differences between male and female figures.

The bony skeleton is rather like interior scaffolding, around which the softer parts of the body are built. Of course, flesh and bone are not separate since they develop in the womb together, but the skeleton provides the rigid framework that supports the mass of muscles and viscera. In a newborn, the bone structure is not able to support the body because the muscles have not developed sufficiently. As the child grows, it gains both muscular strength and an understanding of how to control its movements.

It is important for the artist to know which bits of the skeleton show on the surface of the body because, when drawing, it helps to relate the fixed points of the figure to the appearance of the more fleshy parts. Understanding the structure of the skeleton is the basic requirement for accurate figure drawing.

When you draw the human body, you cannot see exactly where the muscles start and end. However, if you know something about the configuration, you will find it makes it easier to indicate the main shape of any muscle more accurately in your drawing.

It is a good idea to get some knowledge of the larger, more superficial muscles, because then you can refer to them in a life class to clarify which part of the body you are tackling. If you have a good teacher, he or she will know most of the larger muscle names.

One thing that you have to bear in mind when you come to draw the human figure from life is the fact that the muscles of every individual will have developed in different ways. A person who is an athlete will have a muscle structure that is much easier to see on the surface than someone who has led a more sedentary life. In general, women have a thicker layer of fatty tissue than men, and sometimes a muscle that is obvious on a man will be more subtle and softer-looking on a woman. Then, of course, both men and women may have a more fatty development of their surface area overall, which will make it harder to see how the muscles overlap one another.

While we usually see just the surface of the human body, knowledge of what lies beneath the skin helps to produce more significant and convincing drawings. At the end of the section we shall see how master artists over the centuries, trained in the classical tradition, have portrayed the human figure in all its wonderful complexity.

Here we show three simple views of the skeleton, the front, the back and the side view (also called the anterior, the posterior and the lateral views). I have kept the number of bones named here to a minimum, since we will be going into greater detail when looking at the parts of the body in close-up.

TORSO

Clavicle (collarbone)

Coracoid process

Scapula (shoulder blade)

Manubrium

Sternum (breastbone)

Costae (12 pairs of ribs)

5 lumbar vertebrae

Anterior superior iliac spine

Ilium

Symphysis pubis

Pubis (pubic bone)

LEG AND FOOT (lower limb)

Head of femur

Lesser trochanter

Greater trochanter

Patella (kneecap)

Fibula

Tibia (shin bone)

Tarsus

Metatarsus

Phalanges (14 toe bones)

SKULL

Frontal bone

Zygomatic bone (cheekbone)

Maxilla

Mandible (jawbone)

7 cervical vertebrae

ARM AND HAND (upper limb)

Humerus

Radius

Ulna

Carpus (wrist bones)

Metacarpus

Phalanges (14 finger bones)

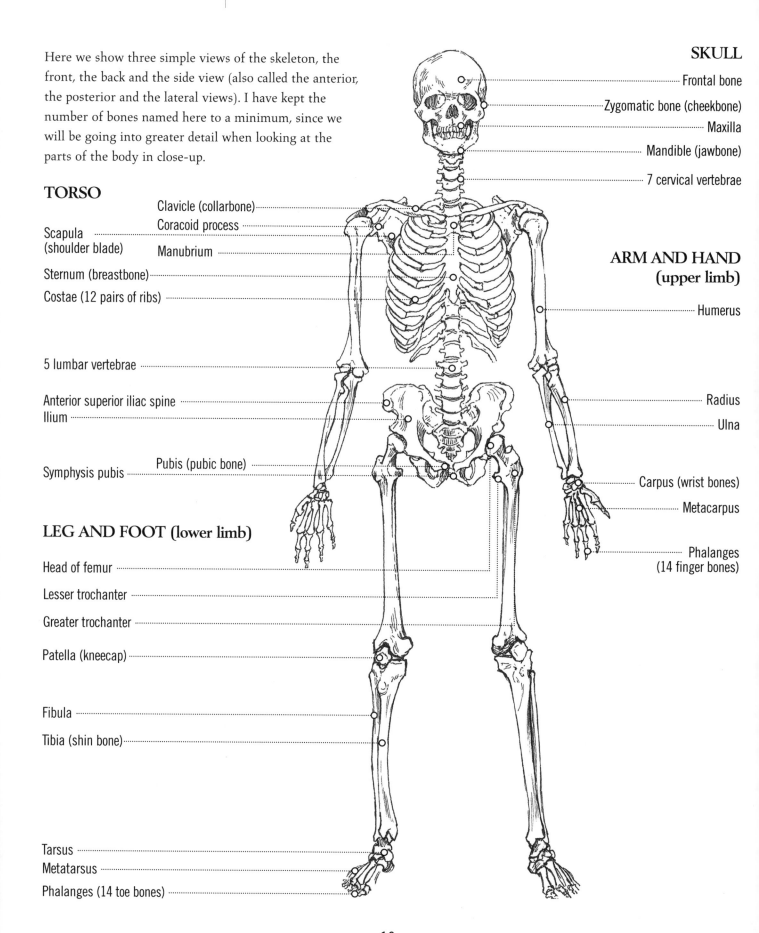

16

SKULL

Parietal bone

Occipital bone

7 cervical vertebrae

ARM AND HAND (upper limb)

Humerus

Radius

Ulna

Carpus (wrist bones)

Metacarpus

Phalanges (14 finger bones)

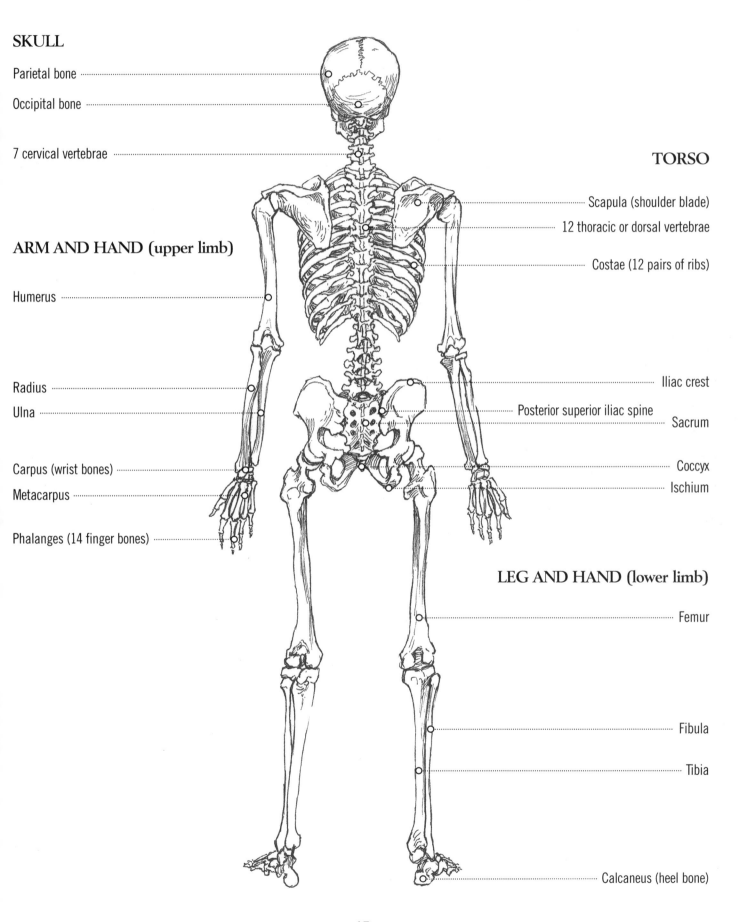

TORSO

Scapula (shoulder blade)

12 thoracic or dorsal vertebrae

Costae (12 pairs of ribs)

Iliac crest

Posterior superior iliac spine

Sacrum

Coccyx

Ischium

LEG AND HAND (lower limb)

Femur

Fibula

Tibia

Calcaneus (heel bone)

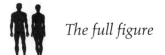

SKULL

Parietal bone

Frontal bone

Occipital bone

Eye socket

Maxilla

7 cervical vertebrae

Mandible

TORSO

Costae (12 pairs of ribs)

12 thoracic or dorsal vertebrae

ARM AND HAND (upper limb)

Humerus

5 lumbar vertebrae

Illiac crest

Radius

Ilium

Sacrum

Ulna

Coccyx

Pubis (pubic bone)

Carpus

LEG AND FOOT (lower limb)

Metacarpus

Greater trochanter

Phalanges (14 finger bones)

Femur

Patella

Tibia

Fibula

Tarsus

Metatarsus

Calcaneus

Phalanges (14 toe bones)

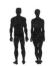

We show here the musculature of the whole body, so as to give some idea of the complexity of the sheaths of muscles over the bone structure. Later in the book, we shall also be looking at some of the deeper muscles in the body, but here only the more superficial muscles are on show.

The drawings that follow are based on a male body. Of course there are slight differences between the male and female musculature, but not much in the underlying structure. The main differences are in the chest area and the pubic area. There are also slight proportional differences and we will look at these later in the chapter. But this complete figure of the muscles of a human being will give you a good idea as to how the muscles are placed over the body.

Frontalis (part of epicranius)

Sternocleidomastoid

Deltoid

Pectoralis major

Biceps brachii

Brachioradialis

Rectus sheath covering the rectus abdominis

Abductor pollicis longus

Extensor pollicis brevis

Adductor pollicis

Gracilis

Sartorius

Rectus femoris

Tendons of rectus femoris

Tibialis anterior

Inferior extensor retinaculum

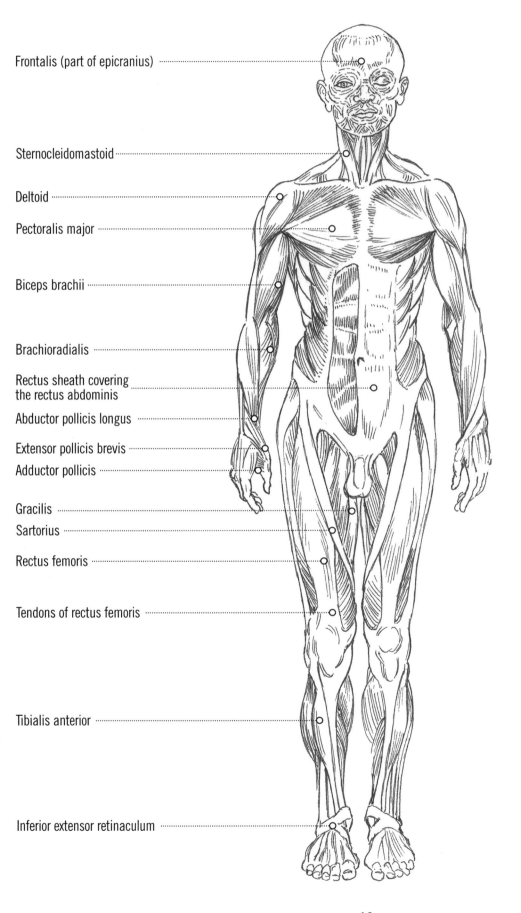

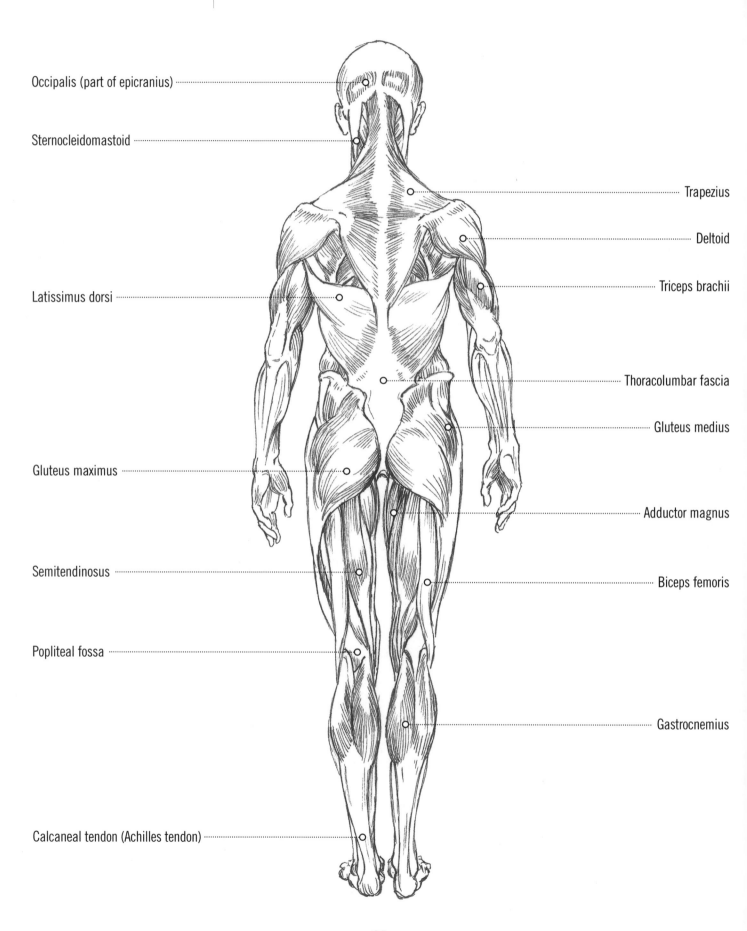

Occipalis (part of epicranius)

Sternocleidomastoid

Latissimus dorsi

Gluteus maximus

Semitendinosus

Popliteal fossa

Calcaneal tendon (Achilles tendon)

Trapezius

Deltoid

Triceps brachii

Thoracolumbar fascia

Gluteus medius

Adductor magnus

Biceps femoris

Gastrocnemius

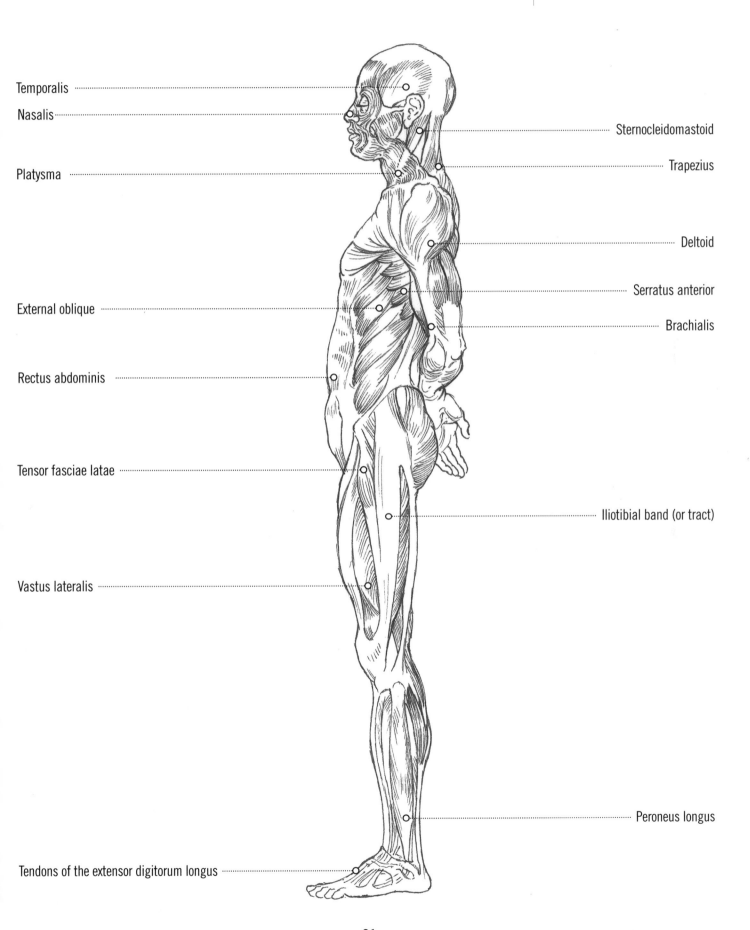

Temporalis

Nasalis

Platysma

External oblique

Rectus abdominis

Tensor fasciae latae

Vastus lateralis

Tendons of the extensor digitorum longus

Sternocleidomastoid

Trapezius

Deltoid

Serratus anterior

Brachialis

Iliotibial band (or tract)

Peroneus longus

FULL FIGURE SHOWING THE SURFACE OF THE BODY
front view – male

When you come to examine the surface of the human body, all the bones and muscles we have looked at are rather disguised by the layers of fat and skin that cover them. For the artist this becomes a sort of detective story, through the process of working out which bulges and hollows represent which features underneath the skin.

To make this easier, I have shown drawings of the body from the front, back and side, which are in a way as diagrammatic as the skeleton and the muscular figures in the previous pages. Because, on the surface, the male and female shapes become more differentiated, I have drawn both sexes. I have also included diagrams of the proportions of figures (see pages 28–31) to make it easier for you to draw the figure correctly.

I cannot stress enough that to draw the human figure effectively, you will eventually need to attend a life class at a local arts facility. Drawing from others' drawings and diagrams is useful, as is drawing from photographs, but you will never make entirely convincing drawings of people unless you also draw from life.

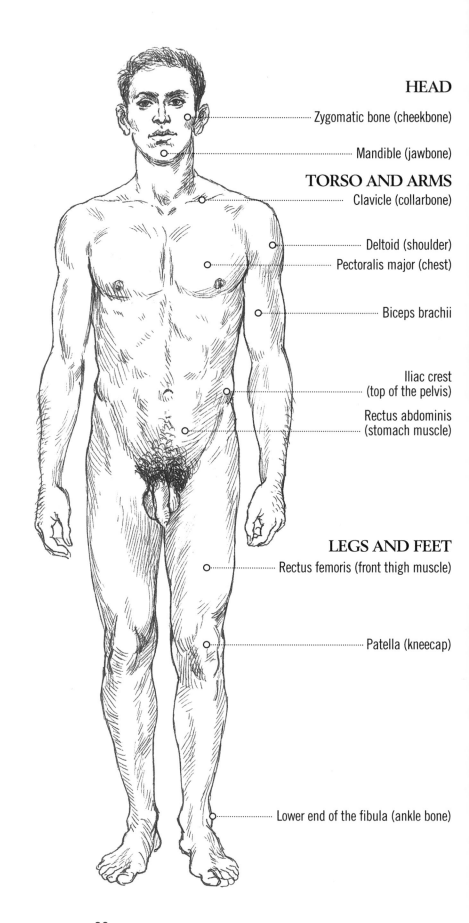

HEAD

Zygomatic bone (cheekbone)

Mandible (jawbone)

TORSO AND ARMS

Clavicle (collarbone)

Deltoid (shoulder)

Pectoralis major (chest)

Biceps brachii

Iliac crest
(top of the pelvis)

Rectus abdominis
(stomach muscle)

LEGS AND FEET

Rectus femoris (front thigh muscle)

Patella (kneecap)

Lower end of the fibula (ankle bone)

HEAD

Frontalis (forehead)

TORSO AND ARMS

Clavicle (collarbone)

Deltoid (shoulder)

Navel

Lower end of radius (wrist bone)

Greater trochanter

Patella (kneecap)

Lower end of tibia (ankle bone)

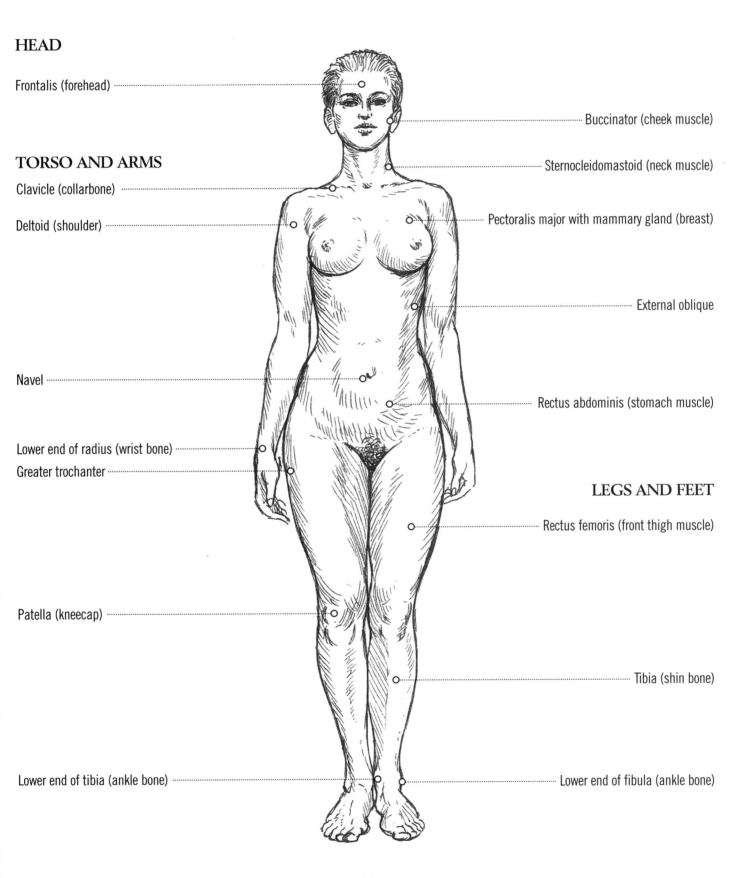

Buccinator (cheek muscle)

Sternocleidomastoid (neck muscle)

Pectoralis major with mammary gland (breast)

External oblique

Rectus abdominis (stomach muscle)

LEGS AND FEET

Rectus femoris (front thigh muscle)

Tibia (shin bone)

Lower end of fibula (ankle bone)

FULL FIGURE SHOWING THE SURFACE OF THE BODY
back view – male

In this view, I have again highlighted the most prominent muscles and parts of the bone structure visible on the surface of the body. The difference between the male and female shapes is clear, in that the male shoulders are wider than any other part of the body, while the female hips and shoulders are of a similar width.

All these body shapes are based on an athletic form, because this shows more clearly the main features of muscle and bone.

Sternocleidomastoid (neck muscle)

Trapezius (top of shoulder)

Acromion

Deltoid (shoulder)

Scapula (shoulder blade)

Teres major

Triceps brachii

Spinal groove

Latissimus dorsi (lower back)

Iliac crest (top edge of pelvis)

Styloid process of radius

Gluteus maximus (buttock)

Biceps femoris (back of thigh)

Iliotibial band

Popliteal fossa (ham)

Gastrocnemius (calf muscle)

Soleus (outer calf)

Medial malleolus of tibia

Tendo calcaneus (Achilles tendon)

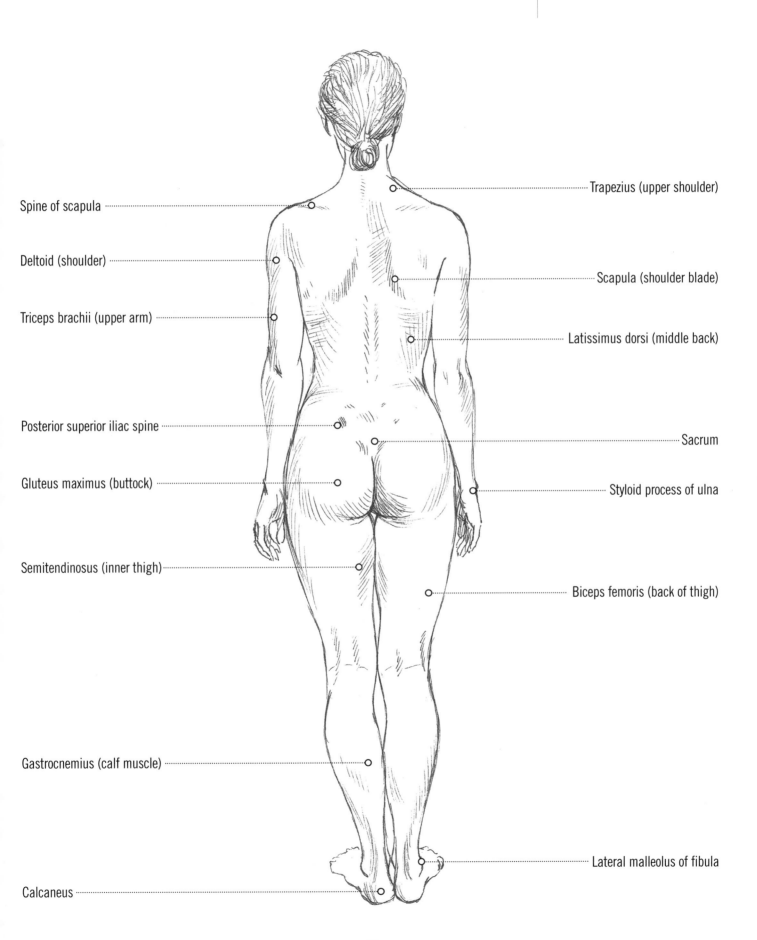

Spine of scapula

Deltoid (shoulder)

Triceps brachii (upper arm)

Posterior superior iliac spine

Gluteus maximus (buttock)

Semitendinosus (inner thigh)

Gastrocnemius (calf muscle)

Calcaneus

Trapezius (upper shoulder)

Scapula (shoulder blade)

Latissimus dorsi (middle back)

Sacrum

Styloid process of ulna

Biceps femoris (back of thigh)

Lateral malleolus of fibula

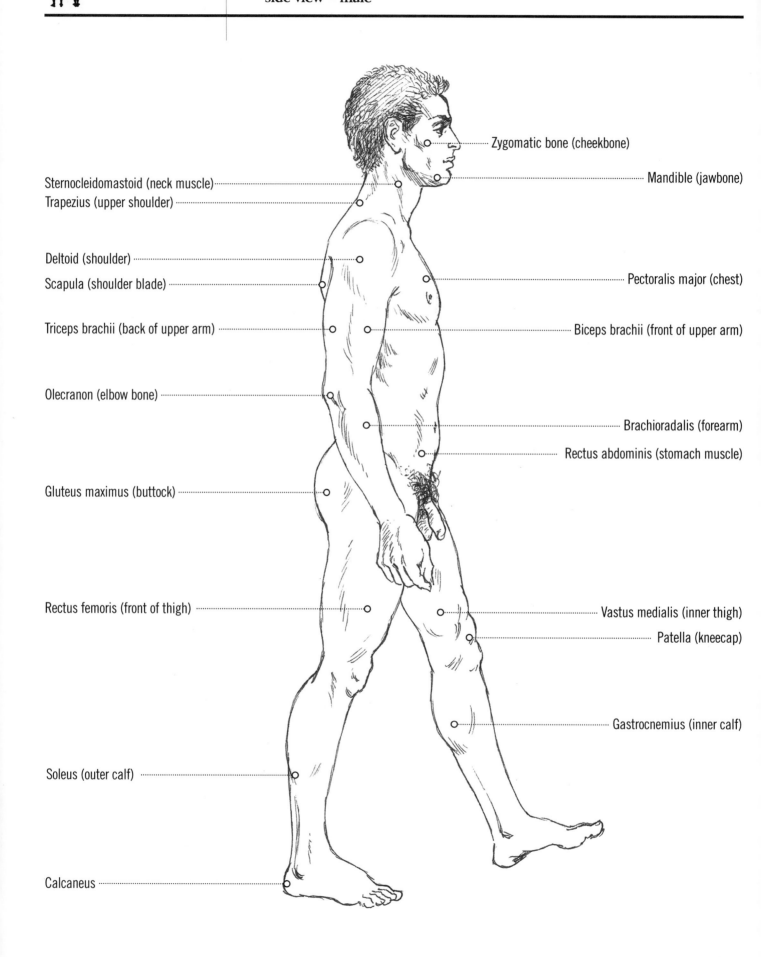

Zygomatic bone (cheekbone)

Sternocleidomastoid (neck muscle)

Mandible (jawbone)

Trapezius (upper shoulder)

Deltoid (shoulder)

Scapula (shoulder blade)

Pectoralis major (chest)

Triceps brachii (back of upper arm)

Biceps brachii (front of upper arm)

Olecranon (elbow bone)

Brachioradalis (forearm)

Rectus abdominis (stomach muscle)

Gluteus maximus (buttock)

Rectus femoris (front of thigh)

Vastus medialis (inner thigh)

Patella (kneecap)

Gastrocnemius (inner calf)

Soleus (outer calf)

Calcaneus

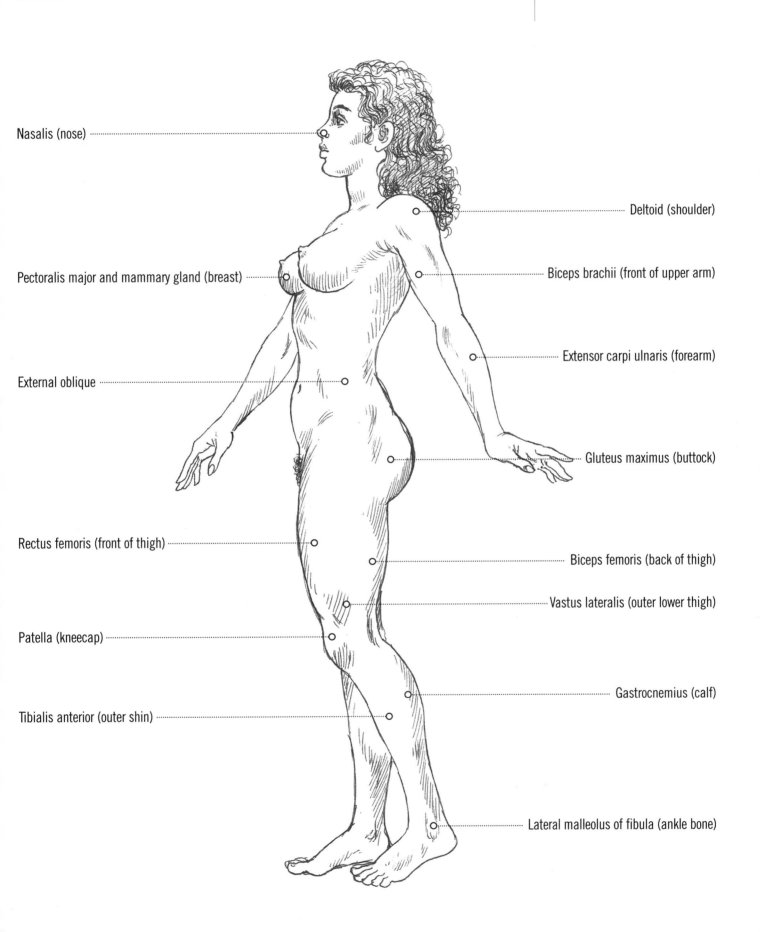

Nasalis (nose)

Deltoid (shoulder)

Pectoralis major and mammary gland (breast)

Biceps brachii (front of upper arm)

Extensor carpi ulnaris (forearm)

External oblique

Gluteus maximus (buttock)

Rectus femoris (front of thigh)

Biceps femoris (back of thigh)

Vastus lateralis (outer lower thigh)

Patella (kneecap)

Gastrocnemius (calf)

Tibialis anterior (outer shin)

Lateral malleolus of fibula (ankle bone)

PROPORTIONAL VIEW OF THE HUMAN BODY
male

In these diagrams, the basic unit of measurement is the length of the head, from the highest point on the top of the skull to the bottom of the chin. The length of the body – from the top of the head to the soles of the feet – is subdivided by the length of the head.

To the left of the male figure is the scale of classical proportion, which makes the head go into the length of the body eight times. This isn't quite accurate, although there may be some tall people with small heads that could fit the scale. It was considered ideal at one time because, drawn like that, the figure had a certain grandeur about it, and so was used for the proportions of heroic and godlike figures.

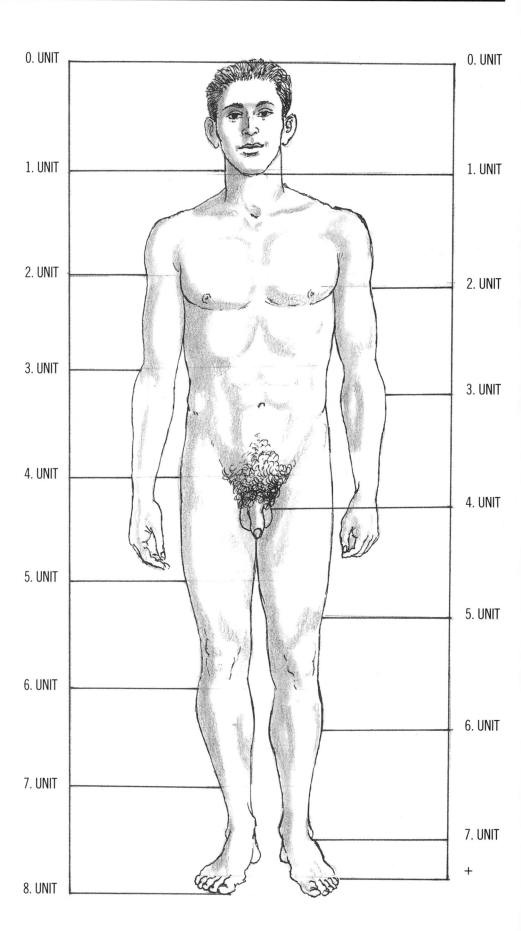

0. UNIT 0. UNIT
1. UNIT 1. UNIT
2. UNIT 2. UNIT
3. UNIT 3. UNIT
4. UNIT 4. UNIT
5. UNIT 5. UNIT
6. UNIT 6. UNIT
7. UNIT 7. UNIT
 +
8. UNIT

28

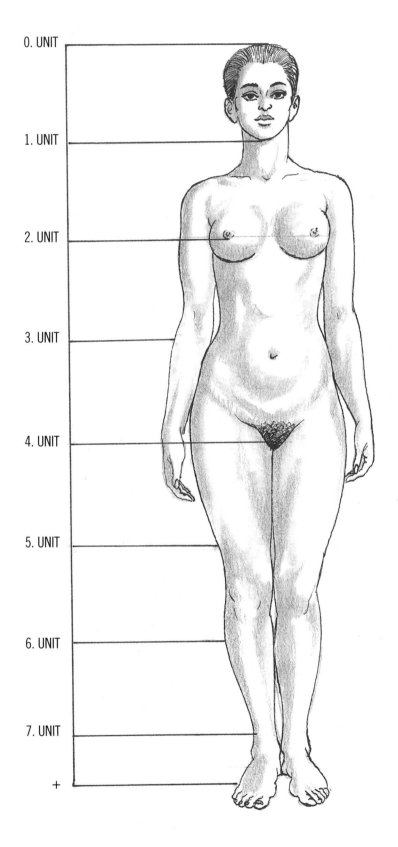

0. UNIT

1. UNIT

2. UNIT

3. UNIT

4. UNIT

5. UNIT

6. UNIT

7. UNIT

+

In fact, most human beings are closer to one head going seven and a half times into the body length. This is the scale shown to the right of the male figure and on the female figure. Even this is an approximation, because not everyone fits the proportion quite so neatly. However, it can be applied to most figures.

What this proportion shows is that two units down from the top of the head marks the position of the nipples on the chest. Three units down from the top marks the position of the navel. Four units down marks the point where the legs divide.

By comparing these two different systems of measurement, you can see that the proportion of one to eight could be made to work, but the proportion of one to seven and a half is closer to reality.

These drawings show the changes in proportion of the human body (male) at different ages. At one year old, only four head lengths fit into the full height of the body, whereas at 25 years old, the head will go into the length of the body about seven and a half times.

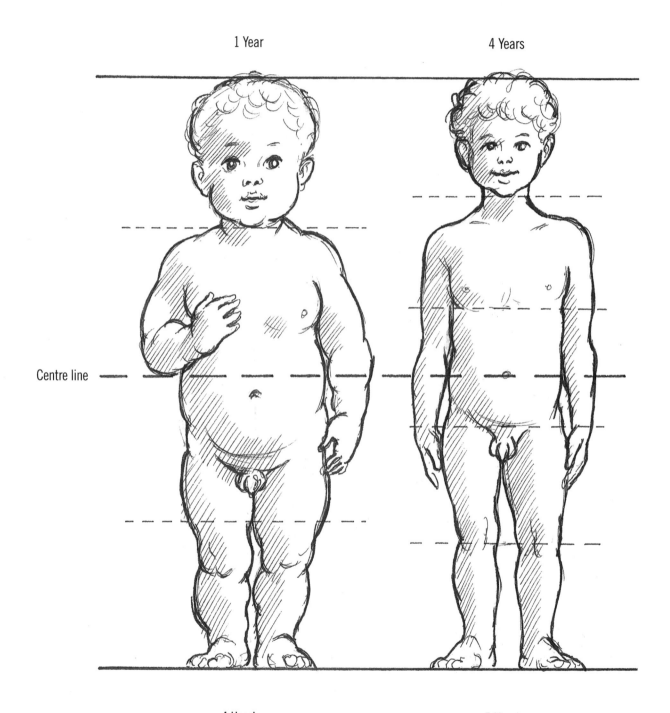

1 Year

4 Years

Centre line

4 Heads

5 Heads

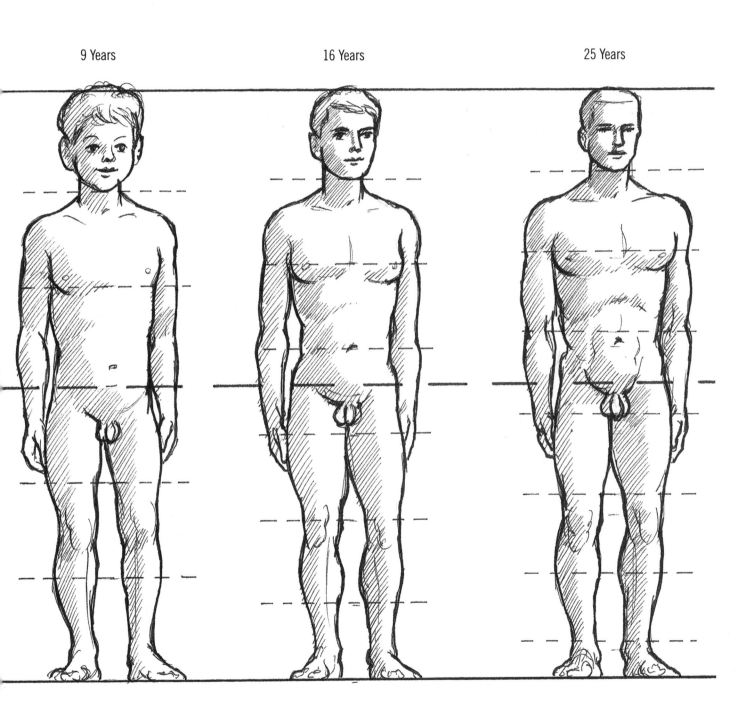

9 Years 16 Years 25 Years

6 Heads 7 Heads 7 ½ Heads

There are differences in structure between the male and female skeleton and between some of the surface muscles. Over the next few pages, I have illustrated those differences that can be identified fairly easily when drawing a figure. Of course, bear in mind that body shape varies widely. Some female figures are nearer to the masculine shape and vice versa.

Generally speaking, the bones of a female skeleton are smaller and more slender than those of a male skeleton. Also the surface of the bone is usually rougher in the male and smoother in the female.

Then, taking the other more obvious differences, the female ribcage is more conical in shape and the breastbone is shorter than the male; this gives an appearance to female shoulders of sloping more than the male. In the male skeleton, the thorax is longer and larger, and the breastbone longer; this makes the shoulders look more square and the neck shorter.

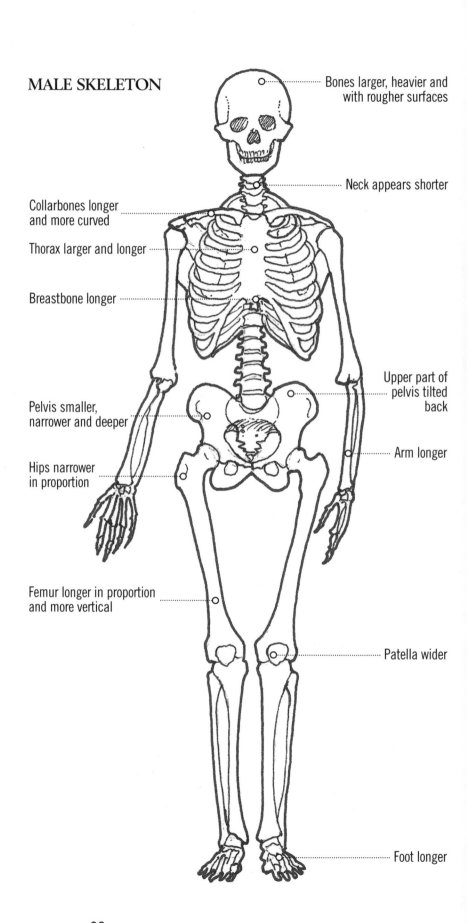

MALE SKELETON

Bones larger, heavier and with rougher surfaces

Neck appears shorter

Collarbones longer and more curved

Thorax larger and longer

Breastbone longer

Upper part of pelvis tilted back

Pelvis smaller, narrower and deeper

Arm longer

Hips narrower in proportion

Femur longer in proportion and more vertical

Patella wider

Foot longer

FEMALE SKELETON

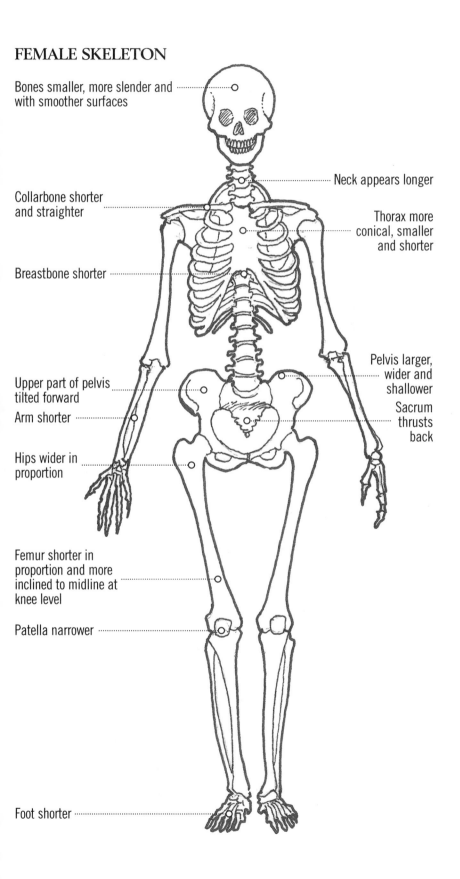

Bones smaller, more slender and with smoother surfaces

Collarbone shorter and straighter

Breastbone shorter

Upper part of pelvis tilted forward

Arm shorter

Hips wider in proportion

Femur shorter in proportion and more inclined to midline at knee level

Patella narrower

Foot shorter

Neck appears longer

Thorax more conical, smaller and shorter

Pelvis larger, wider and shallower

Sacrum thrusts back

Another clear difference between the two sexes is in the disposition of the pelvis. In the female it is broader and shallower than in the male structure. The pubic arch is wider and the sacrum thrusts backwards while the upper part of the pelvis is tilted forwards to accommodate pregnancy and provide the birth canal. In conjunction with this, the female thigh bone (the femur) is generally shorter and inclined more towards the midline at knee level than the male thigh. The effect of this is to make the hips of the female look wider in relation to their height.

Other differences are that the patella, or knee bone, is narrower in the female, and the feet shorter. This is all in proportion to the height of the full figure. Just as the leg is slightly shorter in the female skeleton, so also is the arm in relation to the rest of the skeleton. This all becomes more obvious when you see the skeleton covered with muscles and fat and skin, while in the skeleton itself it is not quite so noticeable. In some cases it can be quite difficult to tell the difference between a male and a female skeleton.

MALE SKULL

Larger and heavier
than the female

Contours rougher

Parietal bone

Temporal bone

Occipital bone

Occipital protuberance more prominent

Auditory canal

Mastoid process larger

Angle of mandible squarer

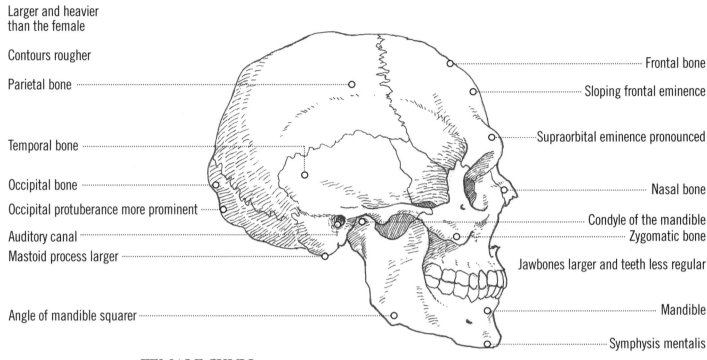

Frontal bone

Sloping frontal eminence

Supraorbital eminence pronounced

Nasal bone

Condyle of the mandible

Zygomatic bone

Jawbones larger and teeth less regular

Mandible

Symphysis mentalis

FEMALE SKULL

Smaller,
lighter and
smoother than
the male skull

Contours
rounder and
smoother

Mastoid process
smaller

Angle of mandible less pronounced

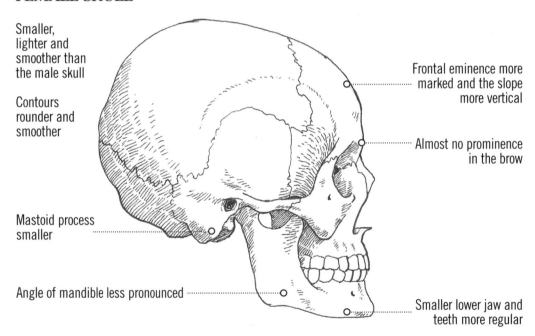

Frontal eminence more
marked and the slope
more vertical

Almost no prominence
in the brow

Smaller lower jaw and
teeth more regular

INFANT SKULL

The main difference between the infant skull and the adult one
is the smaller size of the face compared with the cranium.

The upper and lower jaws are much smaller due to not having
any teeth. As teeth appear, the jaw grows.

MALE PELVIS
seen from the back

Vertebral column

Narrower and deeper
than the female

Sacrum longer, less concave and narrower

FEMALE PELVIS
seen from the back

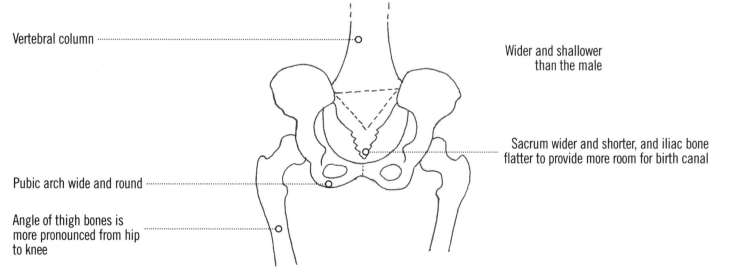

Vertebral column

Wider and shallower
than the male

Sacrum wider and shorter, and iliac bone
flatter to provide more room for birth canal

Pubic arch wide and round

Angle of thigh bones is
more pronounced from hip
to knee

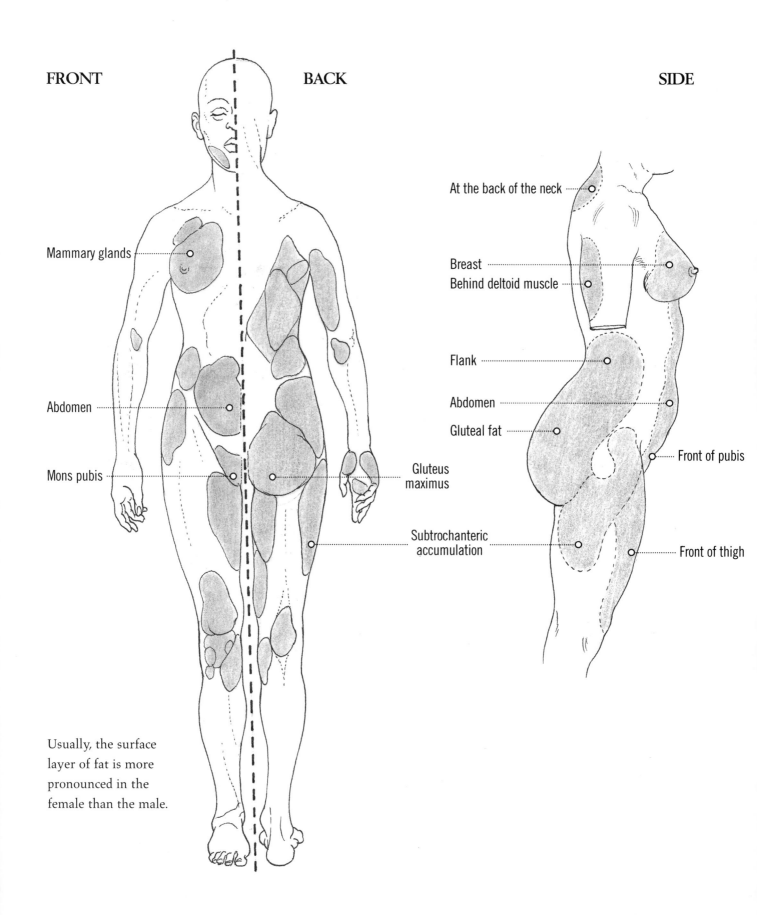

FRONT

BACK

SIDE

Mammary glands

Abdomen

Mons pubis

Gluteus maximus

Subtrochanteric accumulation

At the back of the neck

Breast
Behind deltoid muscle

Flank

Abdomen

Gluteal fat

Front of pubis

Front of thigh

Usually, the surface layer of fat is more pronounced in the female than the male.

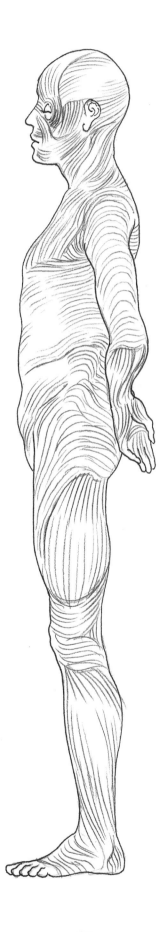

The skin surface tensions are the cleavage lines of the human skin, or the direction in which the skin will crease. Muscle fibres tense along banded patterns, in order to accommodate bodily movement. An incision along these lines will heal well, because the skin's tension pulls the cut together. A cut across them will pucker and scar.

The proportions you learnt on pages 28–31 will not of course apply when you look at the figure from different angles, since what is nearest to you appears to be proportionately larger than what is further away. You can see this clearly from the two drawings on this page. With foreshortening, the actual relative sizes of parts of the body are meaningless.

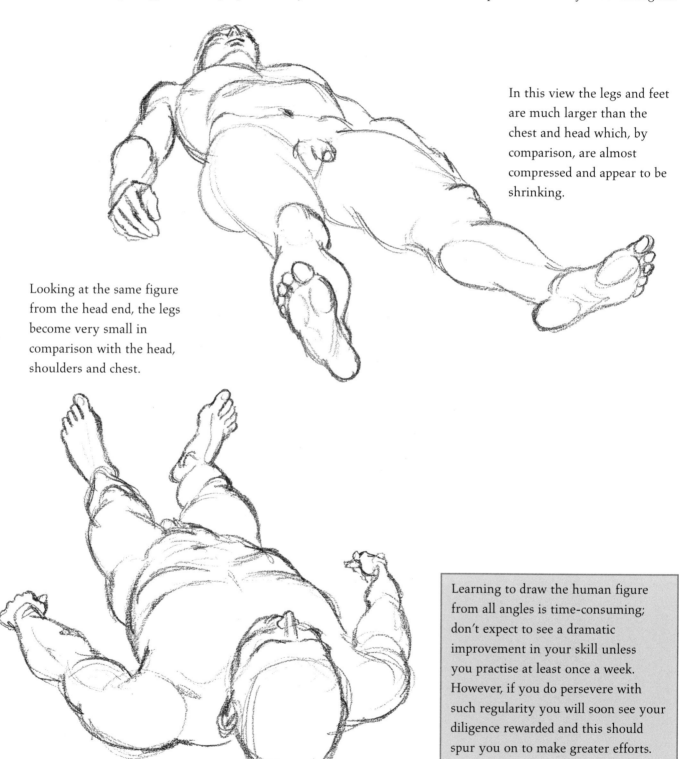

In this view the legs and feet are much larger than the chest and head which, by comparison, are almost compressed and appear to be shrinking.

Looking at the same figure from the head end, the legs become very small in comparison with the head, shoulders and chest.

Learning to draw the human figure from all angles is time-consuming; don't expect to see a dramatic improvement in your skill unless you practise at least once a week. However, if you do persevere with such regularity you will soon see your diligence rewarded and this should spur you on to make greater efforts.

In this drawing after Michelangelo, you can see the extreme foreshortening of part of the figure's right arm. While the upper arm is held straight down, supporting the weight of the upper body, scarcely any of the forearm can be seen as it is directed towards the viewer and masked by the hand. As the foremost part of the limb, the hand looks proportionately larger in relation to the upper arm. While drawing the body in perspective may seem tricky at first, it is only a matter of drawing what you can see – your eye will have instinctively understood what this drawing is telling you about the pose.

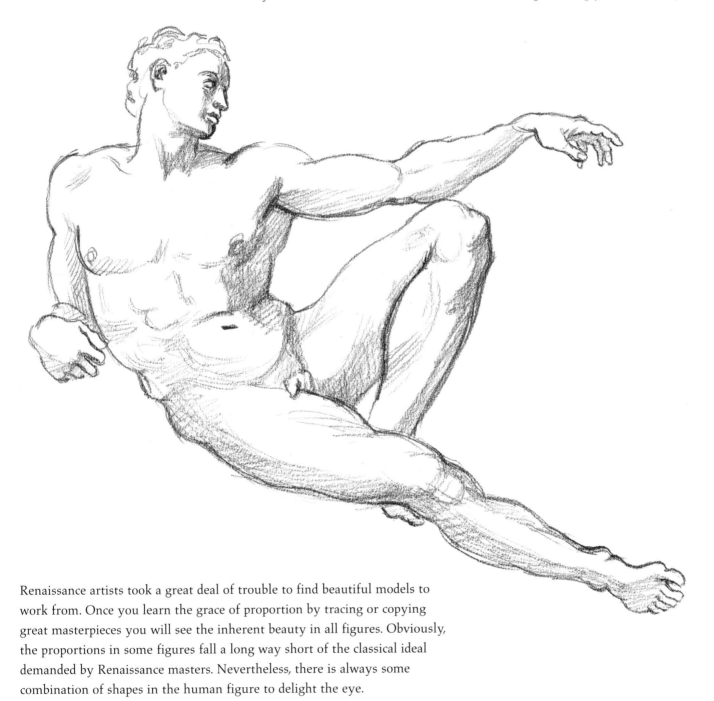

Renaissance artists took a great deal of trouble to find beautiful models to work from. Once you learn the grace of proportion by tracing or copying great masterpieces you will see the inherent beauty in all figures. Obviously, the proportions in some figures fall a long way short of the classical ideal demanded by Renaissance masters. Nevertheless, there is always some combination of shapes in the human figure to delight the eye.

Here I show drawings after two of the great masters of the human form, Michelangelo Buonarroti and Jean-Auguste Dominique Ingres. These artists made many studies of the human body, both adopting very different approaches.

Michelangelo drew almost every muscle that could be shown in his drawings. As well as being an artist, he was also a great sculptor, fascinated by the way the shape of the figure was built up, with muscle forms clearly shown on the surface of the body. His approach was influenced by the relatively new science of dissection, which the Renaissance artists were beginning to explore.

By the time we get to the 19th century, however, the French master Ingres was endeavouring to show how subtle depictions of the human form could be, with all the musculature very softly indicated and tones graduated from one place to the next on the form. This slightly more cosmetic approach was, in a way, a move away from the overtly dramatic methods of showing the human form after the age of Michelangelo.

Nowadays, we tend to use both approaches to our advantage.

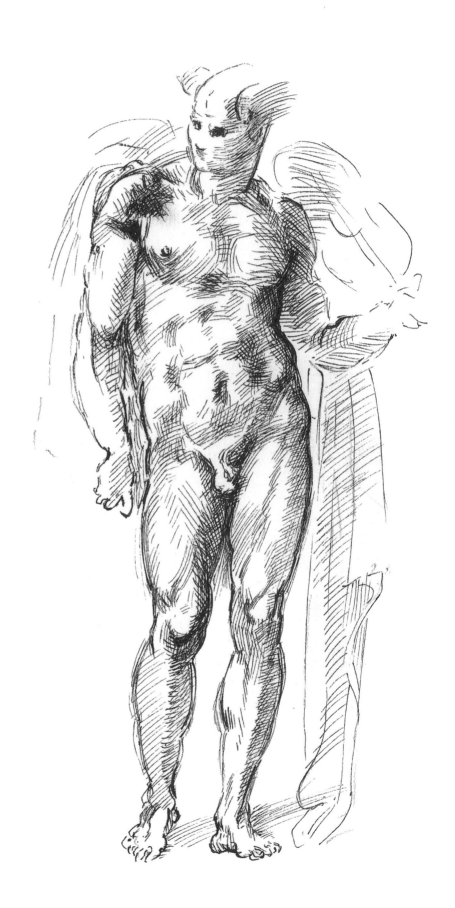

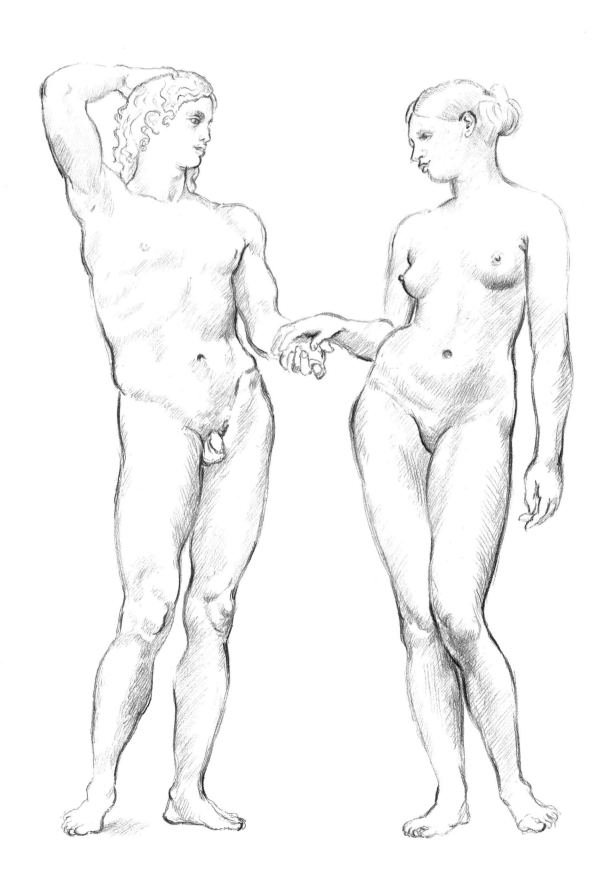

41

THE FULL FIGURE DRAWN BY MASTER ARTISTS
after Camille Corot (1796–1875)

Corot's drawing is interesting to the student of anatomy, because although he primarily shows smooth, flowing forms, it is still possible to see the main shapes of the muscles and bone structure underneath.

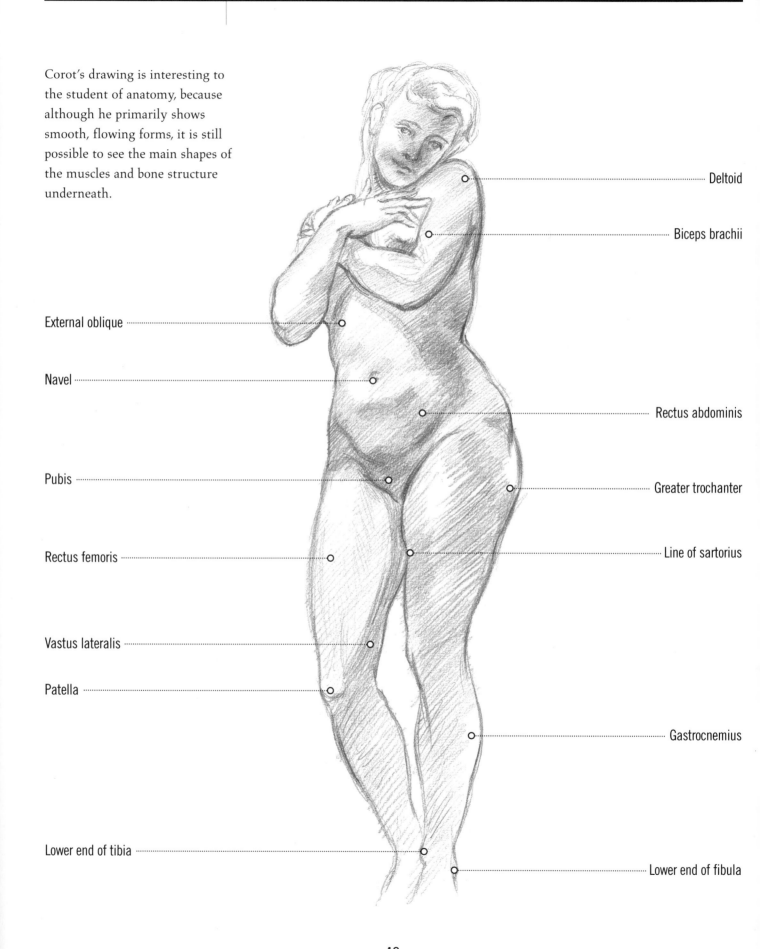

Deltoid

Biceps brachii

External oblique

Navel

Rectus abdominis

Pubis

Greater trochanter

Rectus femoris

Line of sartorius

Vastus lateralis

Patella

Gastrocnemius

Lower end of tibia

Lower end of fibula

In this 18th-century German drawing the musculature is made more obvious by the strong, oblique lighting that throws into relief the edges of the muscles and bones on the surface.

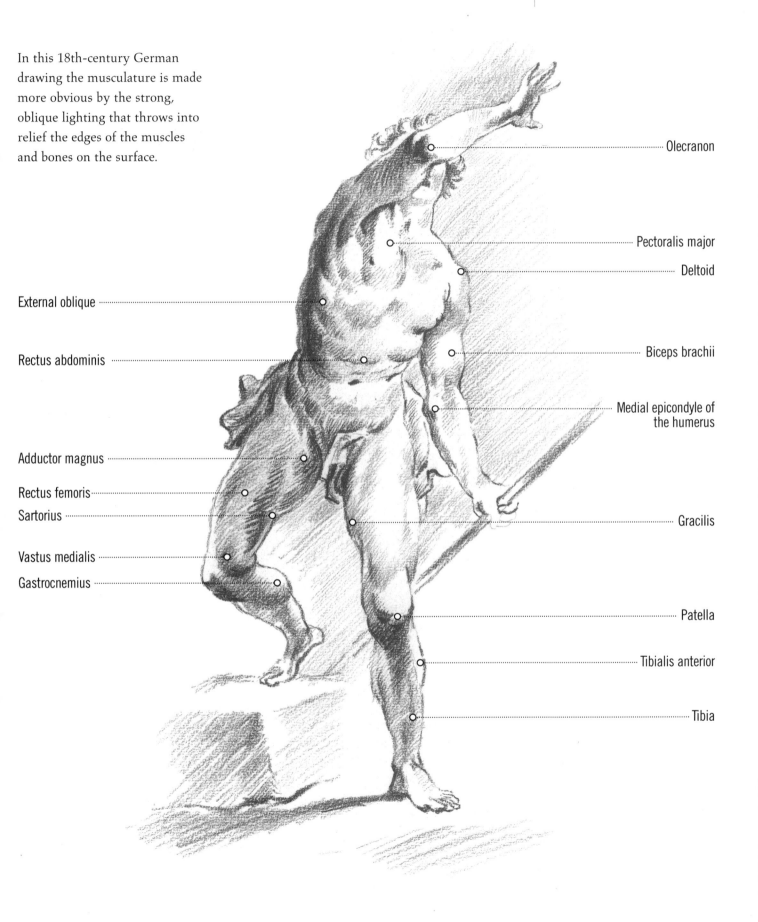

Olecranon

Pectoralis major

Deltoid

External oblique

Biceps brachii

Rectus abdominis

Medial epicondyle of the humerus

Adductor magnus

Rectus femoris

Sartorius

Gracilis

Vastus medialis

Gastrocnemius

Patella

Tibialis anterior

Tibia

THE FULL FIGURE DRAWN BY MASTER ARTISTS
after Luca Signorelli (1445–1523)

Signorelli's figure drawing always shows the large muscles very clearly. This study of the back view of a male figure shows how well he understood the muscularity of the human form.

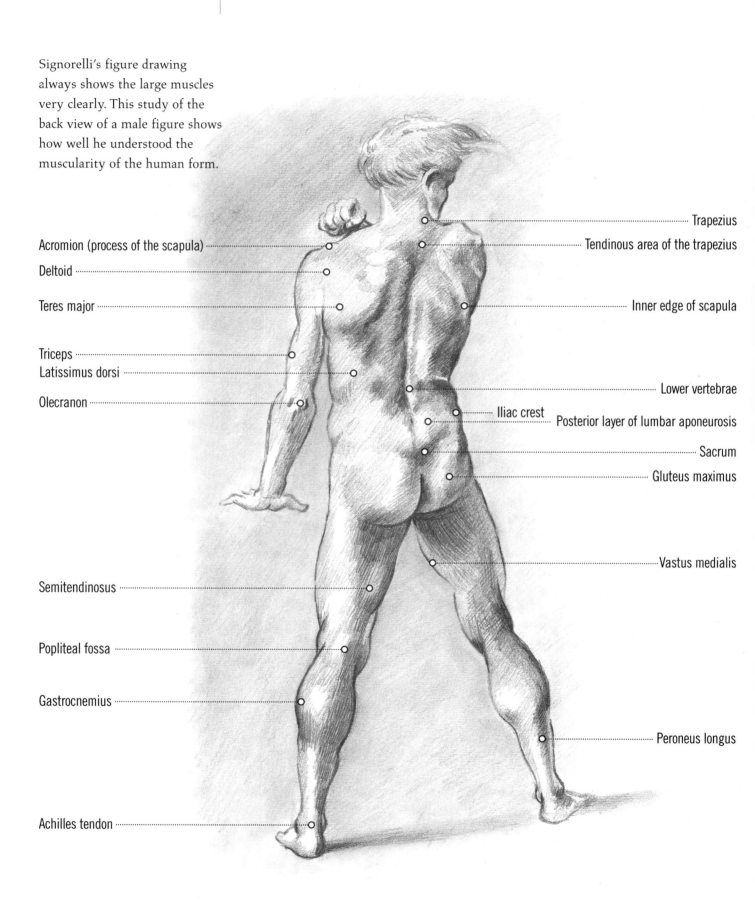

Acromion (process of the scapula)

Deltoid

Teres major

Triceps

Latissimus dorsi

Olecranon

Semitendinosus

Popliteal fossa

Gastrocnemius

Achilles tendon

Trapezius

Tendinous area of the trapezius

Inner edge of scapula

Lower vertebrae

Iliac crest

Posterior layer of lumbar aponeurosis

Sacrum

Gluteus maximus

Vastus medialis

Peroneus longus

Noel-Nicholas Coypel's study of the back of a nymph under a strong, oblique light makes each curve of the body stand out clearly. Note particularly the details of the upper back.

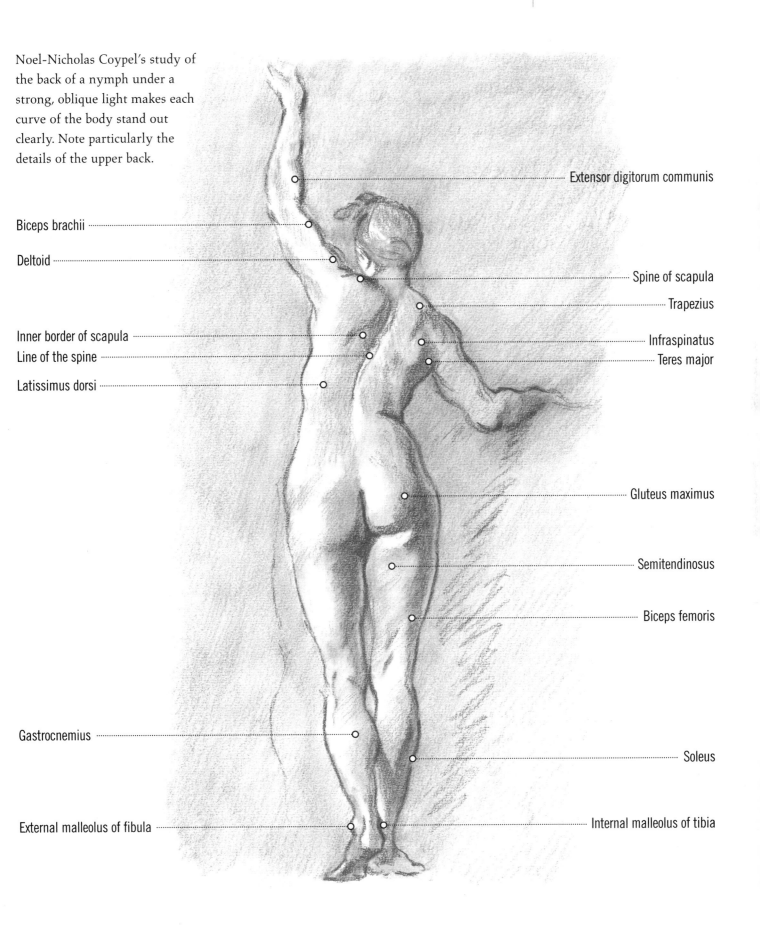

Extensor digitorum communis

Biceps brachii

Deltoid

Spine of scapula

Trapezius

Inner border of scapula

Infraspinatus

Line of the spine

Teres major

Latissimus dorsi

Gluteus maximus

Semitendinosus

Biceps femoris

Gastrocnemius

Soleus

External malleolus of fibula

Internal malleolus of tibia

I would now like to show you some of the finest studies ever made of the human figure and they are all on one particular theme. Since the Renaissance, the female nude has been a favourite subject for artists and here is a selection for comparison.

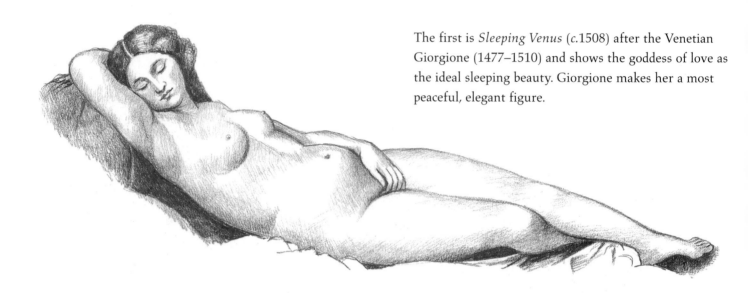

The first is *Sleeping Venus* (*c.*1508) after the Venetian Giorgione (1477–1510) and shows the goddess of love as the ideal sleeping beauty. Giorgione makes her a most peaceful, elegant figure.

The second picture is after Giorgione's famous pupil and collaborator, Titian (1488–1576), another great Venetian painter. Titian pays tribute to his master in the *Venus of Urbino* (*c.*1538). He closely follows Giorgione's pose, but on this occasion the beauty is wide awake and looking directly at us. For the time this was very unusual because the female nude normally posed modestly with downcast eyes. But Titian was no ordinary painter and he draws us into the picture with a strong element of seduction in the portrayal of his Venus.

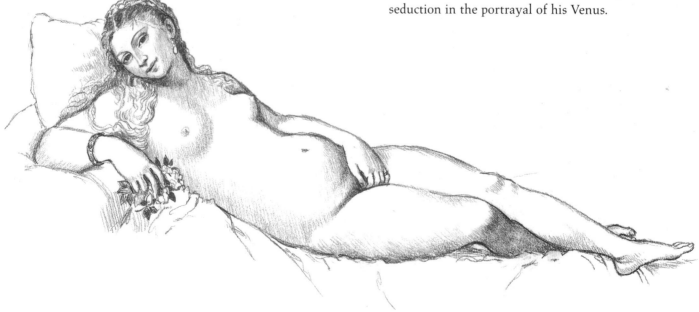

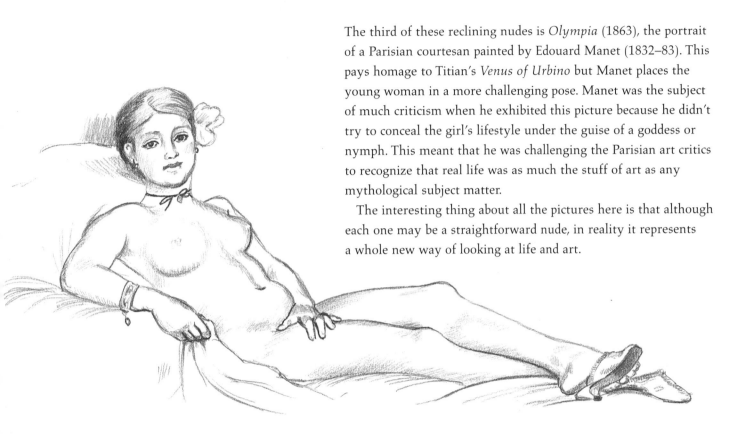

The third of these reclining nudes is *Olympia* (1863), the portrait of a Parisian courtesan painted by Edouard Manet (1832–83). This pays homage to Titian's *Venus of Urbino* but Manet places the young woman in a more challenging pose. Manet was the subject of much criticism when he exhibited this picture because he didn't try to conceal the girl's lifestyle under the guise of a goddess or nymph. This meant that he was challenging the Parisian art critics to recognize that real life was as much the stuff of art as any mythological subject matter.

The interesting thing about all the pictures here is that although each one may be a straightforward nude, in reality it represents a whole new way of looking at life and art.

The last study, *The Naked Maja* (1799–1800) after the Spanish master Francisco Goya (1746–1828), is in the eighteenth-century tradition of the bacchante or nymph, gazing out of the picture at us, relaxed and at ease on her couch, demanding that we appreciate her charms. But there is an indication that the subject of this picture is not quite as decorous as she should be. This is definitely a challenging portrait, and one that was painted for a notorious libertine at the Spanish court, Manuel Godoy.

Don't worry that any pose you might choose has been attempted before: it is what you do with the standard human figure in a particular situation that will make your drawing significant or not.

Now that you have looked at some possibilities with the human figure in a variety of positions, try drawing from a famous classical figure painting, the *Rokeby Venus* by Velasquez, using tone to increase the three-dimensional qualities of your drawing.

Pay attention to the direction of the light source, as this will tell you what is happening to the shape of the body. Keep everything very simple to start with and do not concern yourself with producing a 'beautiful' drawing. Really beautiful drawings are those that express the truth of what you see.

Direction of light source

Line of hips

1. Sketch in the main outline, ensuring that the proportions are correct. Note the lines of the backbone, shoulders and hips. Check the body width in relation to the length and the size of the head in relation to the body length. Pay special attention also to the thickness of the neck, wrists, ankles and knees. All of them should be narrower than the parts either side of them.

2. Finalize the shape of the limbs, torso and head. Then draw in the shapes of muscles and identify the main areas of tone or shadow.

3. Carefully model in darker and lighter tones to show the form. Some areas are very dark, usually those of deepest recession. The highlights or very light areas are the surfaces facing directly towards the source of light, which should look extremely bright in contrast to any other area.

When you have finished applying tone, give your figure a place to exist in by adding tones to the background. These will enhance your drawing by throwing the strongly defined areas of light forwards, thereby increasing the three-dimensional effect.

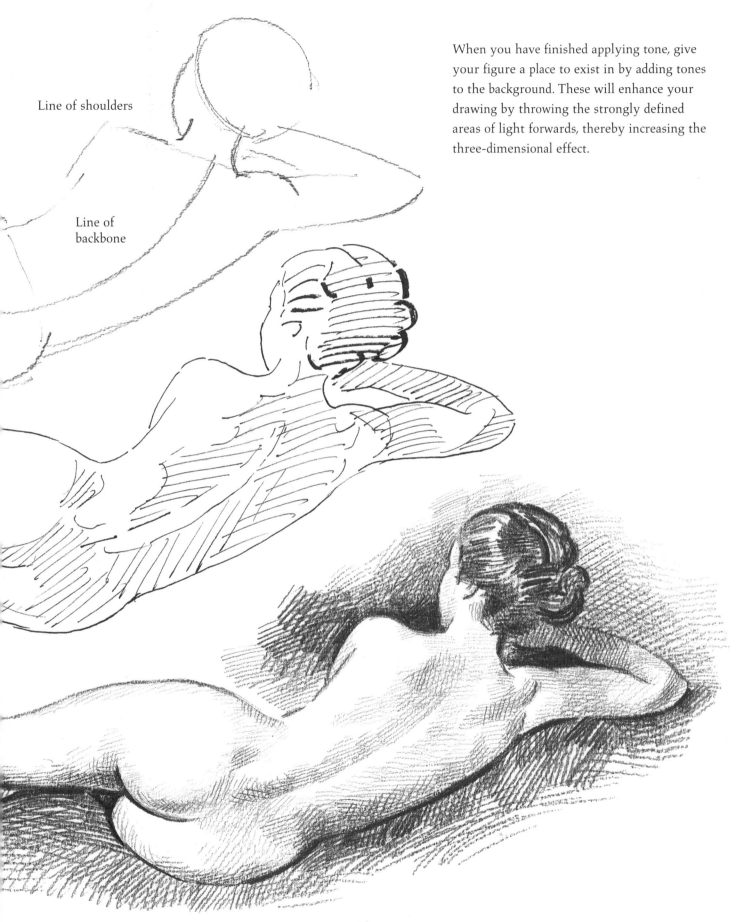

Line of shoulders

Line of backbone

THE HEAD

In the following sections we shall explore each part of the body in greater detail, starting with the head and neck. As in the opening chapter, we begin by looking at the bone structure and then go on to study the musculature.

The skull, or cranium, is made up of several bones, although by the time an individual reaches puberty many of them have fused together in a process called ossification; in doing so they provide a solid case for the delicate organs inside. The joins of these bones are called sutures. At birth, the bones have not yet knitted together because they must be flexible during the birth process; and since the brain will grow quite a bit before adulthood, the sutures in a child's skull do not fuse completely for a number of years. The mandible (jawbone) grows dramatically as the child matures, and an adult jaw is noticeably larger in proportion to the rest of the skull than that of a small child.

Although the muscles of the head are not very large in comparison with the rest

of the body, they are significant because so many of them work to change our facial expressions. The face is the part of the body that we respond to most and, as artists, the chief feature by which we capture the likeness of a person.

The top of the head is generally covered in hair and the artist needs to determine the proportion of this part of the head in relation to the face, so it is best to establish the hairline straightaway by sketching it in across the forehead and down as far as the ears. The shape and location of the eyes are very important; and the length and shape of the nose and the disposition of the mouth give us the rest of the expressive face.

At the end of this section we shall look at the head and face as depicted by various artists, and there is an example of how to make your own straightforward drawing. We shall investigate the features and facial expressions in detail later, on pages 146–161.

The upper part of the skull contains the brain and the organs of sight and hearing. The front and rear parts consist of the thickest bone, where impacts are most likely; the sides of the head are much thinner. There are various openings in the case of the skull such as the nose and ear holes and the eye sockets, which encompass smaller apertures for the passage of the optic nerves to the brain. Underneath we find the nasal cavities and the foramen magnum, through which the spinal column passes and connections are maintained between the brain and the rest of the body.

The lower part of the skull is the mandible, which houses the lower teeth and is hinged at the sides of the upper skull just below the ears. The first (milk) teeth fall out during childhood and are replaced by much larger adult teeth, which fill out the growing jaw.

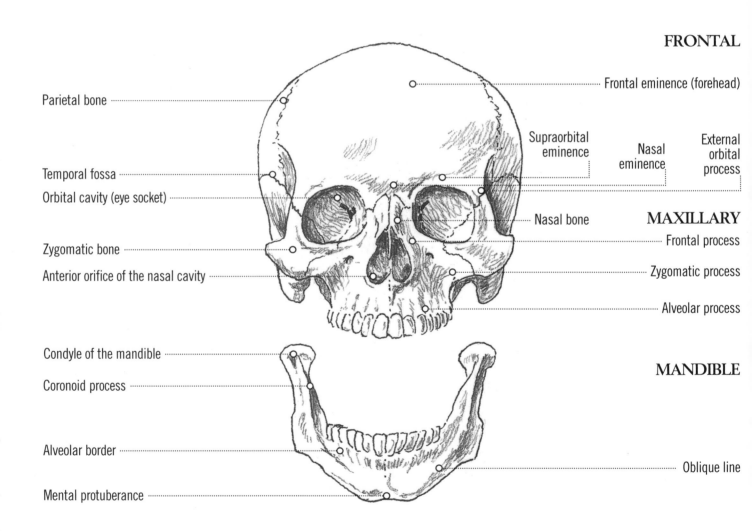

FRONTAL

Parietal bone

Frontal eminence (forehead)

Supraorbital eminence

Nasal eminence

External orbital process

Temporal fossa

Orbital cavity (eye socket)

Nasal bone

MAXILLARY

Zygomatic bone

Frontal process

Anterior orifice of the nasal cavity

Zygomatic process

Alveolar process

Condyle of the mandible

MANDIBLE

Coronoid process

Alveolar border

Oblique line

Mental protuberance

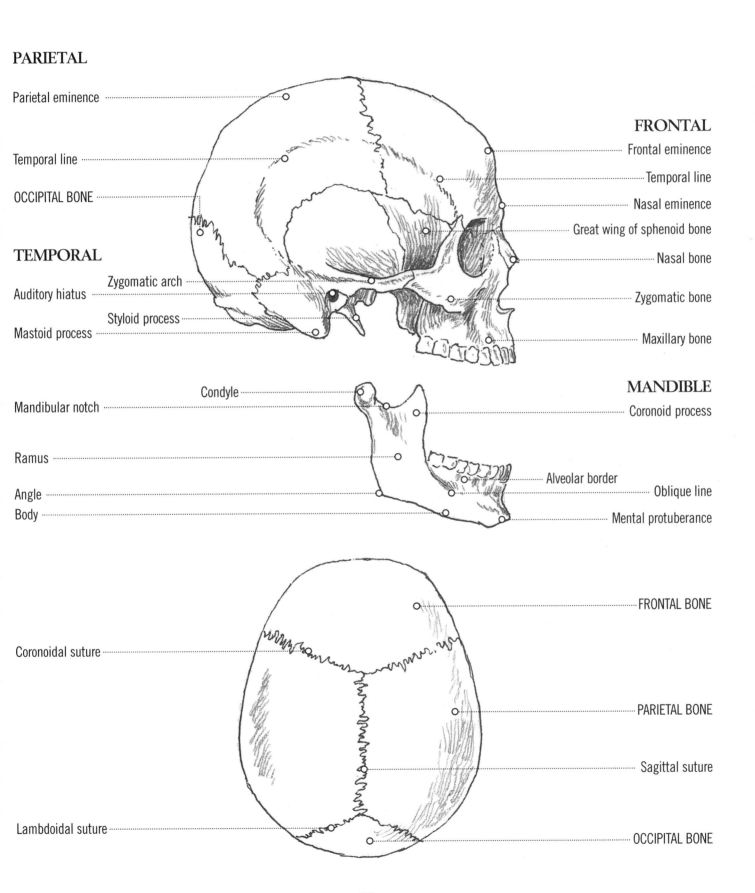

PARIETAL

Parietal eminence

Temporal line

OCCIPITAL BONE

TEMPORAL

Auditory hiatus

Zygomatic arch

Styloid process

Mastoid process

FRONTAL

Frontal eminence

Temporal line

Nasal eminence

Great wing of sphenoid bone

Nasal bone

Zygomatic bone

Maxillary bone

Condyle

Mandibular notch

Ramus

Angle

Body

MANDIBLE

Coronoid process

Alveolar border

Oblique line

Mental protuberance

Coronoidal suture

Lambdoidal suture

FRONTAL BONE

PARIETAL BONE

Sagittal suture

OCCIPITAL BONE

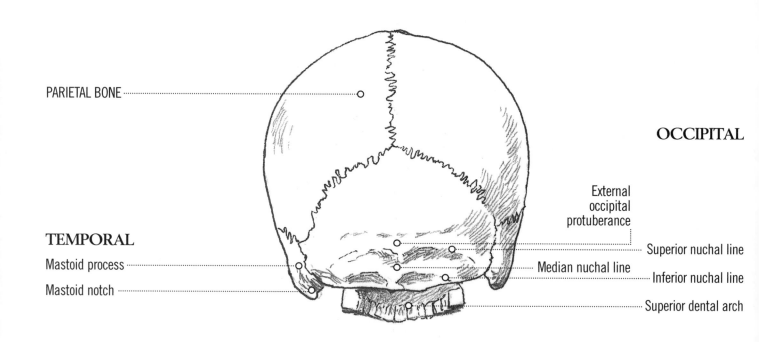

PARIETAL BONE

OCCIPITAL

External occipital protuberance

Superior nuchal line

TEMPORAL

Mastoid process

Median nuchal line

Inferior nuchal line

Mastoid notch

Superior dental arch

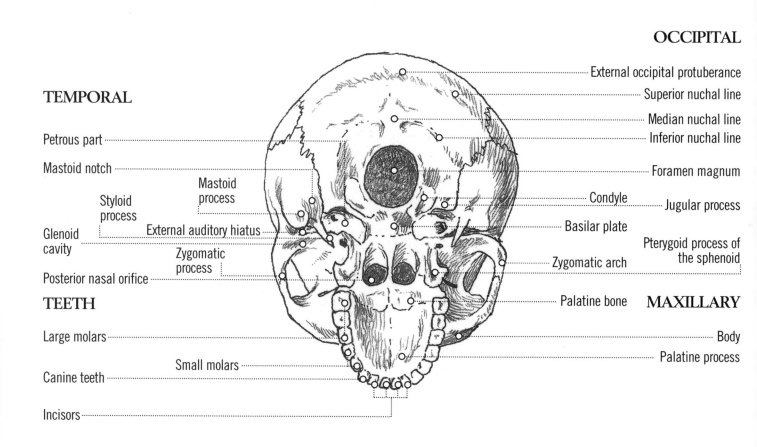

OCCIPITAL

TEMPORAL

External occipital protuberance

Superior nuchal line

Median nuchal line

Petrous part

Inferior nuchal line

Mastoid notch

Mastoid process

Foramen magnum

Styloid process

Condyle

Jugular process

Glenoid cavity

External auditory hiatus

Basilar plate

Zygomatic process

Pterygoid process of the sphenoid

Posterior nasal orifice

Zygomatic arch

TEETH

Palatine bone

MAXILLARY

Large molars

Body

Small molars

Palatine process

Canine teeth

Incisors

These are the muscles that enable us to eat and drink, and of course they surround our organs of sight, sound, smell and taste. Although they don't have the physical power of the larger muscles of the limbs and trunk, they do play an important part in our lives.

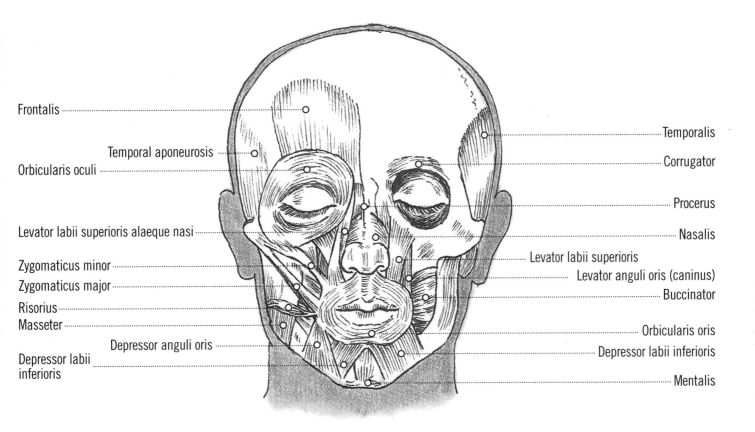

Frontalis

Temporal aponeurosis

Orbicularis oculi

Levator labii superioris alaeque nasi

Zygomaticus minor

Zygomaticus major

Risorius

Masseter

Depressor anguli oris

Depressor labii inferioris

Temporalis

Corrugator

Procerus

Nasalis

Levator labii superioris

Levator anguli oris (caninus)

Buccinator

Orbicularis oris

Depressor labii inferioris

Mentalis

DEEP LAYER

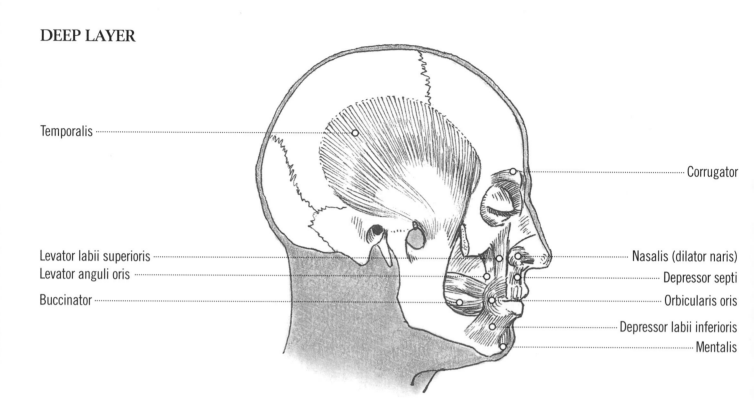

Temporalis

Corrugator

Levator labii superioris
Levator anguli oris
Buccinator

Nasalis (dilator naris)
Depressor septi
Orbicularis oris
Depressor labii inferioris
Mentalis

SUPERFICIAL LAYER

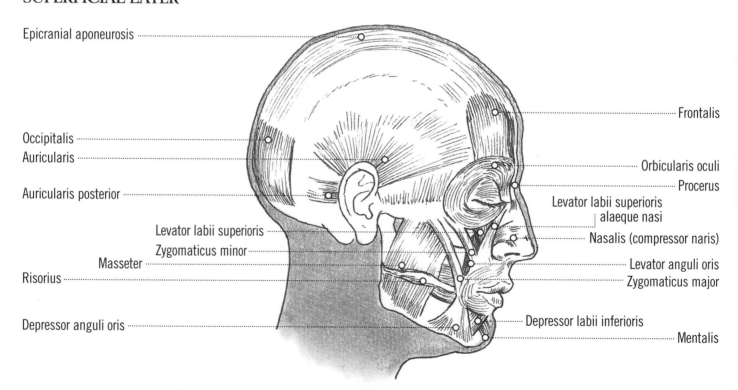

Epicranial aponeurosis

Frontalis

Occipitalis
Auricularis

Orbicularis oculi
Procerus

Auricularis posterior

Levator labii superioris
alaeque nasi

Levator labii superioris
Zygomaticus minor
Masseter
Risorius

Nasalis (compressor naris)
Levator anguli oris
Zygomaticus major

Depressor anguli oris

Depressor labii inferioris
Mentalis

I have included the muscles of the neck with the head because, in most respects, their effect can be closely aligned with the head structure.

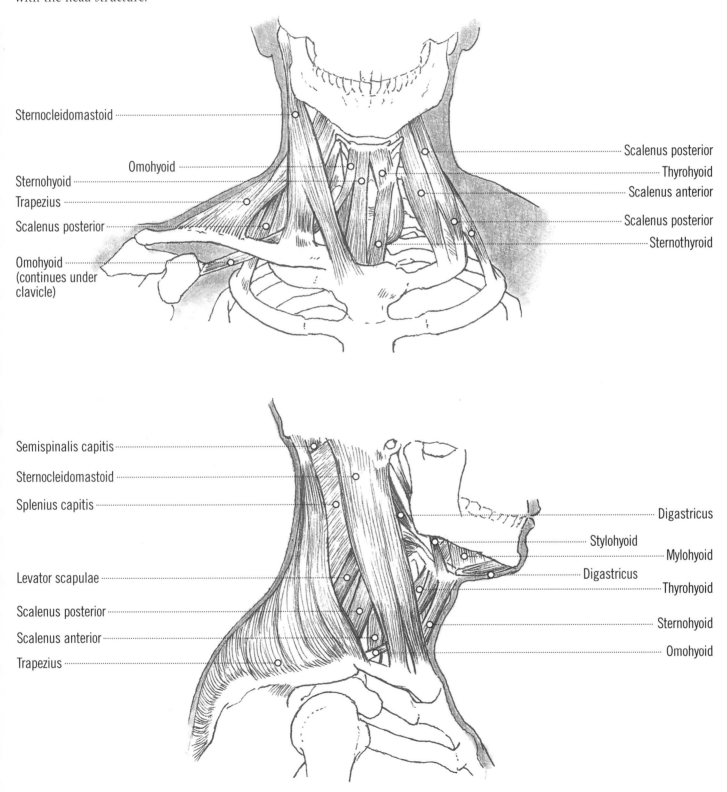

Sternocleidomastoid

Omohyoid

Sternohyoid

Trapezius

Scalenus posterior

Omohyoid
(continues under
clavicle)

Scalenus posterior

Thyrohyoid

Scalenus anterior

Scalenus posterior

Sternothyroid

Semispinalis capitis

Sternocleidomastoid

Splenius capitis

Levator scapulae

Scalenus posterior

Scalenus anterior

Trapezius

Digastricus

Stylohyoid

Mylohyoid

Digastricus

Thyrohyoid

Sternohyoid

Omohyoid

This drawing, made from a very clear and detailed photograph, shows the muscles that can be seen on the surface of a mature man's face.

The temporal line shows clearly at the temple of the forehead, and the temporalis and frontalis muscles, although these don't stand out strongly, are being pulled tightly across the bone structure of the skull. Around the eye, the orbicularis oculi and the procerus muscles are visible.

Around the mouth and nose can be discerned the levator labii superioris alaeque nasi, the compressor naris and the dilator naris (both part of the nasalis), the depressor labii inferioris, the levator anguli oris and the depressor anguli oris.

Further back near the ear is the edge of the zygomatic bone called the zygomatic arch, with the zygomaticus major, which is the muscle that stretches across from the arch to the corner of the mouth. Also on the jaw can be seen the bulge of the masseter muscle.

On the neck, the trapezius, the sternocleidomastoid and the sternothyroid can be seen.

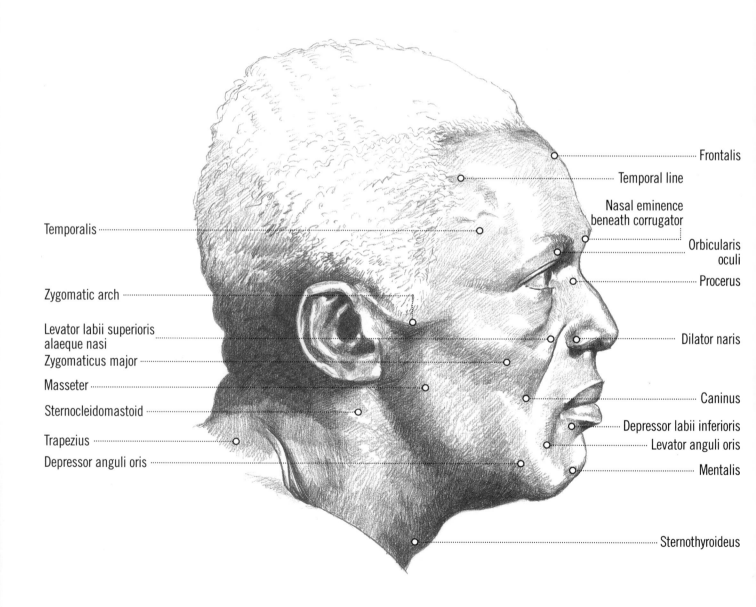

Labels, left side (top to bottom): Temporalis · Zygomatic arch · Levator labii superioris alaeque nasi · Zygomaticus major · Masseter · Sternocleidomastoid · Trapezius · Depressor anguli oris

Labels, right side (top to bottom): Frontalis · Temporal line · Nasal eminence beneath corrugator · Orbicularis oculi · Procerus · Dilator naris · Caninus · Depressor labii inferioris · Levator anguli oris · Mentalis · Sternothyroideus

Here the same muscles can be seen as in the previous portrait, along with others including the corrugator, the mentalis and the buccinator.

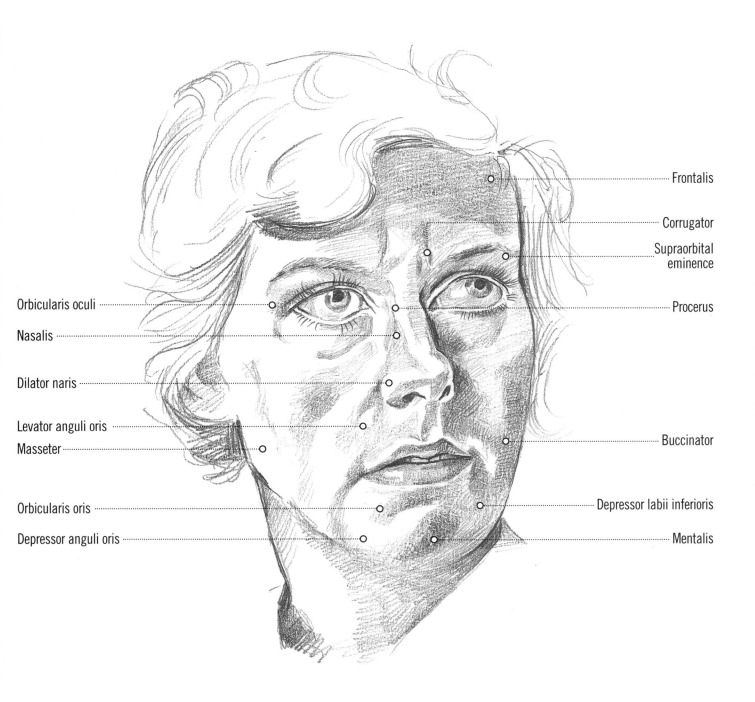

Orbicularis oculi

Nasalis

Dilator naris

Levator anguli oris

Masseter

Orbicularis oris

Depressor anguli oris

Frontalis

Corrugator

Supraorbital eminence

Procerus

Buccinator

Depressor labii inferioris

Mentalis

The same groups of muscles can be seen on the drawings by Michelangelo and Peter Paul Rubens. It is interesting to note that as soon as you start to look for these muscles of the face, they become clearer and it is easier to draw them correctly.

After Michelangelo

Frontalis

Orbicularis oculi

Levator labii superioris alaeque nasi

Nasalis

Orbicularis oris

Levator anguli oris

Mentalis

Sternothyroideus

Masseter

Zygomaticus major

Sternocleidomastoid

Trapezius

Depressor anguli oris

After Peter Paul Rubens (1577–1640)

Corrugator

Nasalis

Orbicularis oris

Mentalis

Frontalis

Orbicularis oculi

Masseter

Zygomaticus major

Depressor anguli oris

In our last drawing, *Self-portrait* from 1913 after the Irish artist William Orpen, we see the main muscles of the human head again quite clearly. It is probably easier to see them on a more mature face and one that does not have too much flesh on it, because younger or more rounded faces don't show the muscles so clearly.

After William Orpen (1878–1931)

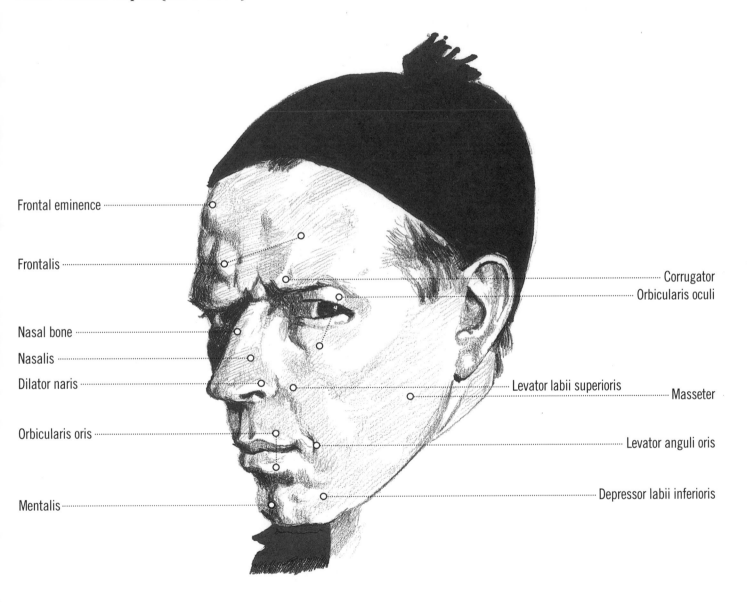

Frontal eminence

Frontalis

Nasal bone

Nasalis

Dilator naris

Orbicularis oris

Mentalis

Corrugator

Orbicularis oculi

Levator labii superioris

Masseter

Levator anguli oris

Depressor labii inferioris

Now have a go at drawing a portrait, remembering the muscle and bone structure you have learnt about; a child's softly rounded face makes for an easy start. The position of the head gives some idea of the kind of person you are drawing. Gentle or introverted people tend to look down, while aggressive people look up or straight ahead, chin raised, so drawing them looking straight at the viewer would capture this part of their personality. Some people smile easily, others look darker or cooler. A profile is often the answer if the expression is less confident.

1. Before you start, look at the shape of the head as a whole to make sure you get this right. Now draw an outline, marking the area of hair and the position of the eyes, nose and mouth.

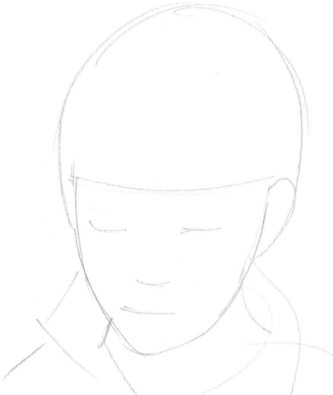

2. Build up the shapes of the ears, eyes, nose, mouth and a few more details such as the hair and neck.

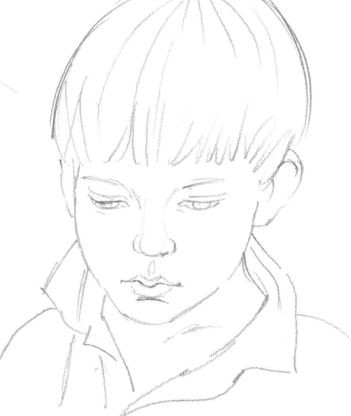

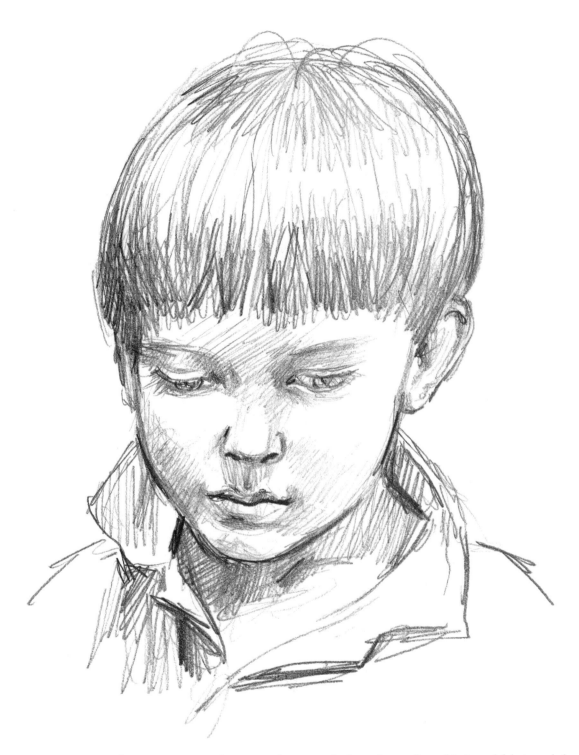

3. To finish the drawing, spend time putting in the areas of tone or shadow, the quality of hair and fabric and the tonal variations of the shading around the eyes, nose and mouth in order to define the features. You'll notice that the lines of tone go in various directions. There is no single, 'right' way of doing this. In your own drawings you can try out single direction toning, multi-direction toning, shading around and in line with the contours and, where appropriate, smudging or softening the shading until it becomes a soft grey tone instead of lines. What you do – and what you think works – is simply a matter of what effect you wish to achieve. Softer, smoother tones give a photographic effect, while more vigorous lines inject liveliness. Here the slight roughness of shading emphasizes a boyish unconcern with appearances.

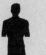

THE TORSO

This section of the body is the most complicated and difficult for the artist to comprehend because it performs so many functions and involves bones of several different types. The torso is capable of bending, stretching and twisting in all directions, thanks to the marvellous design and co-ordination of the spinal vertebrae, ribcage and pelvis.

Although they are flexible, these structures are also very stable, owing to the fact that they have to contain and protect most of the major organs of the body. For instance, the ribs enclose the upper part of the torso and house within them the heart and lungs, while the pelvis supports 7.6 m (25 ft) of small and large intestine and the reproductive organs. The 26 spinal vertebrae run from the base of the skull through the cervical, thoracic and lumbar regions down to the pelvis where they are immobile in the sacral area between the hips, and end in the

coccyx (fused tail bone). The vertebral column encases the spinal cord and connects the rest of the body to the brain and nervous system.

The torso also contains most of the body's largest broad or flat muscles, which help to cover and support the ribcage, vertebrae and pelvis. At the front, the pectorals and the rectus abdominis cover most of the surface area and are easily recognizable in an athletic figure. The shoulder and upper back muscles are very much involved with the movement of the arms and so it is sometimes difficult to decide where the torso muscles finish and those of the arm begin. This is equally true of the musculature surrounding the pelvis and the upper legs. The long valley of the vertebral column, down the centre of the back, is formed by the number of large muscles fanning out from the vertebrae and allows us to feel the bony structure underneath the surface of the skin.

The thorax is the area of the trunk between the neck and the abdomen, including the sternum or breast bone, the 12 ribs or costae and the 12 thoracic vertebrae. These make up the thoracic cage (the ribcage) which protects the heart, lungs and viscera.

Below the thorax, the abdomen is made up of the lumbar vertebrae or column and the pelvic bones.

Mastoid process

Clavicle
Coracoid process
Humerus
Scapula
Sternum
Ilium (iliac bone)
Sacrum
Pubis
Femur

Frontal bone
Temporal fossa
Orbit
Nasal bone
Zygomatic bone
Maxillary bone
Mandible
Cervical column
First rib
Acromion
Manubrium
Gladiolus
Xiphoid process
Lumbar column
Anterior superior iliac spine
Greater trochanter of femur

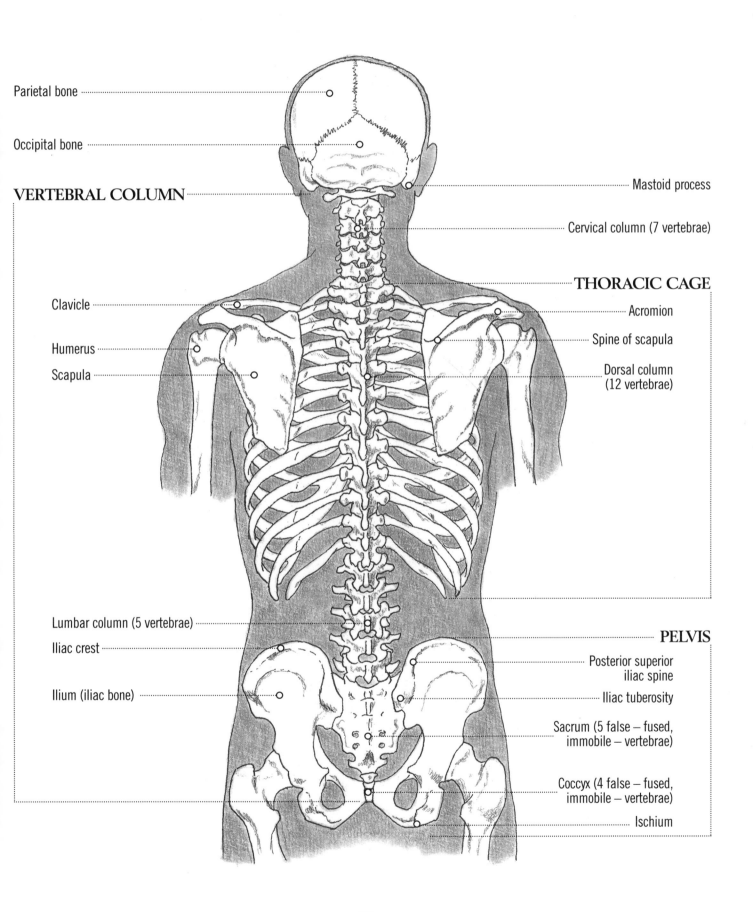

Parietal bone

Occipital bone

VERTEBRAL COLUMN

Clavicle

Humerus

Scapula

Mastoid process

Cervical column (7 vertebrae)

THORACIC CAGE

Acromion

Spine of scapula

Dorsal column
(12 vertebrae)

Lumbar column (5 vertebrae)

Iliac crest

Ilium (iliac bone)

PELVIS

Posterior superior
iliac spine

Iliac tuberosity

Sacrum (5 false — fused,
immobile — vertebrae)

Coccyx (4 false — fused,
immobile — vertebrae)

Ischium

SKELETON OF THE HEAD AND TORSO
side view

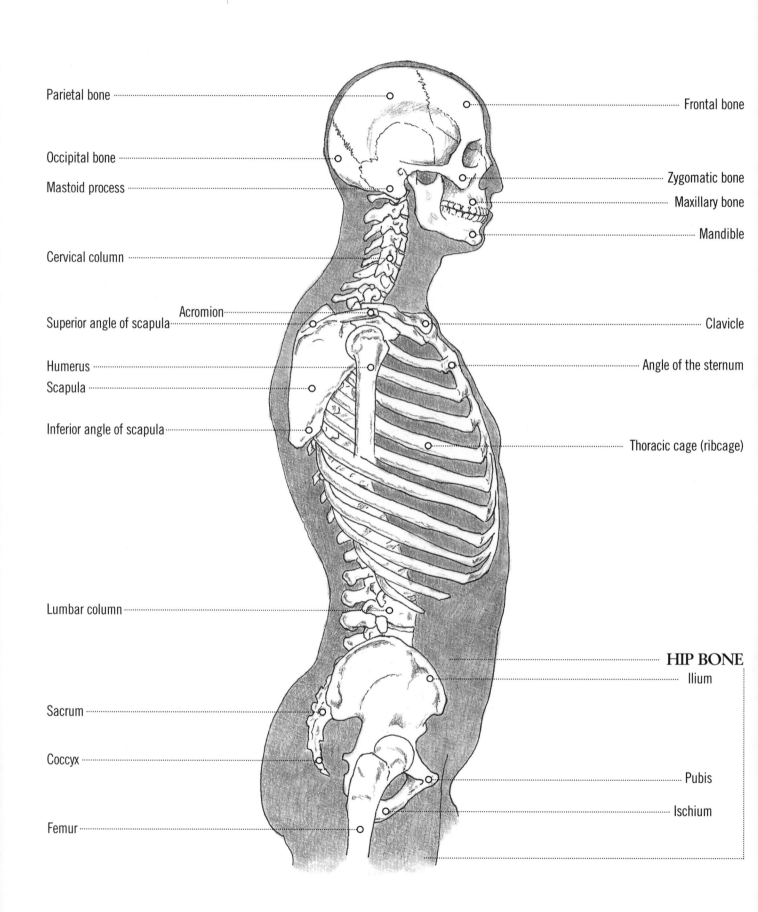

Parietal bone

Occipital bone

Mastoid process

Cervical column

Superior angle of scapula — Acromion

Humerus

Scapula

Inferior angle of scapula

Lumbar column

Sacrum

Coccyx

Femur

Frontal bone

Zygomatic bone

Maxillary bone

Mandible

Clavicle

Angle of the sternum

Thoracic cage (ribcage)

HIP BONE
Ilium

Pubis

Ischium

We examine the vertebral column by itself here, because it is such an important part of the whole skeleton that it needs to be seen separately, without the distractions of the ribs and the pelvis. Note the curved form, and the way the parts are larger at the lower end and smaller at the higher end – a brilliant piece of natural architecture.

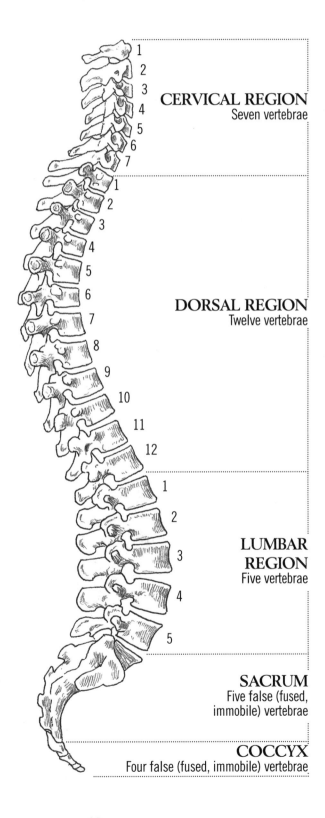

CERVICAL REGION
Seven vertebrae

DORSAL REGION
Twelve vertebrae

LUMBAR REGION
Five vertebrae

SACRUM
Five false (fused, immobile) vertebrae

COCCYX
Four false (fused, immobile) vertebrae

FRONT VIEW

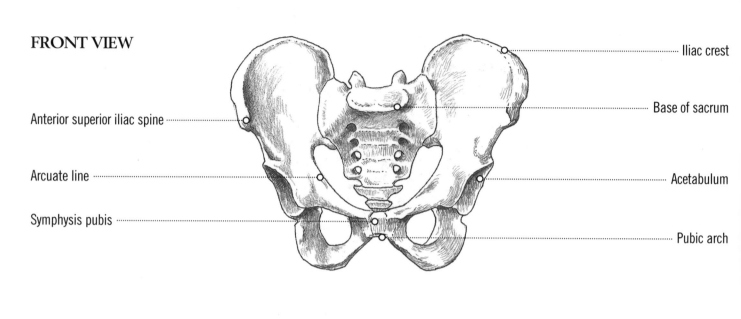

Anterior superior iliac spine

Arcuate line

Symphysis pubis

Iliac crest

Base of sacrum

Acetabulum

Pubic arch

BACK VIEW

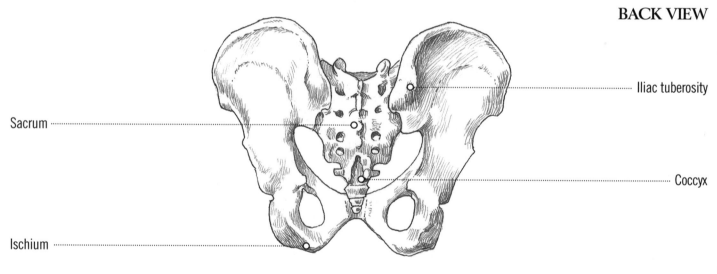

Sacrum

Ischium

Iliac tuberosity

Coccyx

SIDE VIEW

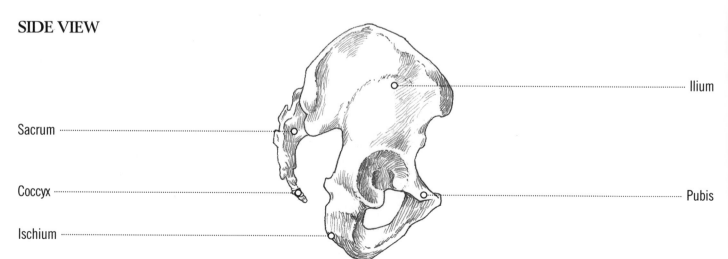

Sacrum

Coccyx

Ischium

Ilium

Pubis

The muscles of the trunk are in the main quite large and fairly flat in shape. They are layered over the ribcage and pelvis and cover the big joints of the hips and shoulders. There are deeper layers of muscle in the back that sometimes help to shape the more superficial muscles (see pages 74–75).

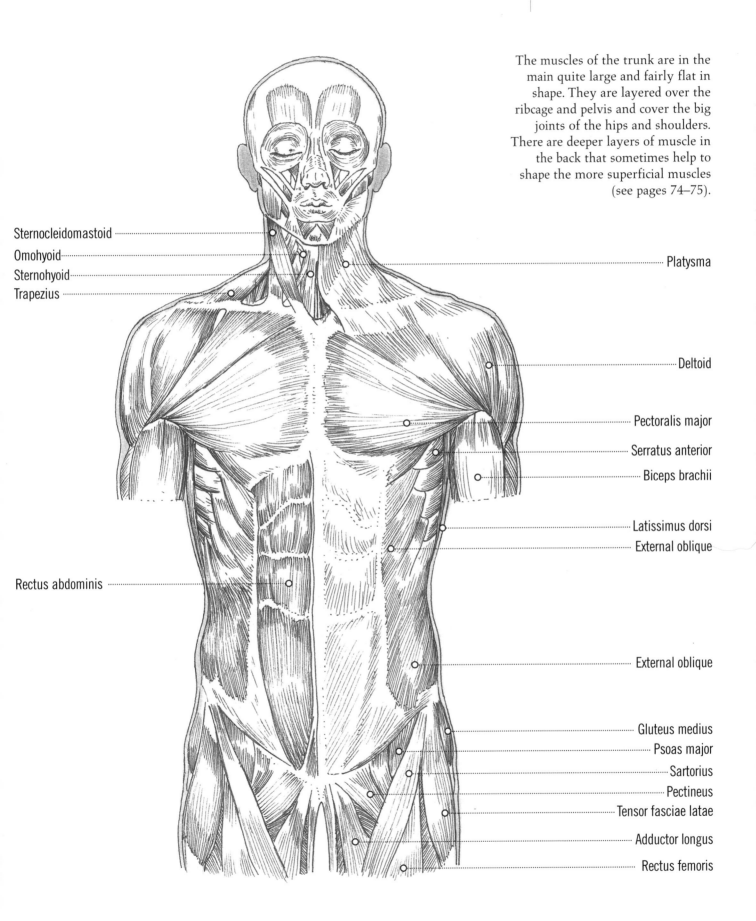

Sternocleidomastoid

Omohyoid

Sternohyoid

Trapezius

Platysma

Deltoid

Pectoralis major

Serratus anterior

Biceps brachii

Latissimus dorsi

External oblique

Rectus abdominis

External oblique

Gluteus medius

Psoas major

Sartorius

Pectineus

Tensor fasciae latae

Adductor longus

Rectus femoris

MUSCLES OF THE TRUNK AND NECK
back view

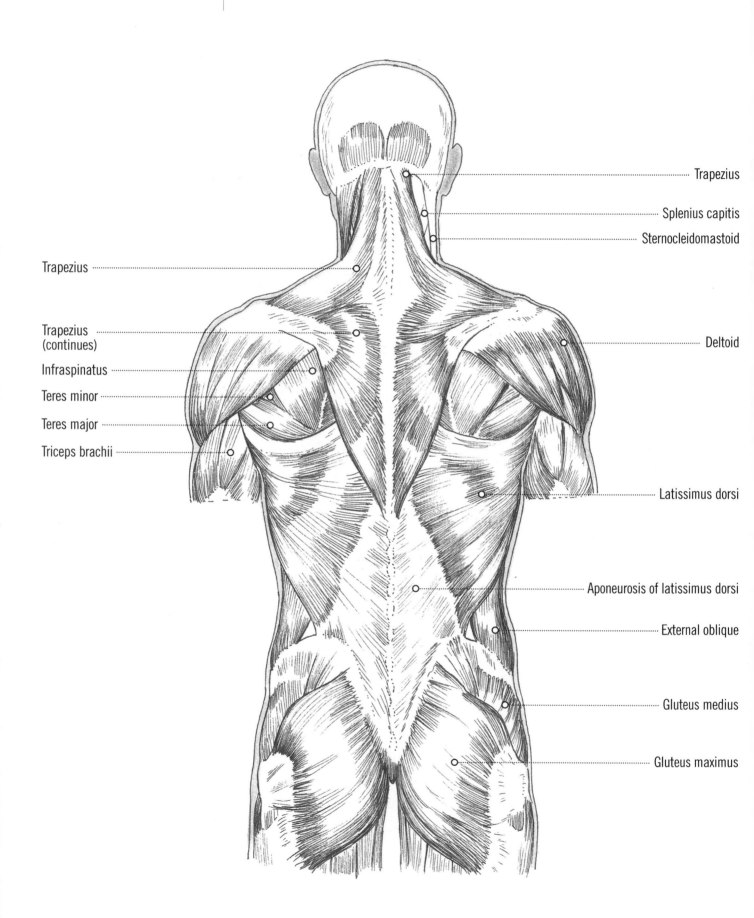

Trapezius

Splenius capitis

Sternocleidomastoid

Trapezius

Trapezius
(continues)

Infraspinatus

Teres minor

Teres major

Triceps brachii

Deltoid

Latissimus dorsi

Aponeurosis of latissimus dorsi

External oblique

Gluteus medius

Gluteus maximus

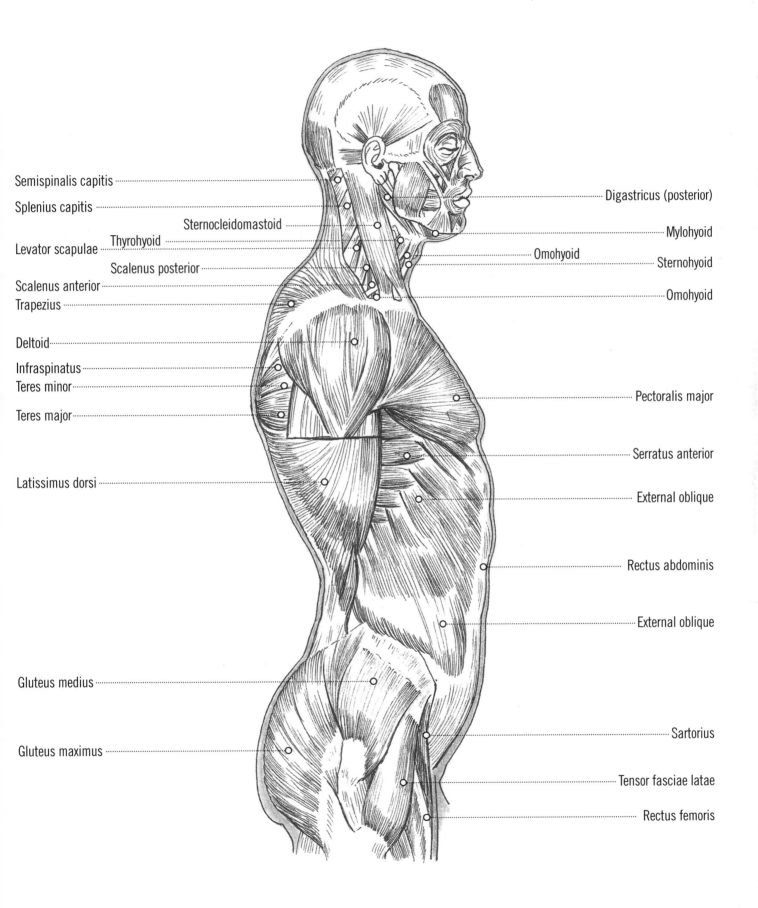

Semispinalis capitis

Splenius capitis

Sternocleidomastoid

Levator scapulae

Thyrohyoid

Scalenus posterior

Scalenus anterior

Trapezius

Deltoid

Infraspinatus

Teres minor

Teres major

Latissimus dorsi

Gluteus medius

Gluteus maximus

Digastricus (posterior)

Mylohyoid

Omohyoid

Sternohyoid

Omohyoid

Pectoralis major

Serratus anterior

External oblique

Rectus abdominis

External oblique

Sartorius

Tensor fasciae latae

Rectus femoris

Here I show the deeper muscles first, and then the mid-depth
ones, with the bone structure of the spinal column on the
left-hand side.

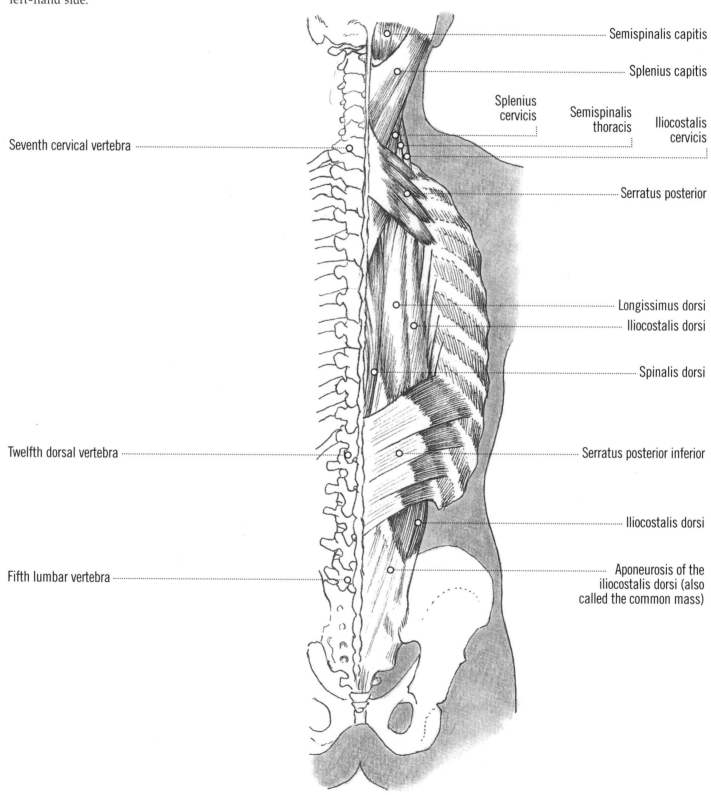

Semispinalis capitis

Splenius capitis

Splenius cervicis

Semispinalis thoracis

Iliocostalis cervicis

Seventh cervical vertebra

Serratus posterior

Longissimus dorsi

Iliocostalis dorsi

Spinalis dorsi

Twelfth dorsal vertebra

Serratus posterior inferior

Iliocostalis dorsi

Fifth lumbar vertebra

Aponeurosis of the iliocostalis dorsi (also called the common mass)

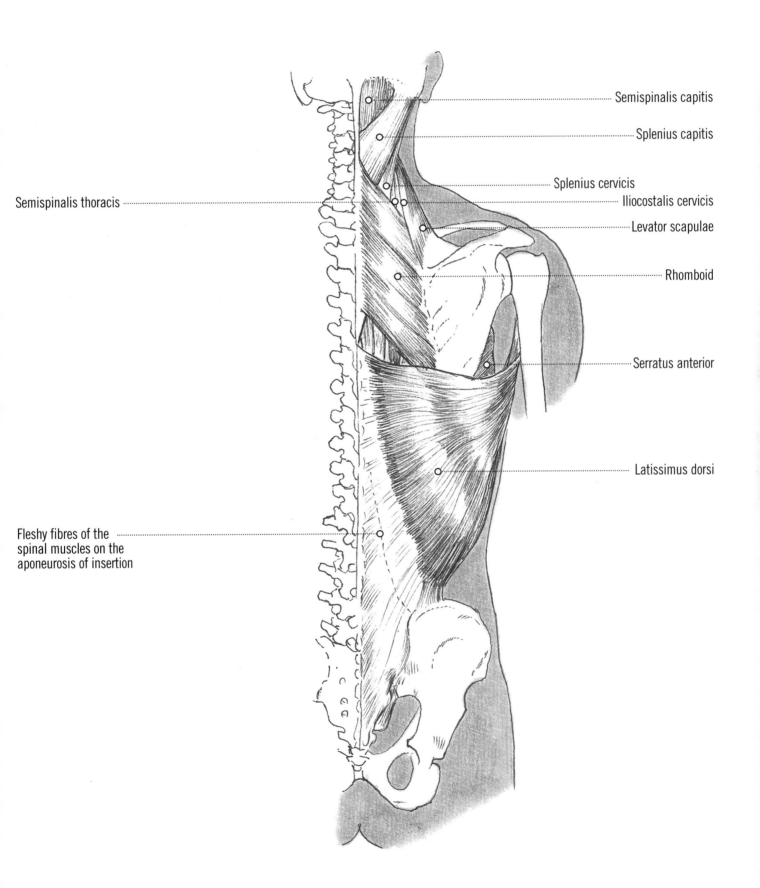

Semispinalis capitis

Splenius capitis

Splenius cervicis

Iliocostalis cervicis

Levator scapulae

Rhomboid

Serratus anterior

Latissimus dorsi

Semispinalis thoracis

Fleshy fibres of the spinal muscles on the aponeurosis of insertion

The surface view of the torso is deceptive, because only the large muscles are immediately obvious. This is particularly true of the front view since the inner organs are covered by large flat areas of the rectus abdominis. This layer is in turn covered by smooth aponeuroses and fasciae. One thing that is clearly visible is the central line of the linea alba running down the front and the spinal groove on the back view. These both serve to highlight the balanced symmetry of the torso.

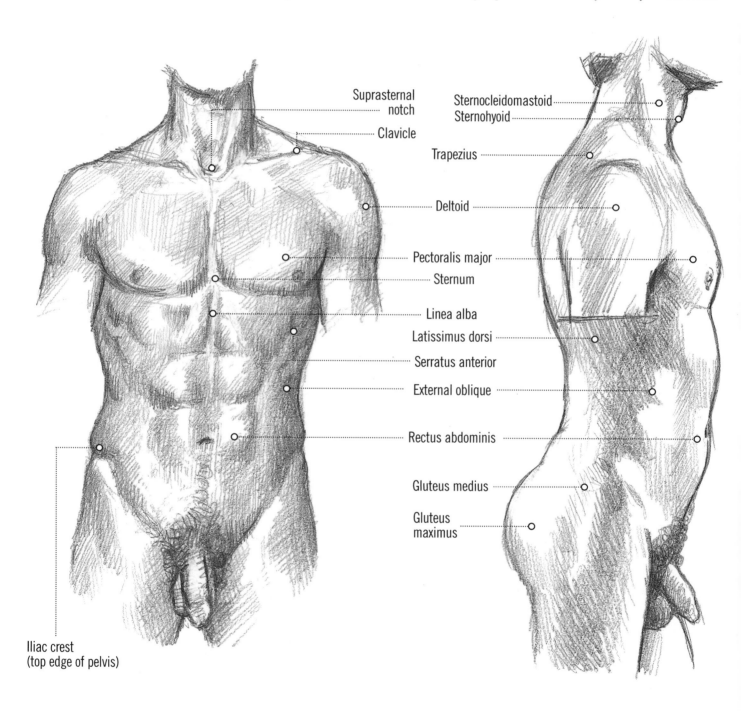

Suprasternal notch

Clavicle

Sternocleidomastoid

Sternohyoid

Trapezius

Deltoid

Pectoralis major

Sternum

Linea alba

Latissimus dorsi

Serratus anterior

External oblique

Rectus abdominis

Gluteus medius

Gluteus maximus

Iliac crest
(top edge of pelvis)

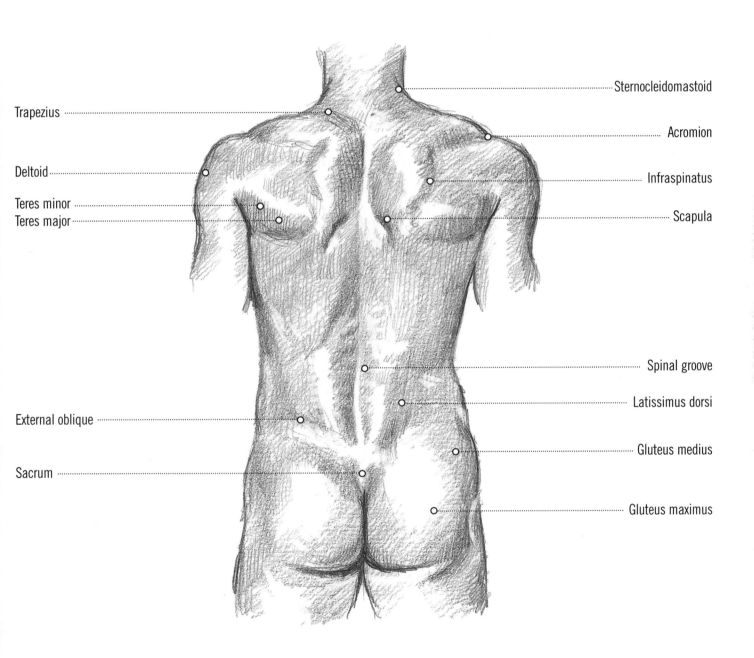

Trapezius

Deltoid

Teres minor
Teres major

External oblique

Sacrum

Sternocleidomastoid

Acromion

Infraspinatus

Scapula

Spinal groove

Latissimus dorsi

Gluteus medius

Gluteus maximus

SURFACE OF THE FEMALE TORSO
front and side view

Notice the difference between the ratio of the width of the
shoulders to the hips in the male and female torso.

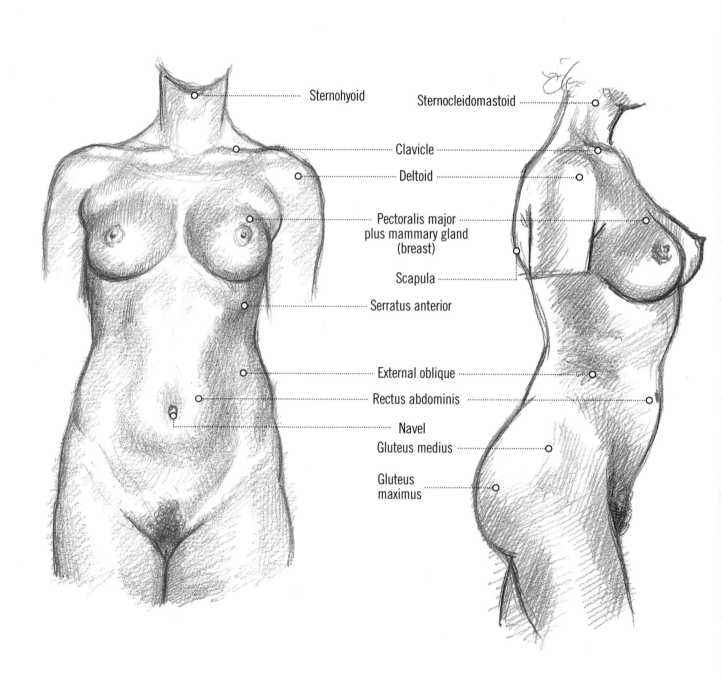

Sternohyoid

Sternocleidomastoid

Clavicle

Deltoid

Pectoralis major
plus mammary gland
(breast)

Scapula

Serratus anterior

External oblique

Rectus abdominis

Navel

Gluteus medius

Gluteus
maximus

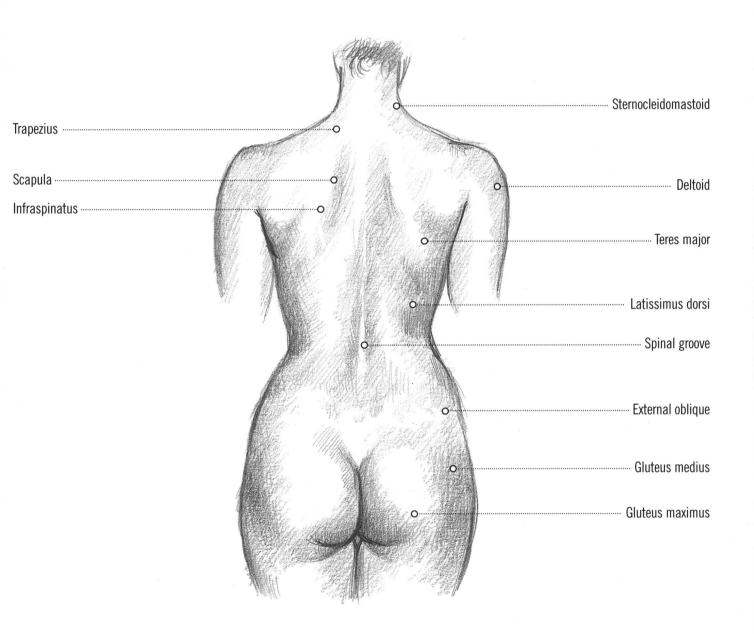

Trapezius

Scapula

Infraspinatus

Sternocleidomastoid

Deltoid

Teres major

Latissimus dorsi

Spinal groove

External oblique

Gluteus medius

Gluteus maximus

In this strong-looking figure with rather wild hair, Tiepolo has drawn the muscles of the back on a tinted paper in dark chalk or charcoal and highlighted them in white chalk. The groove down the centre of the back is interrupted by bony bumps, indicating the spinal vertebrae, and the lower part of the scapula is highlighted on the left shoulder. The other large muscles of the back are fairly easy to see, because of the muscular development of the model. For example, you can see the bulge of the latissimus dorsi thrown into relief by the lower muscles underneath, the serratus anterior.

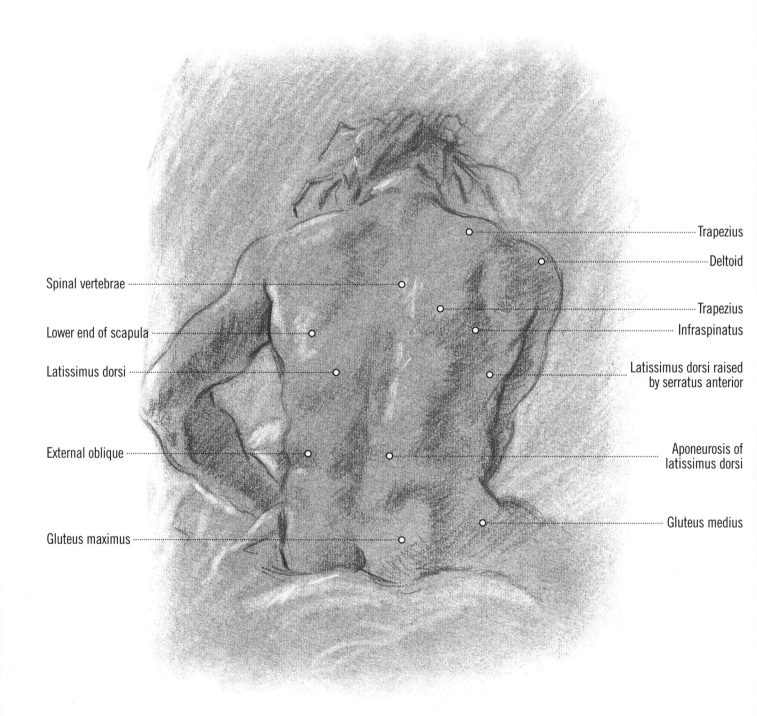

Spinal vertebrae

Lower end of scapula

Latissimus dorsi

External oblique

Gluteus maximus

Trapezius

Deltoid

Trapezius

Infraspinatus

Latissimus dorsi raised
by serratus anterior

Aponeurosis of
latissimus dorsi

Gluteus medius

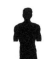
In this drawing of a well-rounded woman from behind, quite a few of the muscles of the back are hidden under a layer of fat. What is clear is the deltoid muscle of the shoulder, the line of the spinal vertebrae and the gluteus maximus.

Because the figure is slightly turned, the trapezius and the latissimus dorsi can be seen more clearly; there is also a slight indication of the edge of the scapula. The other two named muscles are inferred rather than clearly seen.

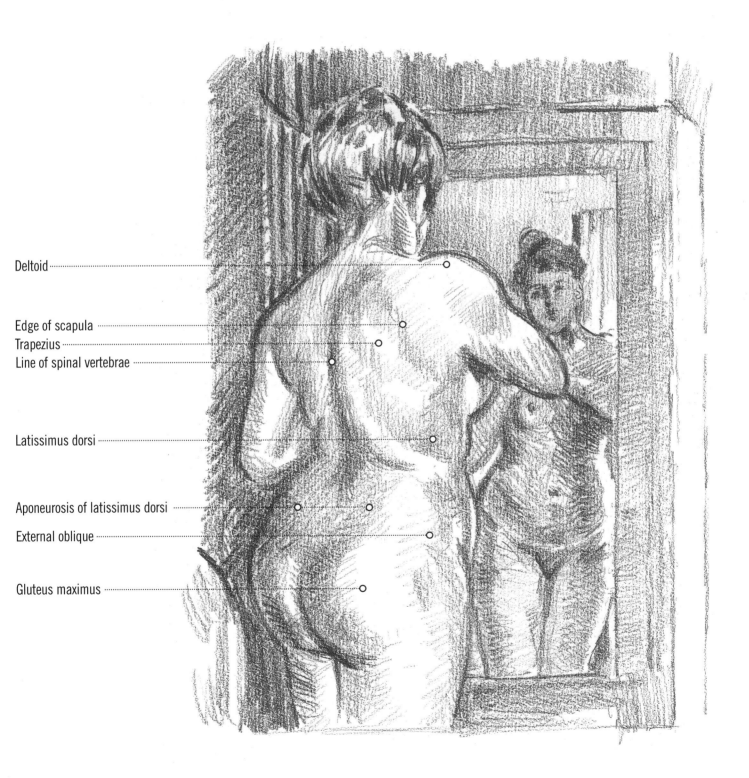

Deltoid

Edge of scapula
Trapezius
Line of spinal vertebrae

Latissimus dorsi

Aponeurosis of latissimus dorsi
External oblique

Gluteus maximus

THE TRUNK DRAWN BY MASTER ARTISTS
after Michelangelo

In characteristic fashion, Michelangelo draws the torso of a male figure with all the muscles clearly shown through his pen strokes. His first love was sculpture, and his drawings always have a sense of growing out from the paper, like a three-dimensional, carved form. Here you can see quite a few of the bony protuberances of the skeleton, as well as the clearly defined muscles of the front of the torso. Michelangelo does not leave out anything that might help to inform the viewer about the shape and three-dimensional effects of the body.

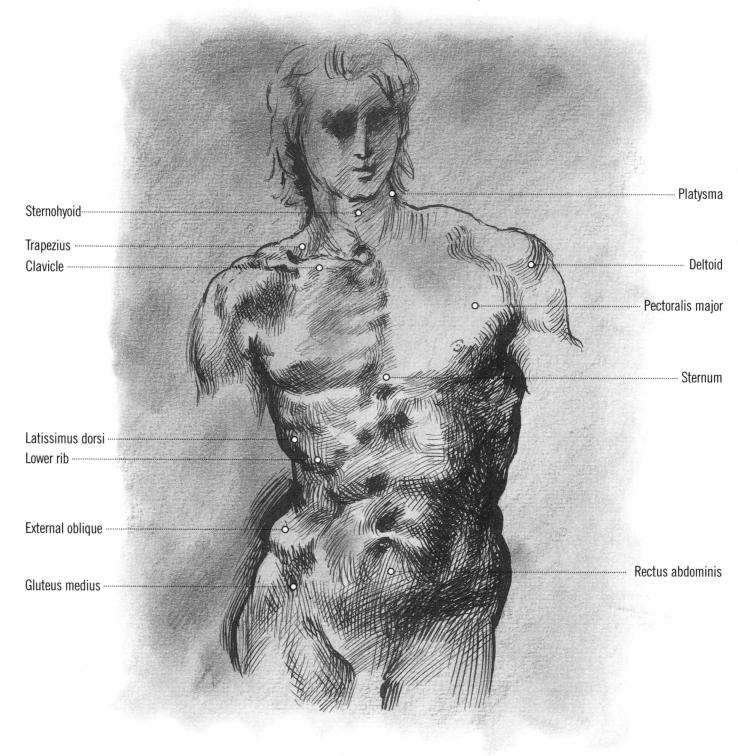

Platysma

Sternohyoid

Trapezius

Clavicle

Deltoid

Pectoralis major

Sternum

Latissimus dorsi

Lower rib

External oblique

Rectus abdominis

Gluteus medius

Bronzino was heavily influenced by Michelangelo, as were most of the artists of this time, but he also responded to the much smoother drawing of Raphael, who was as successful as Michelangelo but had a much shorter life. The carefully modulated forms in this drawing of a goddess have none of the ruggedness of Michelangelo's pen drawing. As painter at the Medici court in Florence, Bronzino knew how to make his models pleasing to the eye, with a seductive modelling style. However, the main muscles of the Bronzino torso are not as obvious as in Michelangelo's dramatic drawings, and the goddess being nicely fleshed out, the divisions between the muscles are much less clearly defined.

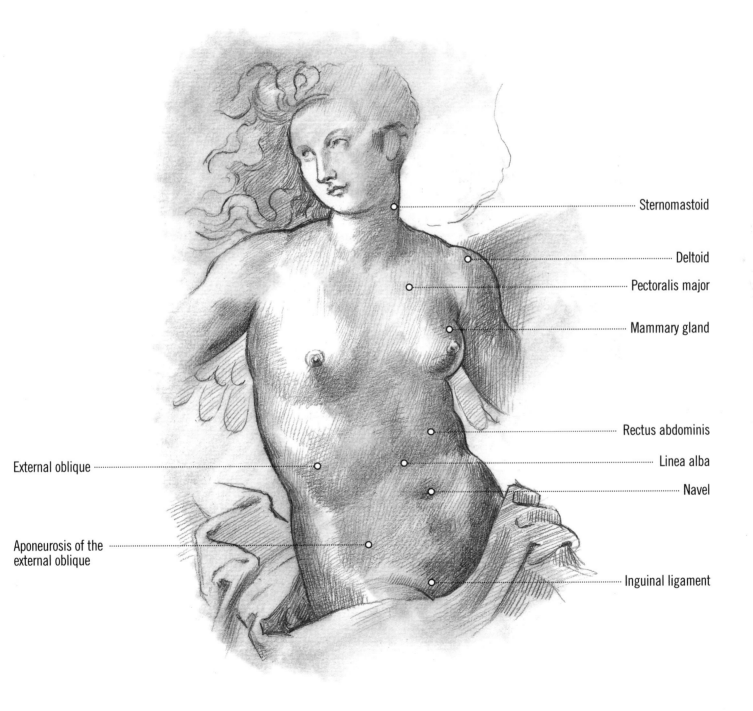

Sternomastoid

Deltoid

Pectoralis major

Mammary gland

Rectus abdominis

Linea alba

Navel

External oblique

Aponeurosis of the
external oblique

Inguinal ligament

THE ARMS AND HANDS

The upper limbs of the body are structured on the basis of the long bones of the humerus, the ulna and the radius, with the additional small bones of the wrist and hand. The design of the arm is very subtle and the hand so flexible and adaptable that almost any movement in any direction is possible. These are the limbs that allow human beings to handle tools, operate machines and do the things that most other animals cannot manage.

The way that the arms work from the shoulders is quite complex and so too is the musculature of the hand; don't be surprised if you find it difficult to retain all the anatomical information. However, as an artist, your main goal is to gain

familiarity with the general structure of the arms and hands, so that when you come to draw them, they will be convincing enough to give your drawing some credibility.

As in previous sections of this book, I first give an outline of the skeleton, then the muscles that surround the bone structure, followed by the surface view of the limb. After that come various drawings of similar views of the limb by master artists, and finally an exercise for you to try – drawing your own hand. At this stage, I will not be showing any particular movements of the arms and hands, nor which muscles govern them; these will appear in a later section (pages 204–233).

SKELETON OF THE ARM AND HAND
front view

The bone structure of the arm appears quite straightforward at first glance. However, the areas of the shoulder and the wrist are quite complex and help to allow the many movements of the limb.

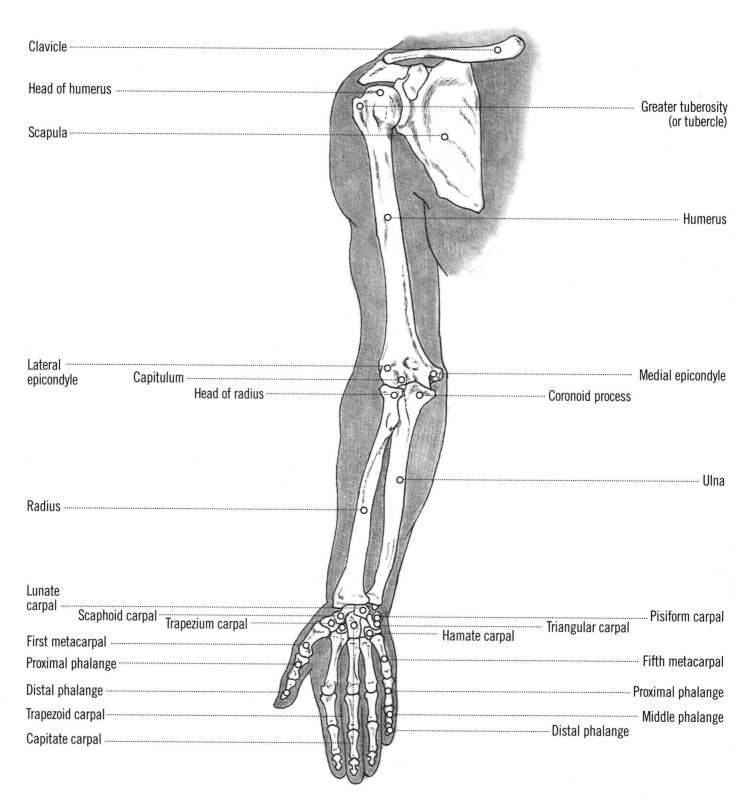

Clavicle

Head of humerus

Scapula

Greater tuberosity
(or tubercle)

Humerus

Lateral
epicondyle

Capitulum

Head of radius

Medial epicondyle

Coronoid process

Ulna

Radius

Lunate
carpal

Scaphoid carpal

Trapezium carpal

Pisiform carpal

Triangular carpal

First metacarpal

Hamate carpal

Proximal phalange

Fifth metacarpal

Distal phalange

Proximal phalange

Trapezoid carpal

Middle phalange

Distal phalange

Capitate carpal

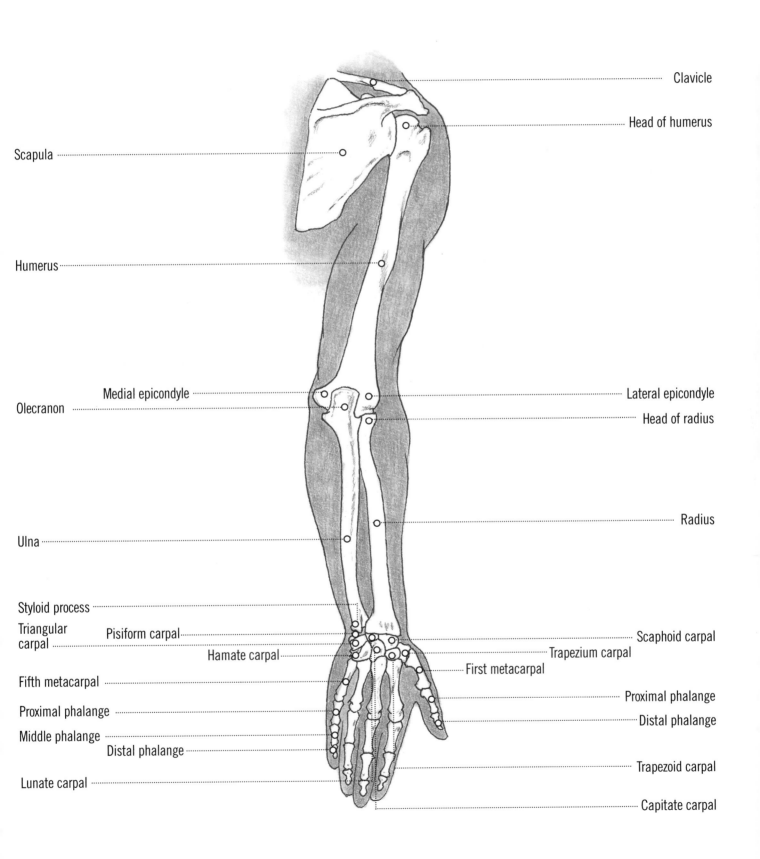

Clavicle

Head of humerus

Scapula

Humerus

Medial epicondyle

Olecranon

Lateral epicondyle

Head of radius

Radius

Ulna

Styloid process

Triangular carpal

Pisiform carpal

Scaphoid carpal

Hamate carpal

Trapezium carpal

First metacarpal

Fifth metacarpal

Proximal phalange

Proximal phalange

Distal phalange

Middle phalange

Distal phalange

Lunate carpal

Trapezoid carpal

Capitate carpal

Notice the complexity of the interleaving muscles around the shoulder and elbow, and the long strands of tendons passing through the wrist. The bone structure only appears at the point of the shoulder, the elbow and the wrist, but of course on the hand, the bones of the fingers are more obvious.

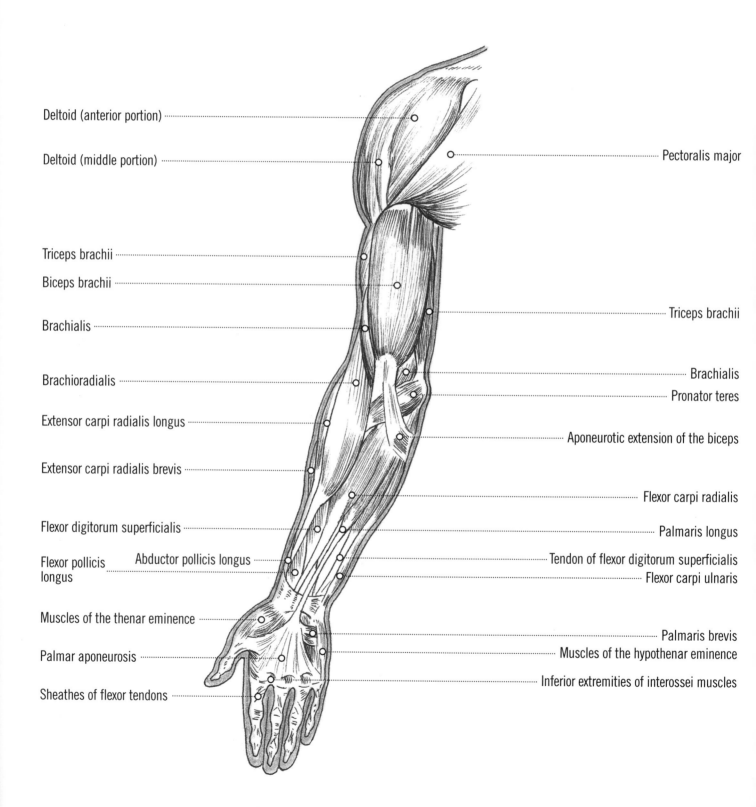

Deltoid (anterior portion)

Deltoid (middle portion)

Triceps brachii

Biceps brachii

Brachialis

Brachioradialis

Extensor carpi radialis longus

Extensor carpi radialis brevis

Flexor digitorum superficialis

Flexor pollicis longus Abductor pollicis longus

Muscles of the thenar eminence

Palmar aponeurosis

Sheathes of flexor tendons

Pectoralis major

Triceps brachii

Brachialis

Pronator teres

Aponeurotic extension of the biceps

Flexor carpi radialis

Palmaris longus

Tendon of flexor digitorum superficialis

Flexor carpi ulnaris

Palmaris brevis

Muscles of the hypothenar eminence

Inferior extremities of interossei muscles

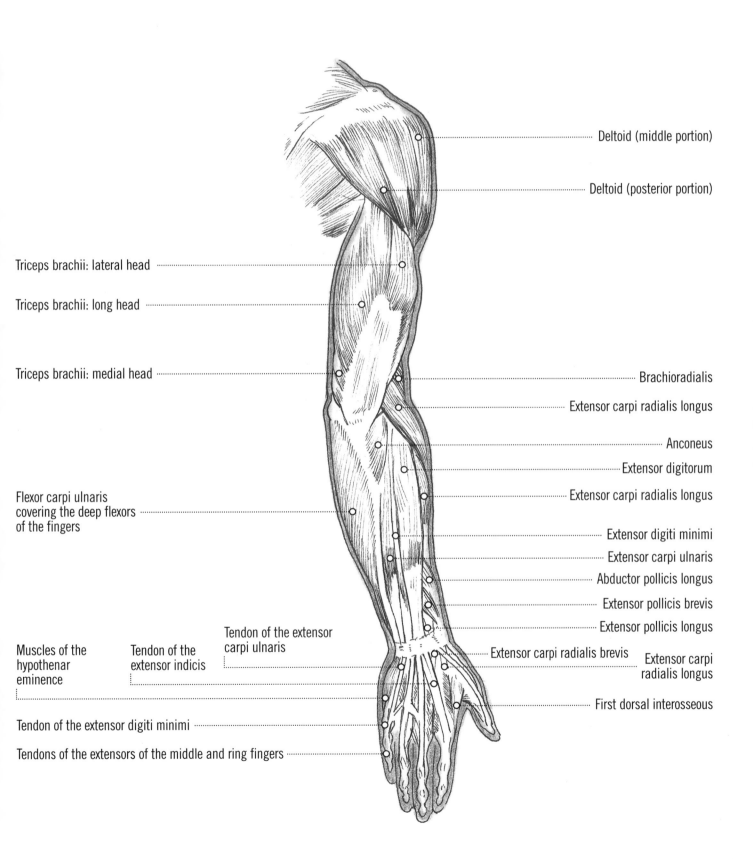

Deltoid (middle portion)

Deltoid (posterior portion)

Triceps brachii: lateral head

Triceps brachii: long head

Triceps brachii: medial head

Brachioradialis

Extensor carpi radialis longus

Anconeus

Extensor digitorum

Flexor carpi ulnaris covering the deep flexors of the fingers

Extensor carpi radialis longus

Extensor digiti minimi

Extensor carpi ulnaris

Abductor pollicis longus

Extensor pollicis brevis

Extensor pollicis longus

Tendon of the extensor carpi ulnaris

Muscles of the hypothenar eminence

Tendon of the extensor indicis

Extensor carpi radialis brevis

Extensor carpi radialis longus

First dorsal interosseous

Tendon of the extensor digiti minimi

Tendons of the extensors of the middle and ring fingers

MUSCLES OF THE ARM AND HAND
side view, external aspect

Deltoid

Triceps brachii: long head

Triceps brachii: lateral head

Triceps brachii: medial head

Triceps brachii: tendon

Olecranon

Anconeus

Extensor carpi ulnaris

Extensor digitorum communis

Abductor pollicis longus

Extensor pollicis brevis

Extensor pollicis longus

Extensor carpi radialis brevis

Tendon of the extensor indicis

Pectoralis major

Biceps brachii

Brachialis

Brachioradialis

Extensor carpi radialis longus

Extensor carpi radialis brevis

Flexor carpi radialis

Extensor carpi radialis longus

First dorsal interosseous

Abductor pollicis

First lumbrical

Sheath for flexor tendon

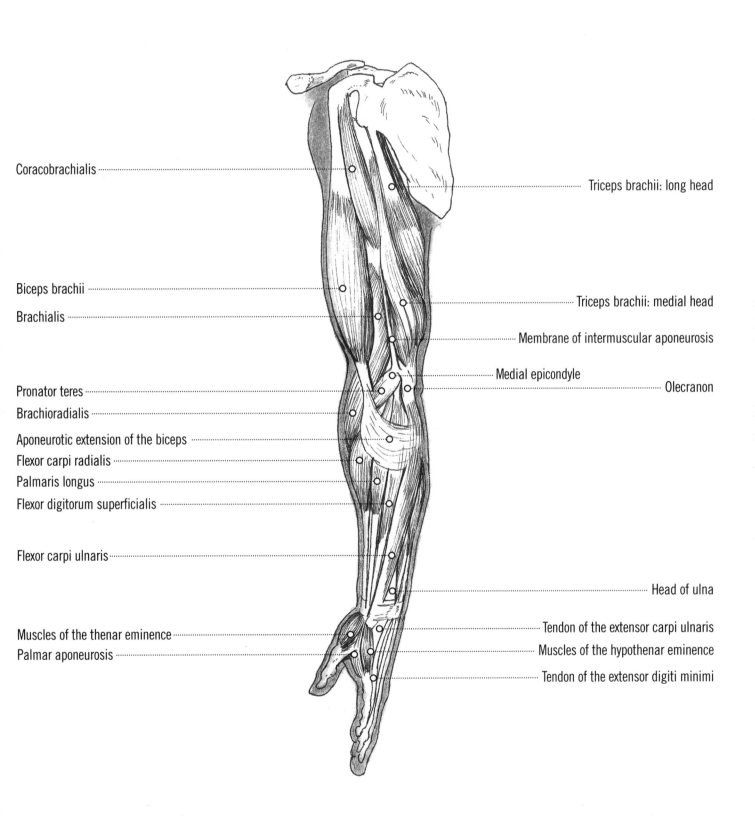

Coracobrachialis

Biceps brachii

Brachialis

Pronator teres

Brachioradialis

Aponeurotic extension of the biceps

Flexor carpi radialis

Palmaris longus

Flexor digitorum superficialis

Flexor carpi ulnaris

Muscles of the thenar eminence

Palmar aponeurosis

Triceps brachii: long head

Triceps brachii: medial head

Membrane of intermuscular aponeurosis

Medial epicondyle

Olecranon

Head of ulna

Tendon of the extensor carpi ulnaris

Muscles of the hypothenar eminence

Tendon of the extensor digiti minimi

SURFACE OF THE MALE ARM AND HAND
palm-up and palm-down view

When the arm is stretched out horizontally, we can see the shapes of the larger muscles at the surface of the limb. Here we look at the outstretched arm from two angles: with the palm facing up (supine view) and with the palm facing down (prone view).

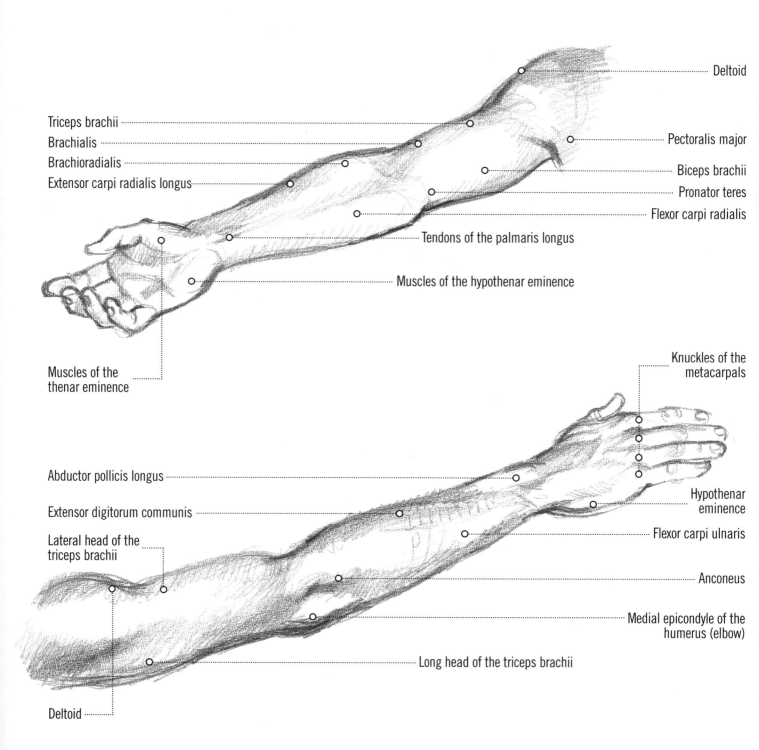

Deltoid

Triceps brachii

Brachialis

Brachioradialis

Extensor carpi radialis longus

Pectoralis major

Biceps brachii

Pronator teres

Flexor carpi radialis

Tendons of the palmaris longus

Muscles of the hypothenar eminence

Muscles of the thenar eminence

Knuckles of the metacarpals

Abductor pollicis longus

Extensor digitorum communis

Lateral head of the triceps brachii

Hypothenar eminence

Flexor carpi ulnaris

Anconeus

Medial epicondyle of the humerus (elbow)

Long head of the triceps brachii

Deltoid

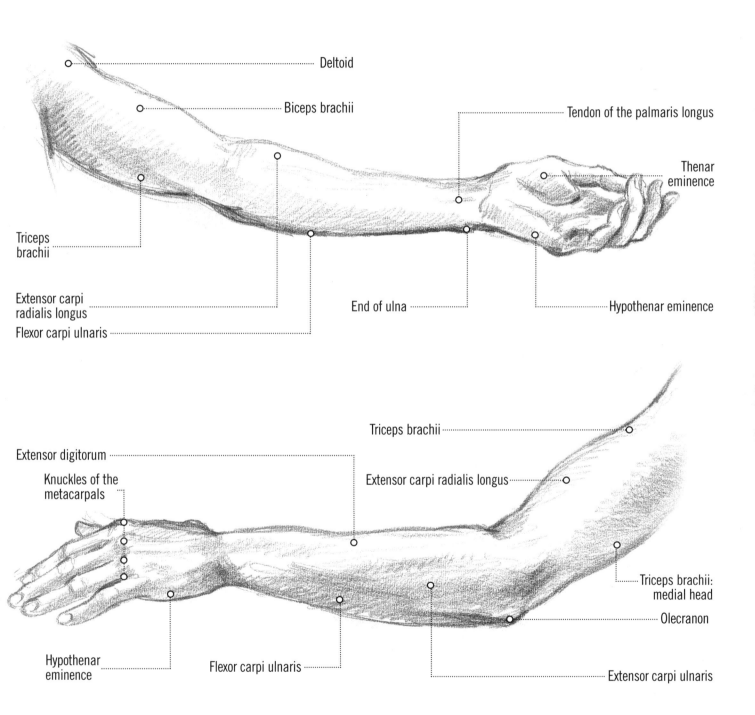

Deltoid

Biceps brachii

Tendon of the palmaris longus

Thenar eminence

Triceps brachii

Extensor carpi radialis longus

Flexor carpi ulnaris

End of ulna

Hypothenar eminence

Triceps brachii

Extensor digitorum

Extensor carpi radialis longus

Knuckles of the metacarpals

Triceps brachii: medial head

Olecranon

Hypothenar eminence

Flexor carpi ulnaris

Extensor carpi ulnaris

Both these studies of masculine arms show the interest that the Renaissance artists had in the careful depiction of the body. These drawings are the equivalent of the best modern photographic work.

After Federico Barocci (c.1530–1612)

After Raphael Sanzio (1483–1520)

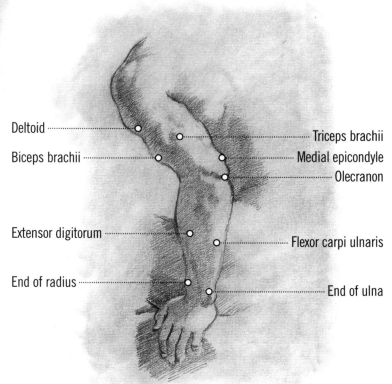

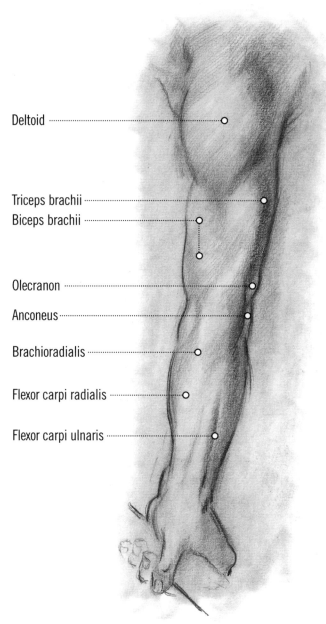

Deltoid

Triceps brachii
Biceps brachii

Olecranon

Anconeus

Brachioradialis

Flexor carpi radialis

Flexor carpi ulnaris

Deltoid

Biceps brachii

Extensor digitorum

End of radius

Triceps brachii
Medial epicondyle
Olecranon

Flexor carpi ulnaris

End of ulna

Here, on the other hand, the artists have shown the different effect of the more gentle shapes of the female arm. All the tonal areas give the effect of a soft undulation of the muscles under the skin.

After Raphael

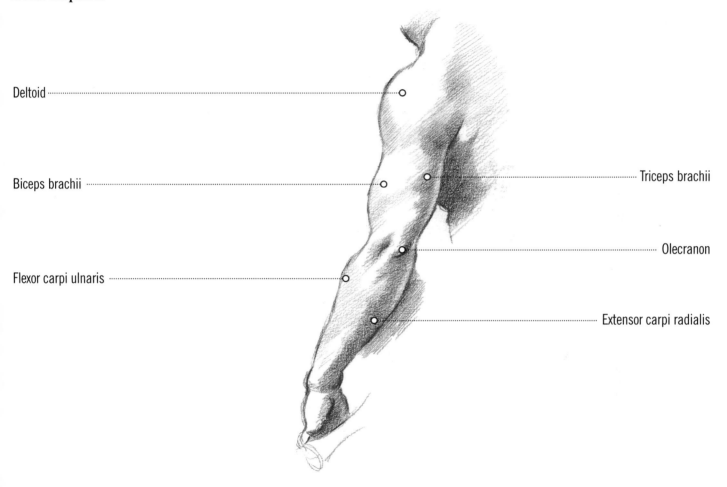

Deltoid

Biceps brachii

Triceps brachii

Olecranon

Flexor carpi ulnaris

Extensor carpi radialis

After Ted Seth Jacobs (1927–)

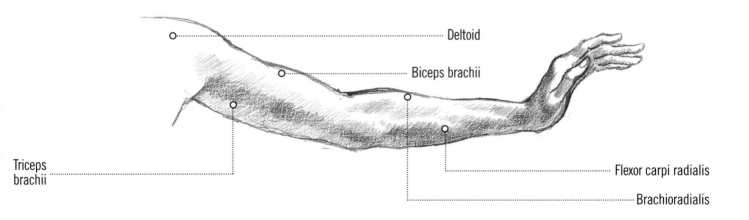

Deltoid

Biceps brachii

Triceps brachii

Flexor carpi radialis

Brachioradialis

SKELETON OF THE HAND
palm-down view

As well as combined drawings of the arm and hand, I am also dealing with the hand separately because it is such an intricate part of the upper limb. These diagrams of the bones of the hand seen from four different angles are well worth studying, so you will be able to recognize them through the covering of muscle and skin.

UPPER ROW OF CARPALS
(wrist bones)

Lunate

Scaphoid

Triquetral (triangular)

Pisiform

Five metacarpals
(palm bones)

First row (proximal) of
5 phalanges (finger bones)

Second row (middle) of 4 phalanges

Third row (distal) of 5 phalanges

LOWER ROW OF CARPALS
(wrist bones)

Capitate

Hamate

Trapezoid

Trapezium
(formed like a saddle –
the thumb sits on it like
a rider on a saddle and
can move back and
forth and to either side)

- Carpals (wrist bones)
- Metacarpals (palm bones)
- Phalanges (finger bones)

LOWER ROW OF CARPALS
(wrist bones)

Trapezium

Capitate

Trapezoid

Hamate

First row (proximal) of 5
phalanges (finger bones)

UPPER ROW OF CARPALS
(wrist bones)

Scaphoid
Lunate

Triquetral (triangular)
Pisiform

Five metacarpals
(palm bones)

Second row (middle)
of 4 phalanges

Third row (distal)
of 5 phalanges

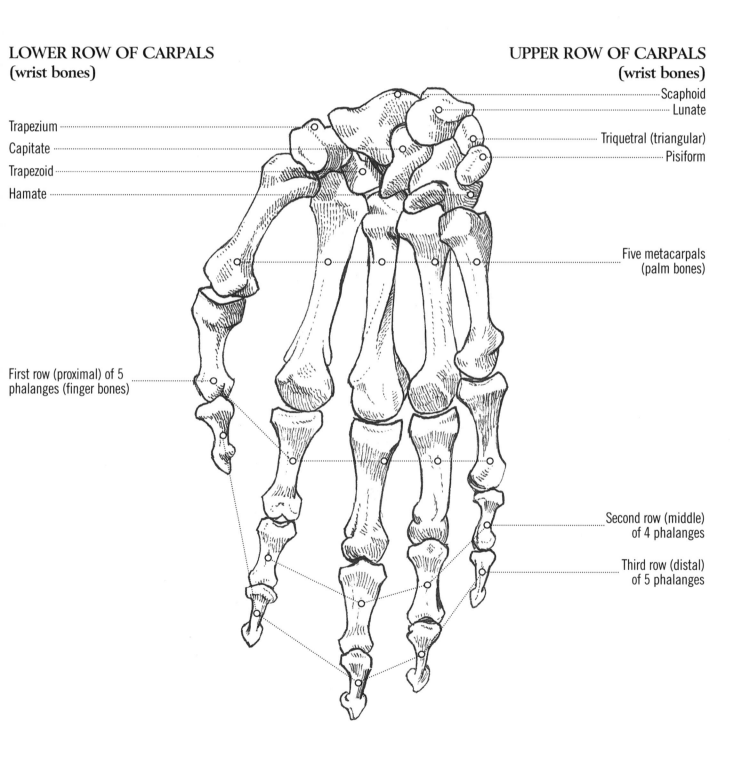

97

Note that the thumb (like the big toe) is made up of just two
phalanges – proximal and distal. Unlike the four fingers, it
has no middle phalange.

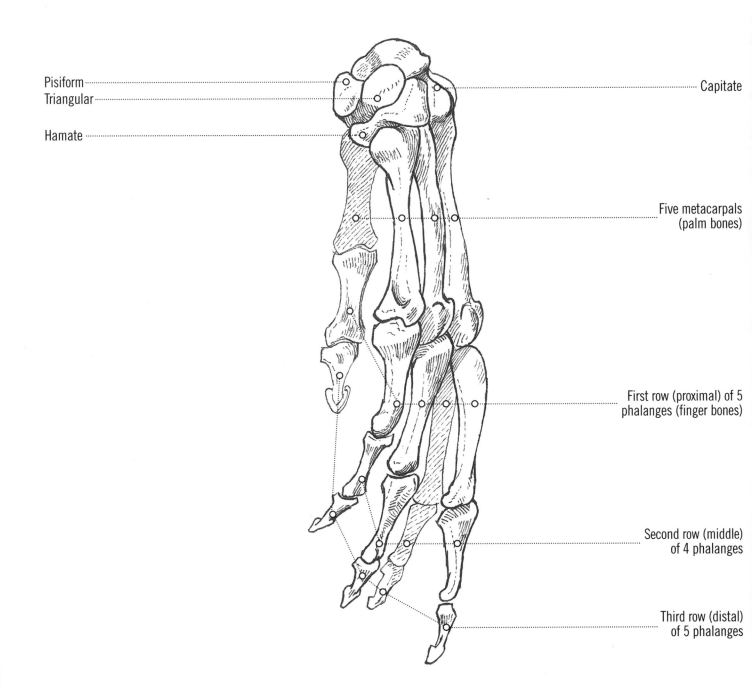

Pisiform

Triangular

Hamate

Capitate

Five metacarpals
(palm bones)

First row (proximal) of 5
phalanges (finger bones)

Second row (middle)
of 4 phalanges

Third row (distal)
of 5 phalanges

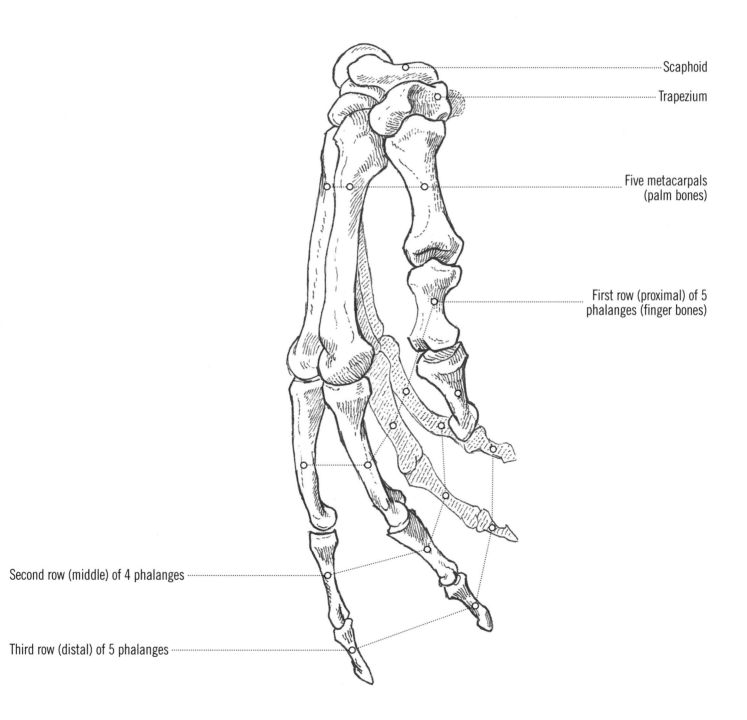

Scaphoid

Trapezium

Five metacarpals (palm bones)

First row (proximal) of 5 phalanges (finger bones)

Second row (middle) of 4 phalanges

Third row (distal) of 5 phalanges

MUSCLES OF THE HAND
palm-down view

The hand, being the part of the body that sets human skills apart from those of all the other animals, is a very complex structure of overlapping muscles and tendons. These allow the fingers and thumb to perform very complicated and subtle motions, enabling humans to construct and handle an enormous number of tools (including the pencil, of course), extending their range of activities far beyond other species.

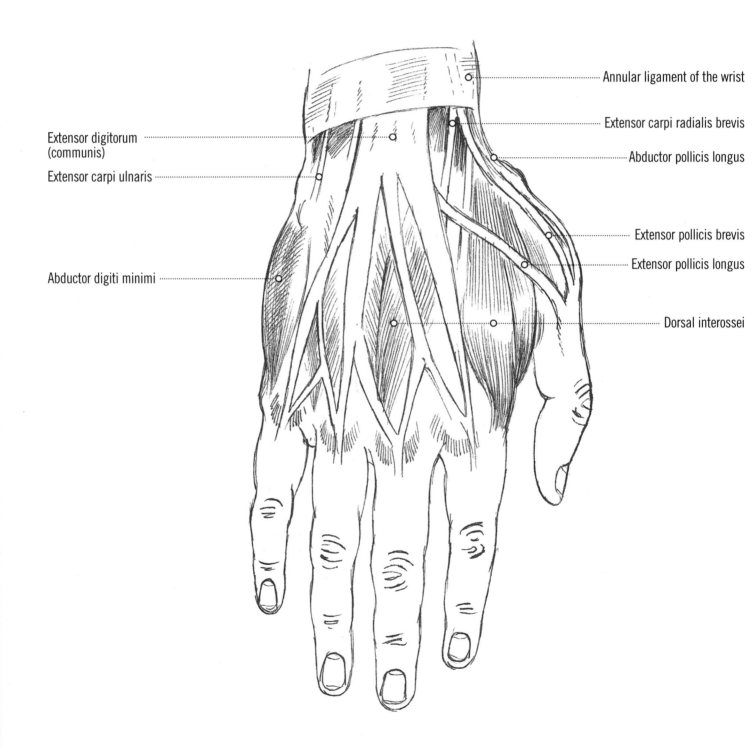

Extensor digitorum (communis)

Extensor carpi ulnaris

Abductor digiti minimi

Annular ligament of the wrist

Extensor carpi radialis brevis

Abductor pollicis longus

Extensor pollicis brevis

Extensor pollicis longus

Dorsal interossei

The main difficulty in drawing the muscles of the hand is that the most significant ones are situated in the arm and are connected to the hand by long tendons. There are some muscles in the hand itself, but they tend to be hidden under the surface pads of the palm and so are not very evident. The most clearly seen muscles are around the base of the thumb and on the opposite edge of the palm.

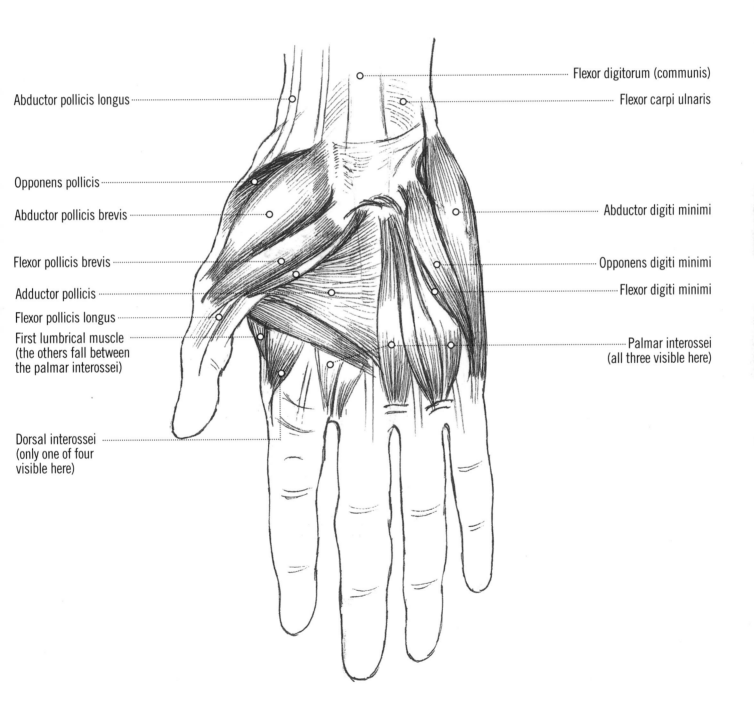

Abductor pollicis longus

Opponens pollicis

Abductor pollicis brevis

Flexor pollicis brevis

Adductor pollicis

Flexor pollicis longus

First lumbrical muscle
(the others fall between
the palmar interossei)

Dorsal interossei
(only one of four
visible here)

Flexor digitorum (communis)

Flexor carpi ulnaris

Abductor digiti minimi

Opponens digiti minimi

Flexor digiti minimi

Palmar interossei
(all three visible here)

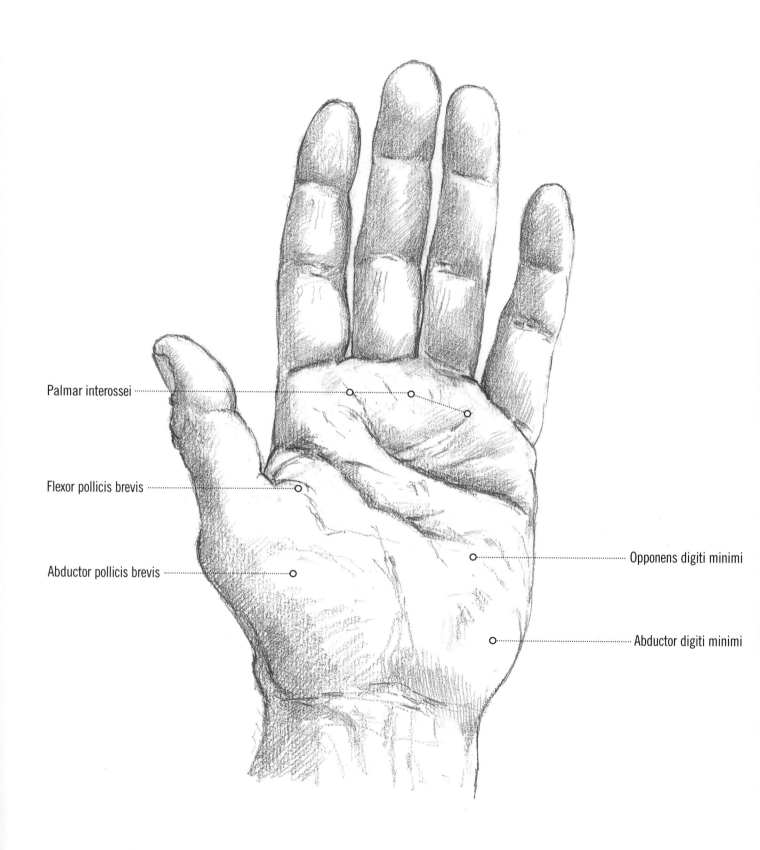

Palmar interossei

Flexor pollicis brevis

Abductor pollicis brevis

Opponens digiti minimi

Abductor digiti minimi

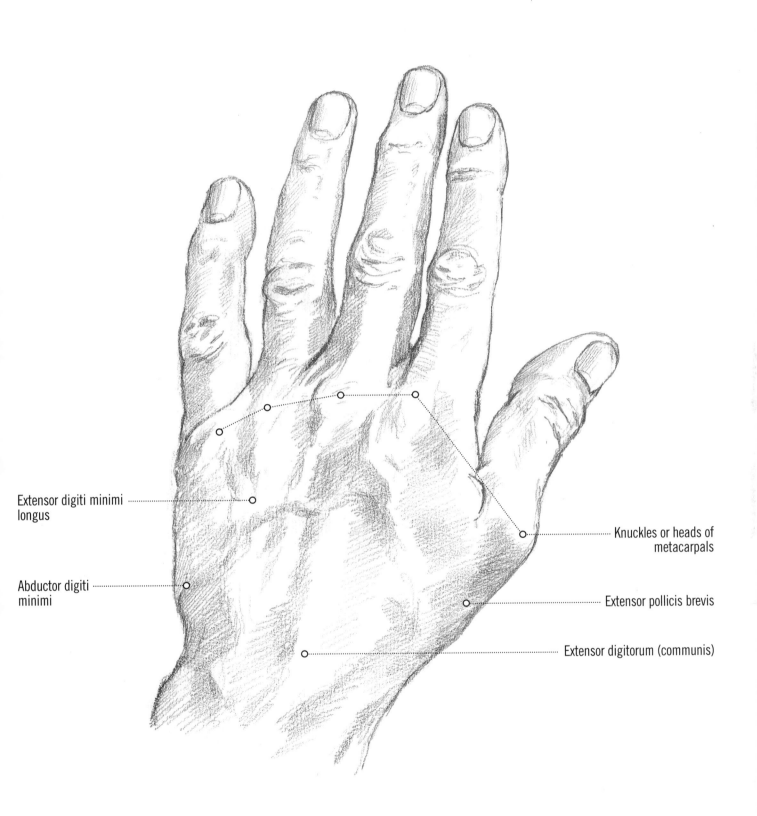

Extensor digiti minimi longus

Abductor digiti minimi

Knuckles or heads of metacarpals

Extensor pollicis brevis

Extensor digitorum (communis)

SURFACE OF THE FEMALE HAND
palm-down view

The female hand is usually softer-looking and with more tapered fingers than the male. The knuckles of the male hand tend to look more prominent and the fingers are squarer in shape. But don't take this for granted in your drawing: sometimes this typical shape can be reversed.

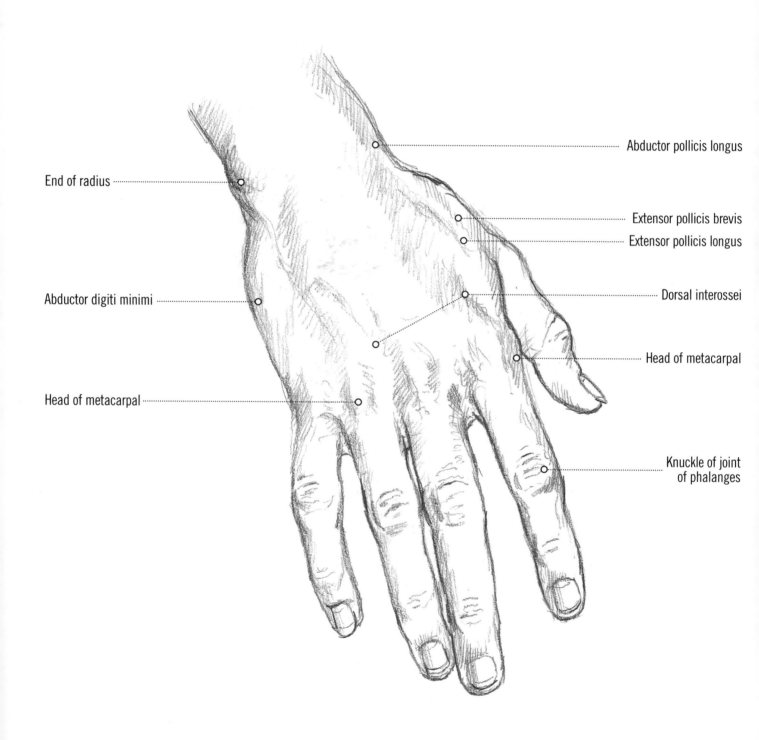

End of radius

Abductor digiti minimi

Head of metacarpal

Abductor pollicis longus

Extensor pollicis brevis

Extensor pollicis longus

Dorsal interossei

Head of metacarpal

Knuckle of joint of phalanges

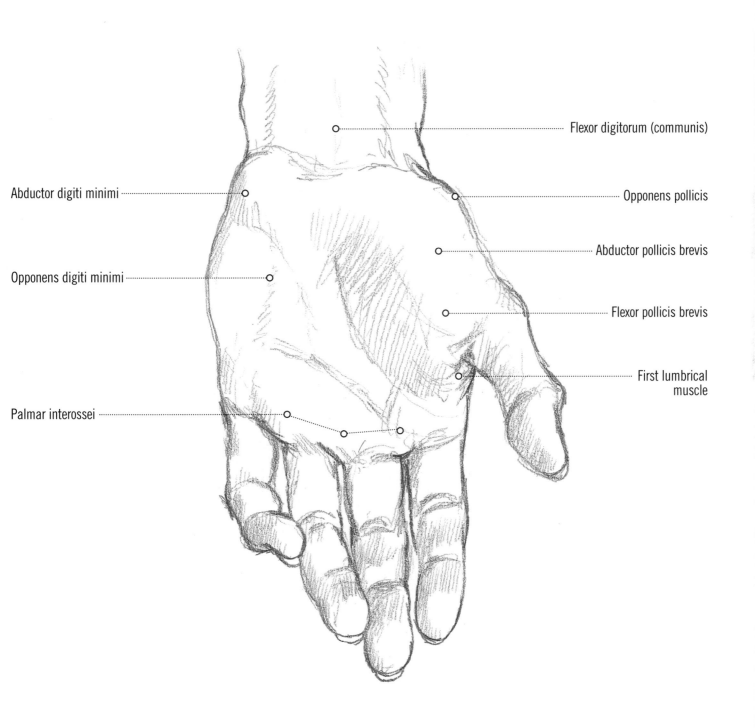

Flexor digitorum (communis)

Abductor digiti minimi

Opponens pollicis

Abductor pollicis brevis

Opponens digiti minimi

Flexor pollicis brevis

First lumbrical muscle

Palmar interossei

The following drawings after master artists show the hand from various different angles. They give a good idea of the complexity of this small but vitally important part of the human body.

After Lucian Freud

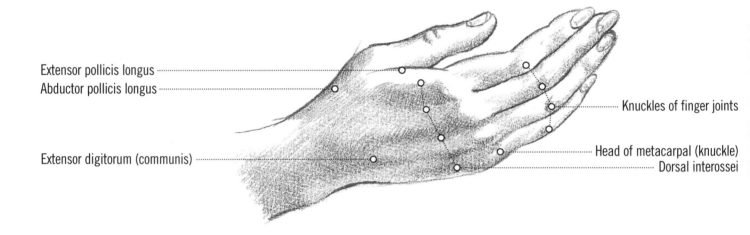

Extensor pollicis longus

Abductor pollicis longus

Knuckles of finger joints

Extensor digitorum (communis)

Head of metacarpal (knuckle)

Dorsal interossei

After Ingres

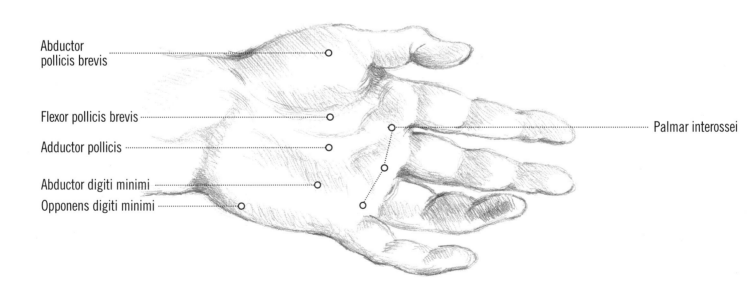

Abductor pollicis brevis

Flexor pollicis brevis

Adductor pollicis

Abductor digiti minimi

Opponens digiti minimi

Palmar interossei

After Lucian Freud

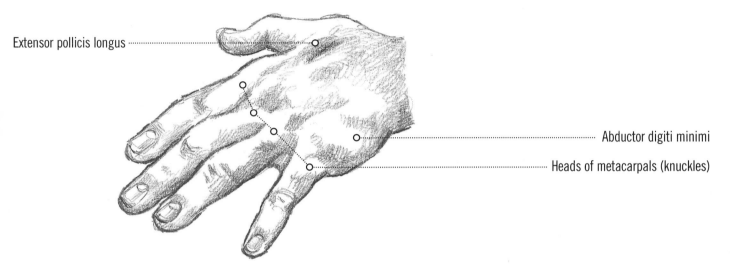

Extensor pollicis longus

Abductor digiti minimi

Heads of metacarpals (knuckles)

After Titian (1485–1576)

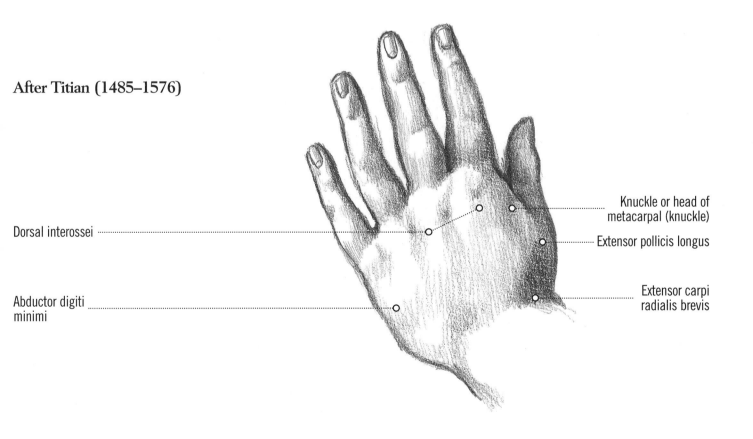

Dorsal interossei

Abductor digiti minimi

Knuckle or head of metacarpal (knuckle)

Extensor pollicis longus

Extensor carpi radialis brevis

107

PRACTICE: DRAWING YOUR OWN HAND

This exercise starts with the simple task of drawing around the outline of your own hand. Just place your hand flat on the paper and then carefully draw all around the shape, making sure that the pencil point does not get too far away from, or too much under, the edge of your hand.

Lift your hand carefully off the paper, keeping it flat and in the same position as before, then draw in all the wrinkles, bumps and hollows that you can see in the simplest way possible, and of course the fingernails too. You will have a fairly good representation of your own hand, matching it for size and shape. Now have a go at drawing it in the same position but without tracing around the edge of it. Does the second drawing look as good as the first one?

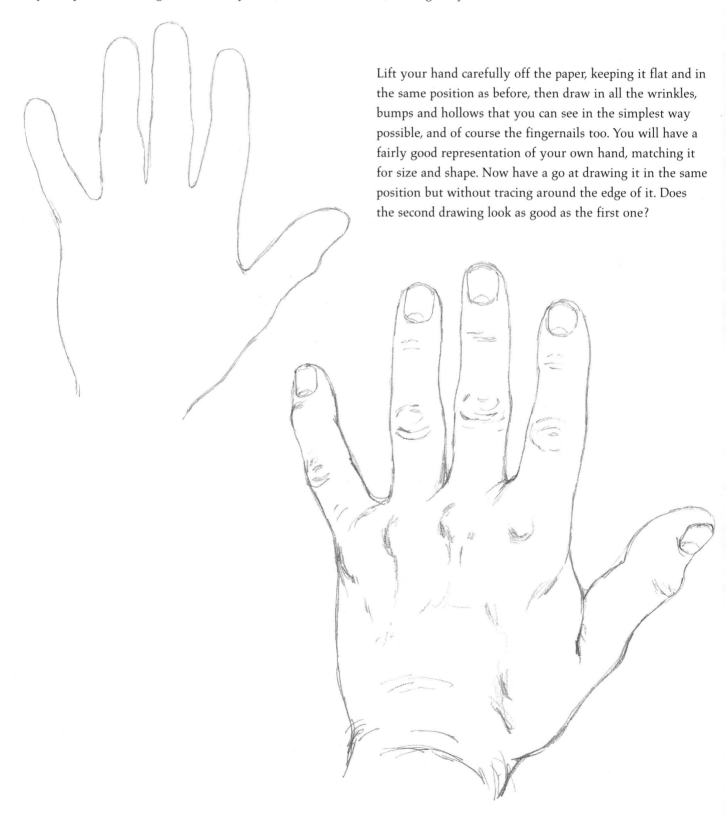

108

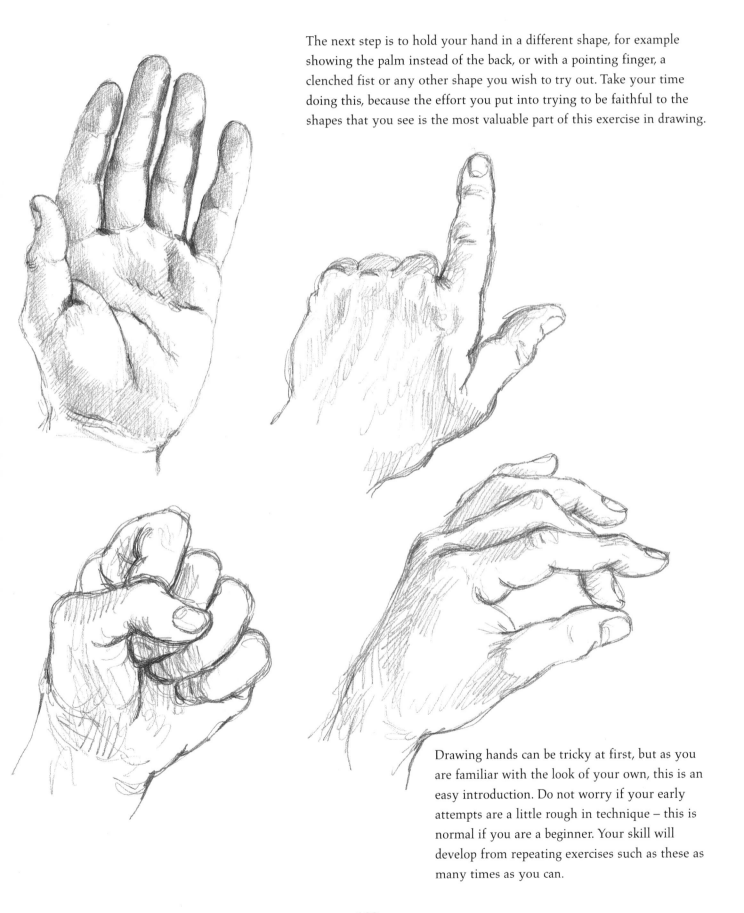

The next step is to hold your hand in a different shape, for example showing the palm instead of the back, or with a pointing finger, a clenched fist or any other shape you wish to try out. Take your time doing this, because the effort you put into trying to be faithful to the shapes that you see is the most valuable part of this exercise in drawing.

Drawing hands can be tricky at first, but as you are familiar with the look of your own, this is an easy introduction. Do not worry if your early attempts are a little rough in technique – this is normal if you are a beginner. Your skill will develop from repeating exercises such as these as many times as you can.

THE LEGS AND FEET

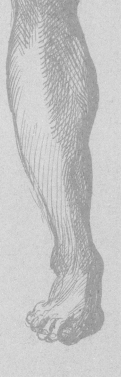

This section is quite extensive, starting with the legs and going on to deal with the feet. Not only do we show the lower limbs from four different angles but also the difference between the male and female versions.

Since they support the entire weight of the body, our legs and feet need to be stronger and larger than the upper limbs, which is why they comprise about half the overall height of the average person.

The knee and ankle joints are just as complex as the elbows and wrists, but because of their weight-bearing facility they are constructed more sturdily.

Ankles still have to be quite flexible but the bones of the feet, unlike the hands, form a rather more solid platform.

The lower limbs must combine extreme flexibility with power and their muscles are usually well developed. The point at which the legs join the torso is immensely important when it comes to the mobility of the body. This means that although the groin and hip area is strongly built and heavily muscled, it is also amazingly supple, as can be seen in the movements of dancers and gymnasts. We will explore these actions in greater detail in a later chapter (pages 234–269).

SKELETON OF THE LEG
front and back view

The skeleton of the lower limb is composed of noticeably longer, stronger bones than the upper limb. The femur is the longest and largest bone in the human body and is in the classic shape that we think of when we visualize a bone, comprising a powerful straight shaft and bulbous ends which help join it to the bone structures of the hip and knee.

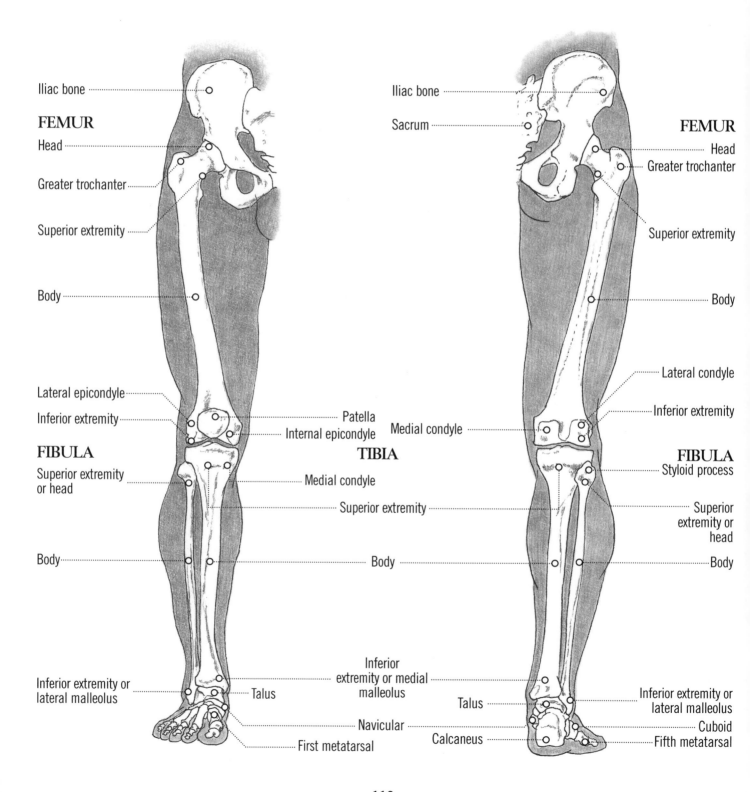

Iliac bone

FEMUR

Head

Greater trochanter

Superior extremity

Body

Lateral epicondyle

Inferior extremity

FIBULA

Superior extremity
or head

Body

Inferior extremity or
lateral malleolus

Patella

Internal epicondyle

Medial condyle

Talus

Navicular

First metatarsal

Iliac bone

Sacrum

FEMUR

Head

Greater trochanter

Superior extremity

Body

Lateral condyle

Inferior extremity

TIBIA

Medial condyle

Superior extremity

Body

Inferior
extremity or medial
malleolus

Talus

Calcaneus

FIBULA

Styloid process

Superior
extremity or
head

Body

Inferior extremity or
lateral malleolus

Cuboid

Fifth metatarsal

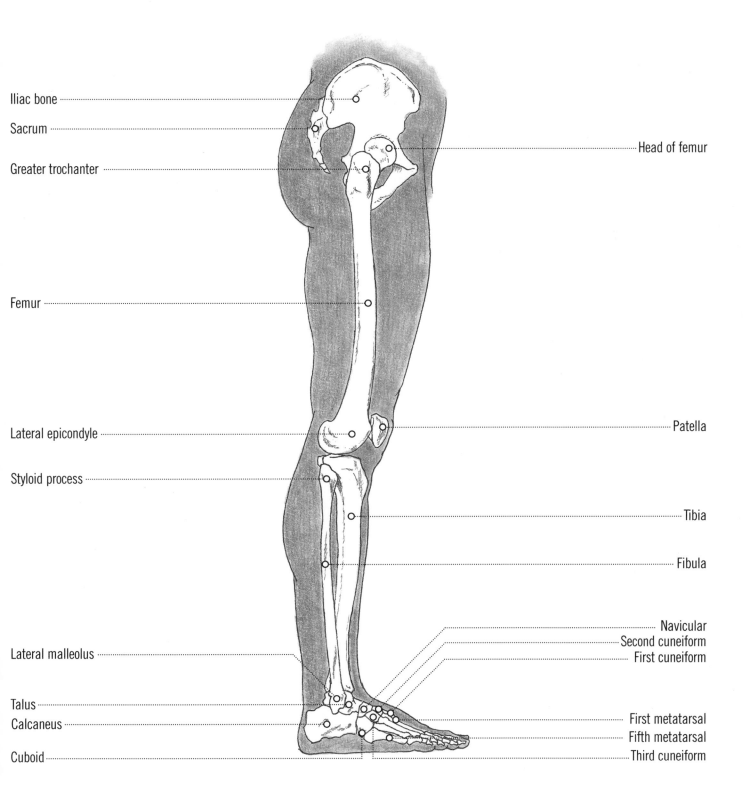

Iliac bone

Sacrum

Greater trochanter

Femur

Lateral epicondyle

Styloid process

Lateral malleolus

Talus

Calcaneus

Cuboid

Head of femur

Patella

Tibia

Fibula

Navicular
Second cuneiform
First cuneiform

First metatarsal
Fifth metatarsal
Third cuneiform

Like the upper limbs, the legs are wrapped in long, layered muscles that help to give flexibility. However, because of the increased strength needed to support the rest of the body's weight, the leg muscles tend to be longer and bigger.

I have included the band of fascia running down the side of the leg over the muscles (the fascia lata and the iliotibial band) and the band of Richer which holds the muscles in at the front of the thigh.

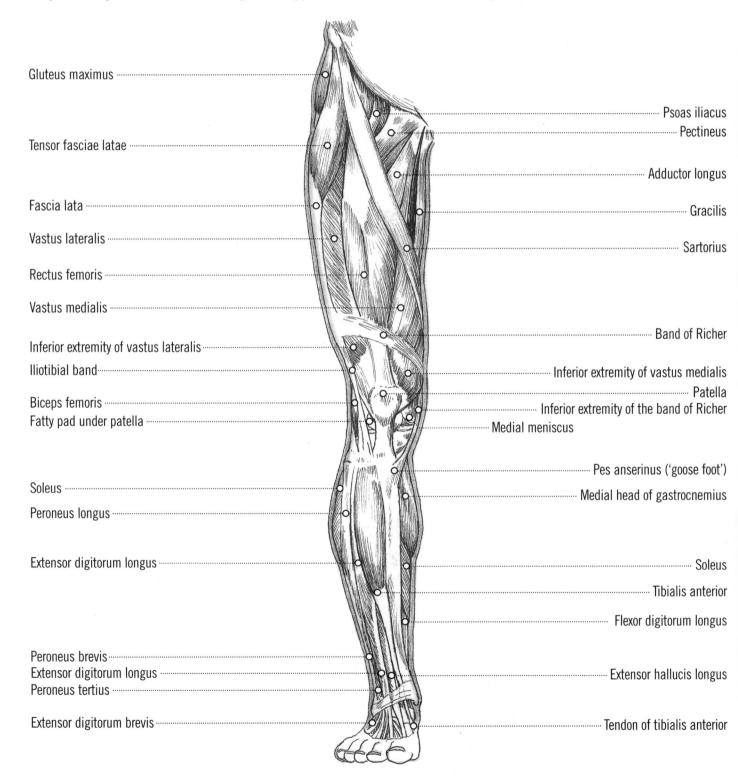

Gluteus maximus

Tensor fasciae latae

Fascia lata

Vastus lateralis

Rectus femoris

Vastus medialis

Inferior extremity of vastus lateralis

Iliotibial band

Biceps femoris

Fatty pad under patella

Soleus

Peroneus longus

Extensor digitorum longus

Peroneus brevis

Extensor digitorum longus

Peroneus tertius

Extensor digitorum brevis

Psoas iliacus

Pectineus

Adductor longus

Gracilis

Sartorius

Band of Richer

Inferior extremity of vastus medialis

Patella

Inferior extremity of the band of Richer

Medial meniscus

Pes anserinus ('goose foot')

Medial head of gastrocnemius

Soleus

Tibialis anterior

Flexor digitorum longus

Extensor hallucis longus

Tendon of tibialis anterior

The group of tendons that run down the back of the leg to the knee are collectively known as the hamstrings. These are the tendons of the biceps femoris, the semitendinosus and the semimembranosus.

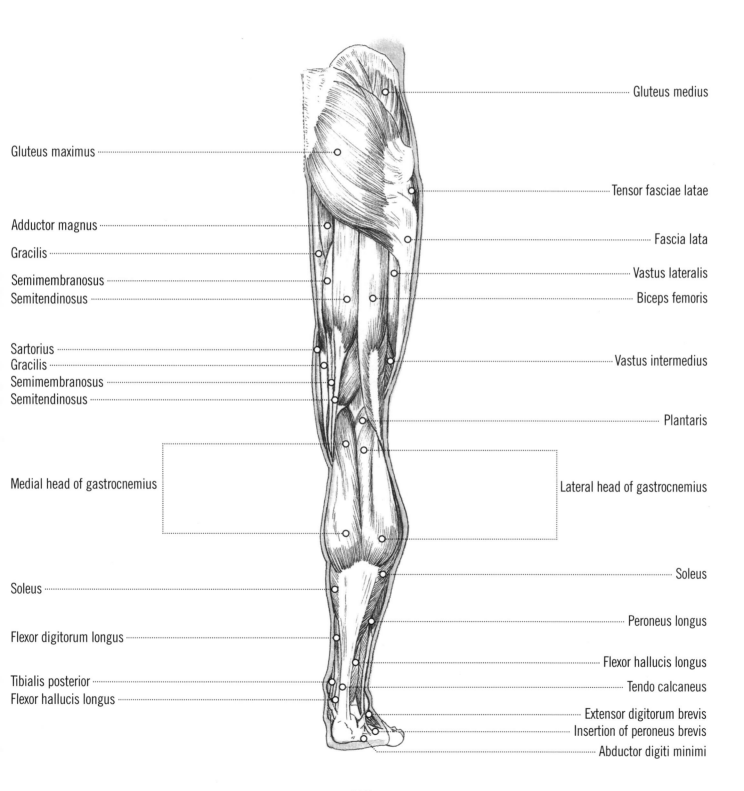

Gluteus medius

Gluteus maximus

Tensor fasciae latae

Adductor magnus

Fascia lata

Gracilis

Vastus lateralis

Semimembranosus

Biceps femoris

Semitendinosus

Sartorius

Vastus intermedius

Gracilis

Semimembranosus

Semitendinosus

Plantaris

Medial head of gastrocnemius

Lateral head of gastrocnemius

Soleus

Soleus

Peroneus longus

Flexor digitorum longus

Flexor hallucis longus

Tibialis posterior

Tendo calcaneus

Flexor hallucis longus

Extensor digitorum brevis

Insertion of peroneus brevis

Abductor digiti minimi

MUSCLES OF THE LEG
side view, external aspect

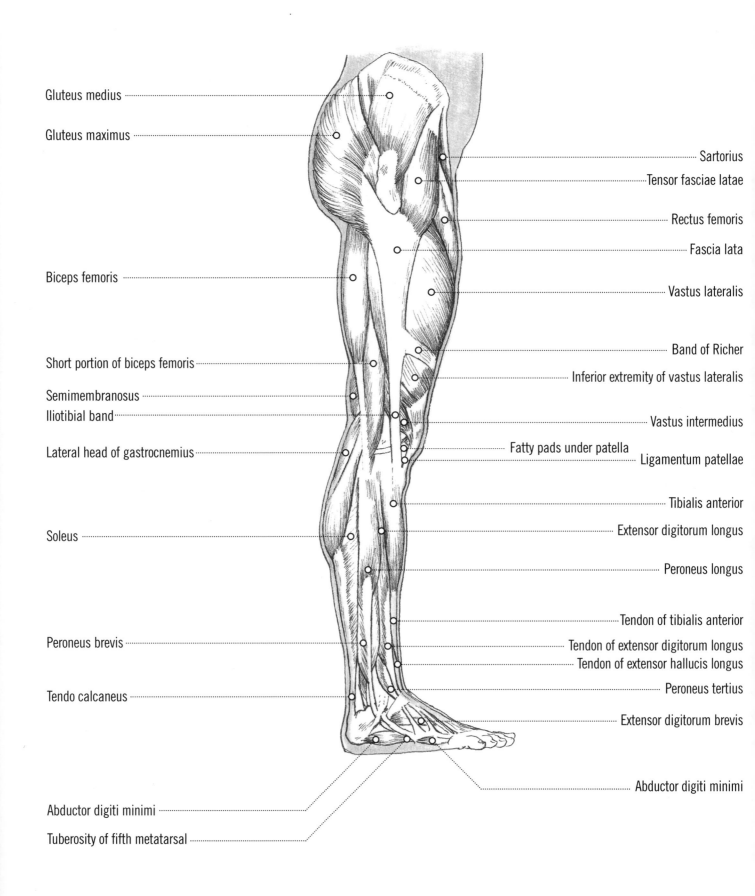

Gluteus medius

Gluteus maximus

Biceps femoris

Short portion of biceps femoris

Semimembranosus

Iliotibial band

Lateral head of gastrocnemius

Soleus

Peroneus brevis

Tendo calcaneus

Abductor digiti minimi

Tuberosity of fifth metatarsal

Sartorius

Tensor fasciae latae

Rectus femoris

Fascia lata

Vastus lateralis

Band of Richer

Inferior extremity of vastus lateralis

Vastus intermedius

Fatty pads under patella

Ligamentum patellae

Tibialis anterior

Extensor digitorum longus

Peroneus longus

Tendon of tibialis anterior

Tendon of extensor digitorum longus

Tendon of extensor hallucis longus

Peroneus tertius

Extensor digitorum brevis

Abductor digiti minimi

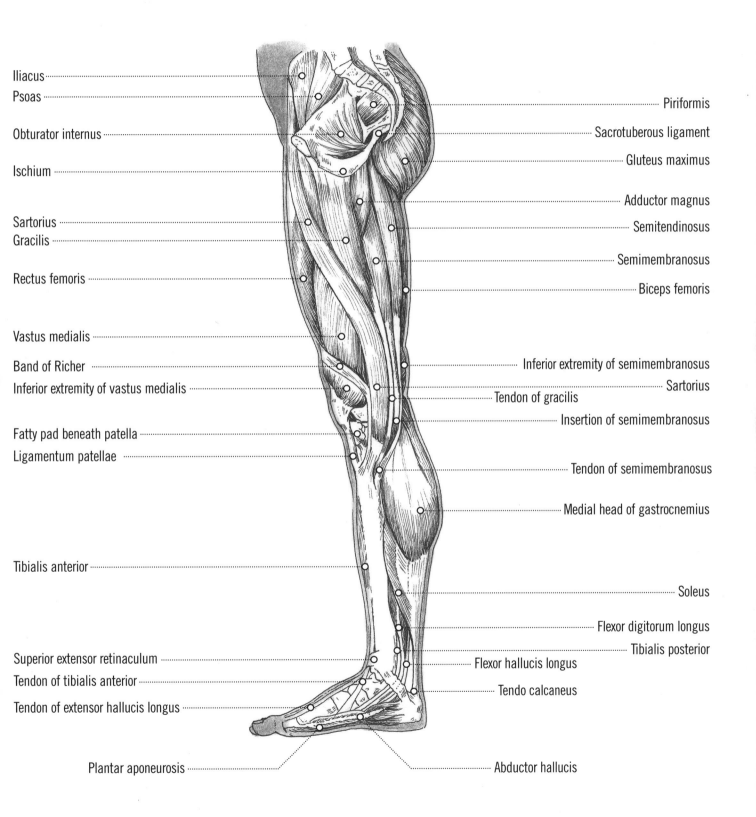

Iliacus

Psoas

Obturator internus

Ischium

Sartorius

Gracilis

Rectus femoris

Vastus medialis

Band of Richer

Inferior extremity of vastus medialis

Fatty pad beneath patella

Ligamentum patellae

Tibialis anterior

Superior extensor retinaculum

Tendon of tibialis anterior

Tendon of extensor hallucis longus

Plantar aponeurosis

Piriformis

Sacrotuberous ligament

Gluteus maximus

Adductor magnus

Semitendinosus

Semimembranosus

Biceps femoris

Inferior extremity of semimembranosus

Sartorius

Tendon of gracilis

Insertion of semimembranosus

Tendon of semimembranosus

Medial head of gastrocnemius

Soleus

Flexor digitorum longus

Tibialis posterior

Flexor hallucis longus

Tendo calcaneus

Abductor hallucis

117

Seeing the leg from the surface gives no real hint of its complexity underneath the skin. On the whole, the larger muscles are the only ones easily seen and the only bone structure visible is at the knee and the ankles. However the tibia (shin bone) creates a long, smooth surface at the front of the lower leg that is clearly noticeable.

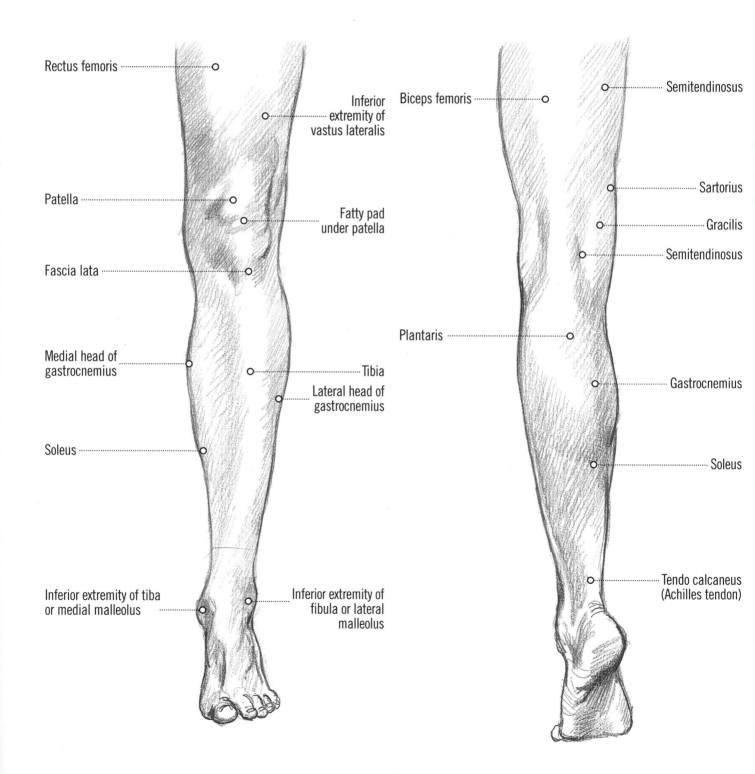

Rectus femoris

Inferior extremity of vastus lateralis

Patella

Fatty pad under patella

Fascia lata

Medial head of gastrocnemius

Tibia

Lateral head of gastrocnemius

Soleus

Inferior extremity of tiba or medial malleolus

Inferior extremity of fibula or lateral malleolus

Biceps femoris

Semitendinosus

Sartorius

Gracilis

Semitendinosus

Plantaris

Gastrocnemius

Soleus

Tendo calcaneus (Achilles tendon)

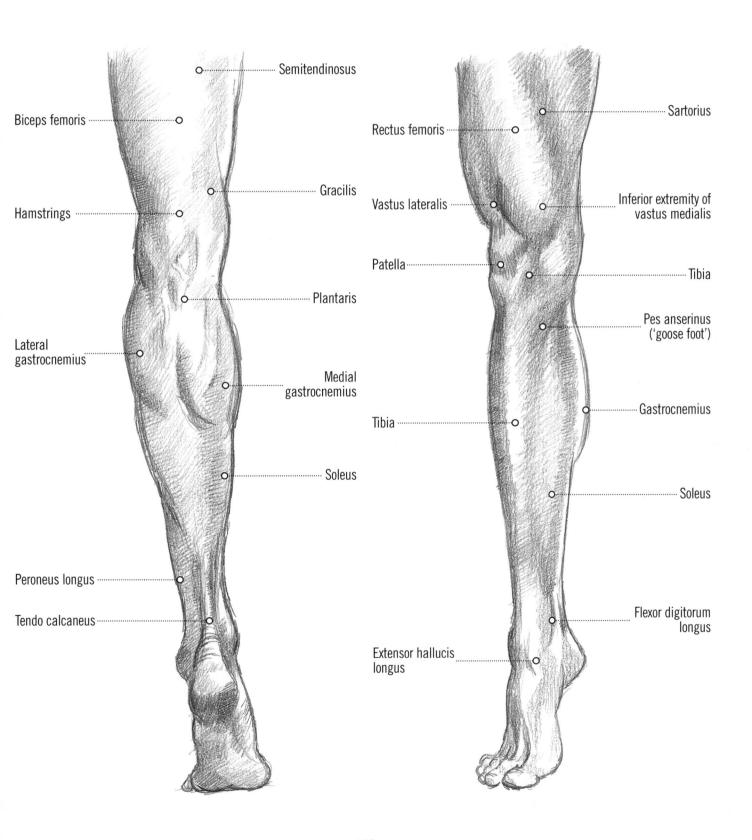

Semitendinosus

Biceps femoris

Hamstrings

Lateral gastrocnemius

Peroneus longus

Tendo calcaneus

Gracilis

Plantaris

Medial gastrocnemius

Soleus

Rectus femoris

Vastus lateralis

Patella

Tibia

Extensor hallucis longus

Sartorius

Inferior extremity of vastus medialis

Tibia

Pes anserinus ('goose foot')

Gastrocnemius

Soleus

Flexor digitorum longus

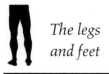
FEMALE OUTSIDE LEG

MALE OUTSIDE LEG

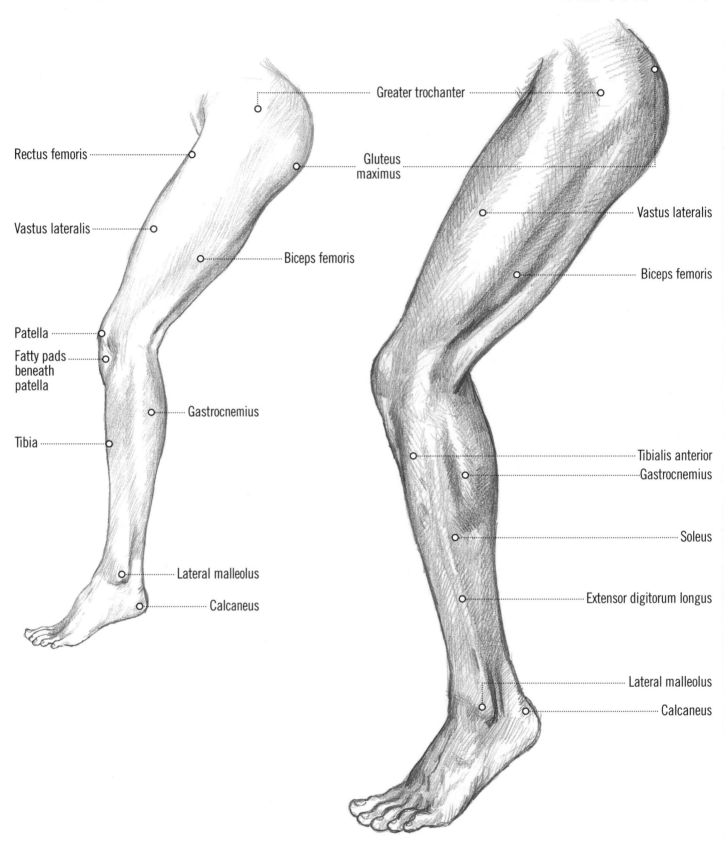

Greater trochanter

Rectus femoris

Gluteus maximus

Vastus lateralis

Biceps femoris

Patella

Fatty pads beneath patella

Tibia

Gastrocnemius

Lateral malleolus

Calcaneus

Vastus lateralis

Biceps femoris

Tibialis anterior

Gastrocnemius

Soleus

Extensor digitorum longus

Lateral malleolus

Calcaneus

FEMALE INSIDE LEG

MALE INSIDE LEG

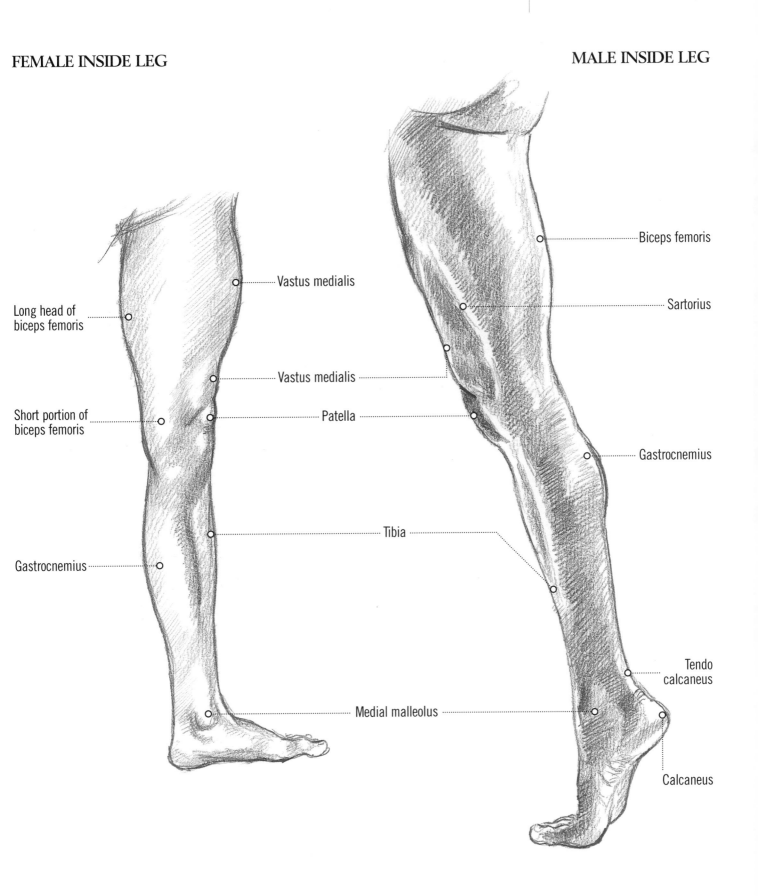

Long head of
biceps femoris

Short portion of
biceps femoris

Gastrocnemius

Vastus medialis

Vastus medialis

Patella

Tibia

Medial malleolus

Biceps femoris

Sartorius

Gastrocnemius

Tendo
calcaneus

Calcaneus

Six drawings of legs are shown in this section, three male and three female. The male legs are from studies by Raphael and Michelangelo and are all drawn in ink. The ink gives a certain sharpness to the definition of forms, while the female versions – by Ingres, von Carolsfeld and Rubens – are drawn in pencil and chalk, which give a softer, rather more subtle effect.

After Raphael

Gluteus maximus

Long head of biceps femoris

Short head of biceps femoris

Semimembranosus

Lateral head of gastrocnemius

Peroneus longus

Tendo calcaneus

Calcaneus

Rectus femoris

Fascia lata

Vastus lateralis

Inferior extremity of vastus lateralis

Patella

Tibialis anterior

Extensor digitorum longus

Lateral malleolus

After Michelangelo

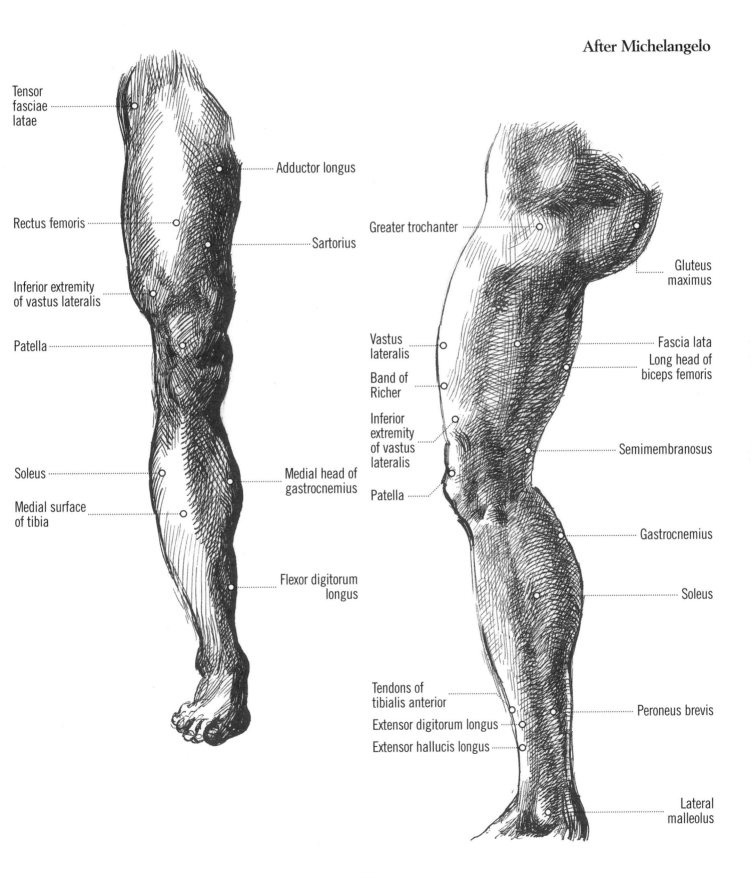

Tensor fasciae latae

Rectus femoris

Inferior extremity of vastus lateralis

Patella

Soleus

Medial surface of tibia

Adductor longus

Sartorius

Medial head of gastrocnemius

Flexor digitorum longus

Greater trochanter

Vastus lateralis

Band of Richer

Inferior extremity of vastus lateralis

Patella

Gluteus maximus

Fascia lata

Long head of biceps femoris

Semimembranosus

Gastrocnemius

Soleus

Tendons of tibialis anterior

Extensor digitorum longus

Extensor hallucis longus

Peroneus brevis

Lateral malleolus

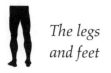
After Ingres

After Julius Schnorr von Carolsfeld (1794–1872)

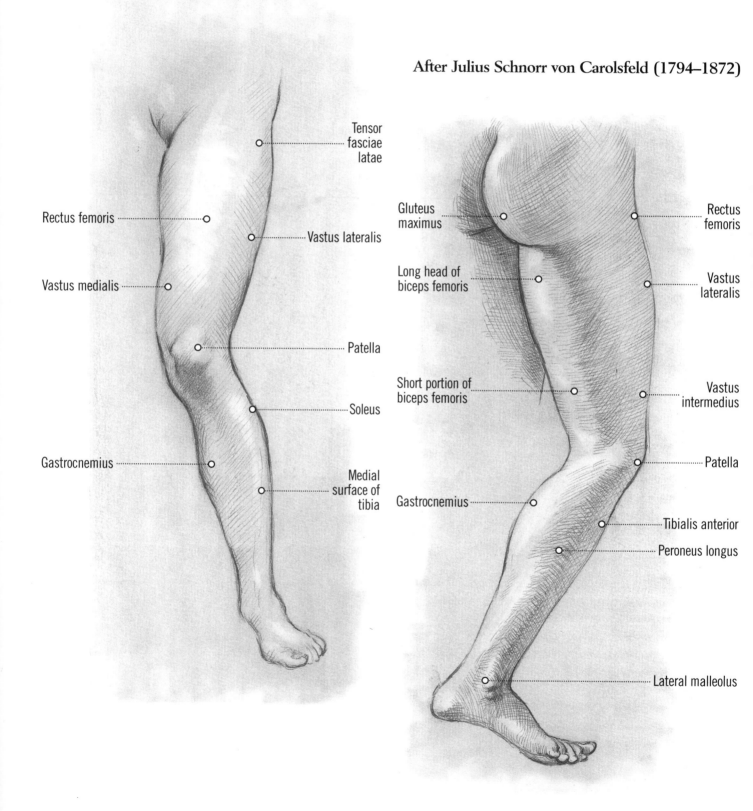

Tensor fasciae latae

Rectus femoris

Vastus lateralis

Vastus medialis

Patella

Soleus

Gastrocnemius

Medial surface of tibia

Gluteus maximus

Rectus femoris

Long head of biceps femoris

Vastus lateralis

Short portion of biceps femoris

Vastus intermedius

Patella

Gastrocnemius

Tibialis anterior

Peroneus longus

Lateral malleolus

After Rubens

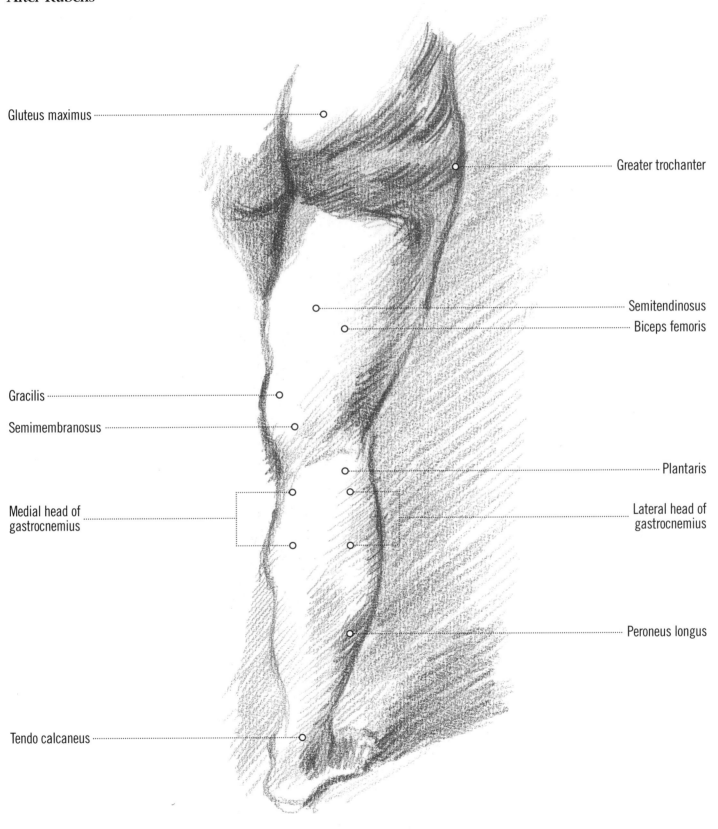

Gluteus maximus

Greater trochanter

Semitendinosus

Biceps femoris

Gracilis

Semimembranosus

Plantaris

Medial head of gastrocnemius

Lateral head of gastrocnemius

Peroneus longus

Tendo calcaneus

As with the hand in the previous chapter, I will deal with the foot separately from the leg, as it is quite a complex feature.

It is not such a familiar part of the body either, as people tend to keep their shoes on when walking about in public.

SIDE VIEW

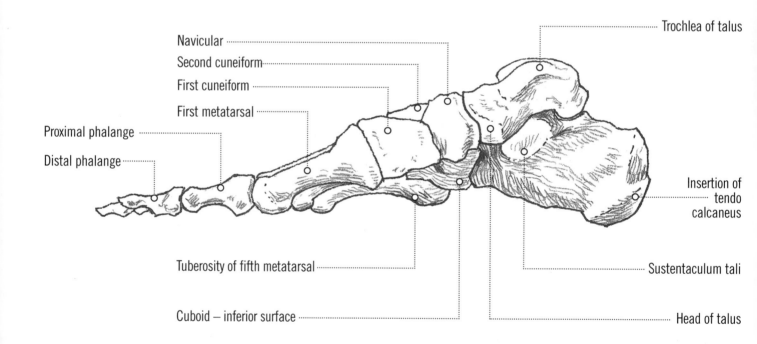

Navicular

Second cuneiform

First cuneiform

First metatarsal

Proximal phalange

Distal phalange

Trochlea of talus

Insertion of tendo calcaneus

Tuberosity of fifth metatarsal

Sustentaculum tali

Cuboid – inferior surface

Head of talus

TOP VIEW

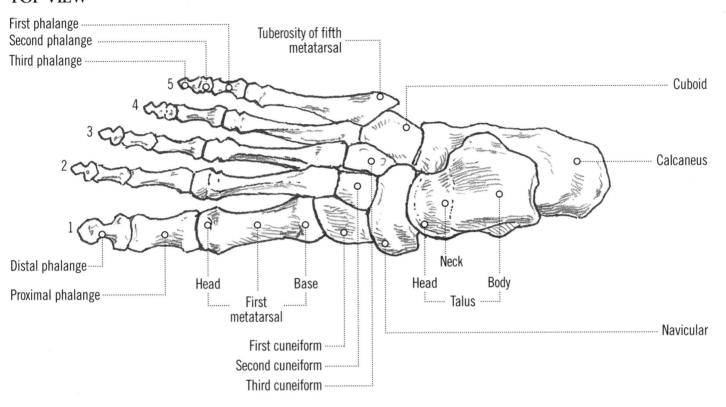

First phalange
Second phalange
Third phalange

Tuberosity of fifth metatarsal

Cuboid

Calcaneus

5
4
3
2
1

Distal phalange
Proximal phalange

Head
Base
First metatarsal

Neck
Head
Body
Talus

Navicular

First cuneiform
Second cuneiform
Third cuneiform

BOTTOM VIEW

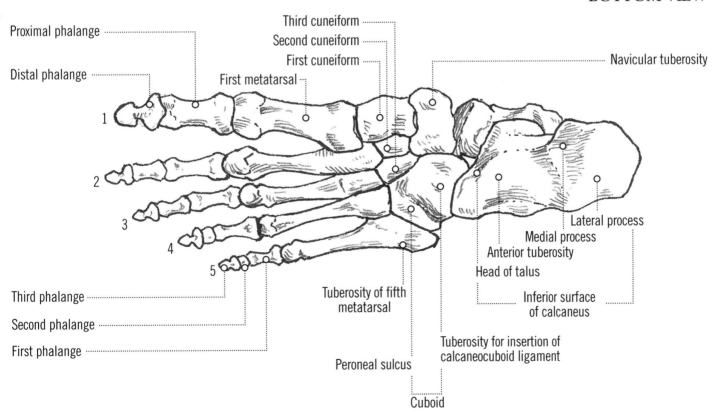

Proximal phalange
Distal phalange

Third cuneiform
Second cuneiform
First cuneiform
First metatarsal

Navicular tuberosity

1
2
3
4
5

Third phalange
Second phalange
First phalange

Tuberosity of fifth metatarsal

Lateral process
Medial process
Anterior tuberosity
Head of talus
Inferior surface of calcaneus

Tuberosity for insertion of calcaneocuboid ligament

Peroneal sulcus

Cuboid

MUSCLES OF THE FOOT

The muscles of the foot have several
complex layers that are not easily seen
on the surface, nor do we have much
opportunity to examine the sole of the
foot, so it is not so familiar to us.

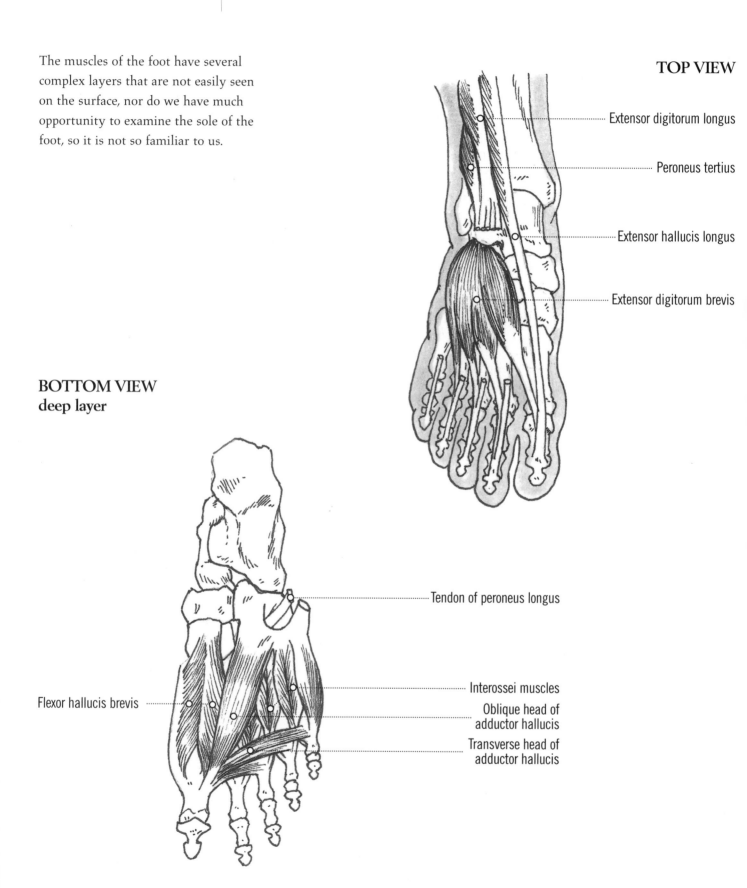

TOP VIEW

Extensor digitorum longus

Peroneus tertius

Extensor hallucis longus

Extensor digitorum brevis

BOTTOM VIEW
deep layer

Tendon of peroneus longus

Flexor hallucis brevis

Interossei muscles

Oblique head of
adductor hallucis

Transverse head of
adductor hallucis

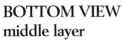

BOTTOM VIEW
middle layer

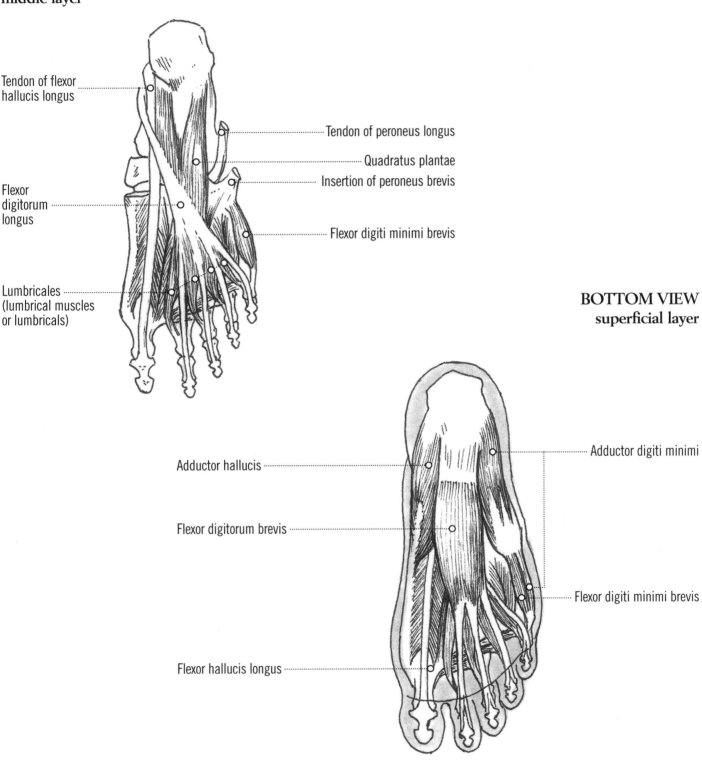

Tendon of flexor
hallucis longus

Flexor
digitorum
longus

Lumbricales
(lumbrical muscles
or lumbricals)

Tendon of peroneus longus

Quadratus plantae

Insertion of peroneus brevis

Flexor digiti minimi brevis

BOTTOM VIEW
superficial layer

Adductor hallucis

Flexor digitorum brevis

Flexor hallucis longus

Adductor digiti minimi

Flexor digiti minimi brevis

FRONT VIEW: MALE

Extensor hallucis longus

Extensor digitorum brevis

Extensor digitorum brevis

Third phalange

Distal phalange

FRONT VIEW: FEMALE

Extensor hallucis longus

Third phalange

Distal phalange

INSIDE VIEW: FEMALE

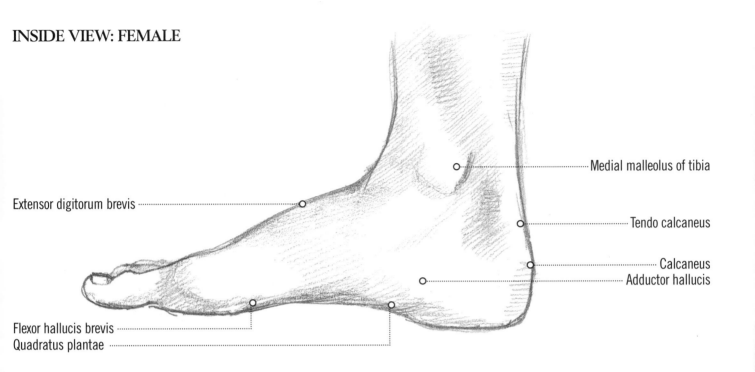

Extensor digitorum brevis

Medial malleolus of tibia

Tendo calcaneus

Calcaneus
Adductor hallucis

Flexor hallucis brevis
Quadratus plantae

INSIDE VIEW: MALE

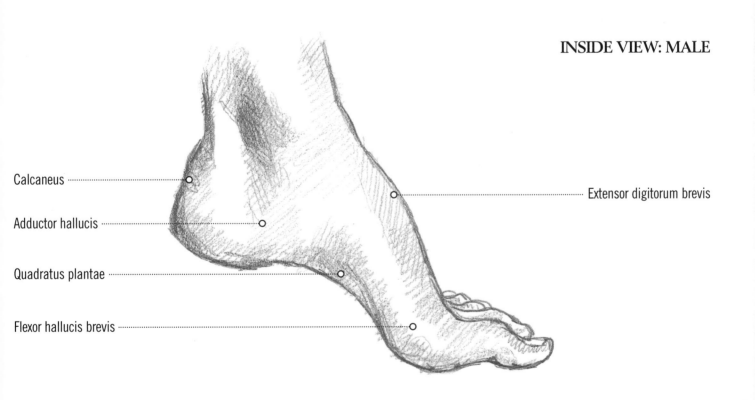

Calcaneus

Adductor hallucis

Quadratus plantae

Flexor hallucis brevis

Extensor digitorum brevis

TOP VIEW: FEMALE

OUTSIDE VIEW: FEMALE

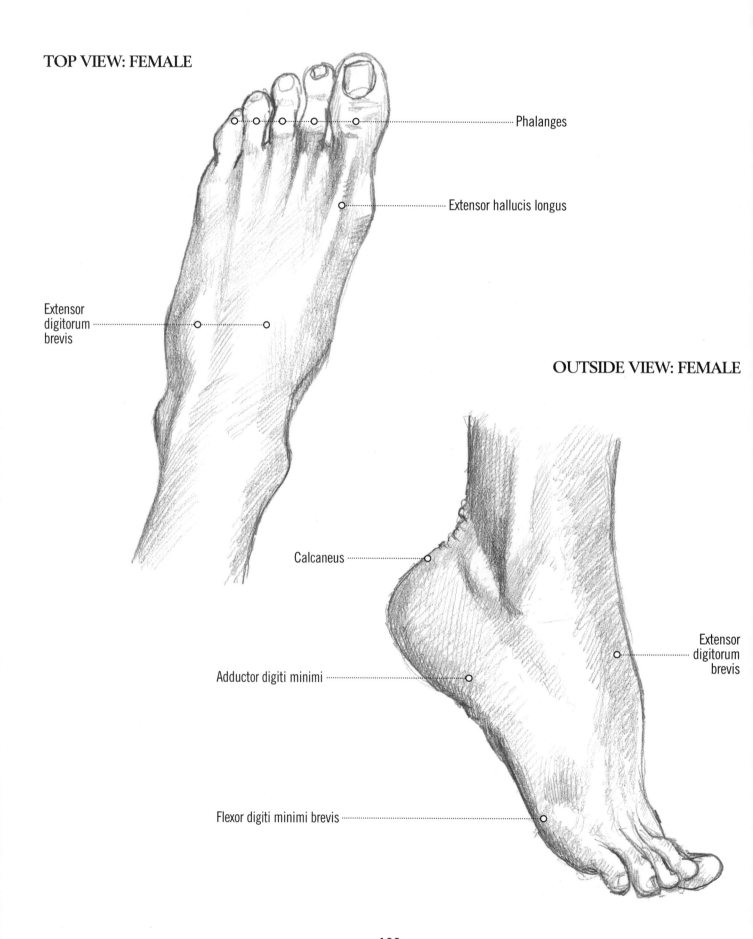

Phalanges

Extensor hallucis longus

Extensor digitorum brevis

Calcaneus

Extensor digitorum brevis

Adductor digiti minimi

Flexor digiti minimi brevis

OUTSIDE VIEW: MALE

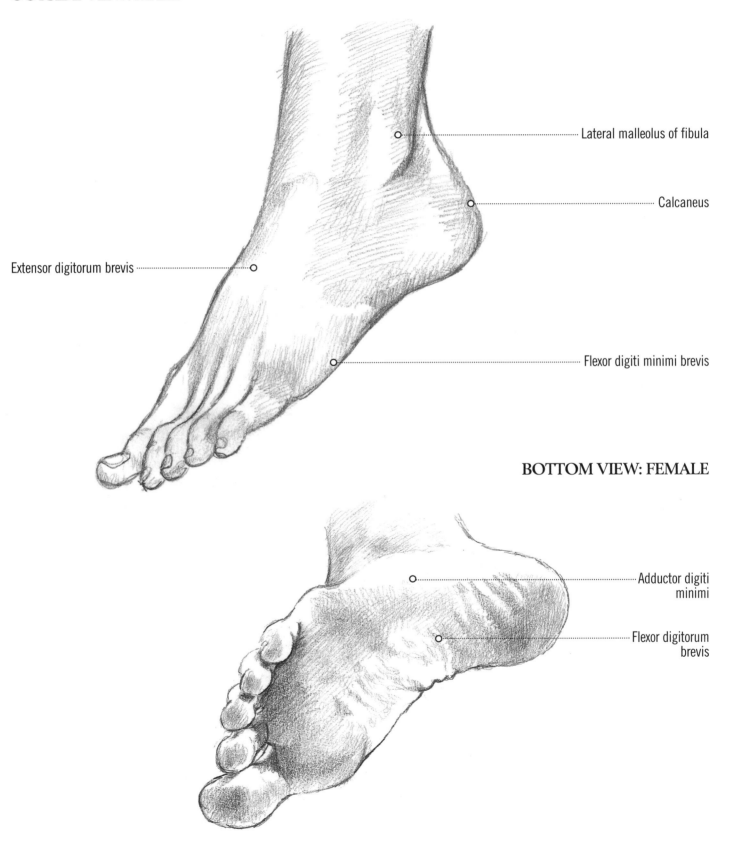

Lateral malleolus of fibula

Calcaneus

Extensor digitorum brevis

Flexor digiti minimi brevis

BOTTOM VIEW: FEMALE

Adductor digiti
minimi

Flexor digitorum
brevis

Examples of the foot drawn by well-known artists have proved more difficult to find than other parts of the body, because detailed feet tend not to feature very strongly in pictures, and the number of specific feet drawings is rather limited. So, as I have found examples from more modern sources, you may not be familiar with some of these artists. However, they are certainly good artists who have drawn the foot very accurately.

After Joseph Sheppard (1930–)

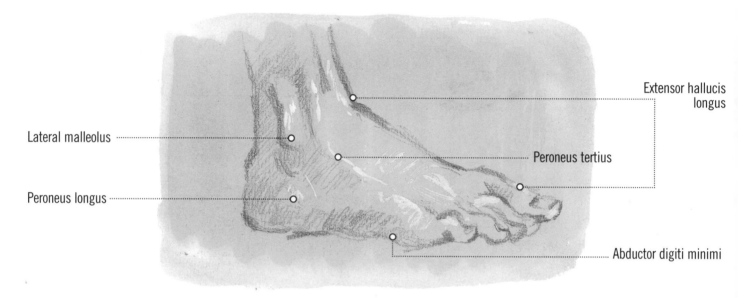

Extensor hallucis longus

Lateral malleolus

Peroneus tertius

Peroneus longus

Abductor digiti minimi

After Joseph Sheppard

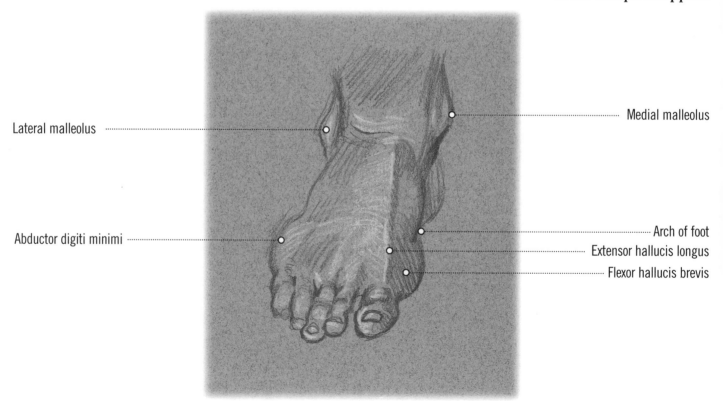

Lateral malleolus

Medial malleolus

Abductor digiti minimi

Arch of foot

Extensor hallucis longus

Flexor hallucis brevis

After Ted Seth Jacobs

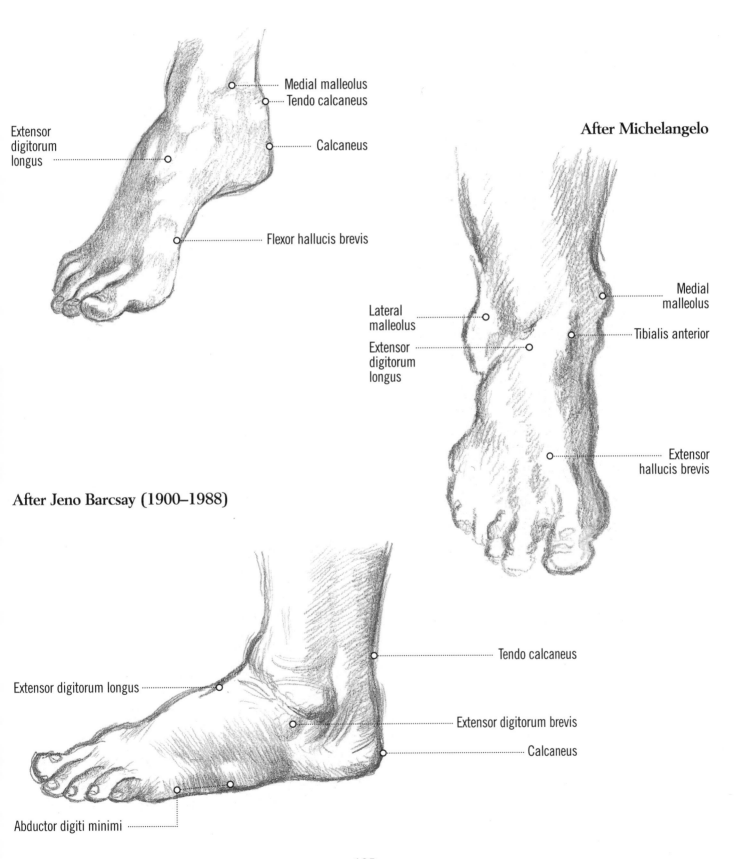

Medial malleolus

Tendo calcaneus

Calcaneus

Extensor digitorum longus

Flexor hallucis brevis

After Michelangelo

Lateral malleolus

Extensor digitorum longus

Medial malleolus

Tibialis anterior

Extensor hallucis brevis

After Jeno Barcsay (1900–1988)

Tendo calcaneus

Extensor digitorum longus

Extensor digitorum brevis

Calcaneus

Abductor digiti minimi

135

THE HEAD IN MOVEMENT

In this section we return to the head, to see how it may be drawn from our anatomical knowledge. We look at it, quite literally, from different angles and relate various expressions to particular facial muscles. The main thing is to start with its overall shape. We are all used to concentrating on the features of the face – particularly the eyes and mouth – because this is where we read people's moods. But it means we tend to disregard the rest of the head, its overall structure and aspect. In order to draw it properly we should start with the basic shape and ignore any distractions.

Then, having worked at the shape of the head, the next thing to consider is movement of the facial features. The jaw is highly mobile, giving expression to

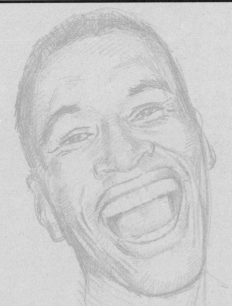

the entire face. But even the slightest movements of the lips and eyes play their part in conferring expressions.

We shall be looking in detail at the muscles involved in expressing a whole range of emotions, from anger to contentment. Familiarity with the muscle structure underlying the face is very useful for capturing the character of a human subject accurately. So, careful investigation of what exactly happens to all these features is important to our studies.

The head is often observed turning from full face towards a profile view. Looking at the full face (1), both eyes are the same shape, the mouth is fully displayed, and the nose is indicated chiefly by the nostrils. As shown in our diagram, when the head turns, the features remain the same distance apart and stay in the same relationship horizontally.

However, as the head rotates away to a three-quarter view (2), we begin to see the shape of the nose becoming more evident, while the far side of the mouth compresses into a shorter line, and the eye farthest from our view appears smaller than the nearer one.

Continuing towards the profile or side view (3), the nose becomes more and more prominent, while one eye disappears completely. Only half of the mouth can now be seen and – given the perspective – this is quite short in length. Notice how the shape of the head also changes from a rather narrow shape – longer than it is broad – to quite a square one, where width and length are almost the same. We can also see the shape of the ear, which at full face was hardly noticeable.

1. 2. 3.

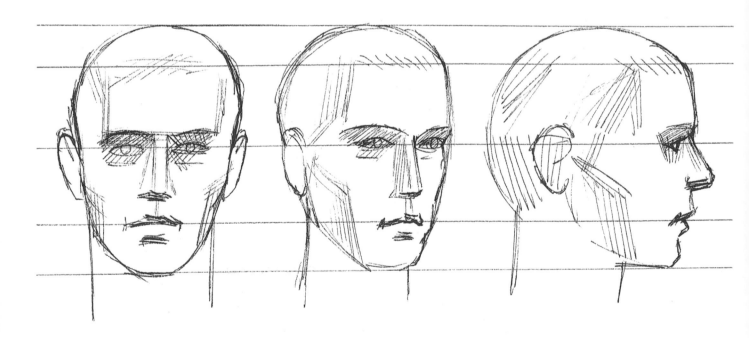

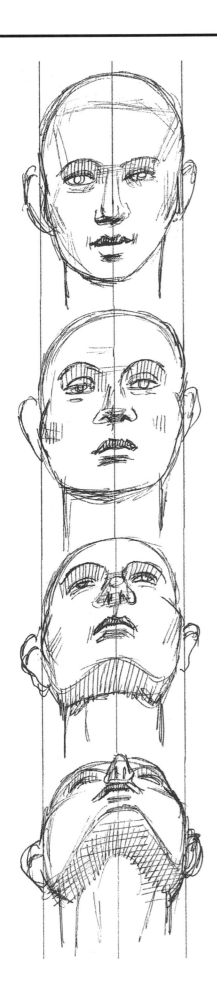

Next, we shall look at the head in another sequence that opens with the full face, but this time the head will be lifted backwards with the chin tilting up, until very little of the face is seen from below.

Note at the beginning that the front view goes from the top of the head to the tip of the chin, and the facial features are all clearly visible.

Now, as we tilt the head backwards, we see less of the forehead and start to reveal the underside of the jaw and the nose. The end of the nose now seems to be about halfway down the head instead of three-quarters, as it was in the first diagram. The eyes appear narrower and the top of the head is invisible.

One more tilt of the head shows an even larger area underneath the jaw, and the mouth seems to curve downwards. The underside of the nose, with both nostrils very clearly visible, starts to look as though it is positioned between the eyes, which are even more narrowed now. The forehead is reduced to a small crescent shape and the cheekbones stand out more sharply. The ears, meanwhile, are descending to a position level with the chin, and the neck is very prominent.

One further tilt lifts the chin so high that we can now see its complete shape; and the nose, mouth and eyebrows are all so close together that they can hardly be seen. This angle of the head is unfamiliar to us, and is only usually seen when someone is lying down and we are looking up towards their head.

Note how the head looks vastly different from this angle, appearing as a much shorter, compacted shape.

139

These examples show variations on viewing the head from slightly unusual angles, and you can see how they all suggest different expressions of the body's movement. Although the models for these drawings were not trying to express any particular feelings, the very fact of the movement of the head lends a certain element of drama to the drawings. This is because we don't usually move our heads without meaning something, and the inclination of the head one way or another looks as though something is meant by the action.

Leaning back seen from below

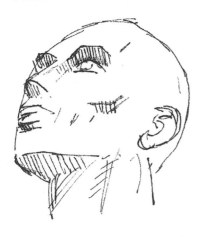

Leaning forward seen from above

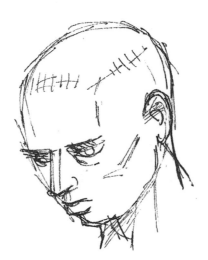

Leaning back seen from below

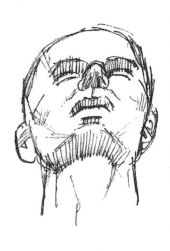

Chin tilted up seen in profile

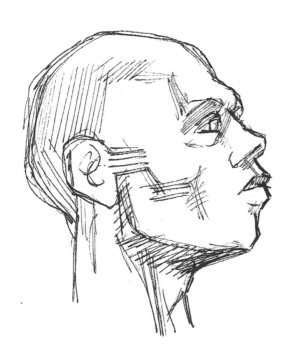

Three-quarter view, head tilted towards viewer

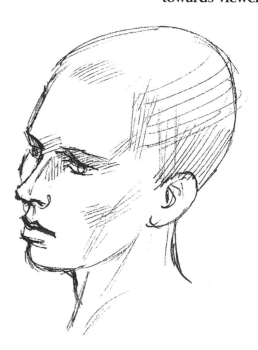

Three-quarter view seen from below

Three-quarter view seen from same level

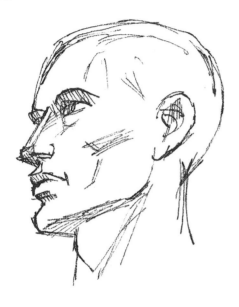

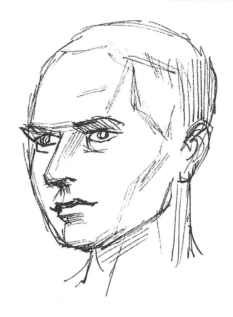

Three-quarter view from the front, seen from almost the same level

Three-quarter view seen tilted forward from above

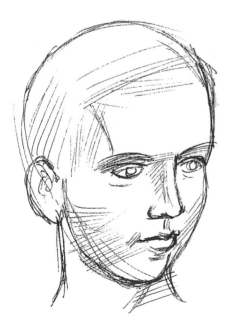

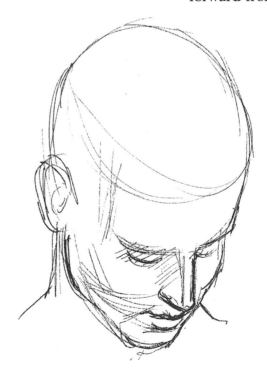

Front view seen from above

Profile seen from a slightly rear view

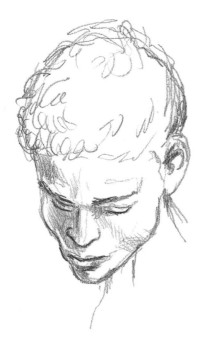

Profile turning toward three-quarter view

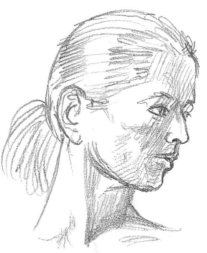

Slightly angled, seen from below

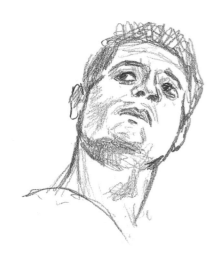

Tilted back, seen from below

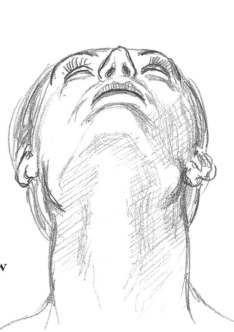

Here we have a few examples after a range of artists of the head seen from different angles. A number of the drawings that follow are after a modern artist, Louise Gordon, who specializes in anatomical drawings and has produced several anatomy books herself. Her drawings are particularly accurate, and I have endeavoured to reproduce them as closely as possible.

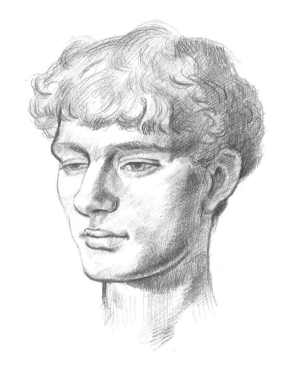

The first is a remarkable portrait by an unknown artist of Mark Gertler (1891–1939), himself an artist who became well known in the period between the two World Wars. The drawing shows the most popular pose for a portrait head, the three-quarter view. This is a very careful drawing of the face, clearly showing the main sets of muscles on a young male head.

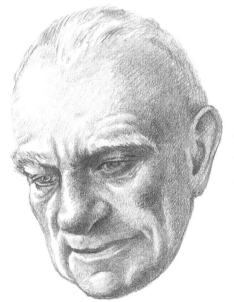

The second portrait is after Louise Gordon, of an elderly man. Once more, it is a three-quarter view, but this time seen from slightly above. The muscles are well defined and can be easily identified, if you have done your homework.

The third example is by the great master Peter Paul Rubens. It shows a young woman, three-quarter view again, but with her head inclined forward. One touching detail is the way the full cheeks of the girl respond to the pull of gravity as she leans forward.

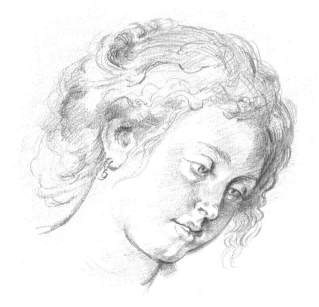

Now we have another study by Louise Gordon, and the first of these is of a girl with her head tilted back and a little to one side. Note how the nose overlaps the far eye. The mouth is curved, and because of the angle the half furthest from us is shorter and partly hidden. If you look closely, you can even see how the curve of the lens on the iris of the eye actually shows against the upper eyelid.

After Louise Gordon
Young girl looking up seen from below

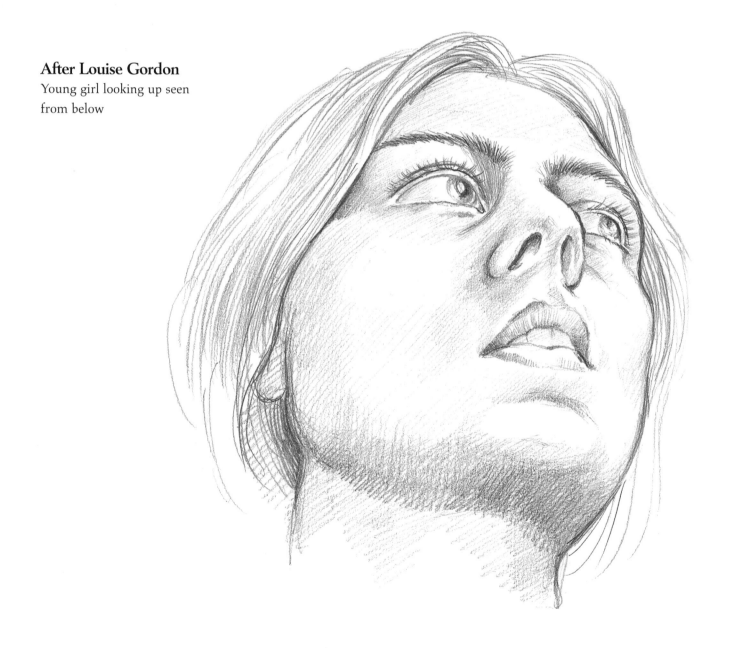

The last of Louise Gordon's drawings shows the back of the model's head; the angle gives a clear view of the rear of the neck. It has a great deal in common with the next drawing, by Michelangelo, of a head seen from the back but with the neck twisted, so that we glimpse a bit of the facial form.

These drawings, from their various angles, serve to show why the whole shape of the head has to be taken into account when drawing people's faces.

After Louise Gordon

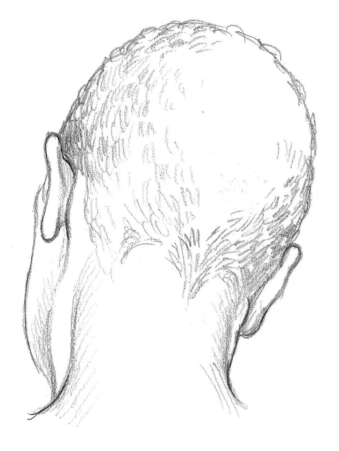

After Michelangelo

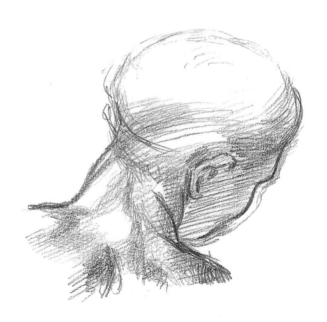

145

Now we move on to the other great challenge of drawing the head: capturing expression. Here are a series of expressions showing the dominant muscles. Check them and then persuade your friends or family to make similar faces, and see if you can identify the muscles responsible.

MUSCLES USED WHEN SMILING, GRINNING AND LAUGHING

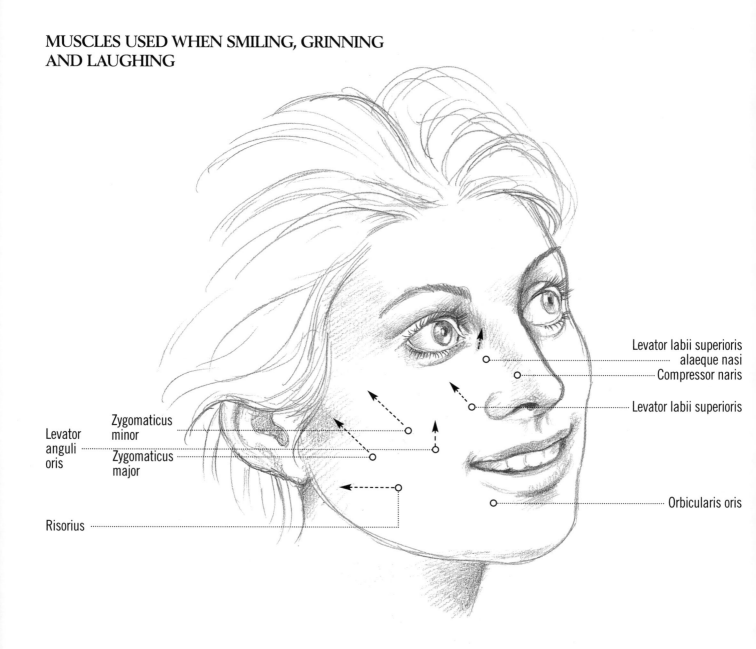

Levator anguli oris

Zygomaticus minor

Zygomaticus major

Risorius

Levator labii superioris alaeque nasi

Compressor naris

Levator labii superioris

Orbicularis oris

146

SHOUTING OUT LOUD

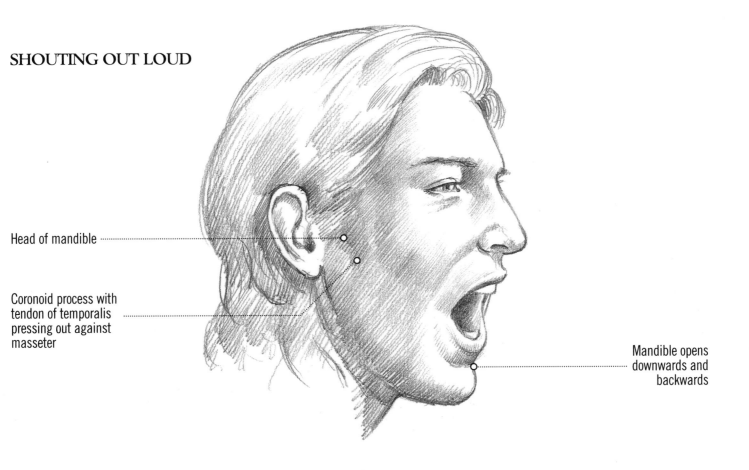

Head of mandible

Coronoid process with tendon of temporalis pressing out against masseter

Mandible opens downwards and backwards

FILLING CHEEKS WITH AIR TO BLOW

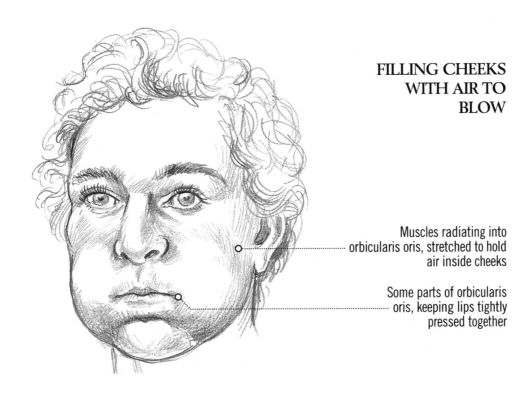

Muscles radiating into orbicularis oris, stretched to hold air inside cheeks

Some parts of orbicularis oris, keeping lips tightly pressed together

147

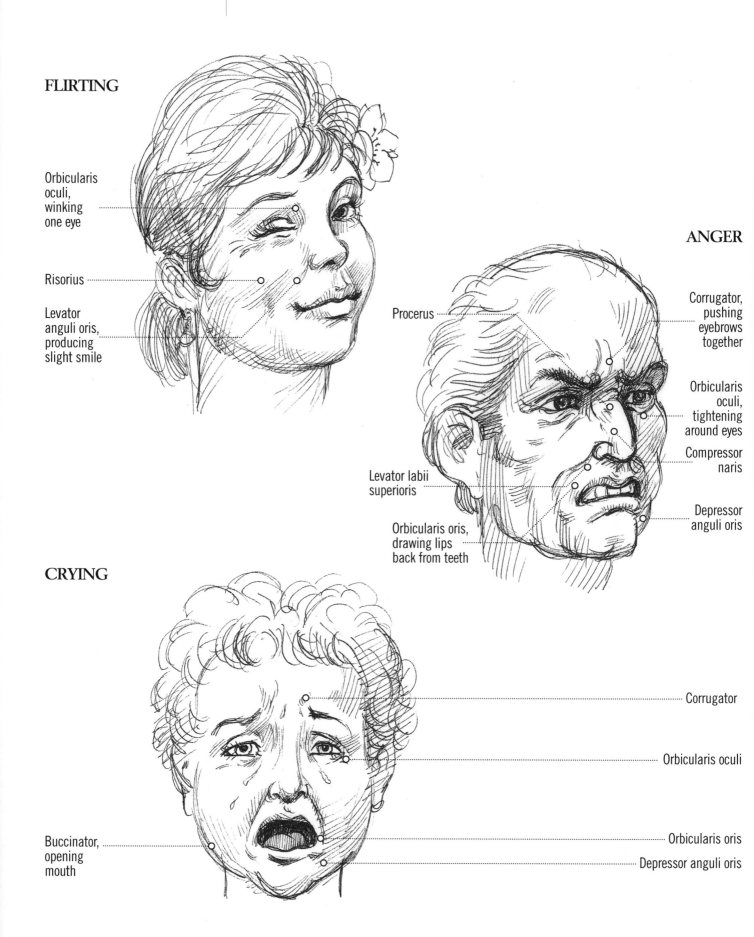

FLIRTING

Orbicularis oculi, winking one eye

Risorius

Levator anguli oris, producing slight smile

ANGER

Procerus

Corrugator, pushing eyebrows together

Orbicularis oculi, tightening around eyes

Compressor naris

Levator labii superioris

Depressor anguli oris

Orbicularis oris, drawing lips back from teeth

CRYING

Corrugator

Orbicularis oculi

Buccinator, opening mouth

Orbicularis oris

Depressor anguli oris

148

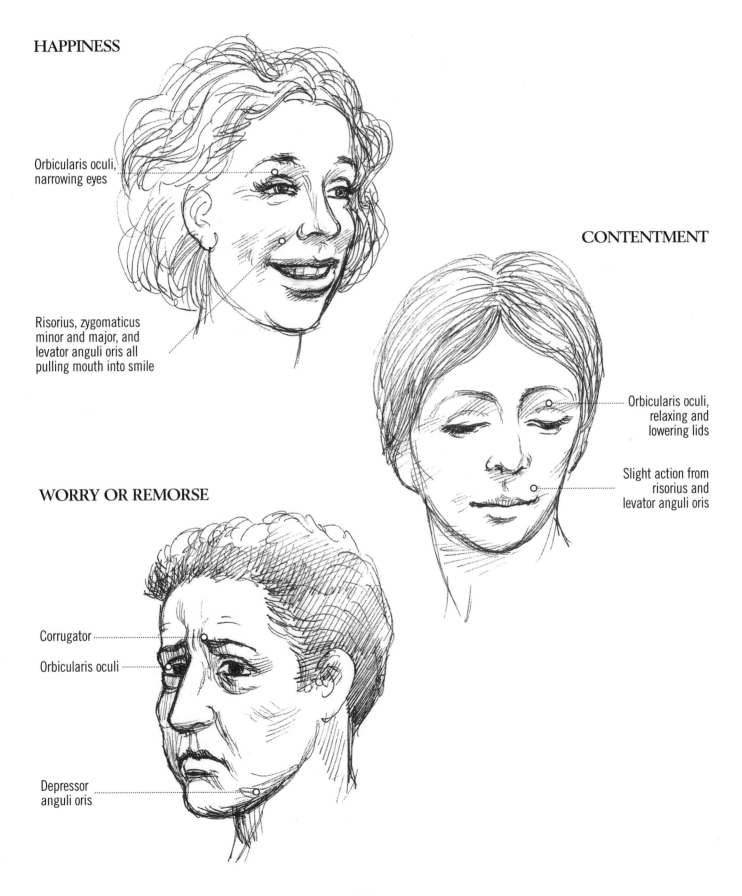

HAPPINESS

Orbicularis oculi, narrowing eyes

Risorius, zygomaticus minor and major, and levator anguli oris all pulling mouth into smile

CONTENTMENT

Orbicularis oculi, relaxing and lowering lids

Slight action from risorius and levator anguli oris

WORRY OR REMORSE

Corrugator

Orbicularis oculi

Depressor anguli oris

149

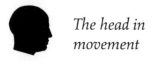

FEAR

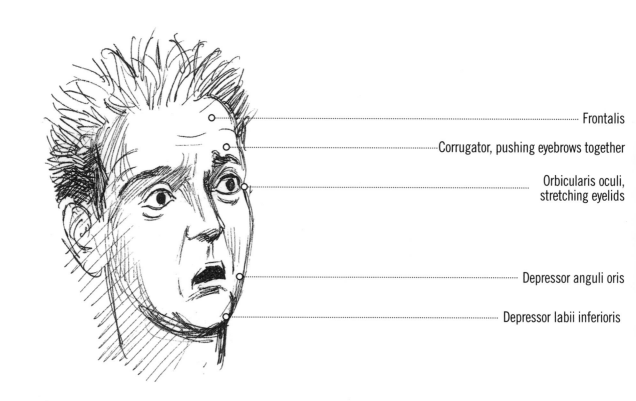

Frontalis

Corrugator, pushing eyebrows together

Orbicularis oculi, stretching eyelids

Depressor anguli oris

Depressor labii inferioris

SURPRISE

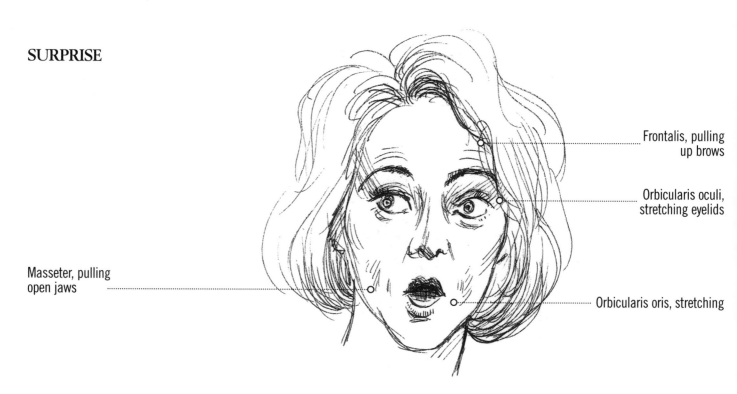

Frontalis, pulling up brows

Orbicularis oculi, stretching eyelids

Masseter, pulling open jaws

Orbicularis oris, stretching

YAWNING

Procerus, tensing

Orbicularis oris, stretching

Masseter, stretching

Procerus, tensing

SEVERE PAIN

Corrugator, pushing eyebrows together

Orbicularis oculi, squeezing eyes shut

Orbicularis oris

Depressor anguli oris

ADMIRATION

Orbicularis, pushing up lower lid

Levator anguli oris, pulling mouth into a smile

Risorius, pulling corner of mouth outward

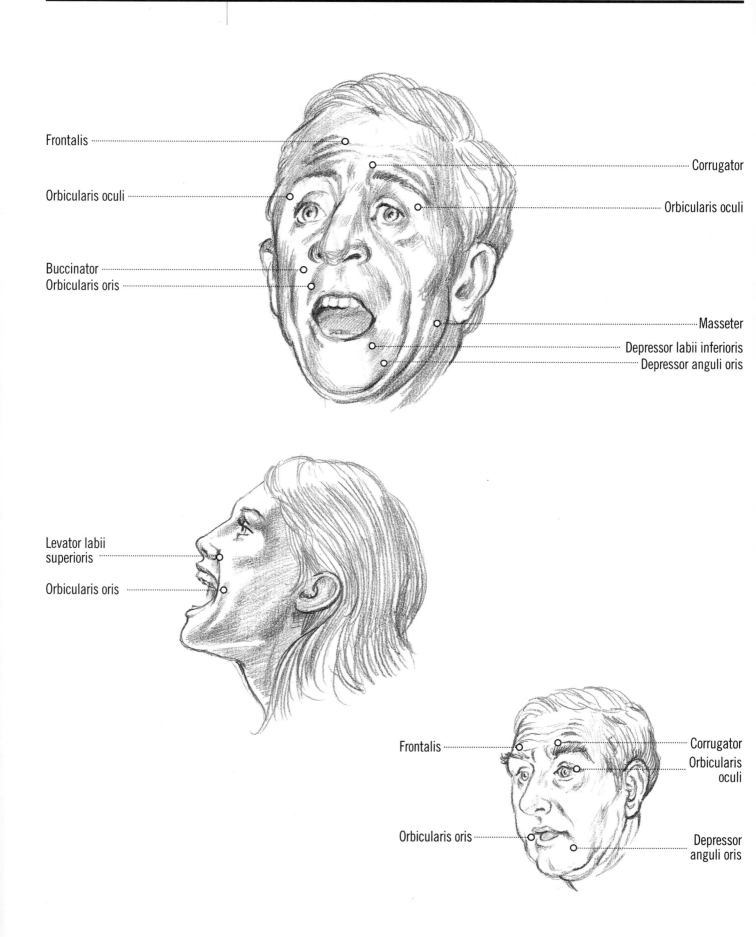

Frontalis

Orbicularis oculi

Buccinator
Orbicularis oris

Corrugator

Orbicularis oculi

Masseter
Depressor labii inferioris
Depressor anguli oris

Levator labii superioris

Orbicularis oris

Frontalis

Orbicularis oris

Corrugator
Orbicularis oculi

Depressor anguli oris

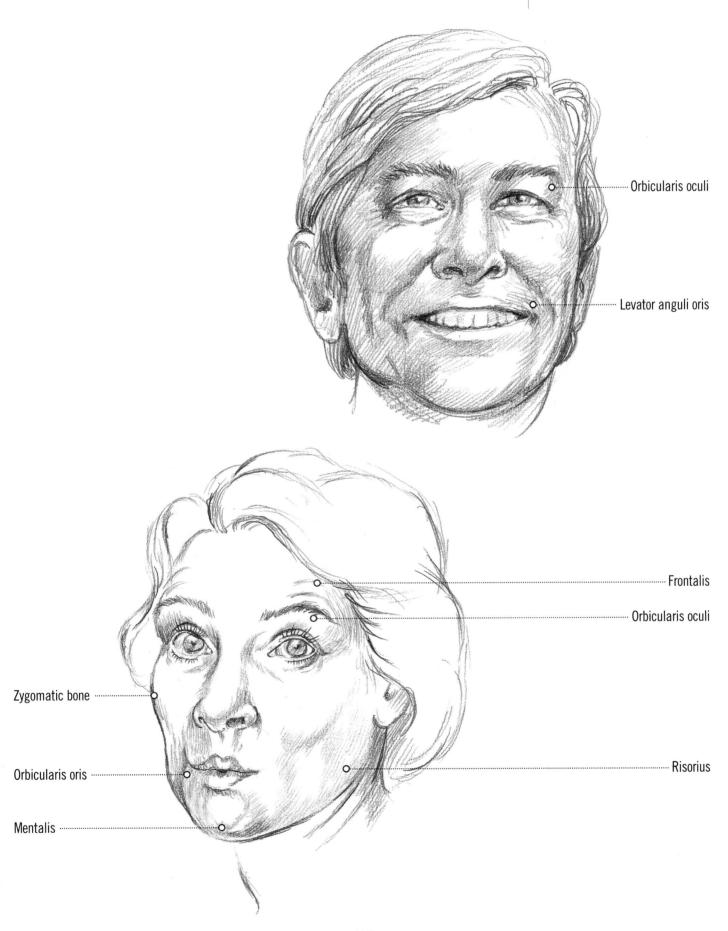

Orbicularis oculi

Levator anguli oris

Frontalis

Orbicularis oculi

Zygomatic bone

Risorius

Orbicularis oris

Mentalis

The next six drawings are in the nature of a quiz, to try out your new-found expertise in identifying muscles of the head.

1. Here is a man with eyes wide open and mouth open as well. Which muscles are doing this?

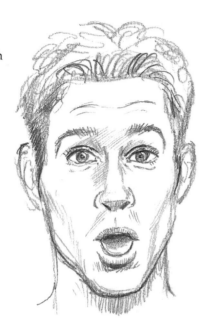

2. This man has his forehead wrinkled, eyes narrowed and mouth pursed into an 'O' shape. Which muscles are in operation here?

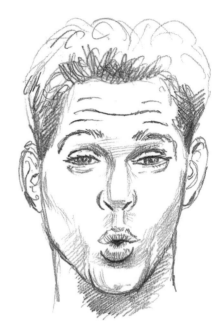

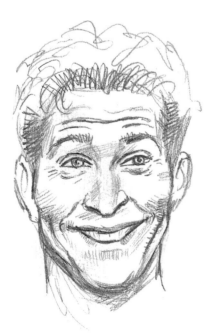

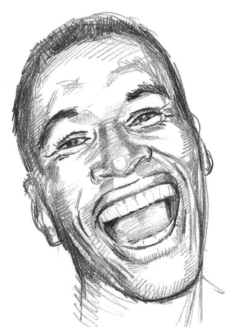

3. Next are two faces of men laughing or grinning. Which muscles are operating here?

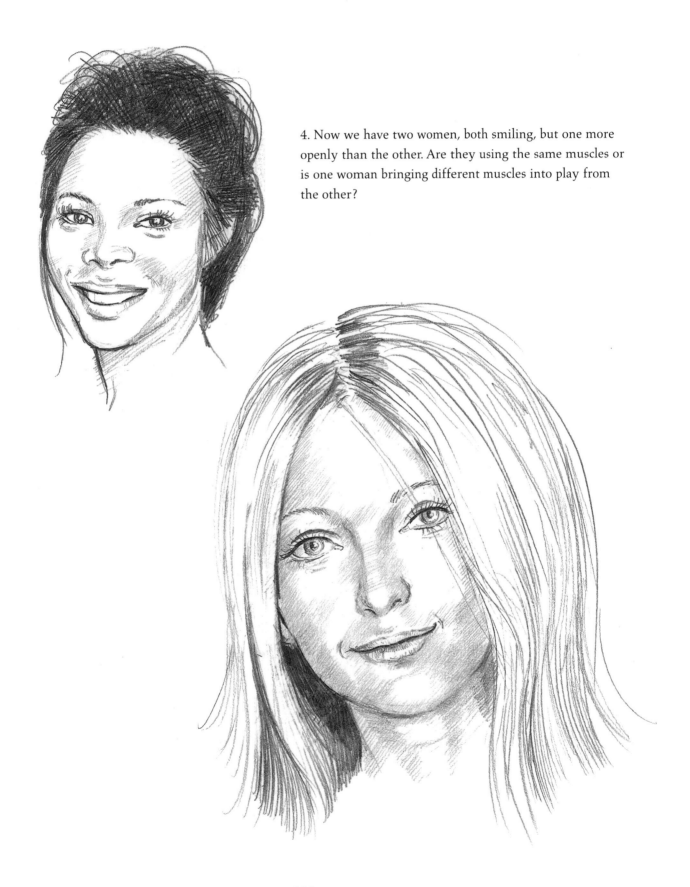

4. Now we have two women, both smiling, but one more openly than the other. Are they using the same muscles or is one woman bringing different muscles into play from the other?

These are the answers to the questions on the previous pages. First, try them out without looking, to see how your memory is working.

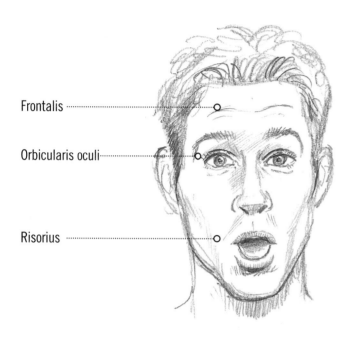

Frontalis

Orbicularis oculi

Risorius

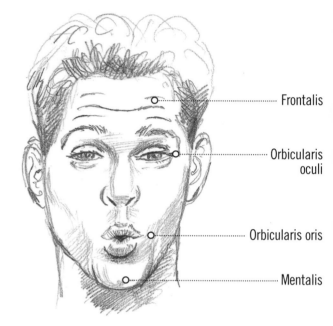

Frontalis

Orbicularis oculi

Orbicularis oris

Mentalis

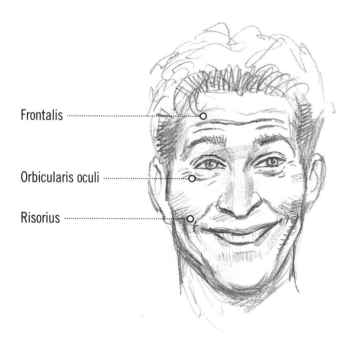

Frontalis

Orbicularis oculi

Risorius

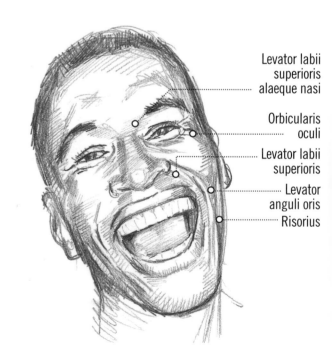

Levator labii superioris alaeque nasi

Orbicularis oculi

Levator labii superioris

Levator anguli oris

Risorius

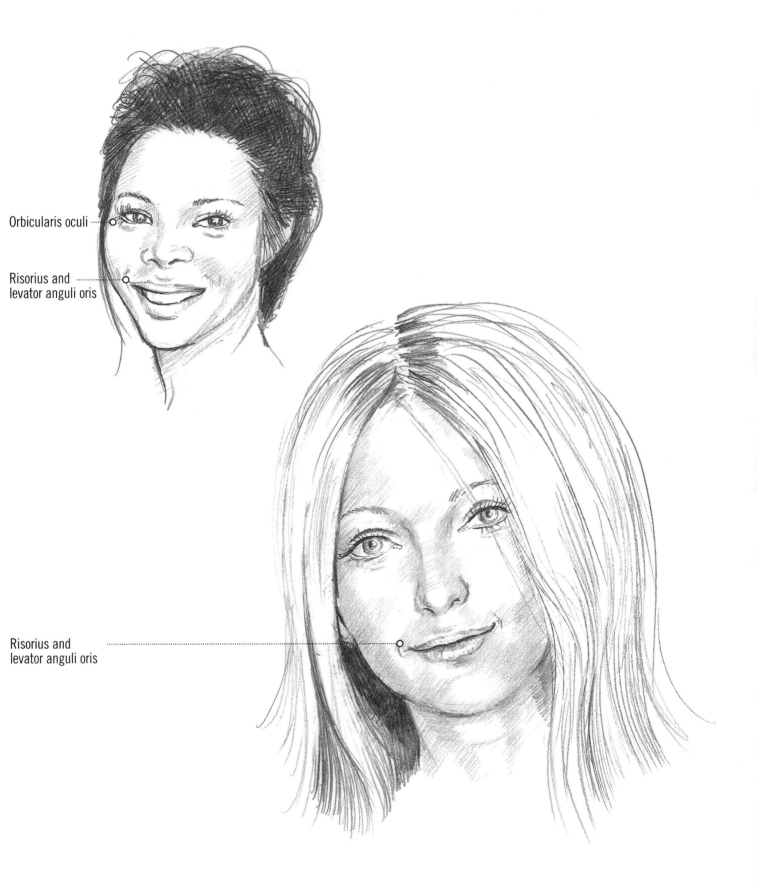

Orbicularis oculi

Risorius and
levator anguli oris

Risorius and
levator anguli oris

Here we show the individual features of the face: the eye, the mouth, the nose and the ear, giving some information about the normal formation of these features. What we will show is the basic structure of these features and their most obvious shape, but bear in mind that the features of individuals do vary quite dramatically sometimes.

First note that the normal position of the eye, when open and looking straight ahead, has part of the iris hidden under the upper eyelid, and the lower edge of the iris just touching the lower lid.

FRONT VIEW

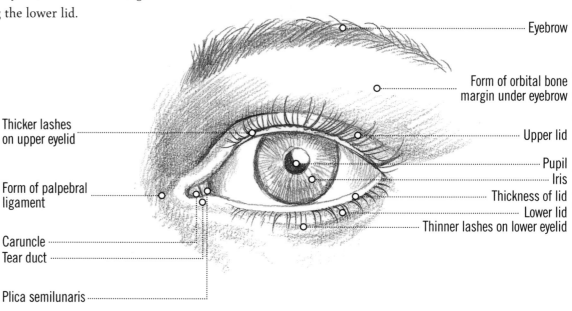

Eyebrow

Form of orbital bone margin under eyebrow

Upper lid

Pupil

Iris

Thickness of lid

Lower lid

Thinner lashes on lower eyelid

Thicker lashes on upper eyelid

Form of palpebral ligament

Caruncle

Tear duct

Plica semilunaris

SIDE VIEW

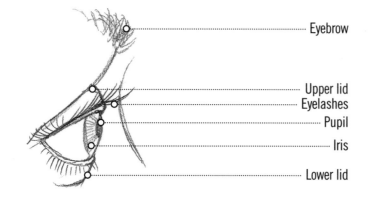

Eyebrow

Upper lid

Eyelashes

Pupil

Iris

Lower lid

Note the tendency of the eye's inner corner (medial canthus) to be slightly lower than the outer corner (lateral canthus), to help tear drainage.

VARIOUS EYE SHAPES

Narrow eyes

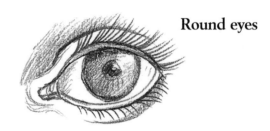

Round eyes

Heavy-lidded eyes

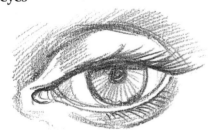

Oriental eyes

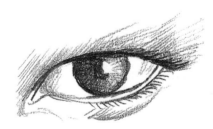

FRONT VIEW
Normal structure of lips

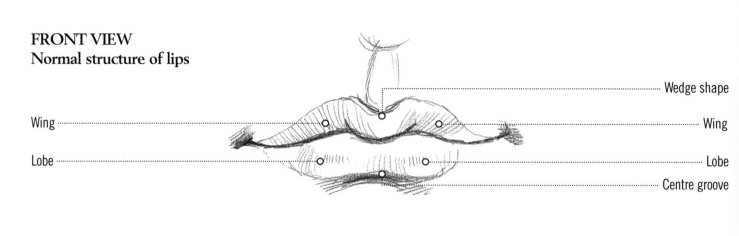

Wedge shape

Wing · Wing

Lobe · Lobe

Centre groove

VARIOUS MOUTH SHAPES
FRONT VIEWS SIDE VIEWS

Full lips

Full lips

Angled: lower lip
behind upper lip

Thin lips

Thin lips

Lower and upper
lips protrude the
same amount
(pouting)

Average 'Cupid's bow' lips

Average lips

Angled: lower lip
projecting beyond
upper lip

NOSES: SIDE VIEWS

Long nose **Short straight nose** **Aquiline nose** **Hook nose** **Broken nose** **Retroussé or snub nose**

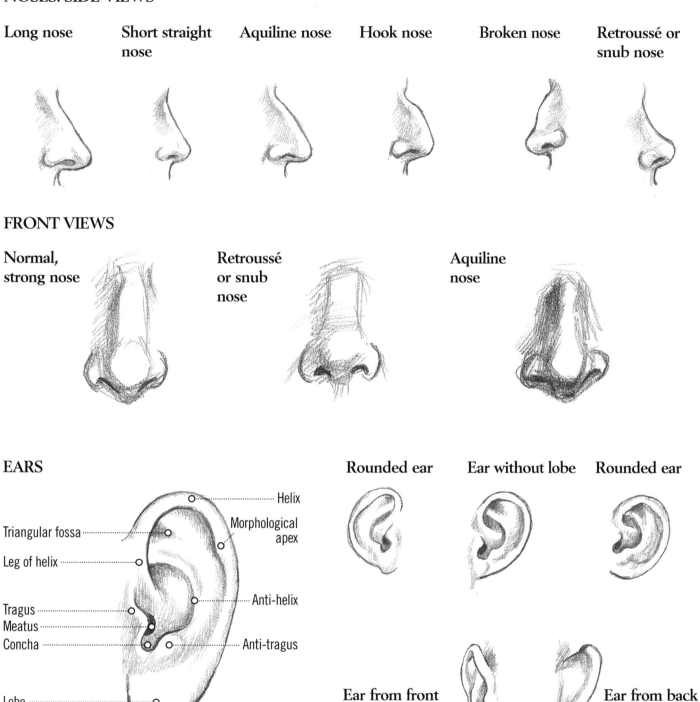

FRONT VIEWS

Normal, strong nose **Retroussé or snub nose** **Aquiline nose**

EARS

Helix

Triangular fossa

Morphological apex

Leg of helix

Tragus

Anti-helix

Meatus

Concha

Anti-tragus

Lobe

Rounded ear **Ear without lobe** **Rounded ear**

Ear from front **Ear from back**

As previously stated, there are enormous variations in the shapes of these features, and these pictures show only a few. However, their basic structure is the same and the artist needs to grasp this generalized information before exploring the detailed differences.

Because they are so intimately connected, it is difficult to make the head look natural without drawing the neck too.

On the following pages I show the bones of the neck as well as the musculature in order to make the structure as clear as possible.

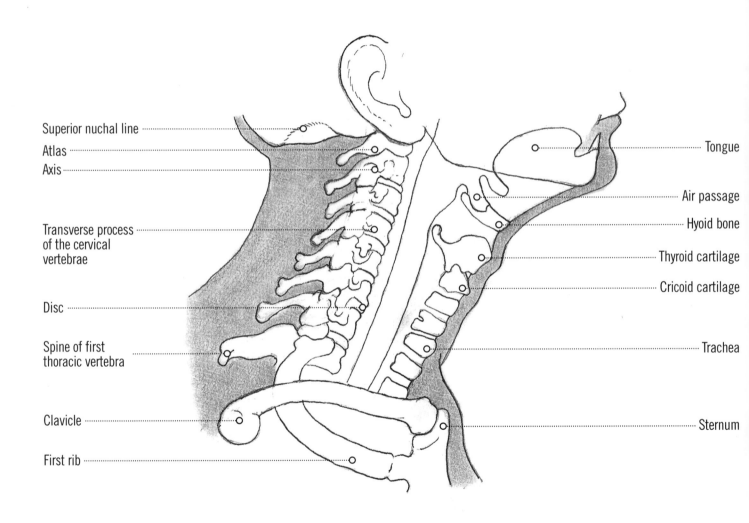

Superior nuchal line

Atlas

Axis

Transverse process of the cervical vertebrae

Disc

Spine of first thoracic vertebra

Clavicle

First rib

Tongue

Air passage

Hyoid bone

Thyroid cartilage

Cricoid cartilage

Trachea

Sternum

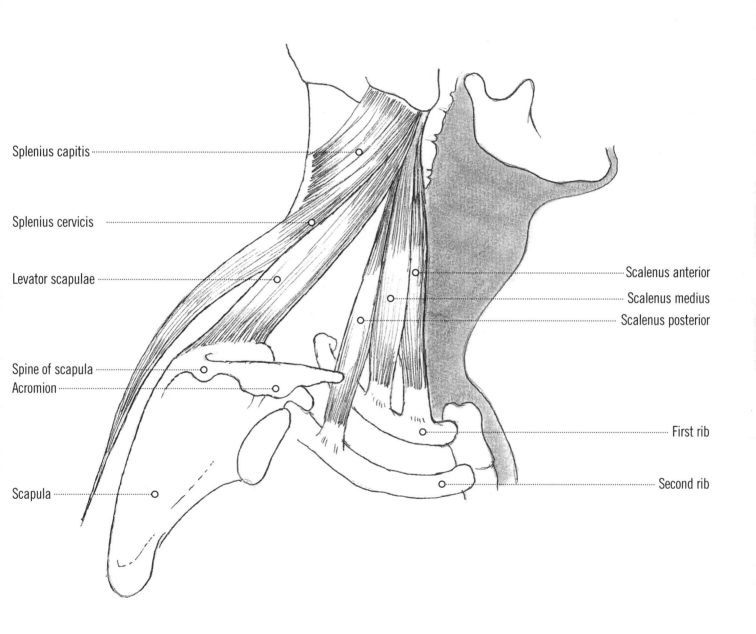

Splenius capitis

Splenius cervicis

Levator scapulae

Spine of scapula

Acromion

Scapula

Scalenus anterior

Scalenus medius

Scalenus posterior

First rib

Second rib

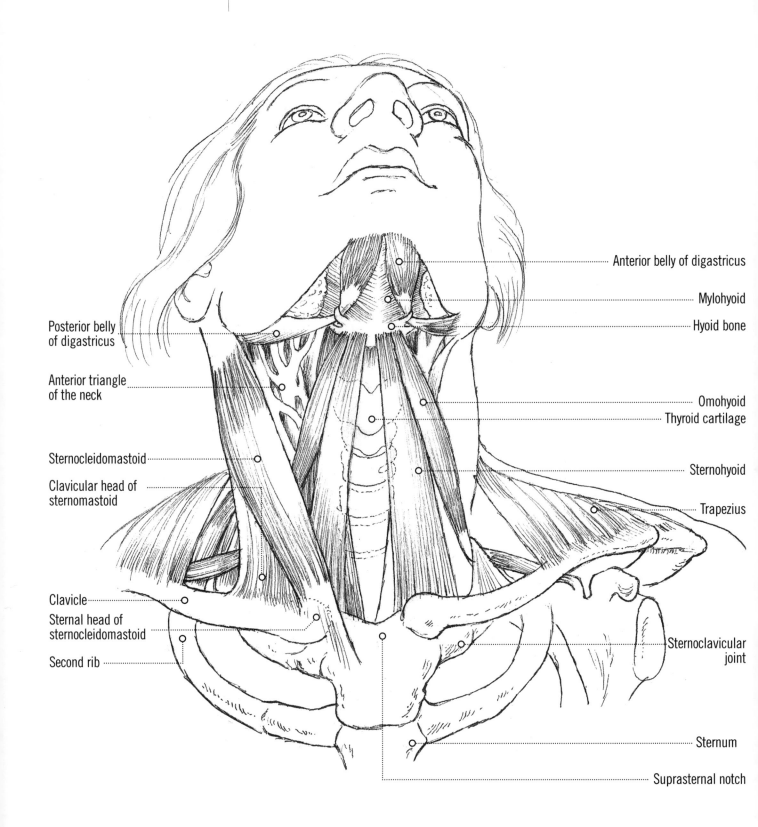

Posterior belly of digastricus

Anterior triangle of the neck

Sternocleidomastoid

Clavicular head of sternomastoid

Clavicle

Sternal head of sternocleidomastoid

Second rib

Anterior belly of digastricus

Mylohyoid

Hyoid bone

Omohyoid

Thyroid cartilage

Sternohyoid

Trapezius

Sternoclavicular joint

Sternum

Suprasternal notch

164

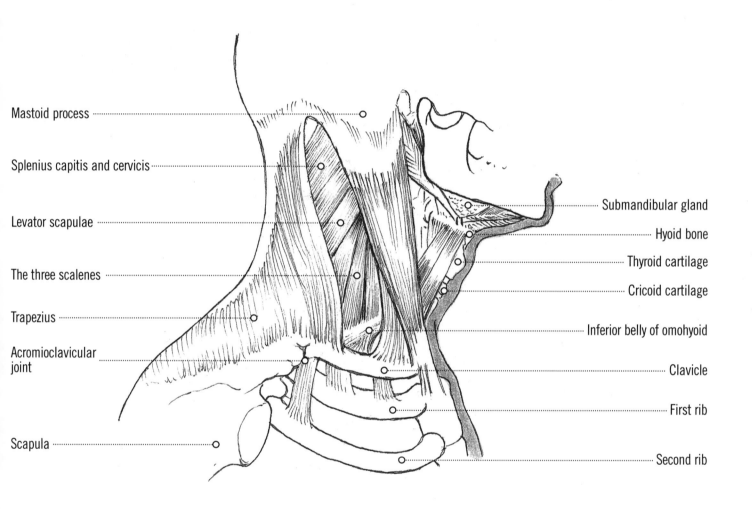

Mastoid process

Splenius capitis and cervicis

Levator scapulae

The three scalenes

Trapezius

Acromioclavicular joint

Scapula

Submandibular gland

Hyoid bone

Thyroid cartilage

Cricoid cartilage

Inferior belly of omohyoid

Clavicle

First rib

Second rib

THE TORSO IN MOVEMENT

The torso and head are two sections of the human body that most artists are interested in drawing, chiefly because of their subtlety and the challenge of rendering them convincingly. Of the two, the torso is less familiar, because we do not usually see it totally unclothed.

The main skeleton is in three parts: the spinal vertebrae; the ribcage with the shoulder girdle, from which the arms depend; and the pelvis from which the legs depend. The numerous muscles stretched across the skeleton are extremely difficult to draw, owing to the way that layers of muscle and fat overlie one another and disguise a good deal of the bone structure. This chapter will feature diagrams of the deeper muscles, but only to show how they affect the appearance of the more superficial ones.

The significant thing about the torso from an artist's point of view is that although it looks like a pretty solid piece of work, it is actually highly mobile. It can bend forwards, backwards and sideways, and stretch out and contract to some extent. It can also twist around, enabling the shoulders to face sideways from the hips. Because the large muscles in the back and the front of the torso are so prominent, it is usually easy to see them working. However there are not so many seen on the surface and some of these are affected by muscles underneath them.

Look out for the differences between the male and female torso: whereas the muscles are very pronounced on an athletic male figure, the female shape is smoother and large muscles like the pectoralis major are not so visible under the mammary glands.

Because so much of the skeleton is hidden, it may be difficult to differentiate between muscle and bone. However, listed below are the bones that are visible on most bodies of average build. There may be some people with more developed areas of fatty deposit that disguise the less obvious ones, but usually the following bones can be seen:

• Clavicle
• Sternum
• Parts of the scapula
• Seven cervical vertebrae
• First and twelfth thoracic vertebrae, in certain positions

• First and twelfth ribs
• Pubis
• Iliac crest
• Iliac tuberosity
• Anterior superior iliac spine

For an artist, recognizing these bony points on the surface of the body is very useful, since they make good measuring points. Unlike the muscles and fatty parts, they do not move.

Look out too for the suprasternal notch: this is the space between the two clavicles where they meet the manubrium or the upper part of the sternum (breast bone). It is a useful

ABDOMINAL MUSCLES flex torso forwards into curled position, straightening arch of lumbar vertebrae. Compress viscera to force expiration, or strain in childbirth and defecation. The three layers create strong walls on either side of the abdomen.

DELTOID contraction of entire muscle will raise arm to horizontal plane. Partial contraction will result in pulling the arm backward or forward.

ERECTOR SPINAE GROUP made up of the LONGISSIMUS, the SPINALIS and the ILIO-COSTALIS. Lift torso when rising from stooped position. Straighten spine, extend spine backwards or to either side. Draw pelvis backwards and upwards. Help support the weight of the head. Sometimes referred to as the Sacrospinalis.

INFRASPINATUS rotates arm outwards and backwards.

INTERNAL and EXTERNAL OBLIQUE flex trunk. Isolated action of one side turns anterior surface of trunk to that side. Bends spinal column laterally. Co-operates with the

other abdominal muscles. Simultaneous contraction of muscles of both sides, results in forward bending of trunk. If chest is fixed, pelvis is brought into flexion. Constricts abdominal cavity, ribs are compressed and pulled downwards.

LATISSIMUS DORSI throws back shoulders. Draws arm backwards and towards the centre line. Rotates it inwards and lowers it. If shoulders are fixed, it raises trunk and suspends it.

LEVATOR SCAPULAE steadies scapula during movements of the arms.

PECTORALIS MAJOR draws arm forward, rotates it inwards and lowers arm.

QUADRATUS LUMBORUM holds firm the twelfth rib and pulls lumbar region of the spine to its own side and helps straighten or raise pelvis.

RECTUS ABDOMINIS flexes trunk.

RHOMBOIDS MAJOR and MINOR elevate, rotate scapula. Draw it towards the median line.

SEMISPINALIS CAPITIS two deep neck muscles beneath trapezius, where they help to draw head backwards or rotate it to either side.

SERRATUS ANTERIOR draws scapula forwards and laterally. Helps trapezius in raising the arm above the horizontal plane.

SERRATUS POSTERIOR MUSCLES steady the erector spinae group. Superior pair elevate upper ribs, helping us to breathe in. Inferior pair are expiratory, depressing lower ribs as we breathe out.

SPLENIUS CAPITIS pulls head backwards and sideways, rotates head.

SPLENIUS CERVICIS pulls neck backwards and sideways, rotates atlas (top vertebra) along with head.

SUBCLAVIUS fixes and pulls clavicle downwards and forwards.

SUBSCAPULARIS (beneath scapula) rotates arm inward.

SUPRASPINATUS raises and rotates arm outwards.

TERES MAJOR raises arm forwards or sideways from trunk. Rotates arm inwards.

TERES MINOR rotates arm outwards.

TRAPEZIUS extends head, inclines it to one side and turns head in opposite direction. Middle part lifts scapula. Inferior part lowers scapula.

marker for measuring the head and shoulders because it remains at a fixed point at the base of the neck. The notch is visible on the vast majority of humans.

There are more than a hundred muscles in the torso, and they tend to be paired on either side of the body's medial line, and layered in groups. A series of divided muscles support and articulate the spine. There are broad, thin sheets of muscle enfolding the abdomen and the pelvis. Thick,

heavy muscles give strength to the shoulders and hips. The diagonally arranged muscles of the ribcage help with breathing and the flexibility of the upper torso.

On the opposite page, I have detailed the major muscles of the torso and some of the movements they produce by contracting or flexing. Try performing some of these movements and feeling your own muscles at work.

FRONT VIEW

The relaxed torso is shown first in order to relate the muscles to the bone structure.

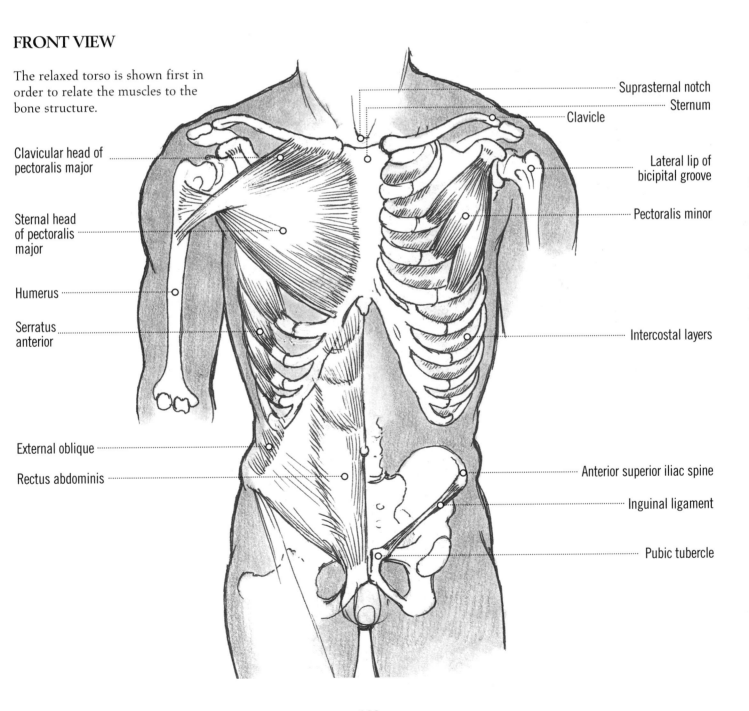

Clavicular head of pectoralis major

Sternal head of pectoralis major

Humerus

Serratus anterior

External oblique

Rectus abdominis

Suprasternal notch

Sternum

Clavicle

Lateral lip of bicipital groove

Pectoralis minor

Intercostal layers

Anterior superior iliac spine

Inguinal ligament

Pubic tubercle

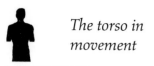

SIDE VIEW
showing the internal oblique

Latissimus dorsi

Aponeurosis of the internal oblique

Internal oblique

Iliac crest

SIDE VIEW
showing the external oblique

Latissimus dorsi

Serratus anterior

External oblique

Costal margin

Rectus abdominis sheath

Linea alba

Anterior superior spine of the pelvis

Inguinal ligament

Pubic tubercle

170

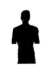
FRONT VIEW

In this drawing after Louise Gordon you can see the torso bending to the right and extending on the left of the body. Note how the normally horizontal lines of the shoulders, the waist and the hips are now tilted in opposite directions.

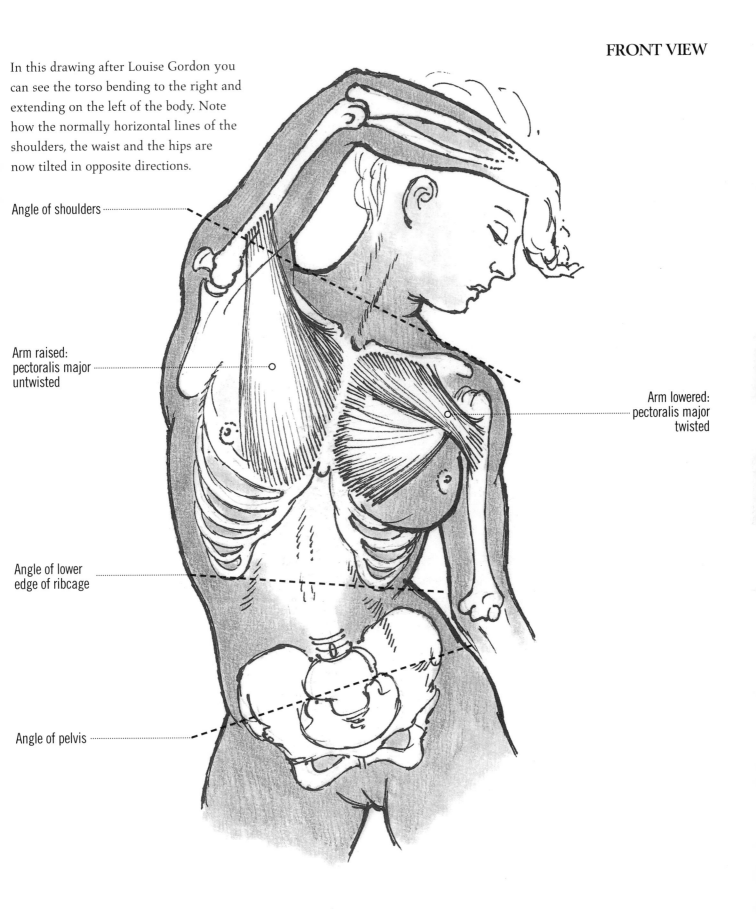

Angle of shoulders

Arm raised:
pectoralis major
untwisted

Arm lowered:
pectoralis major
twisted

Angle of lower
edge of ribcage

Angle of pelvis

FRONT VIEW

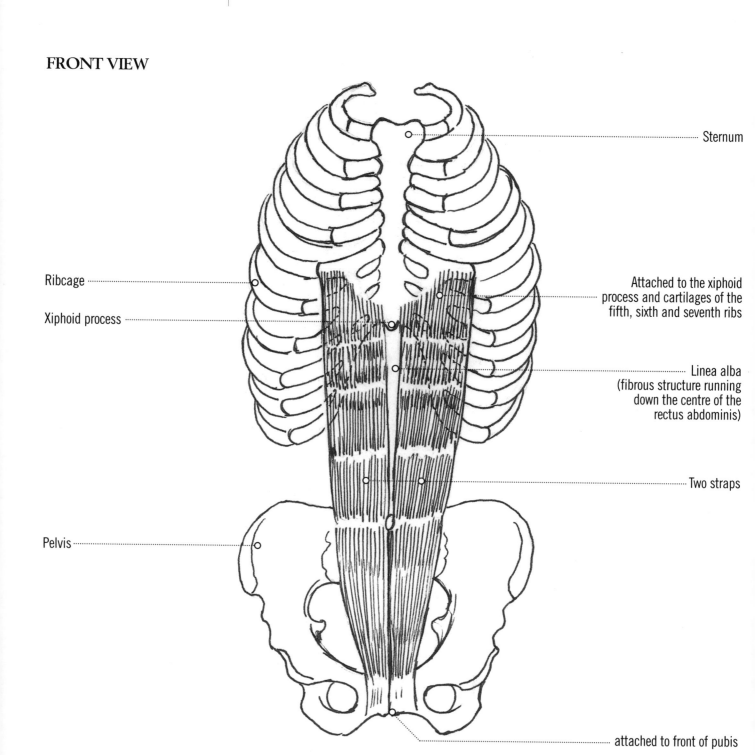

Sternum

Ribcage

Attached to the xiphoid process and cartilages of the fifth, sixth and seventh ribs

Xiphoid process

Linea alba (fibrous structure running down the centre of the rectus abdominis)

Two straps

Pelvis

attached to front of pubis

FRONT VIEW
the rectus abdominis stretched by
the muscles of the back

SIDE VIEW
the torso bending backwards

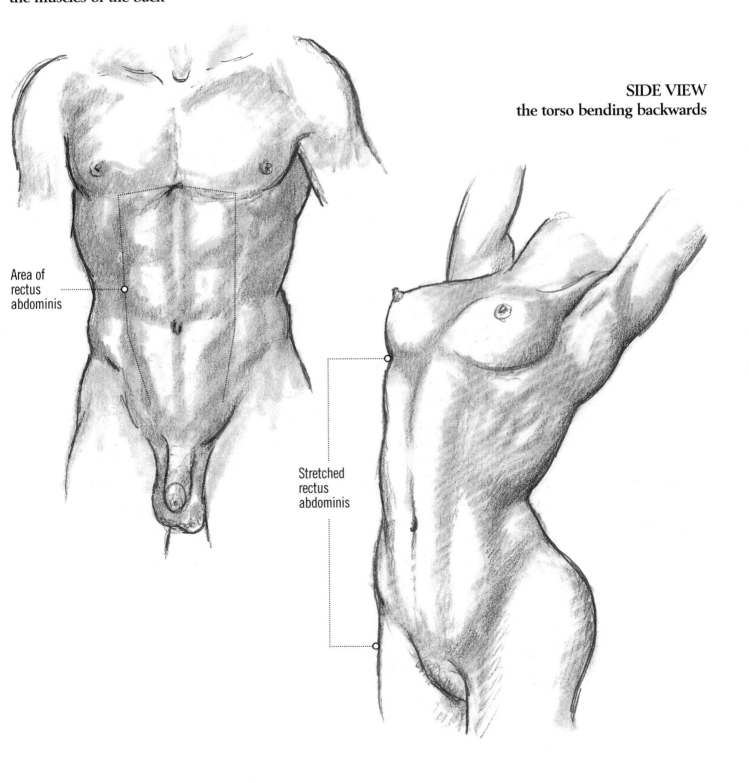

Area of
rectus
abdominis

Stretched
rectus
abdominis

SIDE VIEW
the torso bending to the ground

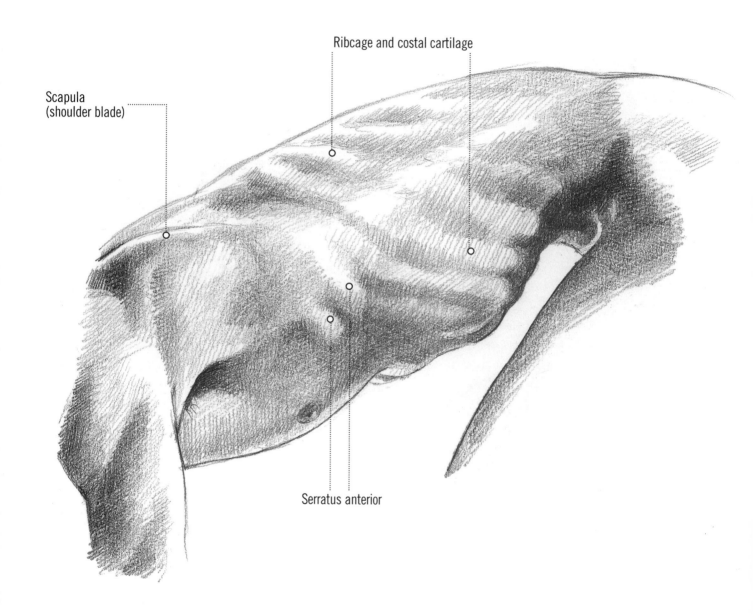

Ribcage and costal cartilage

Scapula
(shoulder blade)

Serratus anterior

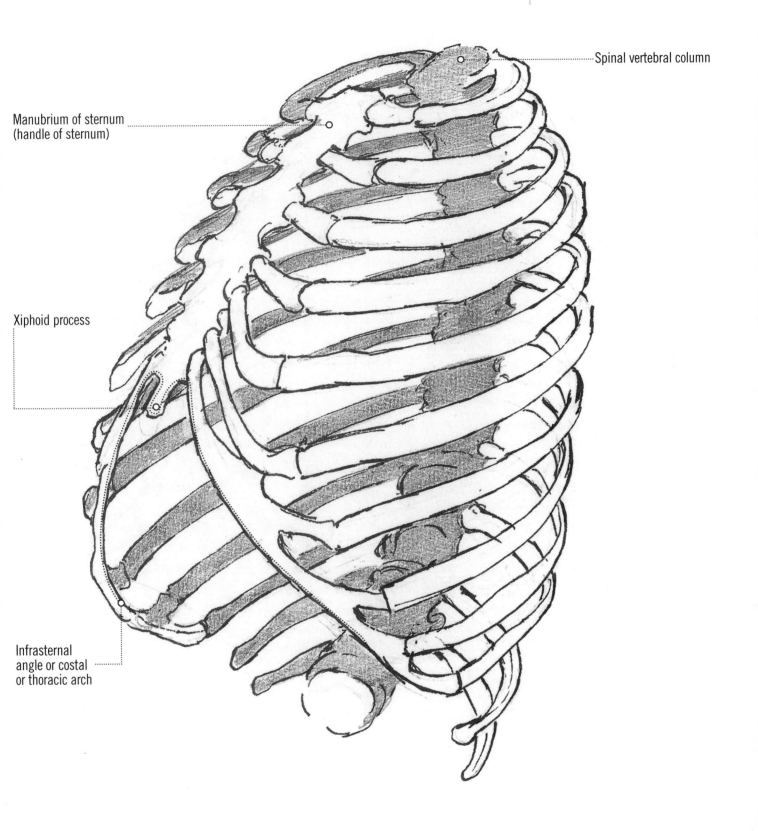

Spinal vertebral column

Manubrium of sternum
(handle of sternum)

Xiphoid process

Infrasternal
angle or costal
or thoracic arch

FRONT VIEW WITH ARMS RAISED

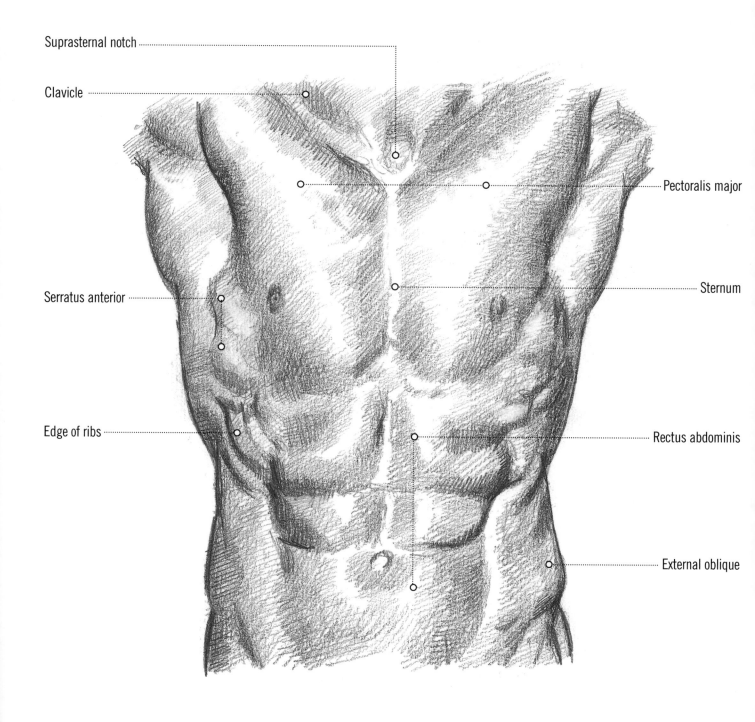

Suprasternal notch

Clavicle

Serratus anterior

Edge of ribs

Pectoralis major

Sternum

Rectus abdominis

External oblique

SIDE VIEW WITH ARMS RAISED

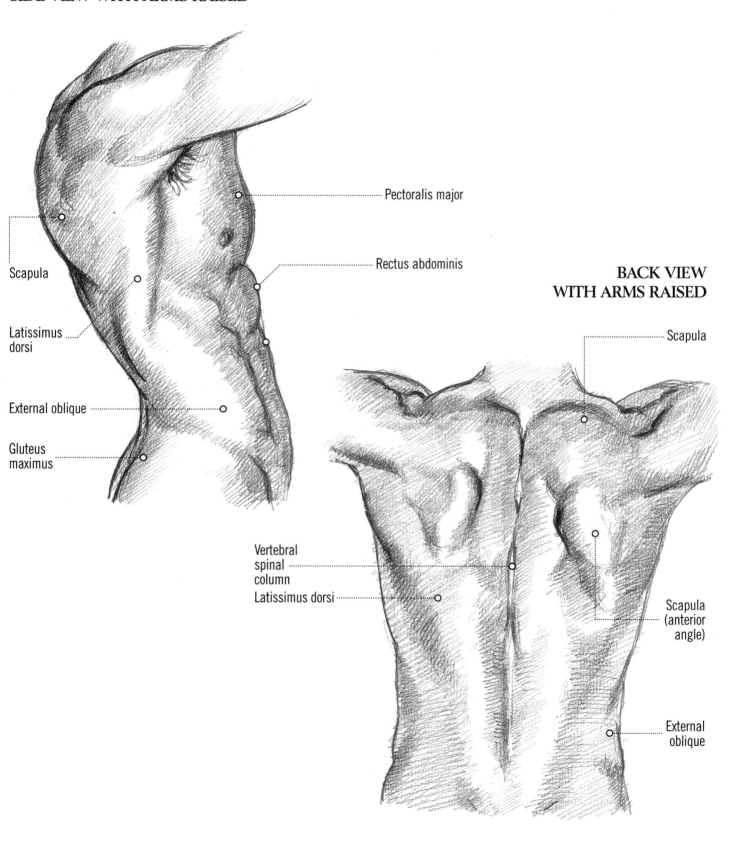

Pectoralis major

Scapula

Rectus abdominis

Latissimus dorsi

BACK VIEW WITH ARMS RAISED

External oblique

Scapula

Gluteus maximus

Vertebral spinal column

Latissimus dorsi

Scapula (anterior angle)

External oblique

THE MALE TORSO, STRETCHED BACKWARDS, ARMS RAISED

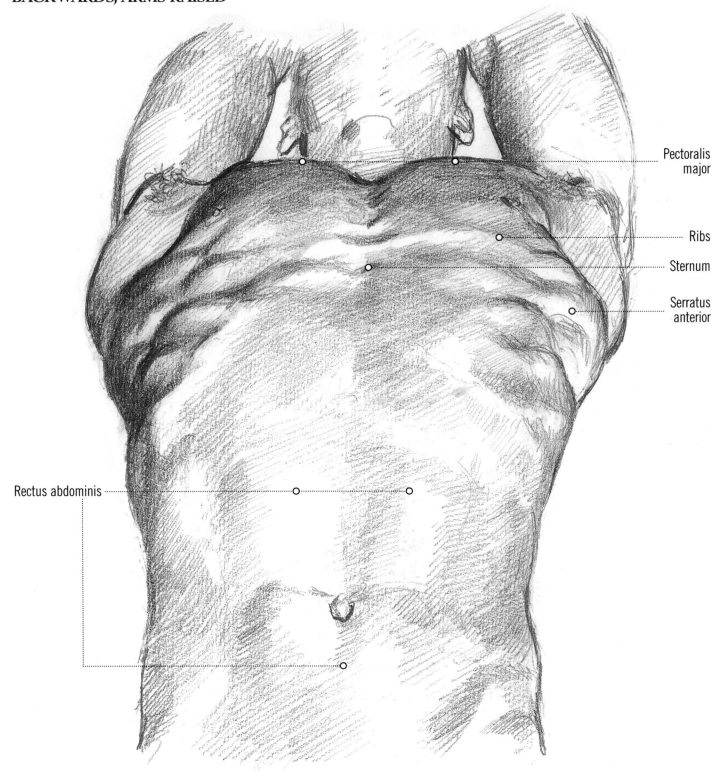

Pectoralis major

Ribs

Sternum

Serratus anterior

Rectus abdominis

THE FEMALE TORSO, RIBS TILTED AND SPINE CURVED

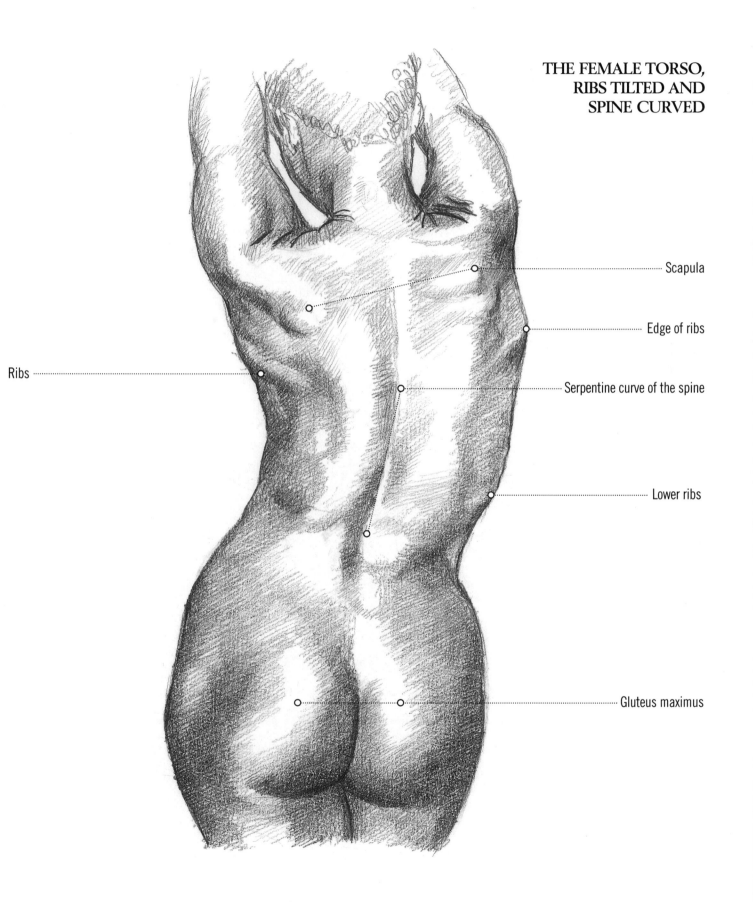

Scapula

Edge of ribs

Ribs

Serpentine curve of the spine

Lower ribs

Gluteus maximus

SIDE VIEW OF THE MALE TORSO
WITH MUSCLES TENSED

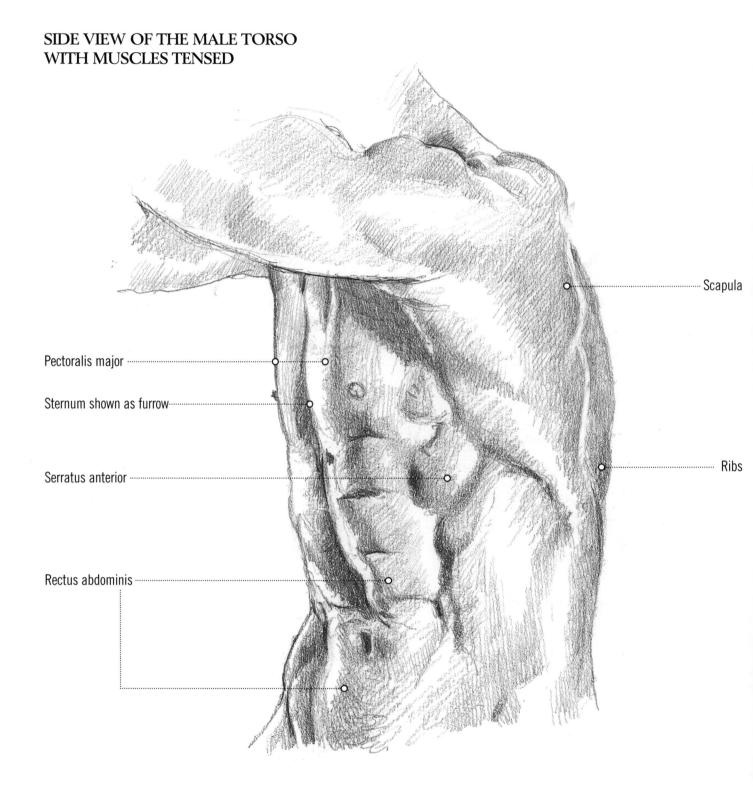

Scapula

Pectoralis major

Sternum shown as furrow

Ribs

Serratus anterior

Rectus abdominis

THE FEMALE TORSO SUPINE, STRETCHED

Lowest ribs

Pectoralis major plus mammary glands

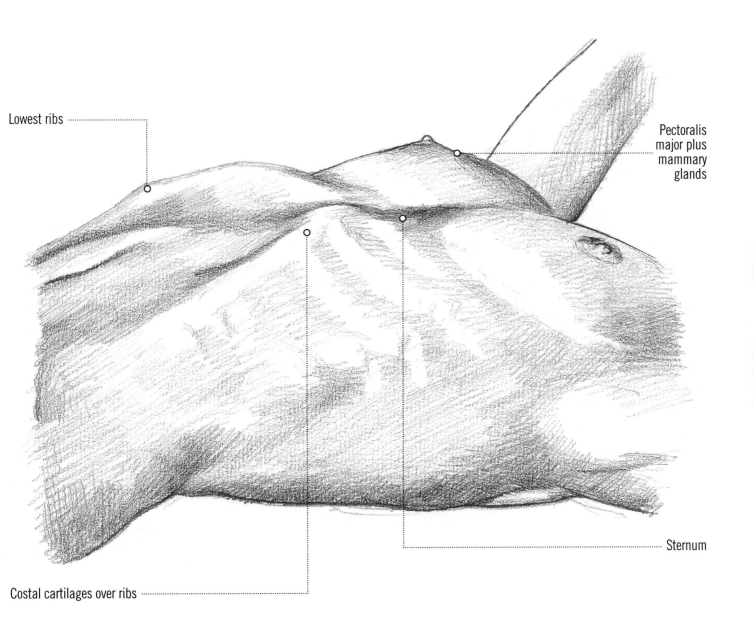

Sternum

Costal cartilages over ribs

This diagram helps to clarify the muscles along the spinal vertebrae, shown in three columns overlaying each other. The three muscles of the erector spinae group are shown on the right.

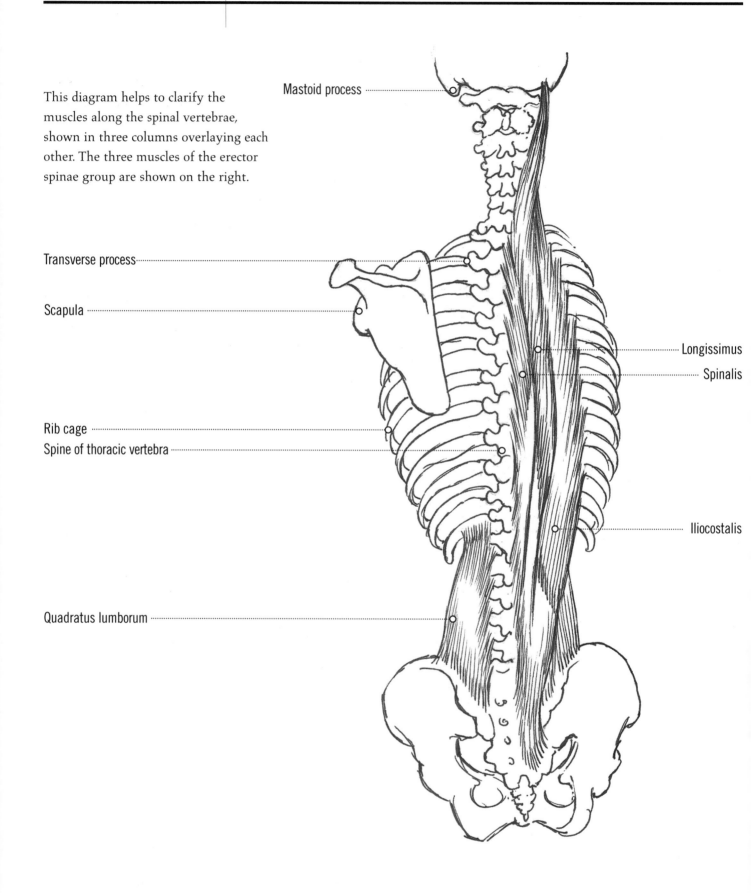

Mastoid process

Transverse process

Scapula

Longissimus

Spinalis

Rib cage

Spine of thoracic vertebra

Iliocostalis

Quadratus lumborum

Body bending to the left: spinal muscles contracting one side

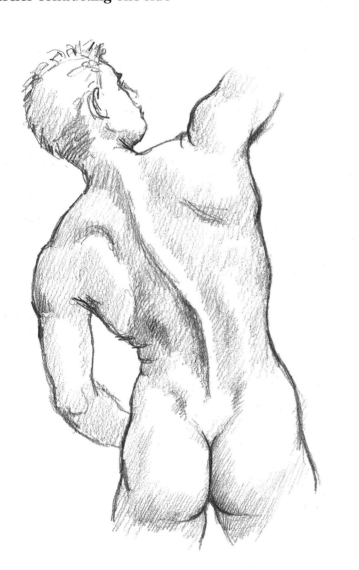

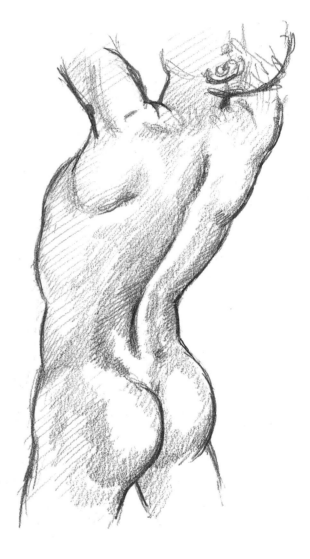

Body bending back: spinal muscles contracting on both sides

MID-DEPTH MUSCLES OF THE BACK
back view

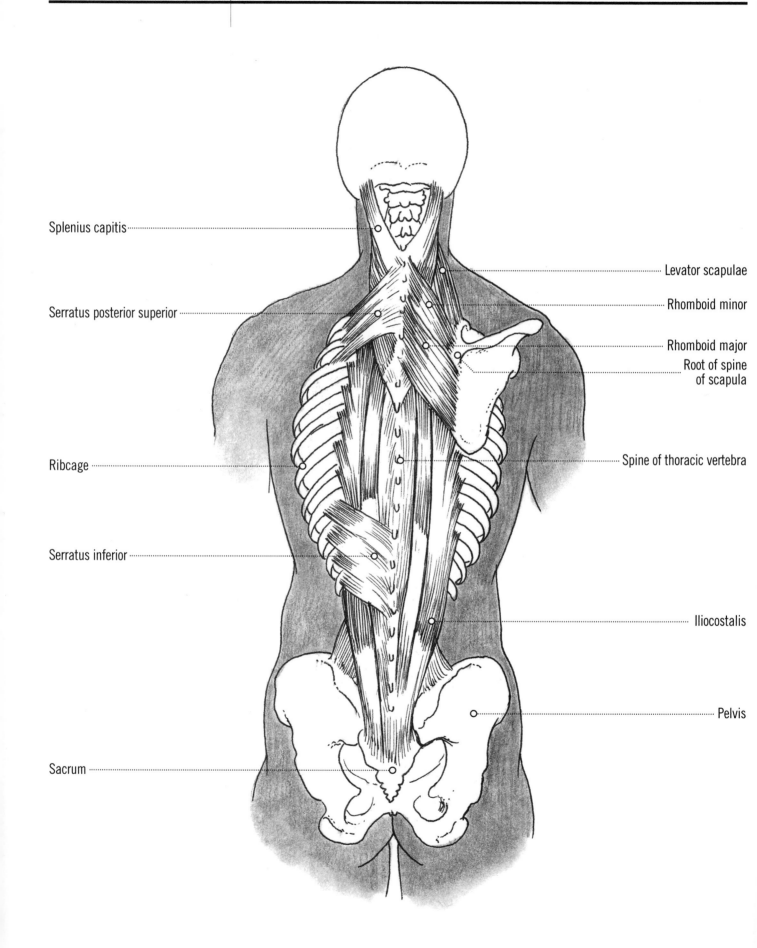

Splenius capitis

Serratus posterior superior

Ribcage

Serratus inferior

Sacrum

Levator scapulae

Rhomboid minor

Rhomboid major

Root of spine
of scapula

Spine of thoracic vertebra

Iliocostalis

Pelvis

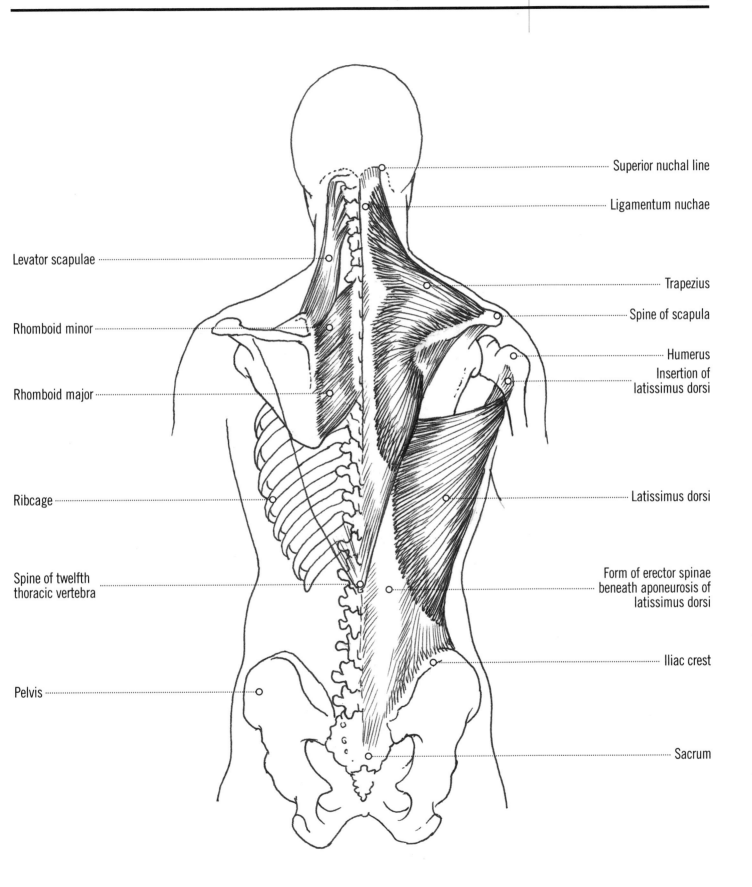

Superior nuchal line

Ligamentum nuchae

Levator scapulae

Trapezius

Spine of scapula

Rhomboid minor

Humerus

Insertion of latissimus dorsi

Rhomboid major

Ribcage

Latissimus dorsi

Spine of twelfth thoracic vertebra

Form of erector spinae beneath aponeurosis of latissimus dorsi

Iliac crest

Pelvis

Sacrum

SIDE VIEW: THE TORSO CURLED

This interesting view of the back and shoulder gives some idea of the complexity of the muscles, particularly noticeable around the moving parts of the joints. The triangle of auscultation behind the scapula is used by doctors for listening to the lungs using a stethoscope.

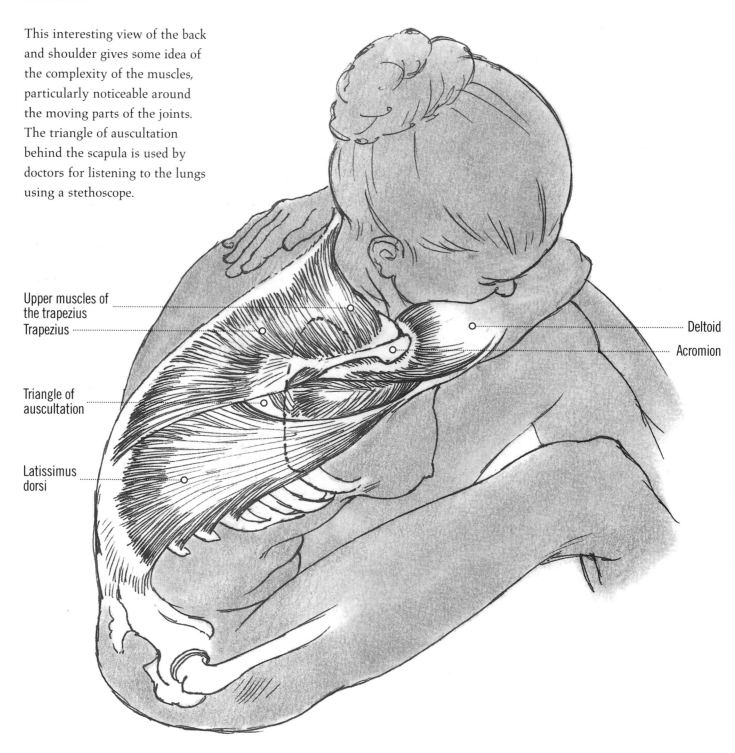

Upper muscles of the trapezius

Trapezius

Triangle of auscultation

Latissimus dorsi

Deltoid

Acromion

BACK VIEW: BENDING SIDEWAYS

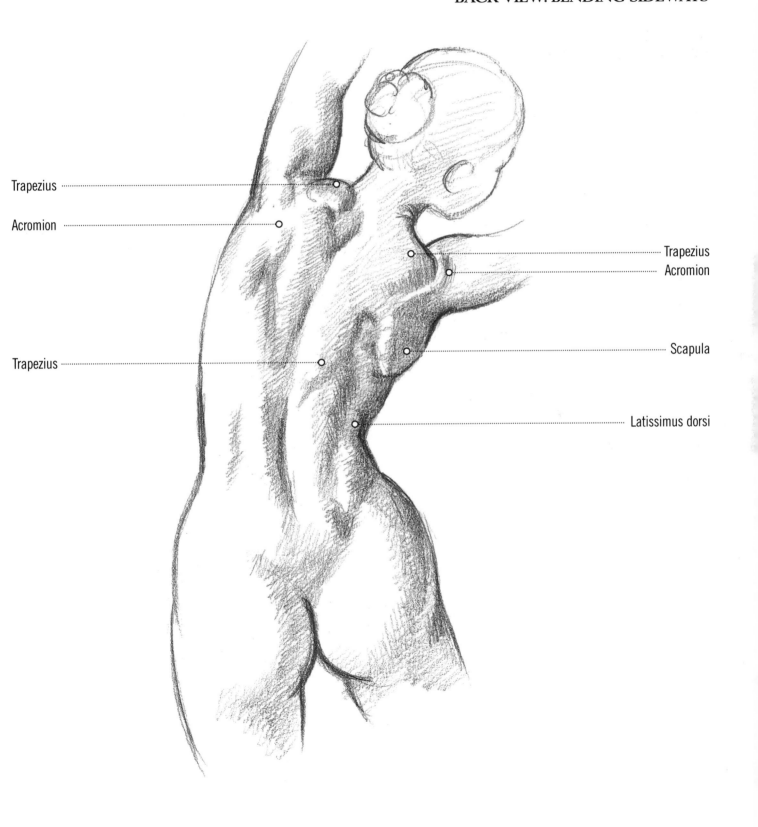

Trapezius

Acromion

Trapezius

Trapezius

Acromion

Scapula

Latissimus dorsi

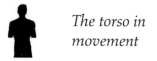
The statuesque quality of the torso, seen from the back, gives an impression of strength and simplicity. However, beneath the skin, as we have seen, it is complex, although the large muscles help to keep the overall form simple.

BACK VIEW: FEMALE BENDING FORWARDS

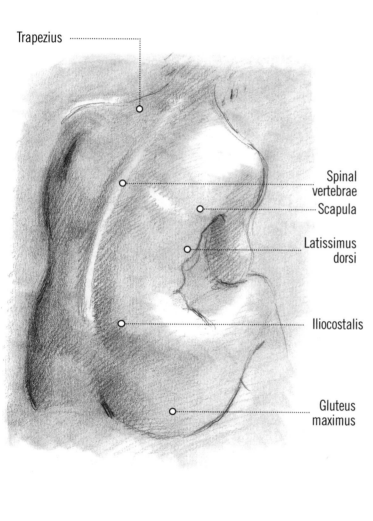

Trapezius

Spinal vertebrae

Scapula

Latissimus dorsi

Iliocostalis

Gluteus maximus

BACK VIEW: FEMALE TWISTING

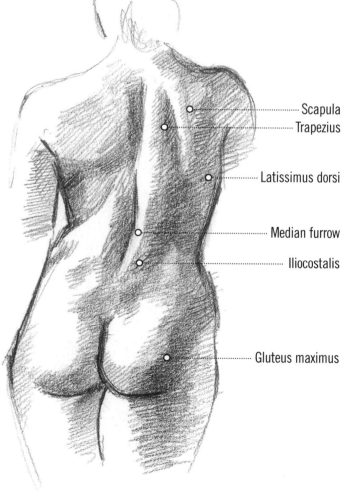

Scapula

Trapezius

Latissimus dorsi

Median furrow

Iliocostalis

Gluteus maximus

BACK VIEW: MALE BENDING FORWARDS AND TWISTING

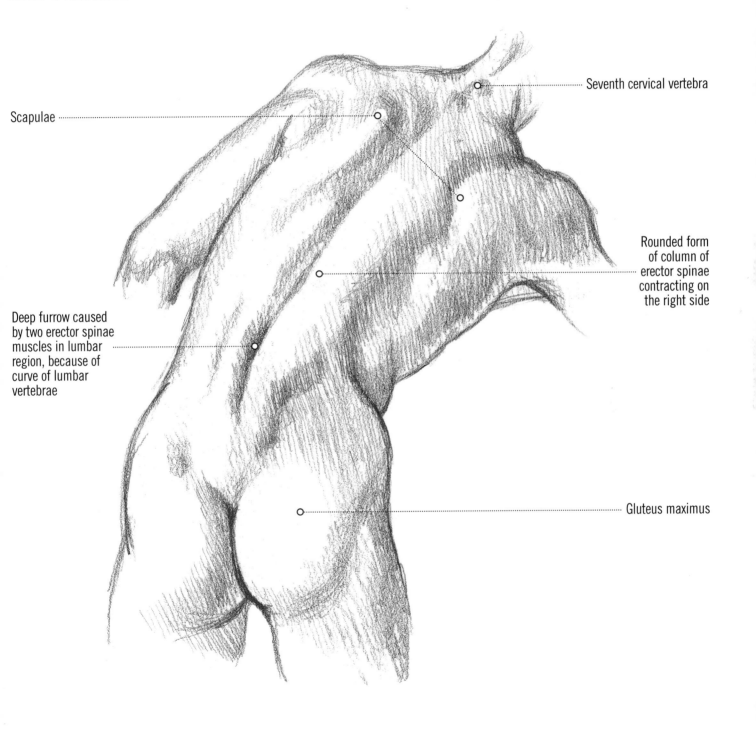

Seventh cervical vertebra

Scapulae

Rounded form of column of erector spinae contracting on the right side

Deep furrow caused by two erector spinae muscles in lumbar region, because of curve of lumbar vertebrae

Gluteus maximus

Drawing the torso of a human being without showing all the other limbs is almost like drawing a landscape. Light throws the undulating shapes into relief, like rolling hills.

These two views show the torso with the shoulders twisted one way and the hips the other.

BACK VIEW: FEMALE RECLINING

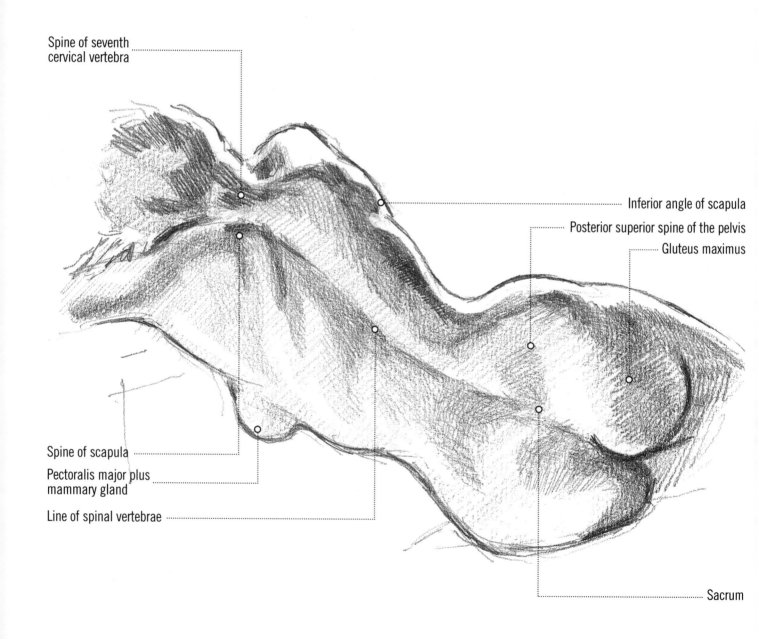

Spine of seventh cervical vertebra

Inferior angle of scapula

Posterior superior spine of the pelvis

Gluteus maximus

Spine of scapula

Pectoralis major plus mammary gland

Line of spinal vertebrae

Sacrum

BACK VIEW: FEMALE STANDING

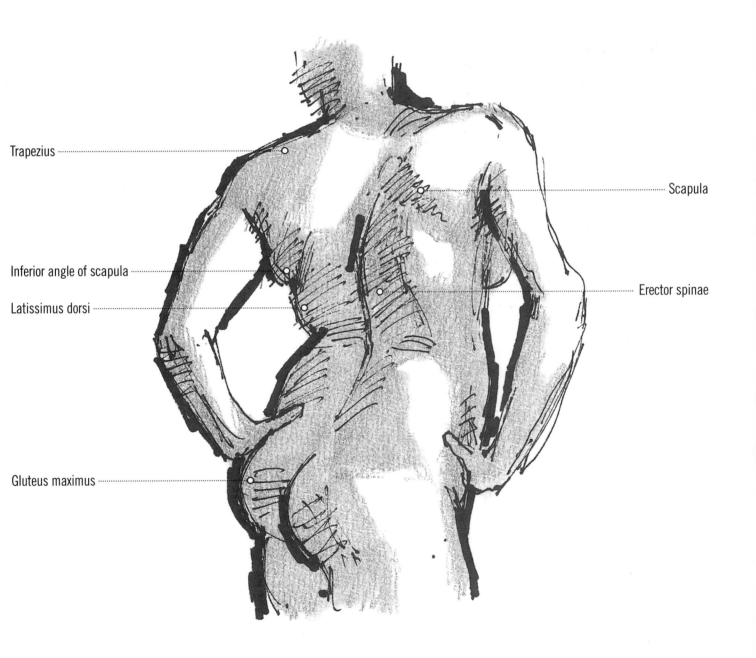

Trapezius

Scapula

Inferior angle of scapula

Erector spinae

Latissimus dorsi

Gluteus maximus

This selection of master drawings shows how well these artists knew their anatomy despite the lack of medical knowledge at the time. The definition of the muscles and bone structure under the skin is beautifully indicated in these works, and they are worth studying in order to see how carefully the shapes under the skin were reproduced. A period of intense life drawing, with the help of an anatomy book like this, soon makes you aware of the multiplicity of subtle shapes that show themselves on the surface of the human body.

After Michelangelo
This is a drawing for a 'Deposition', showing the dead body of Christ being lowered from the cross.

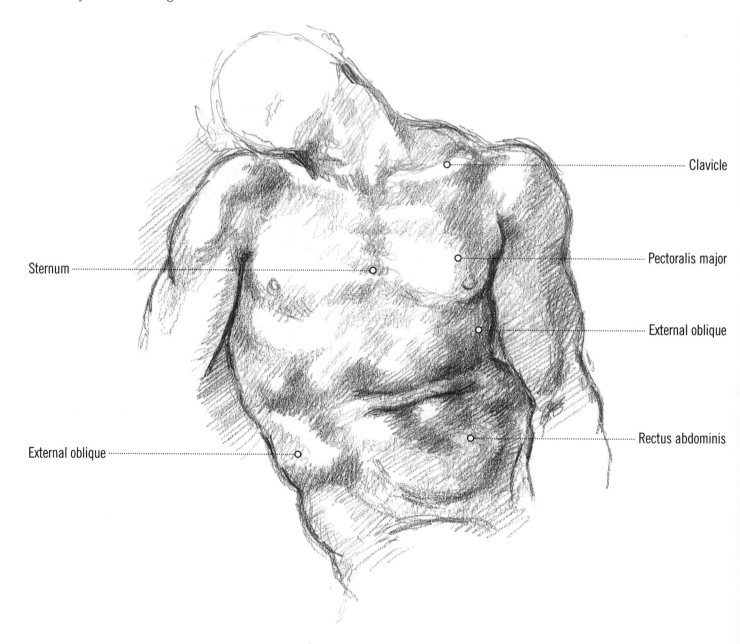

Clavicle

Sternum

Pectoralis major

External oblique

Rectus abdominis

External oblique

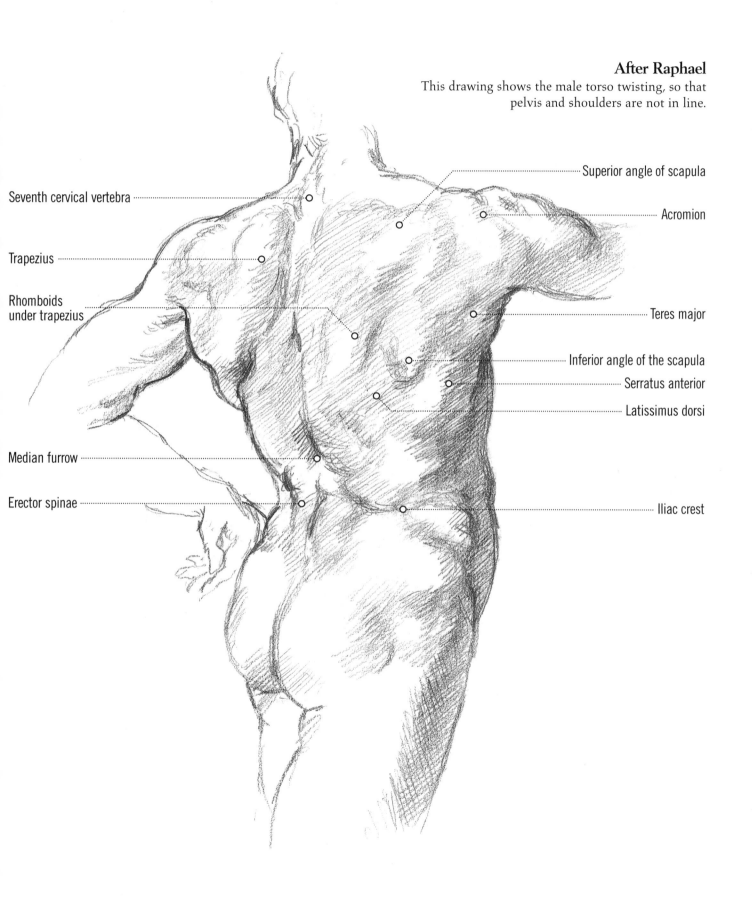

After Raphael

This drawing shows the male torso twisting, so that pelvis and shoulders are not in line.

Seventh cervical vertebra

Trapezius

Rhomboids under trapezius

Median furrow

Erector spinae

Superior angle of scapula

Acromion

Teres major

Inferior angle of the scapula

Serratus anterior

Latissimus dorsi

Iliac crest

The front view of the torso also has a statuesque quality,
partly due to the effect of the musculature.

After Sebastiano del Piombo (1483–1547)

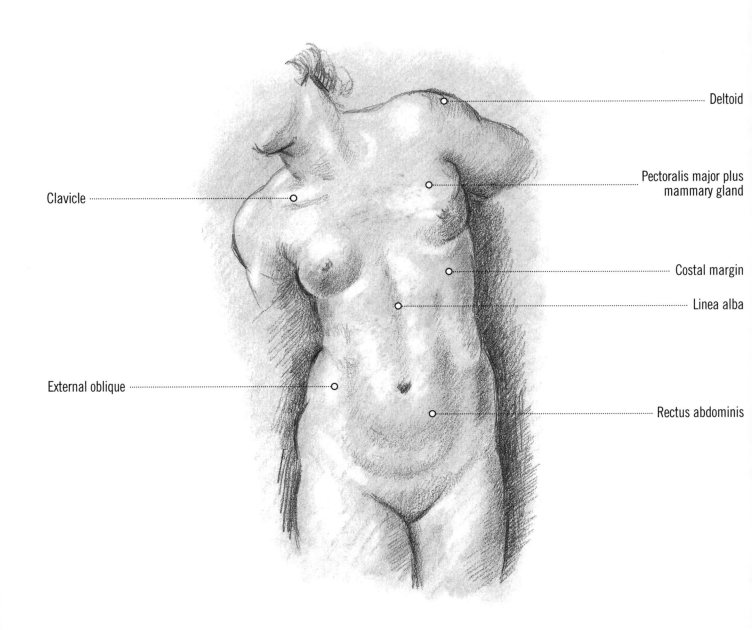

Deltoid

Pectoralis major plus
mammary gland

Clavicle

Costal margin

Linea alba

External oblique

Rectus abdominis

After Raphael

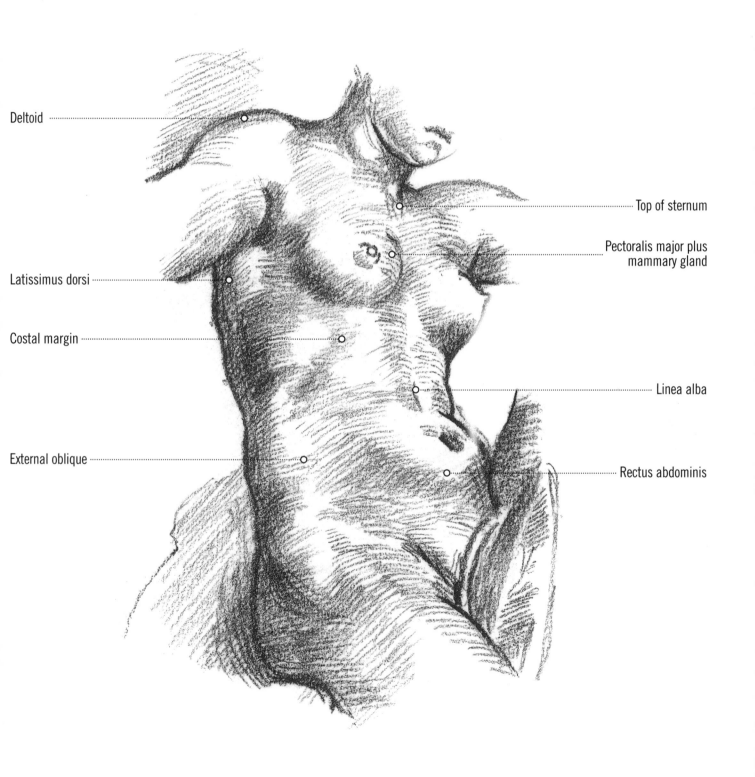

Deltoid

Top of sternum

Pectoralis major plus mammary gland

Latissimus dorsi

Costal margin

Linea alba

External oblique

Rectus abdominis

After Pierre Paul Prud'hon (1758–1823)

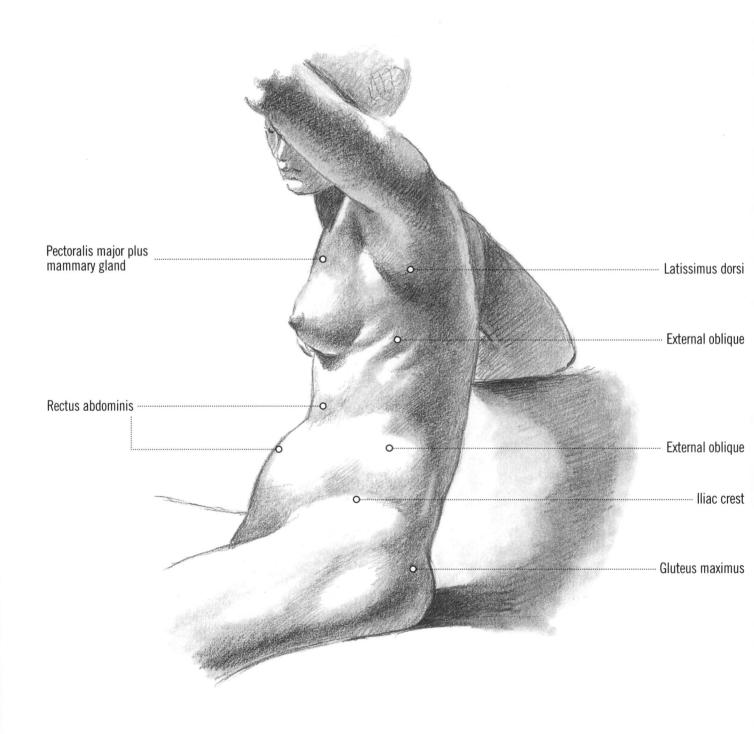

Pectoralis major plus
mammary gland

Latissimus dorsi

External oblique

Rectus abdominis

External oblique

Iliac crest

Gluteus maximus

The following three drawings of the male torso demonstrate the flexibility and strength of the section between the ribcage and the pelvis.

**After Jan Gossaert [Mabuse]
(1470–1541)**

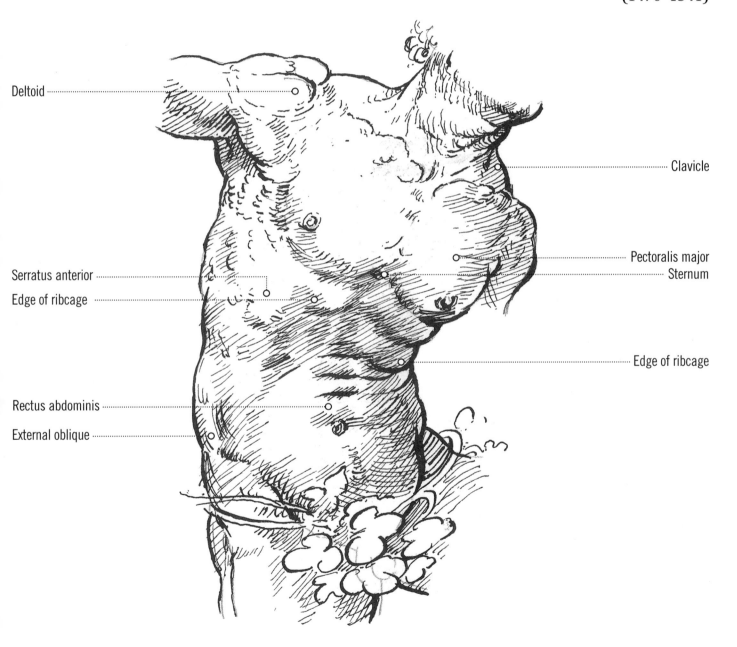

Deltoid

Clavicle

Pectoralis major
Sternum

Serratus anterior
Edge of ribcage

Edge of ribcage

Rectus abdominis
External oblique

After Michelangelo

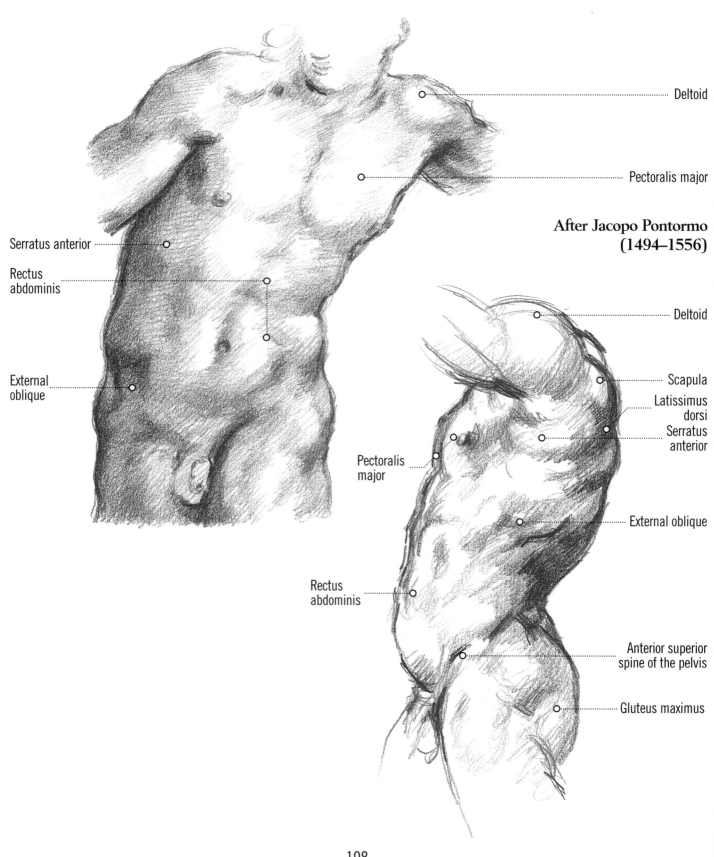

Deltoid

Pectoralis major

After Jacopo Pontormo (1494–1556)

Serratus anterior

Rectus abdominis

External oblique

Deltoid

Scapula

Latissimus dorsi

Serratus anterior

Pectoralis major

External oblique

Rectus abdominis

Anterior superior spine of the pelvis

Gluteus maximus

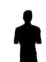
Over the next pages I have shown more torso shapes after master artists, giving dynamic effects through the twisting and turning of the shoulders and hips.

After Pierre Mignard (1612–1693)

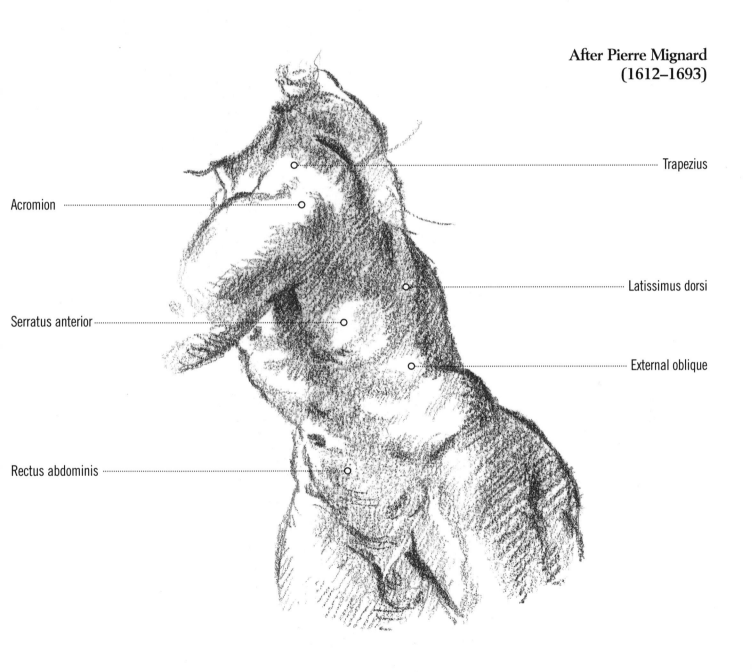

Acromion

Serratus anterior

Rectus abdominis

Trapezius

Latissimus dorsi

External oblique

199

After Bartolommeo Passarotti (1529–1592)

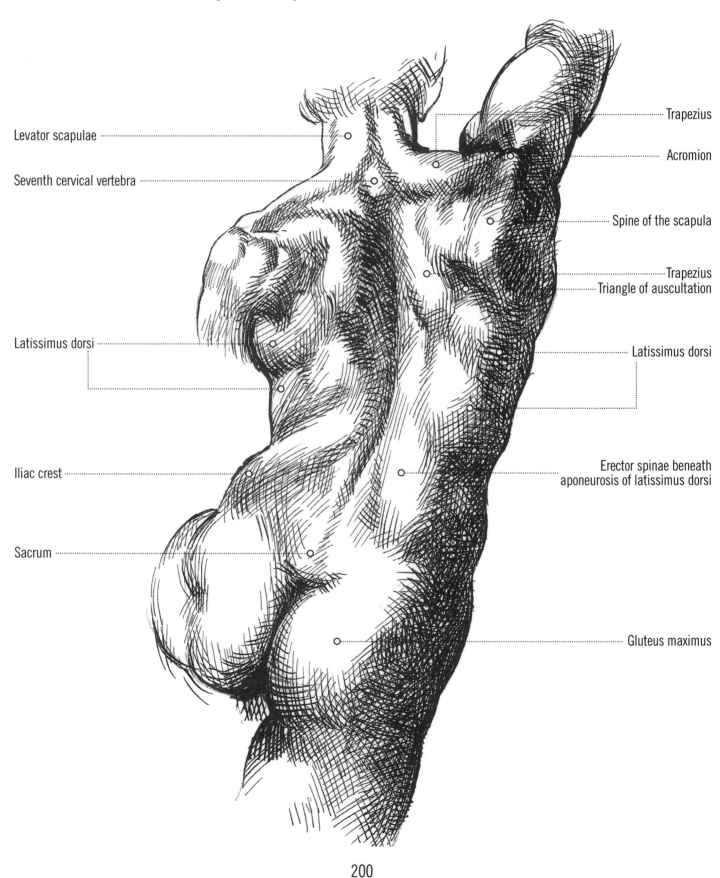

Levator scapulae

Seventh cervical vertebra

Latissimus dorsi

Iliac crest

Sacrum

Trapezius

Acromion

Spine of the scapula

Trapezius
Triangle of auscultation

Latissimus dorsi

Erector spinae beneath
aponeurosis of latissimus dorsi

Gluteus maximus

After Franz von Stuck
(1863–1928)

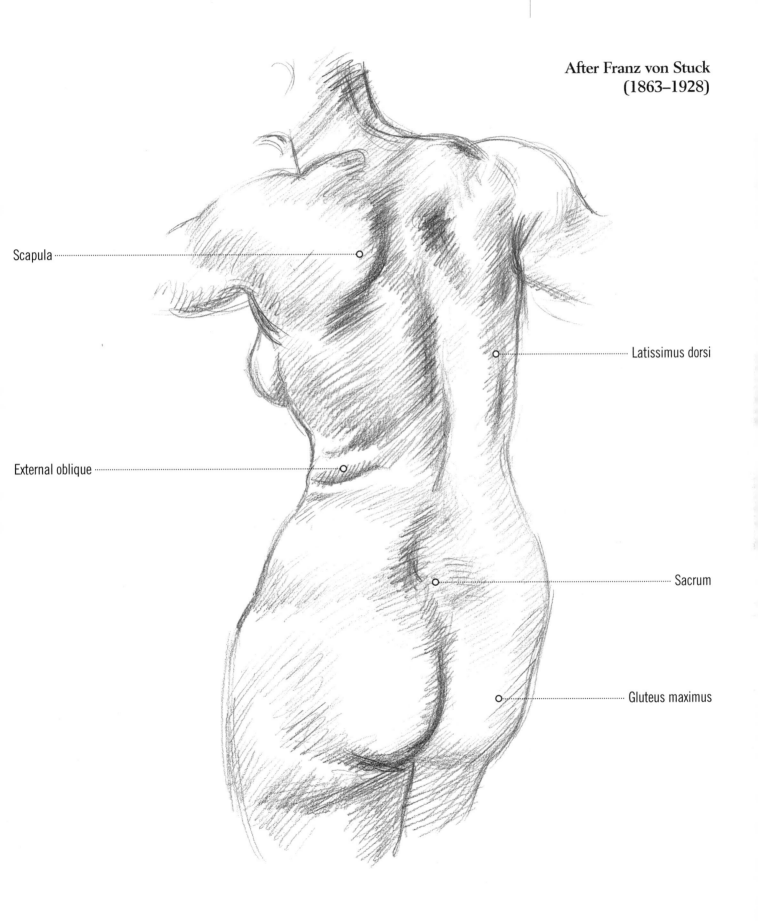

Scapula

Latissimus dorsi

External oblique

Sacrum

Gluteus maximus

201

**After Johann Anton de Peters
(1723–1793)**

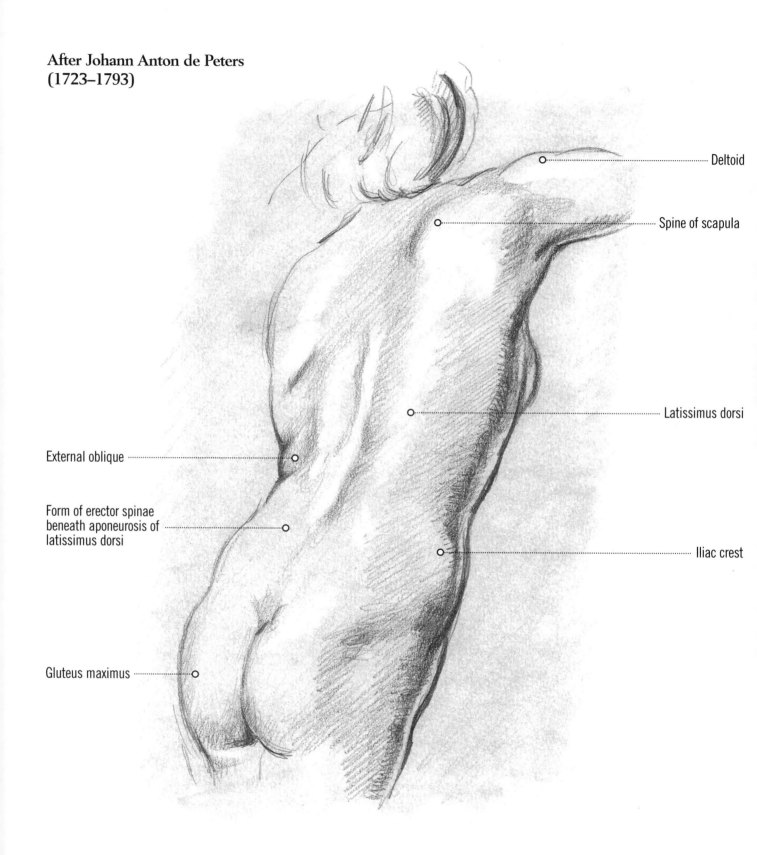

Deltoid

Spine of scapula

Latissimus dorsi

External oblique

Form of erector spinae
beneath aponeurosis of
latissimus dorsi

Iliac crest

Gluteus maximus

After Rubens

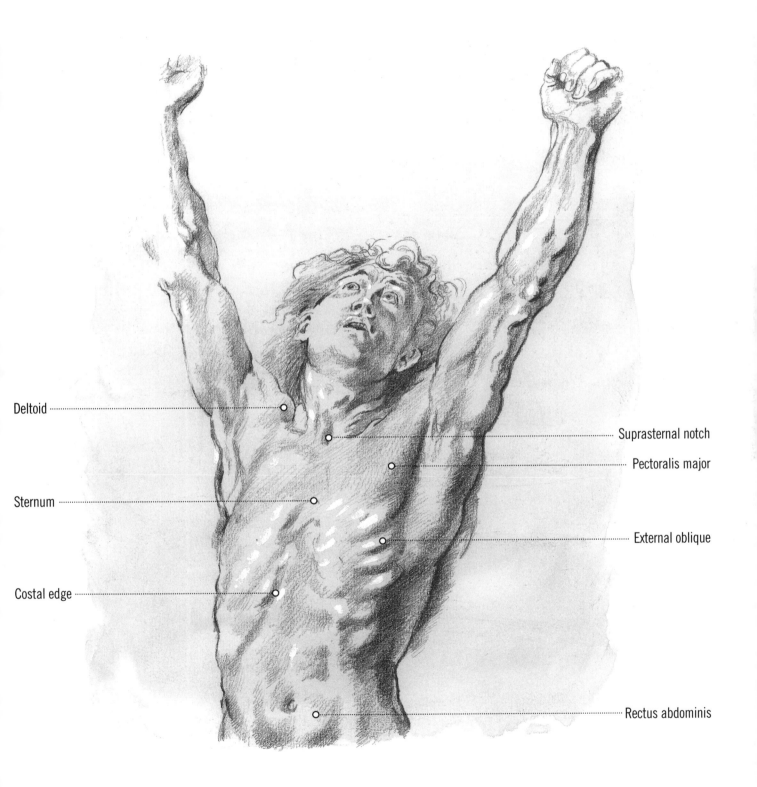

Deltoid

Sternum

Costal edge

Suprasternal notch

Pectoralis major

External oblique

Rectus abdominis

THE ARMS AND HANDS IN MOVEMENT

The diagrams and drawings of arms and hands in this chapter will give you some idea of the extraordinary, subtle movements that they can achieve. Most of our work and skill in handling all manner of things are thanks to the flexibility and strength of these parts of the body.

I have rotated diagrams of the underlying muscle and bone structure with drawings of the same movements as seen from the surface. In many cases you can actually observe the muscles moving under the skin, provided the arm is not too heavily covered in flesh.

Students of anatomy can help their understanding by flexing and relaxing the muscles in their own arms. Observation through touching and feeling is often as

useful as the visual kind. In this book, I can only begin to show the range of movements possible in the arms and hands.

It is worth remembering that the muscles of the upper arm affect the lower arm and even the fingers. As with other parts of the body, the connections are complex and it is difficult to isolate even simple movements to only one set of muscles.

Study of these complicated muscle systems is not easy, but worth the effort because of the extra insight it gives us into the workings of the body.

THE UPPER ARM AND SHOULDER IN DETAIL
muscle and bone structure

Because of the complex attachment of the arm to the torso via the shoulder, we now examine it in some depth. These diagrams show how the muscles are linked to the bone structure and how they all show on the surface of the arm.

BICEPS BRACHII flexes elbow joint and supinates forearm.

BRACHIALIS flexes forearm.

CORACOBRACHIALIS flexes and adducts shoulder.

DELTOID pulls limb forward when arm raised level with shoulder. Raises and holds arm horizontal, and draws limb backwards when horizontal.

INFRASPINATUS and TERES MINOR help to rotate arm backwards.

LATISSIMUS DORSI powerfully draws the arm backwards.

PECTORALIS MAJOR extends arm and draws it across the front of the torso.

PECTORALIS MINOR holds scapula against ribcage and raises ribs during forced breathing. It also pulls shoulder down and forwards.

RHOMBOIDS MAJOR AND MINOR (beneath trapezius) draw scapula towards the median line.

SERRATUS ANTERIOR pulls shoulder forward and gives force to punch. Prevents shoulder blade from swinging to side.

SUBCLAVIUS fixes and pulls clavicle downwards and forwards.

SUBSCAPULARIS (beneath scapula) rotates arm inward.

SUPRASPINATUS raises and rotates arm outwards.

TERES MAJOR with LATISSIMUS DORSI extends, adducts and rotates arm inwards.

TENDON AND APONEUROSIS OF TRICEPS flatten back of arm above elbow.

TRAPEZIUS raises and lowers shoulders and draws head to either side.

TRICEPS BRACHII extends limb.

FRONT VIEW

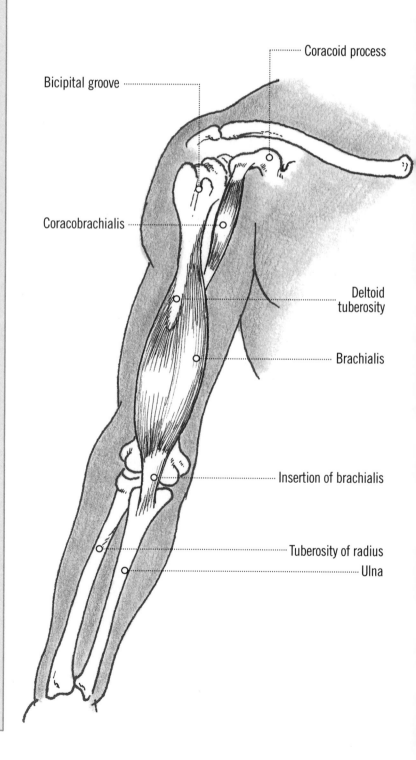

Coracoid process

Bicipital groove

Coracobrachialis

Deltoid tuberosity

Brachialis

Insertion of brachialis

Tuberosity of radius

Ulna

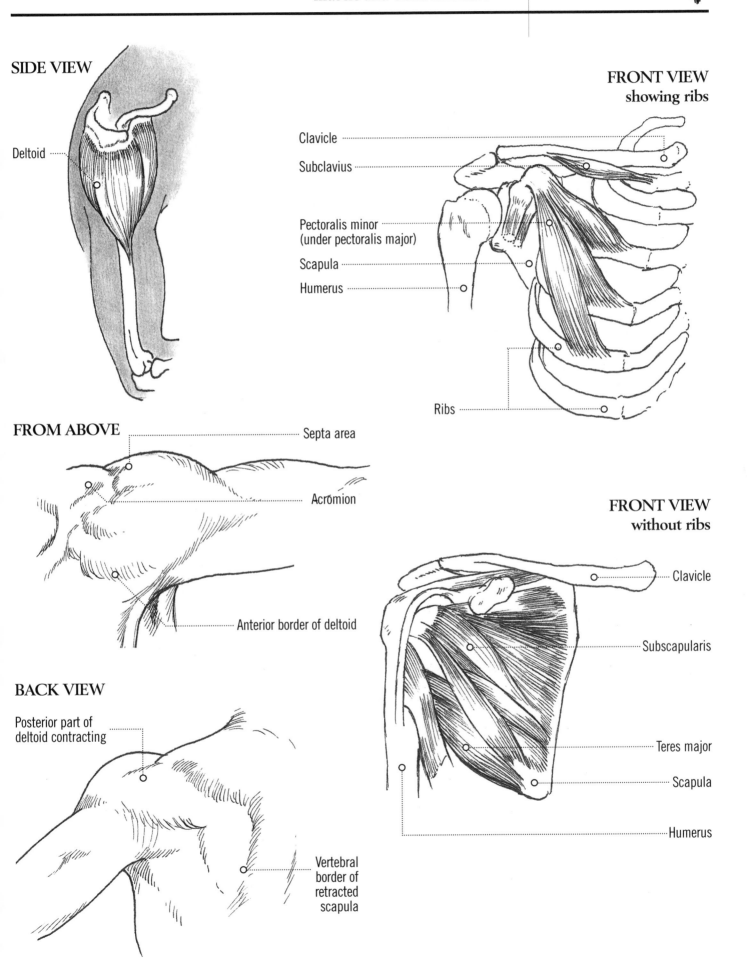

SIDE VIEW

Deltoid

FROM ABOVE

Septa area

Acromion

Anterior border of deltoid

BACK VIEW

Posterior part of deltoid contracting

Vertebral border of retracted scapula

FRONT VIEW
showing ribs

Clavicle

Subclavius

Pectoralis minor (under pectoralis major)

Scapula

Humerus

Ribs

FRONT VIEW
without ribs

Clavicle

Subscapularis

Teres major

Scapula

Humerus

207

Note how these muscles fit under and over each other, forming a strong mass that enables the arm to move easily in any direction without damage. All the muscles affect each other when flexing or contracting, which translates as a 'rippling' effect on the surface of the arm. This is particularly visible in athletes and weightlifters.

FRONT VIEW

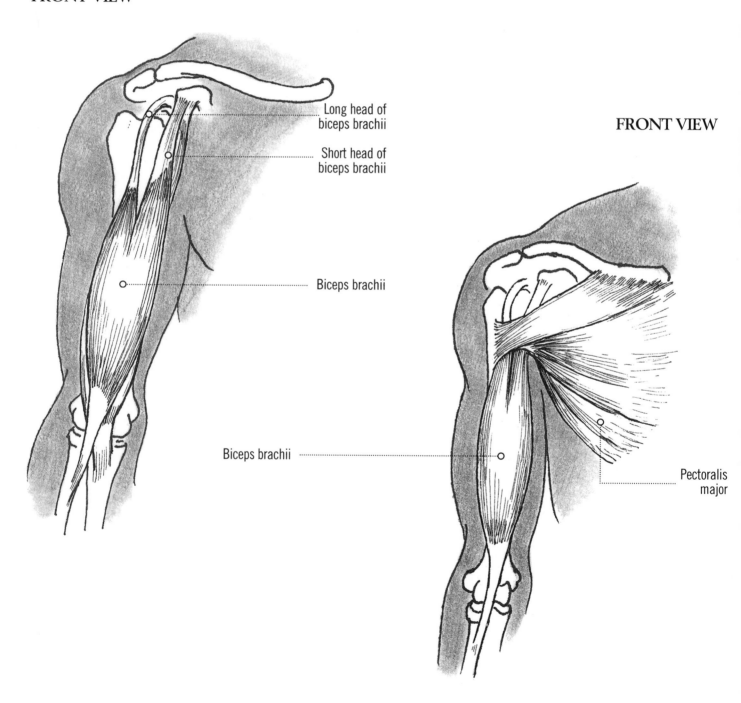

Long head of biceps brachii

Short head of biceps brachii

Biceps brachii

Biceps brachii

FRONT VIEW

Pectoralis major

BACK VIEW

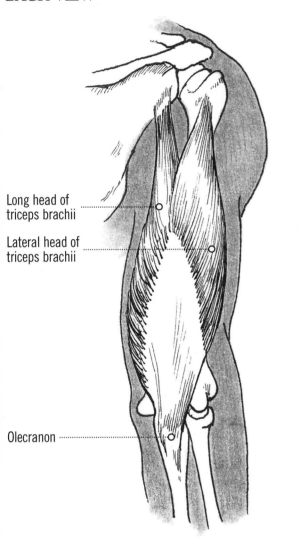

Long head of
triceps brachii

Lateral head of
triceps brachii

Olecranon

BACK VIEW

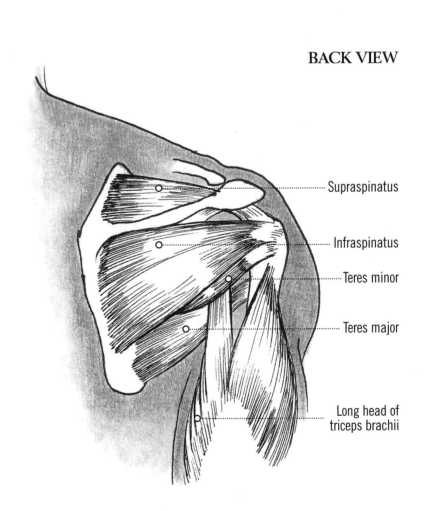

Supraspinatus

Infraspinatus

Teres minor

Teres major

Long head of
triceps brachii

FRONT VIEW

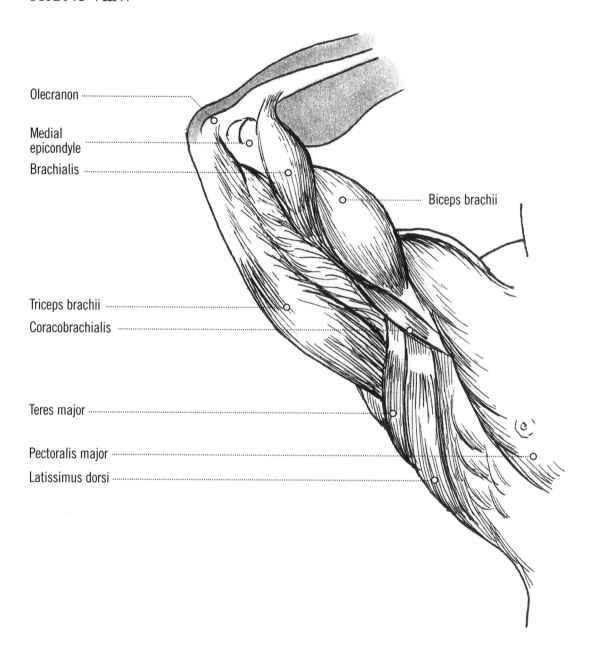

Olecranon

Medial epicondyle

Brachialis

Biceps brachii

Triceps brachii

Coracobrachialis

Teres major

Pectoralis major

Latissimus dorsi

FRONT VIEW

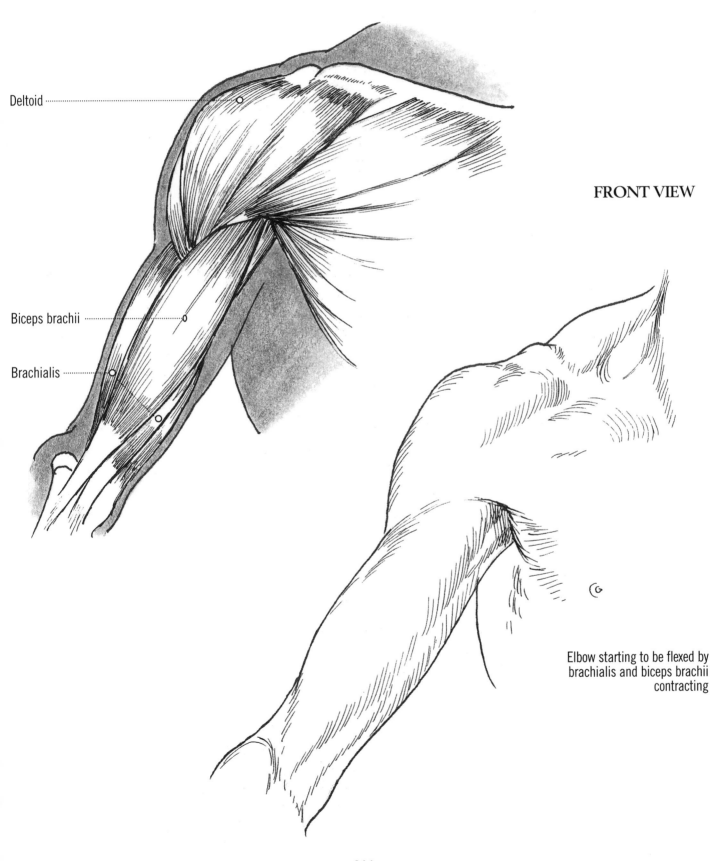

Deltoid

Biceps brachii

Brachialis

FRONT VIEW

Elbow starting to be flexed by brachialis and biceps brachii contracting

THE ARM IN MOVEMENT
turning the arm

BACK VIEWS

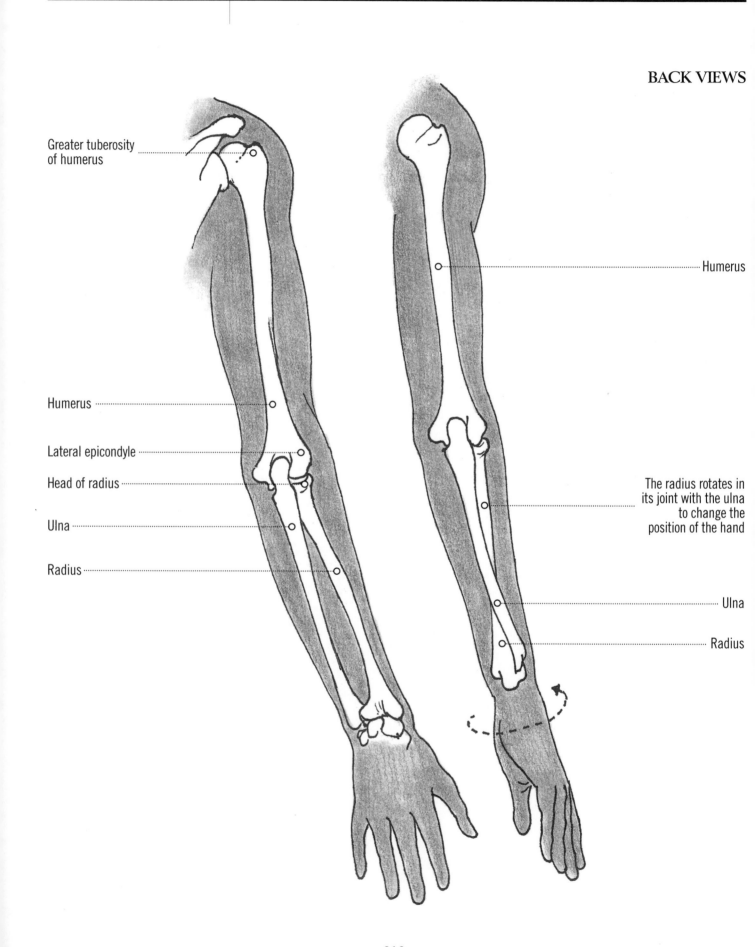

Greater tuberosity of humerus

Humerus

Humerus

Lateral epicondyle

Head of radius

Ulna

Radius

The radius rotates in its joint with the ulna to change the position of the hand

Ulna

Radius

212

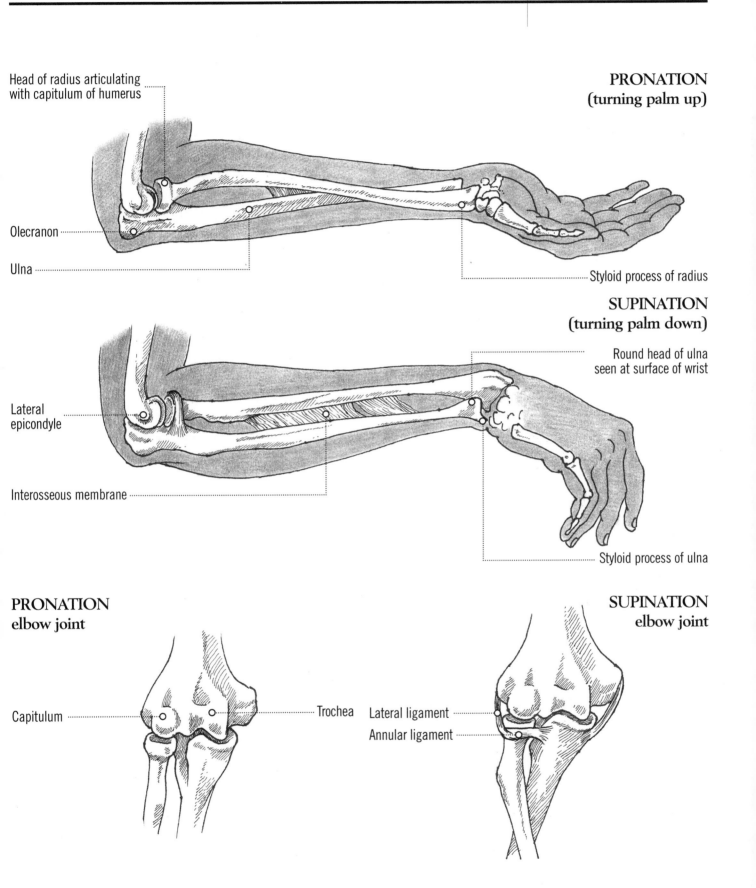

Head of radius articulating
with capitulum of humerus

**PRONATION
(turning palm up)**

Olecranon

Ulna

Styloid process of radius

**SUPINATION
(turning palm down)**

Round head of ulna
seen at surface of wrist

Lateral
epicondyle

Interosseous membrane

Styloid process of ulna

PRONATION
elbow joint

SUPINATION
elbow joint

Capitulum

Trochea

Lateral ligament

Annular ligament

THE MUSCLES OF THE LOWER ARM AND HOW THEY WORK

ABDUCTOR POLLICIS LONGUS extends and abducts the thumb.

ANCONEUS extends forearm.

BRACHIORADIALIS flexes elbow joint.

LONG EXTENSOR MUSCLES on posterior forearm pass into the back of hand.

EXTENSOR DIGITORUM extends fingers (not thumb);

EXTENSOR DIGITI MINIMI extends little finger.

EXTENSOR CARPI ULNARIS extends wrist, adducts hand.

EXTENSOR POLLICIS BREVIS extends proximal phalanx of thumb.

EXTENSOR INDICIS extends forefinger.

EXTENSOR CARPI RADIALIS BREVIS extends the hand at the wrist.

EXTENSOR CARPI RADIALIS LONGUS extends wrist on side of radius.

EXTENSOR POLLICIS LONGUS extends the thumb.

FLEXOR CARPI RADIALIS flexes and rotates hand inwards.

FLEXOR CARPI ULNARIS flexes wrist on side of ulna.

FLEXOR DIGITI MINIMI BREVIS flexes little finger.

FLEXOR DIGITORUM PROFUNDUS flexes middle and distal phalanges of fingers (not thumb).

FLEXOR DIGITORUM SUPERFICIALIS flexes middle and distal phalanges of fingers (not thumb) and wrist.

FLEXOR POLLICIS LONGUS flexes distal phalanx.

PALMARIS LONGUS the weakest, least significant muscle, sometimes missing in one forearm, flexes hand.

PRONATOR QUADRATUS causes pronation of radius.

PRONATOR TERES causes pronation of forearm, helps in flexion of forearm.

SUPINATOR the shortest extensor, rotates radius outwards on its own axis.

THE MUSCLES OF THE HAND AND HOW THEY WORK

Note that there are no muscles in the fingers, only bones and tendons, tied by fibrous bands. The small fatty pads on the end of fingers carry blood and nerves and cushion flexor tendons.

ABDUCTOR DIGITI MINIMI moves little finger outwards.

ABDUCTOR POLLICIS BREVIS draws thumb forward at a right angle to palm.

ADDUCTOR POLLICIS draws thumb towards palm.

DORSAL INTEROSSEI abduct fingers from midline of hand.

FLEXOR and EXTENSOR RETINACULA enable tendons of hand to change direction at wrist.

FLEXOR POLLICIS BREVIS flexes proximal phalanx of thumb.

LUMBRICALES flex the proximal and extend the middle and distal phalanges.

OPPONENS DIGITI MINIMI draws fifth metacarpal forwards and inwards, to hollow the palm.

OPPONENS POLLICIS allows opposition of thumb.

PALMAR MUSCLES lie beneath palmar aponeurosis (thickened fascia) holding skin to muscles and bones below.

PALMAR INTEROSSEI move fingers inward to midline of hand.

Here are four views of the lower arm, palm up, showing the layers of muscle from deepest (1) to most superficial (4).

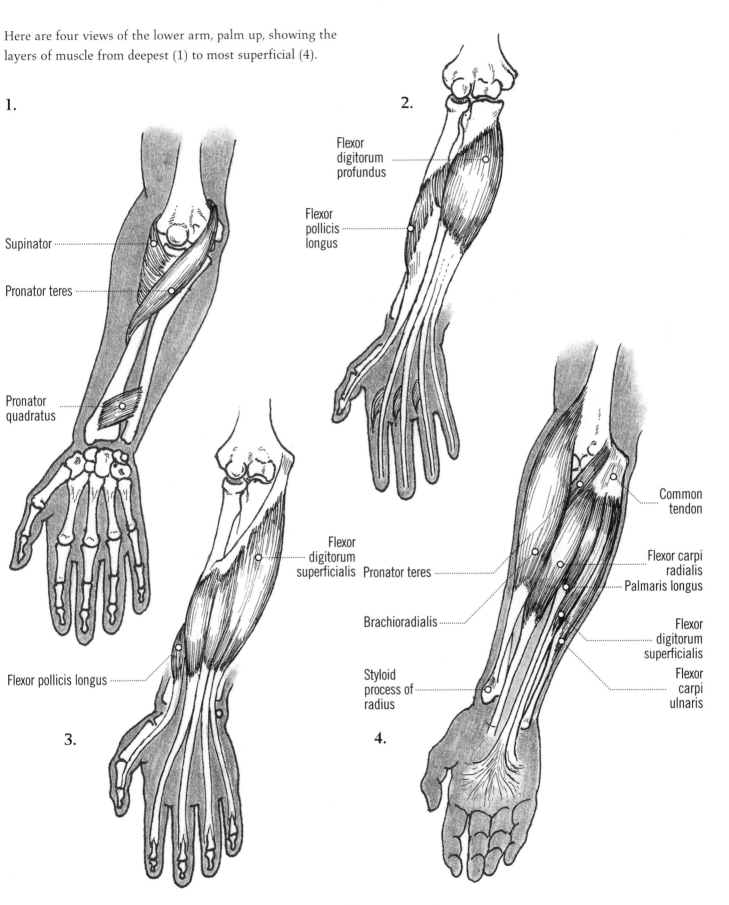

1.

Supinator

Pronator teres

Pronator quadratus

Flexor pollicis longus

2.

Flexor digitorum profundus

Flexor pollicis longus

3.

Flexor digitorum superficialis

4.

Pronator teres

Brachioradialis

Styloid process of radius

Common tendon

Flexor carpi radialis

Palmaris longus

Flexor digitorum superficialis

Flexor carpi ulnaris

DEEP LEVEL

SUPERFICIAL LEVEL

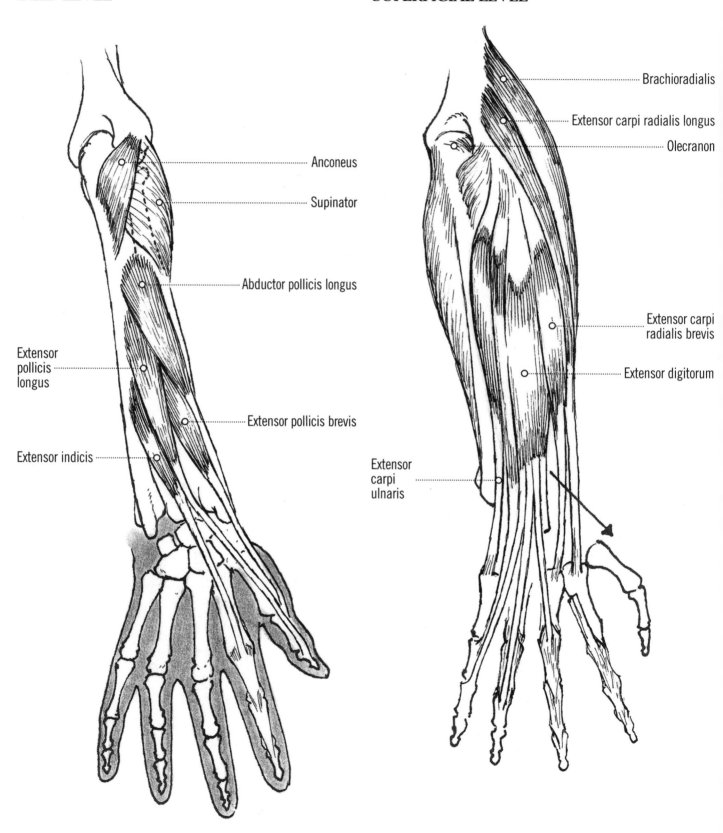

Anconeus

Supinator

Abductor pollicis longus

Extensor pollicis longus

Extensor pollicis brevis

Extensor indicis

Brachioradialis

Extensor carpi radialis longus

Olecranon

Extensor carpi radialis brevis

Extensor digitorum

Extensor carpi ulnaris

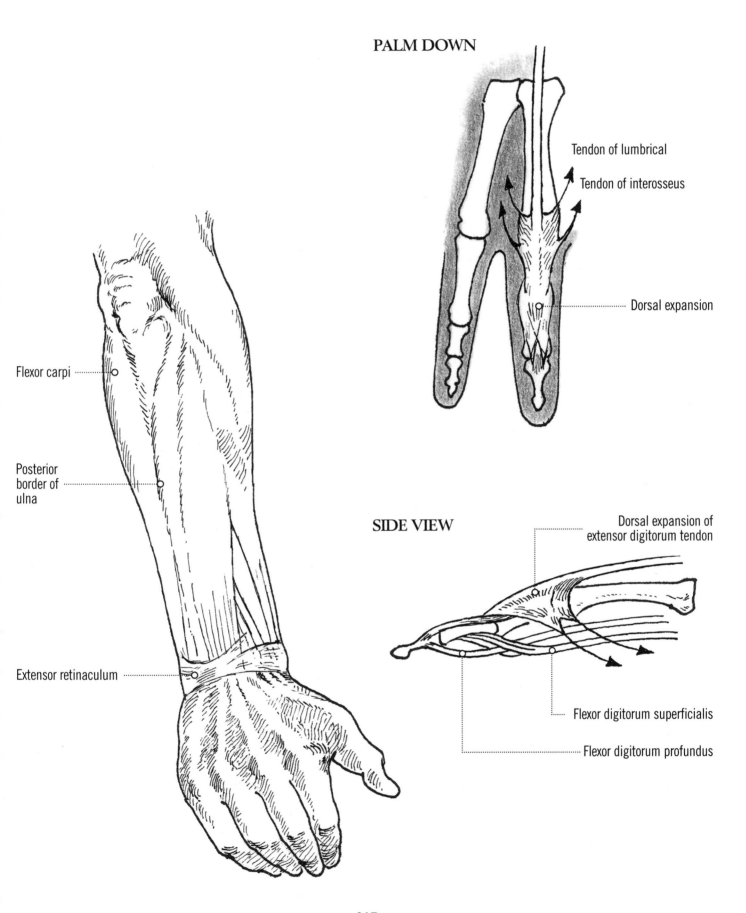

PALM DOWN

Tendon of lumbrical

Tendon of interosseus

Dorsal expansion

SIDE VIEW

Dorsal expansion of extensor digitorum tendon

Flexor digitorum superficialis

Flexor digitorum profundus

Flexor carpi

Posterior border of ulna

Extensor retinaculum

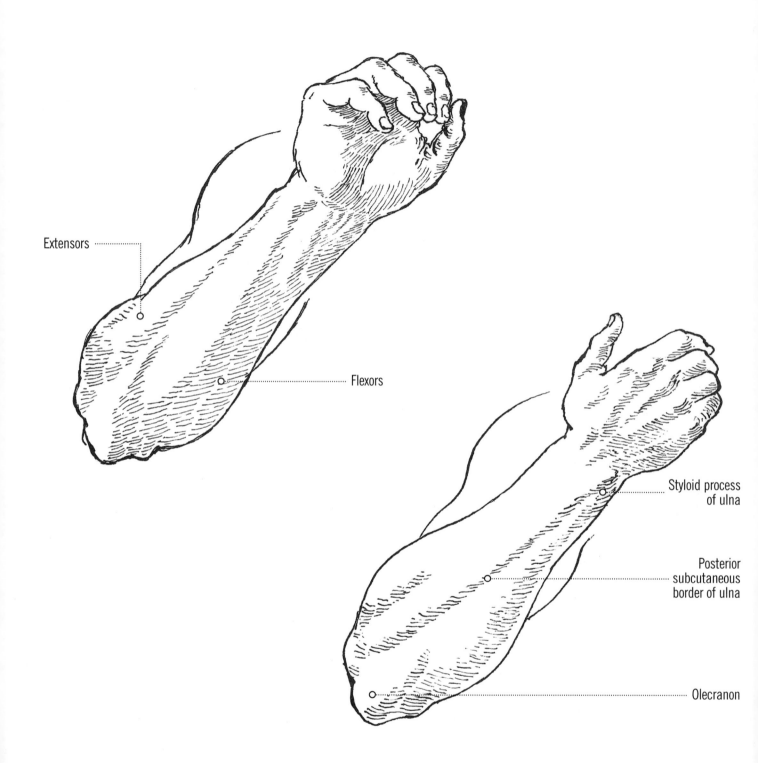

Extensors

Flexors

Styloid process
of ulna

Posterior
subcutaneous
border of ulna

Olecranon

FLEXED ARM

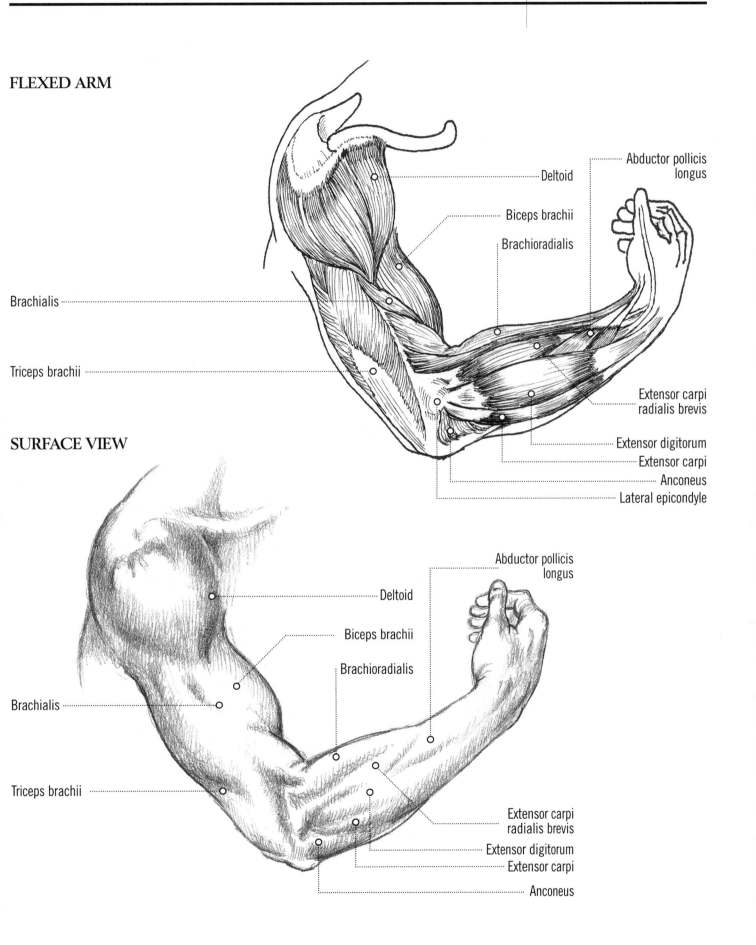

Deltoid

Biceps brachii

Brachioradialis

Abductor pollicis longus

Brachialis

Triceps brachii

Extensor carpi radialis brevis

Extensor digitorum

Extensor carpi

Anconeus

Lateral epicondyle

SURFACE VIEW

Deltoid

Biceps brachii

Brachioradialis

Abductor pollicis longus

Brachialis

Triceps brachii

Extensor carpi radialis brevis

Extensor digitorum

Extensor carpi

Anconeus

DEEP VIEW

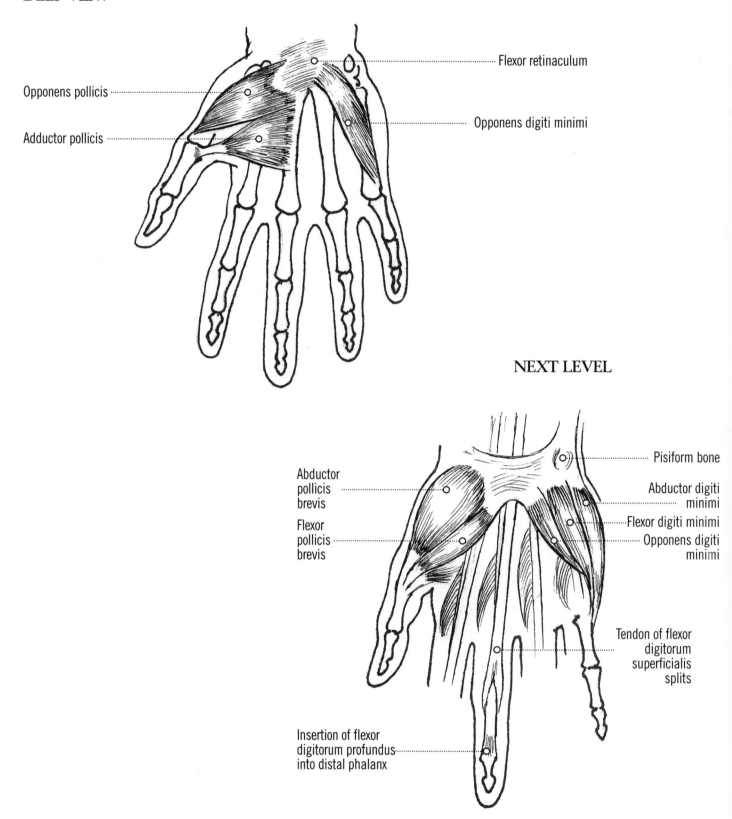

Flexor retinaculum

Opponens pollicis

Opponens digiti minimi

Adductor pollicis

NEXT LEVEL

Pisiform bone

Abductor pollicis brevis

Abductor digiti minimi

Flexor digiti minimi

Flexor pollicis brevis

Opponens digiti minimi

Tendon of flexor digitorum superficialis splits

Insertion of flexor digitorum profundus into distal phalanx

EXTENSION

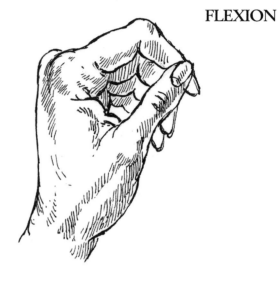

FLEXION

Adductor pollicis acting

The two opponens muscles acting

It is well worth studying the movements of the hand in detail, as they can be very expressive and capturing them accurately will add a lot to your drawing.

The movements of the hand are mainly produced by the muscles higher up the arm. When you move your own hand, notice the the muscles of your forearm or upper arm where the action originates.

Look out for details like the pads on the palm of the hand and the front of the fingers which push out when the hand is closed into a fist.

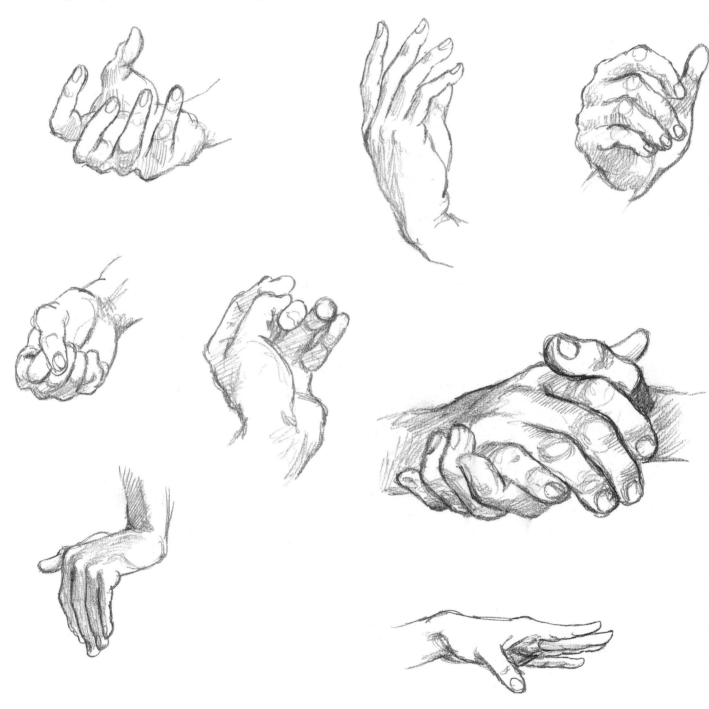

MORE PRECISE HAND MOVEMENTS

Holding a pencil

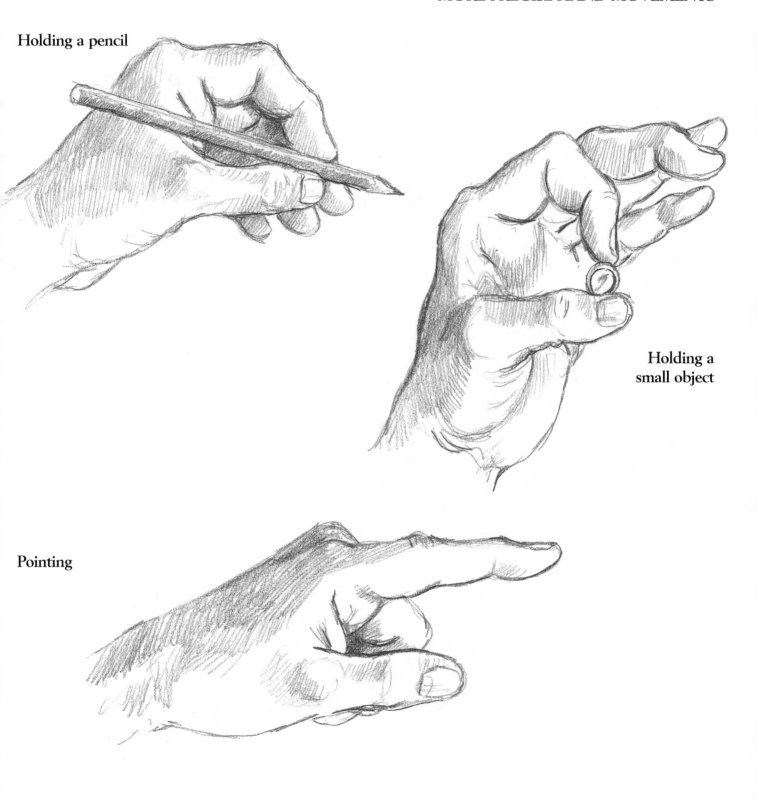

Holding a
small object

Pointing

What is clear is how flexible and sensitive the hands are, being able to make large, strong movements and detailed, precise ones. The following range of movements are just a few of the hundreds of actions the hand can perform.

Pushing

Holding

Holding

Clenching

Clutching

Grasping

Holding and arranging hair

Over the following pages I have drawn several images of the arm and hand after master artists. Note the difference in muscularity between portrayals of the male and female arm.

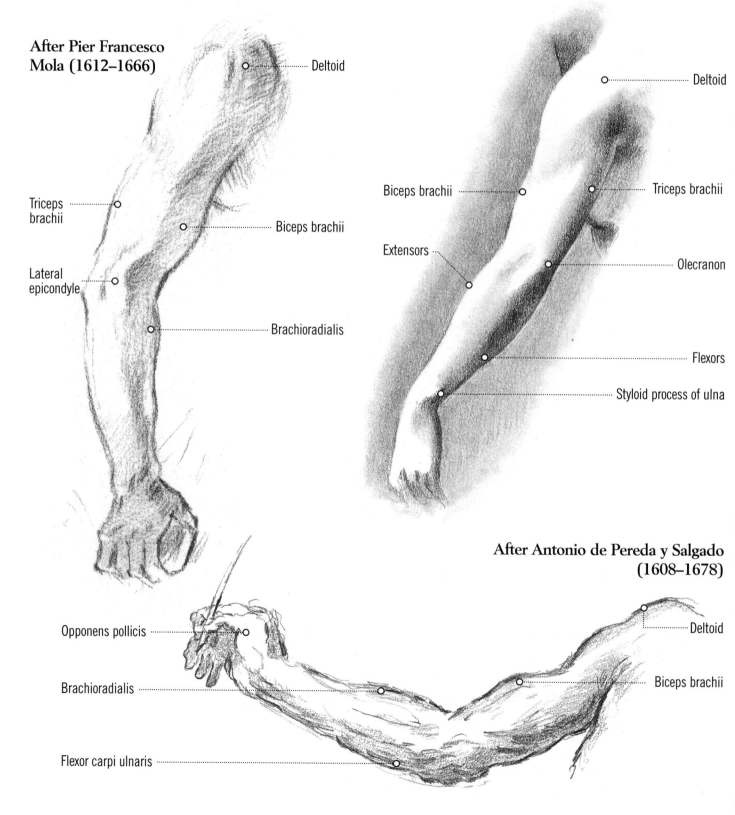

After Pier Francesco Mola (1612–1666)

Deltoid

Triceps brachii

Biceps brachii

Lateral epicondyle

Brachioradialis

After Prud'hon

Deltoid

Biceps brachii

Triceps brachii

Extensors

Olecranon

Flexors

Styloid process of ulna

After Antonio de Pereda y Salgado (1608–1678)

Opponens pollicis

Brachioradialis

Flexor carpi ulnaris

Deltoid

Biceps brachii

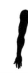

Four drawings after Michelangelo

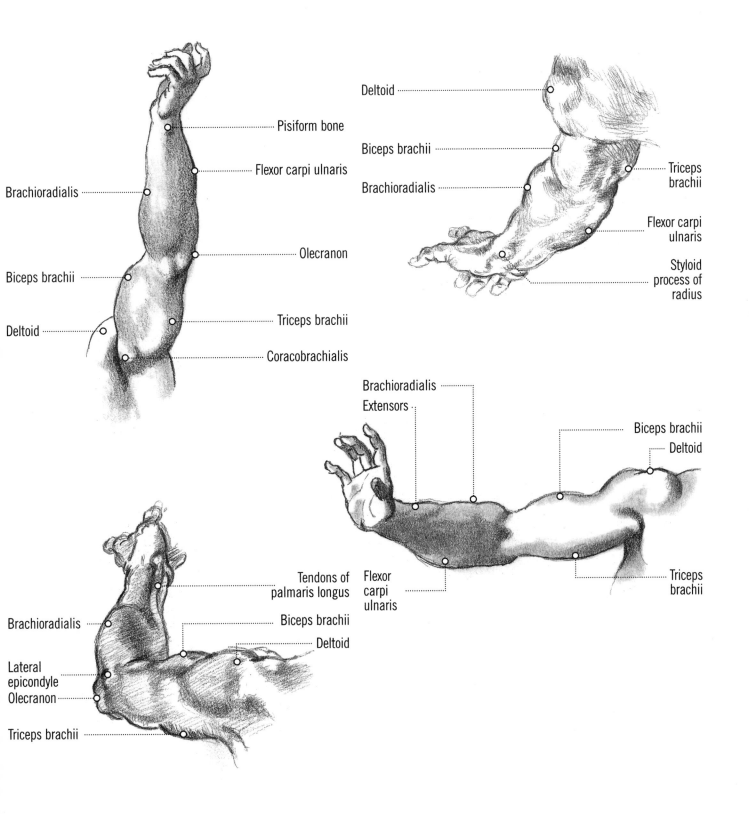

Brachioradialis

Pisiform bone

Flexor carpi ulnaris

Biceps brachii

Olecranon

Deltoid

Triceps brachii

Coracobrachialis

Deltoid

Biceps brachii

Brachioradialis

Triceps brachii

Flexor carpi ulnaris

Styloid process of radius

Brachioradialis

Extensors

Biceps brachii

Deltoid

Tendons of palmaris longus

Flexor carpi ulnaris

Brachioradialis

Biceps brachii

Deltoid

Lateral epicondyle

Olecranon

Triceps brachii

Triceps brachii

After Jean-Antoine Watteau (1684–1781)

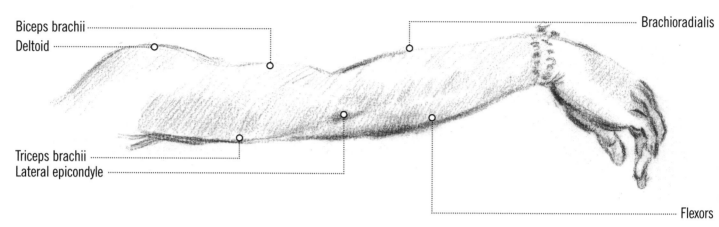

Biceps brachii
Deltoid
Brachioradialis
Triceps brachii
Lateral epicondyle
Flexors

After Charles-Joseph Natoire (1700–1777)

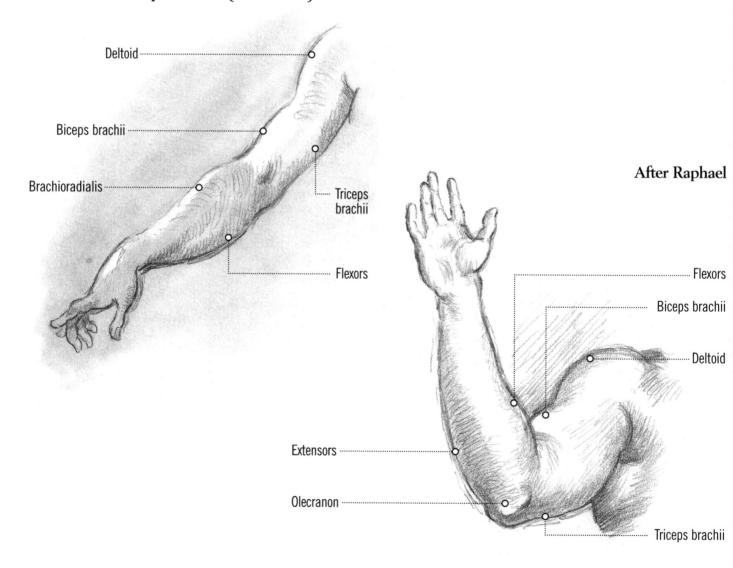

Deltoid

Biceps brachii

Brachioradialis

Triceps brachii

Flexors

After Raphael

Flexors

Biceps brachii

Deltoid

Extensors

Olecranon

Triceps brachii

After Raphael

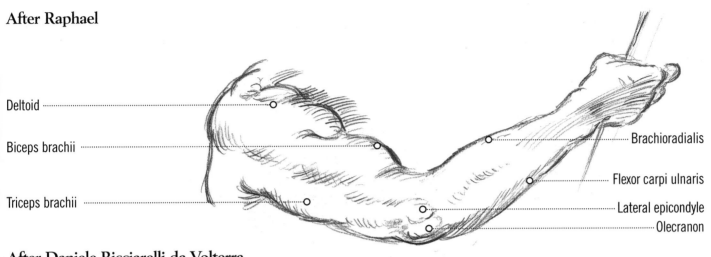

Deltoid

Biceps brachii

Triceps brachii

Brachioradialis

Flexor carpi ulnaris

Lateral epicondyle

Olecranon

After Daniele Ricciarelli da Volterra (1509–1566)

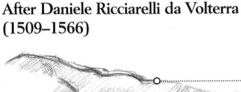

Triceps brachii

Olecranon

Flexor carpi ulnaris

Brachioradialis

After Raphael

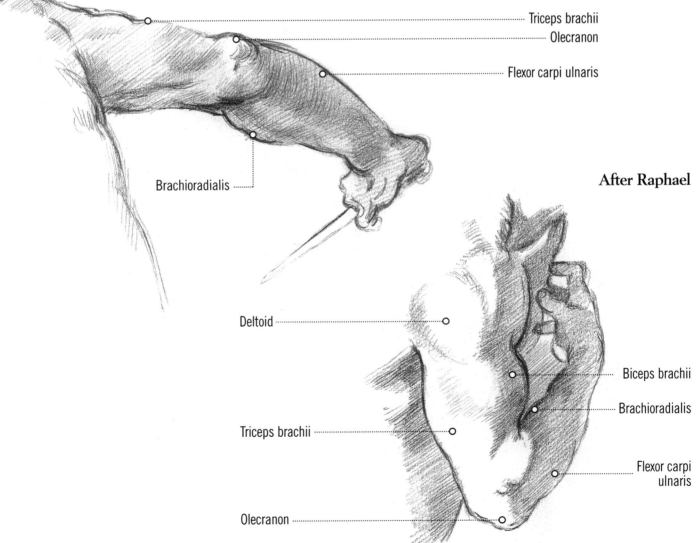

Deltoid

Triceps brachii

Olecranon

Biceps brachii

Brachioradialis

Flexor carpi ulnaris

Here are some more examples of very clearly drawn musculature, which I have not annotated. See if you can identify the various muscles shown. Refer to the detailed diagrams of muscles and the drawings on the previous pages to check your results. Pencil in your ideas before checking and see how many you get correct. This exercise is well worth doing.

After Rubens

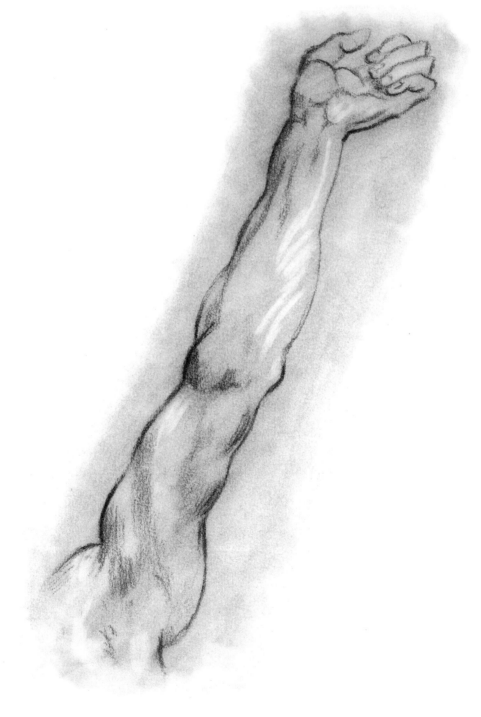

After François Boucher (1703–1770)

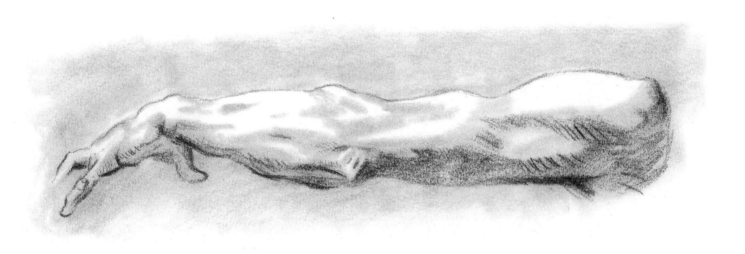

After Eugène Delacroix (1798–1863)

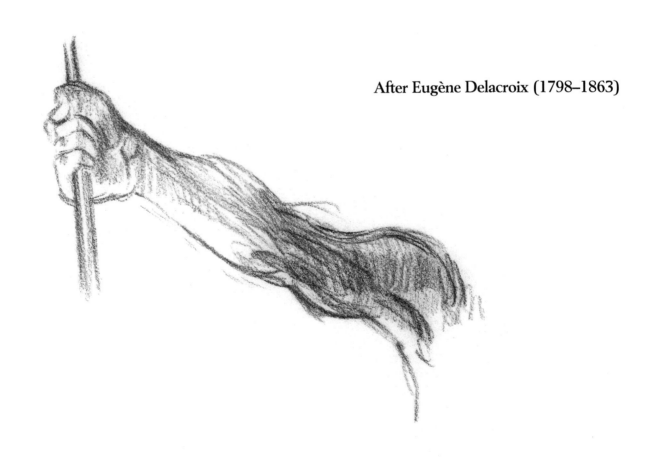

**After Leonardo da Vinci
(1452–1519)**

After Michelangelo

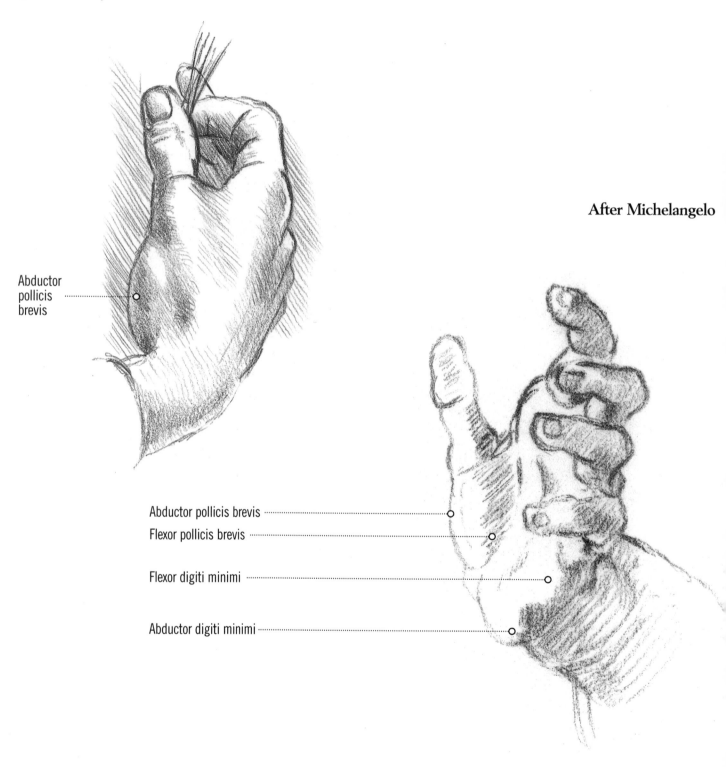

Abductor
pollicis
brevis

Abductor pollicis brevis

Flexor pollicis brevis

Flexor digiti minimi

Abductor digiti minimi

After Rubens

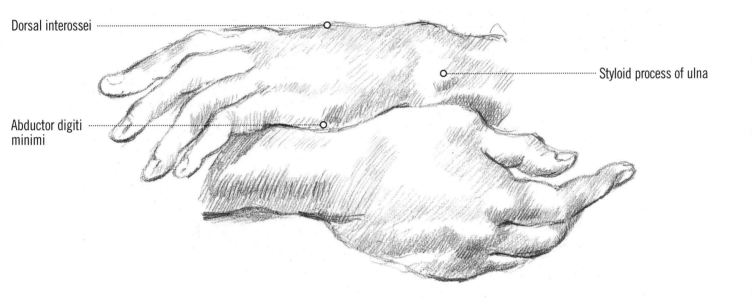

Dorsal interossei

Abductor digiti minimi

Styloid process of ulna

After Andrea del Sarto (1486–1531)

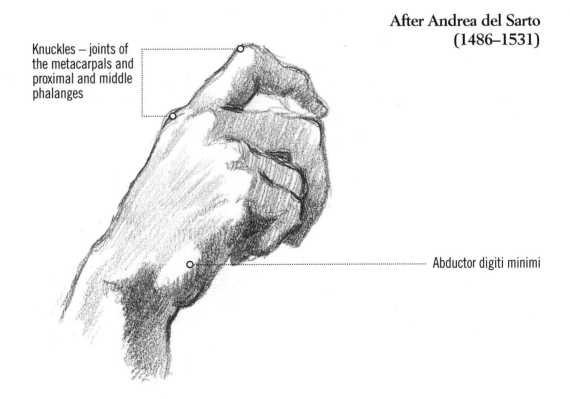

Knuckles – joints of the metacarpals and proximal and middle phalanges

Abductor digiti minimi

233

THE LEGS AND FEET IN MOVEMENT

Our lower limbs are probably the most powerful parts of the body, having the largest bones and the strongest muscles. This is no surprise, since the legs not only support the total body weight but also have to propel it along in the world.

The hingeing of the legs on to the torso is very strongly supported, both in the shape and construction of the skeletal structure and in the completeness of the muscle system that holds it all together and allows it to move. Legs and feet are less delicate in their movements than our arms and hands, but commensurably stronger and harder to damage. This means that the lower limbs are less pliable and sensitive in their movements than the upper limbs, sacrificing flexibility in the cause of greater strength.

Despite the lower and upper limbs being basically similar in form, the feet are more solid and their movements less subtle than the hands, which have to perform so many more complex tasks. Nor does the knee joint have quite the same range as the elbow, or the ankle as the wrist. The toes are clearly less dexterous than the fingers, despite being constructed along similar lines, but they are also considerably stronger.

So what is most evident in the lower limbs is the power and strength, and the ability to support the whole body mass. All movements of the legs and feet are simple, but strong and distinctive.

The thigh extends down one long, strong bone (the femur) from the pelvis – where the ball and socket joint of the hip connects with the torso – to the knee joint, where the two lower bones of the leg meet it. The muscle systems are closely bound around these joints and are generally large muscles that cover the long bone structure entirely.

The pelvis, which we have already studied (see page 70), has a nicely hollowed shape on each side, into which the rounded top of each femur fits. It also contains the twin iliac crests, to which are attached the powerful muscles connecting the legs to the torso.

FRONT VIEW

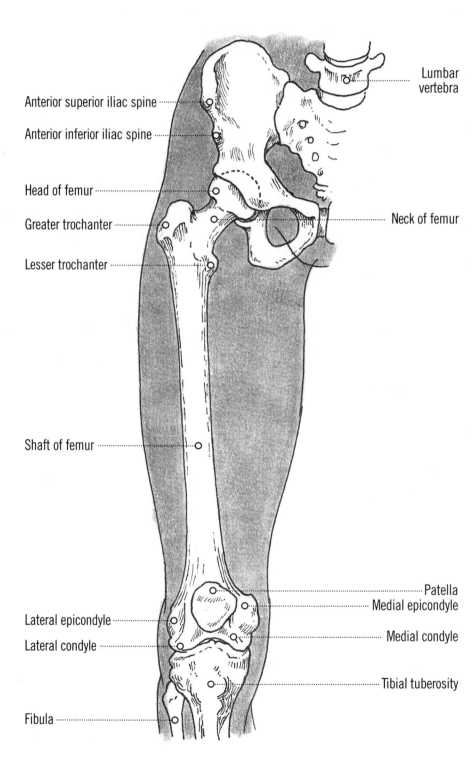

Anterior superior iliac spine

Anterior inferior iliac spine

Head of femur

Greater trochanter

Lesser trochanter

Shaft of femur

Lateral epicondyle

Lateral condyle

Fibula

Lumbar vertebra

Neck of femur

Patella
Medial epicondyle

Medial condyle

Tibial tuberosity

FRONT VIEW

SIDE VIEW

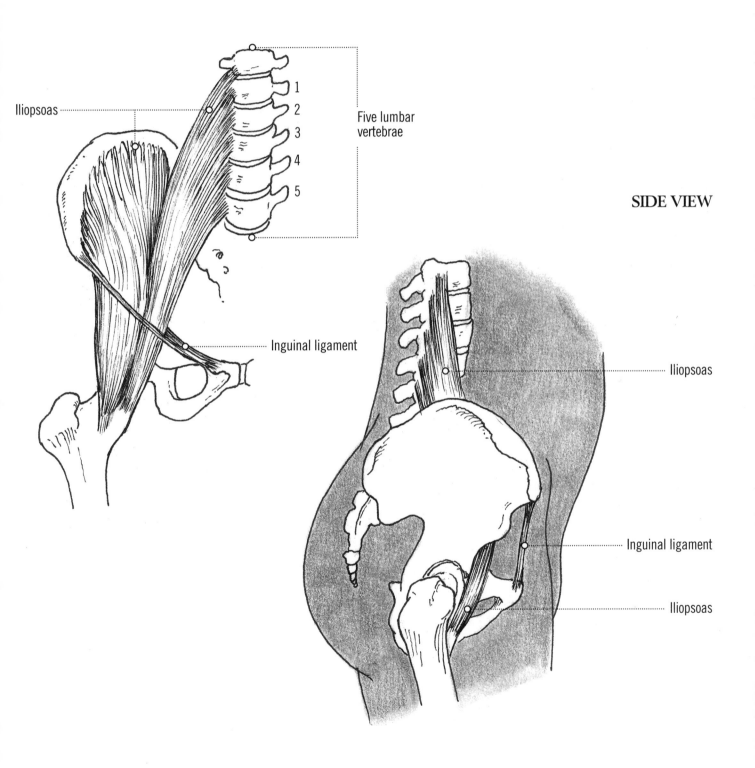

Iliopsoas

1
2
3
4
5

Five lumbar
vertebrae

Inguinal ligament

Iliopsoas

Inguinal ligament

Iliopsoas

ADDUCTOR MAGNUS, ADDUCTOR BREVIS and ADDUCTOR LONGUS: simultaneous contraction of these muscles results in moving thigh towards centre line.

BICEPS FEMORIS flexes and then rotates leg towards centre line.

GEMELLUS SUPERIOR and GEMELLUS INFERIOR rotate thigh outwards.

GLUTEUS MAXIMUS extends from thigh onto fixed trunk. When leg is fixed, trunk is bent backwards by its contraction. It extends hip joint when subject climbs stairs or rises to erect posture after stooping.

GLUTEUS MEDIUS rotates thigh inwards and outwards.

GLUTEUS MINIMUS rotates thigh inwards and outwards.

GRACILIS flexes and rotates leg towards centre line.

ILIOPSOAS when trunk is fixed, flexes and rotates femur inwards; when leg is fixed, flexes trunk.

PECTINEUS moves thigh towards centre line and flexes it.

QUADRATUS FEMORIS rotates thigh outwards.

QUADRICEPS MUSCLES these are the VASTUS INTERMEDIUS/ LATERALIS/ MEDIALIS and the RECTUS FEMORIS; they extend and flex the knee.

TENSOR FASCIAE LATAE stretches fascia, elevates and moves thigh outwards.

RECTUS FEMORIS (see quadriceps) extends knee joint.

SARTORIUS moves thigh away from body and rotates it sideways, and flexes leg at knee joint.

SEMIMEMBRANOSUS flexes and then rotates leg towards centre line.

SEMITENDINOSUS flexes and then rotates leg towards centre line.

VASTUS MUSCLES (see quadriceps) extend and flex the knee.

DEEP MUSCLES
FRONT VIEW: ADDUCTOR GROUP
OF MUSCLES

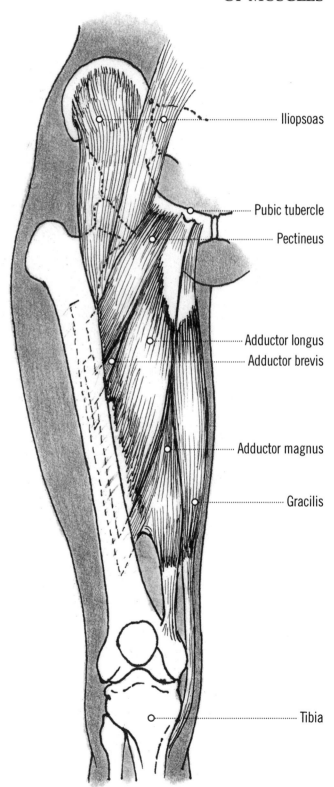

- Iliopsoas
- Pubic tubercle
- Pectineus
- Adductor longus
- Adductor brevis
- Adductor magnus
- Gracilis
- Tibia

MID-DEPTH MUSCLES
BACK VIEW: ADDUCTOR GROUP OF MUSCLES

MID-DEPTH MUSCLES
FRONT VIEW: QUADRICEPS MUSCLES

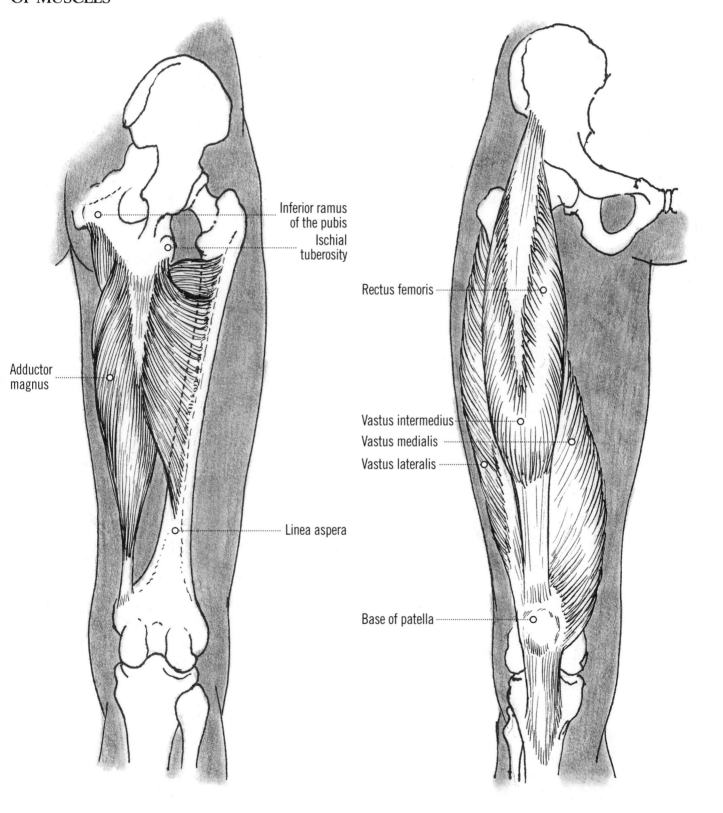

Inferior ramus of the pubis

Ischial tuberosity

Adductor magnus

Linea aspera

Rectus femoris

Vastus intermedius

Vastus medialis

Vastus lateralis

Base of patella

239

DEEP VIEW FROM THE BACK

MID-DEPTH VIEW FROM THE BACK

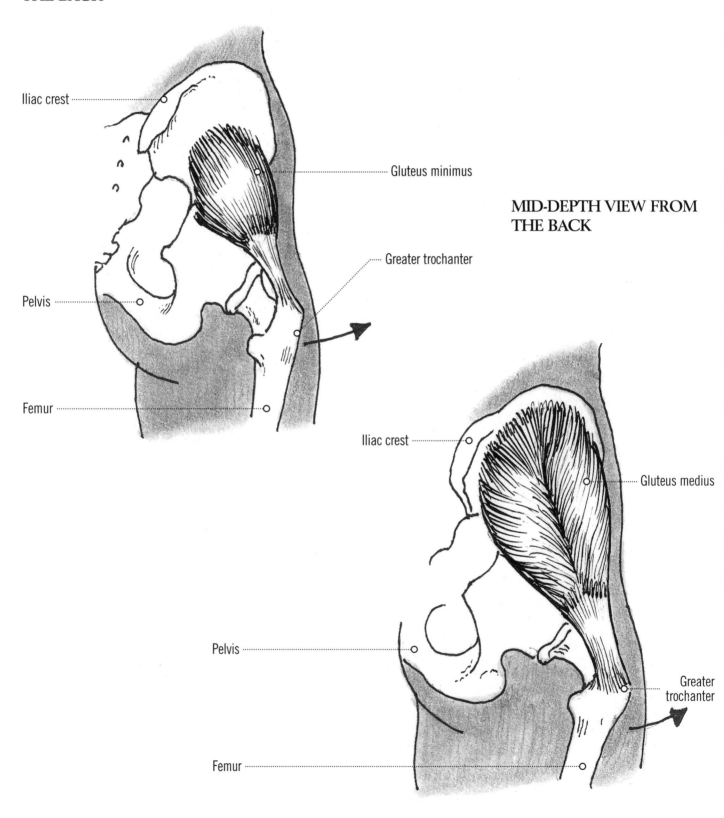

Iliac crest

Gluteus minimus

Greater trochanter

Pelvis

Femur

Iliac crest

Gluteus medius

Pelvis

Greater trochanter

Femur

SUPERFICIAL VIEW FROM THE BACK

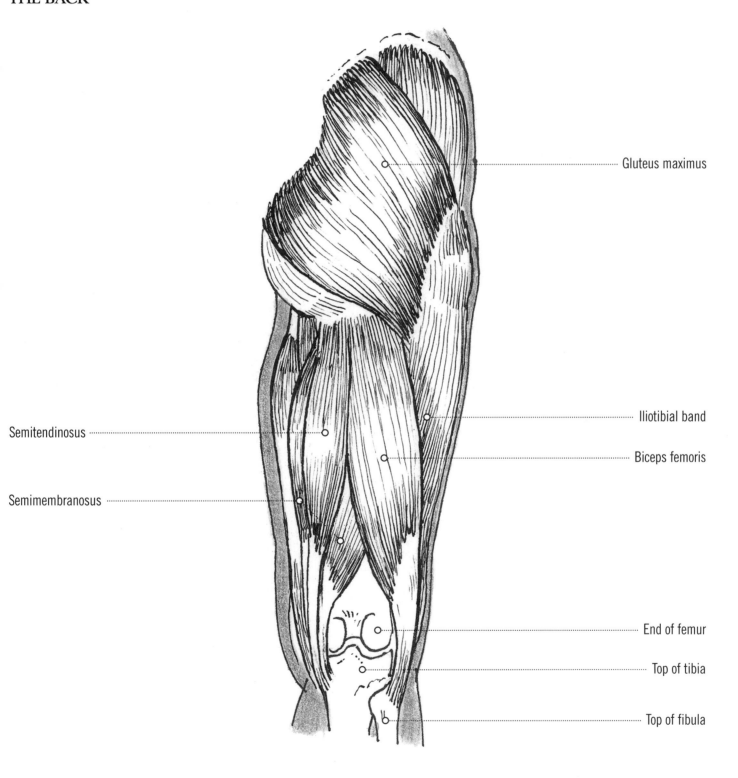

Gluteus maximus

Iliotibial band

Biceps femoris

Semitendinosus

Semimembranosus

End of femur

Top of tibia

Top of fibula

MID-DEPTH MUSCLES
BACK VIEW

SUPERFICIAL MUSCLES
FRONT VIEW

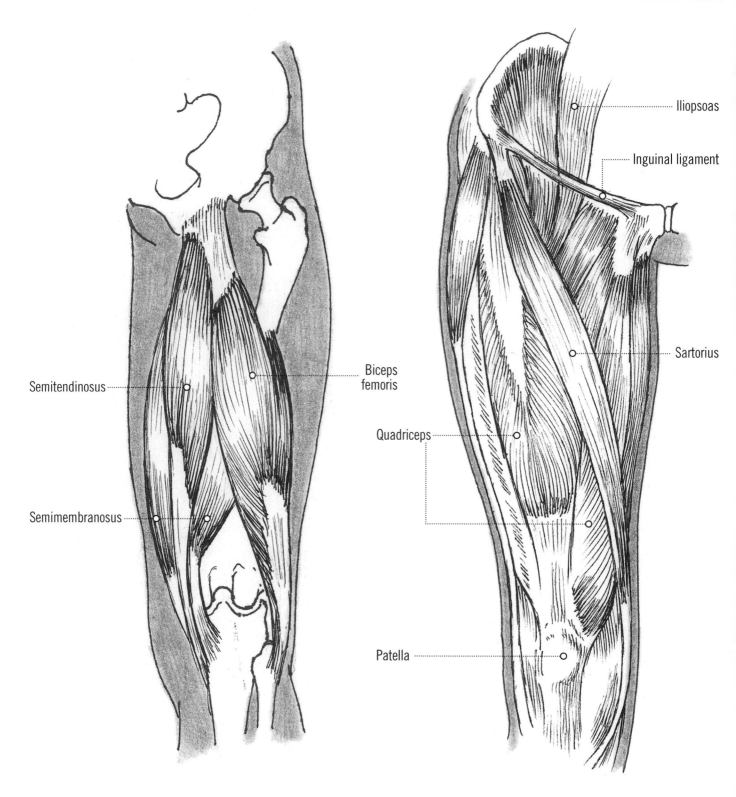

Iliopsoas

Inguinal ligament

Sartorius

Semitendinosus

Biceps femoris

Quadriceps

Semimembranosus

Patella

LEG FLEXED

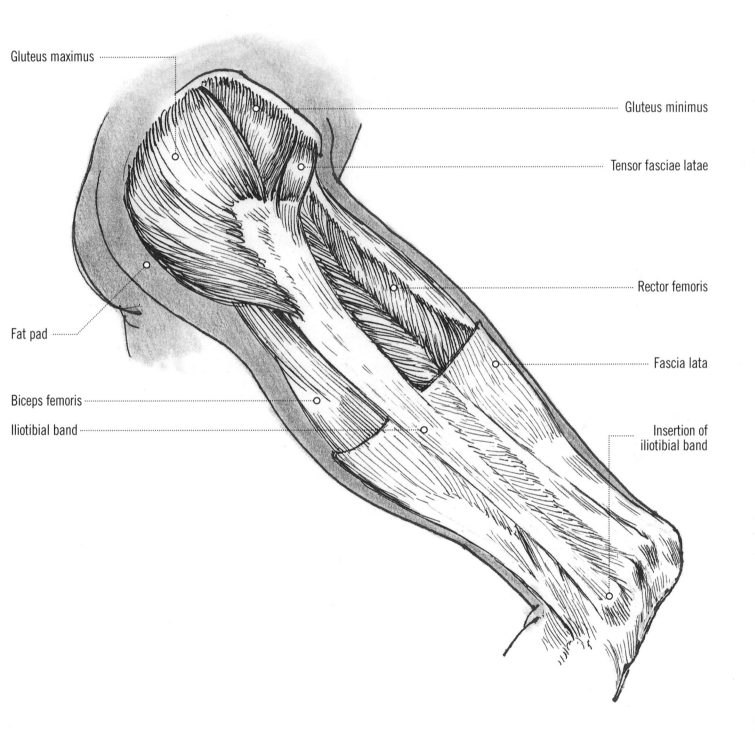

Gluteus maximus

Gluteus minimus

Tensor fasciae latae

Rector femoris

Fat pad

Fascia lata

Biceps femoris

Iliotibial band

Insertion of iliotibial band

FLEXED AND UNFLEXED

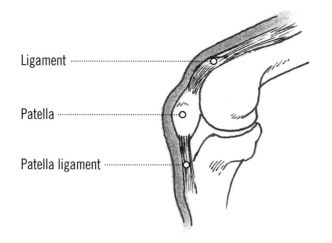

Ligament

Patella

Patella ligament

Ligament

Patella

FOUR QUADRICEPS TENDONS: ACTION OF PATELLA AND PATELLA LIGAMENT TO EXTEND LEG

KNEE JOINT: PATELLA REMOVED SHOWING LIGAMENTS

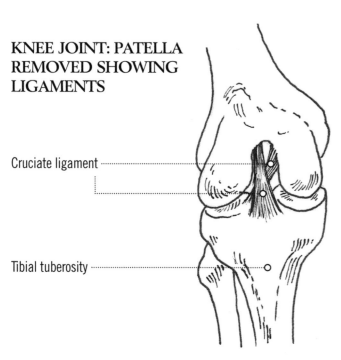

Cruciate ligament

Tibial tuberosity

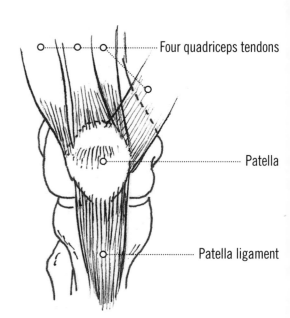

Four quadriceps tendons

Patella

Patella ligament

KNEE FLEXED

Quadriceps

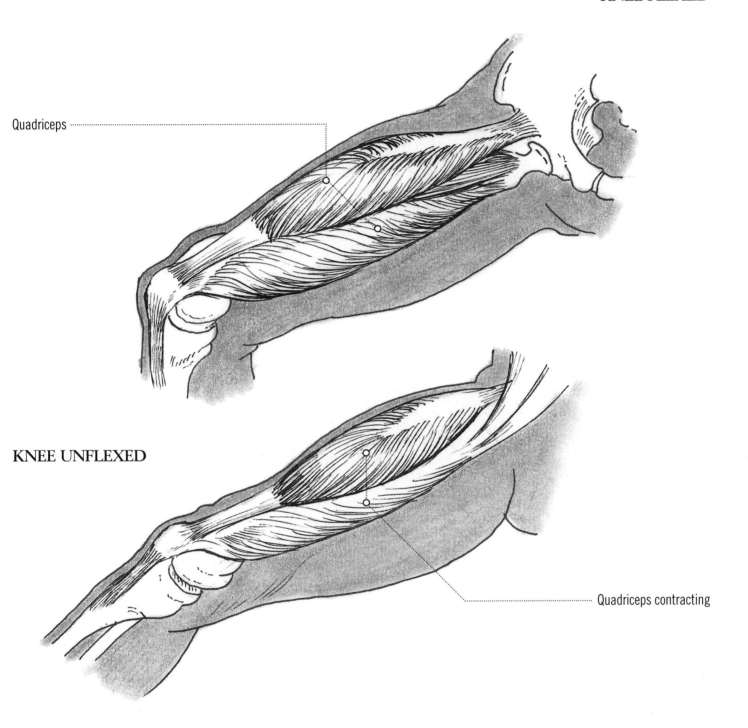

KNEE UNFLEXED

Quadriceps contracting

MUSCLES OF THE LOWER LEG AND HOW THEY WORK

FRONT VIEW

EXTENSOR DIGITORUM LONGUS straightens four lesser toes.

EXTENSOR HALLUCIS LONGUS straightens great toe.

EXTENSOR RETINACULUM, SUPERIOR AND INFERIOR enable tendons of the foot to change direction at the ankle.

FLEXOR DIGITORUM LONGUS bends second to fifth toes, helps in bending foot.

FLEXOR HALLUCIS LONGUS bends big toe (hallux) and through this the foot. Takes part in rotation of foot.

GASTROCNEMIUS extends foot downwards.

PERONEUS BREVIS raises outside edge of foot.

PERONEUS LONGUS bends and turns foot outwards, supports lateral side of arch, steadies leg on the foot, especially when standing on one leg.

PERONEUS TERTIUS raises the foot upwards and outwards.

PLANTARIS weakly flexes ankle and knee joint.

POPLITEUS bends and then, rotates leg towards centre line.

SOLEUS extends foot downwards.

TIBIALIS LONGUS (ANTERIOR) straightens foot, raises foot arch.

TIBIALIS POSTERIOR straightens foot, turns foot inwards, supports foot arch.

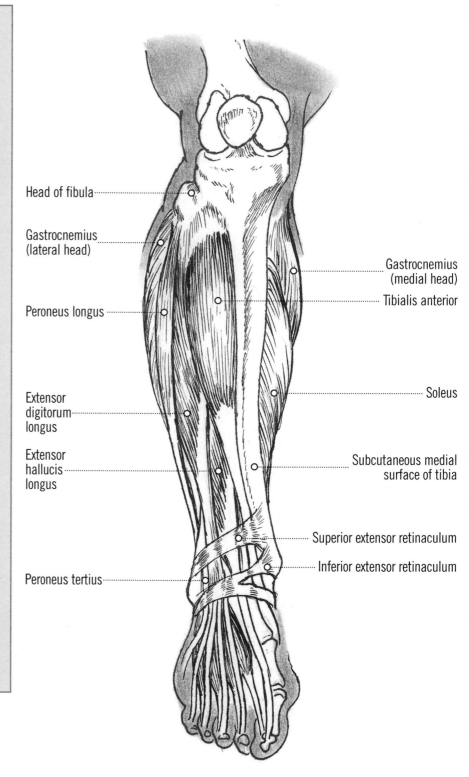

Head of fibula

Gastrocnemius (lateral head)

Peroneus longus

Extensor digitorum longus

Extensor hallucis longus

Peroneus tertius

Gastrocnemius (medial head)

Tibialis anterior

Soleus

Subcutaneous medial surface of tibia

Superior extensor retinaculum

Inferior extensor retinaculum

INSIDE VIEW

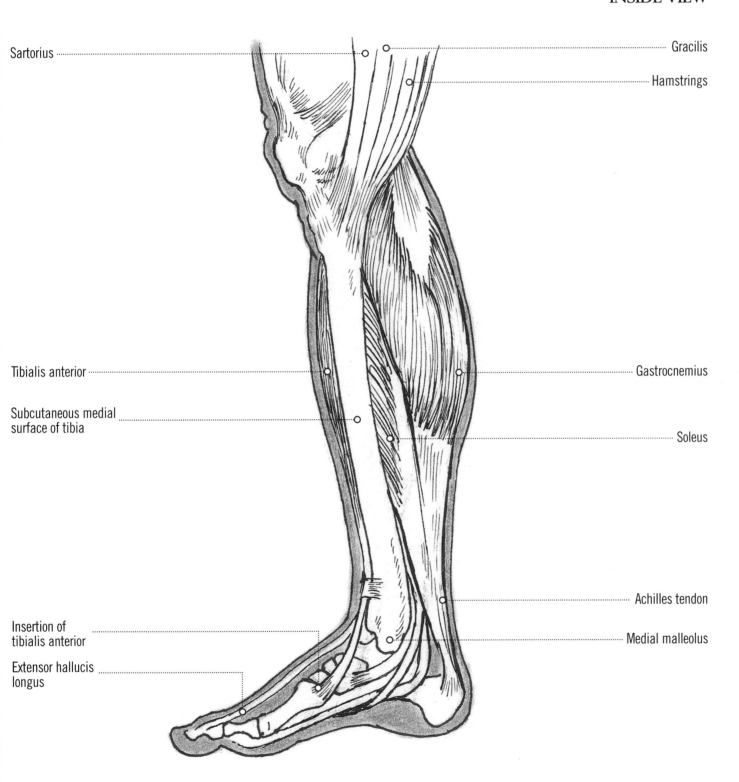

Sartorius

Gracilis

Hamstrings

Tibialis anterior

Subcutaneous medial surface of tibia

Gastrocnemius

Soleus

Achilles tendon

Insertion of tibialis anterior

Medial malleolus

Extensor hallucis longus

OUTSIDE VIEW: BENDING

BACK VIEW: DEEP MUSCLES

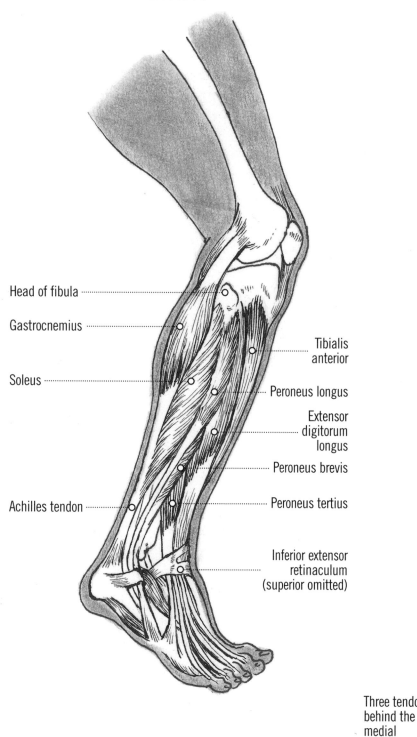

Head of fibula

Gastrocnemius

Soleus

Achilles tendon

Tibialis anterior

Peroneus longus

Extensor digitorum longus

Peroneus brevis

Peroneus tertius

Inferior extensor retinaculum (superior omitted)

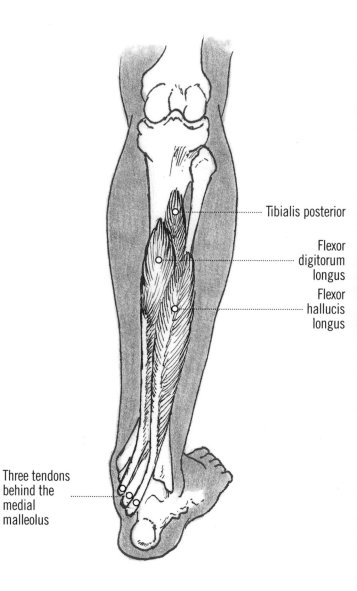

Tibialis posterior

Flexor digitorum longus

Flexor hallucis longus

Three tendons behind the medial malleolus

BACK VIEW: MID-DEPTH MUSCLES

BACK VIEW: SUPERFICIAL MUSCLES

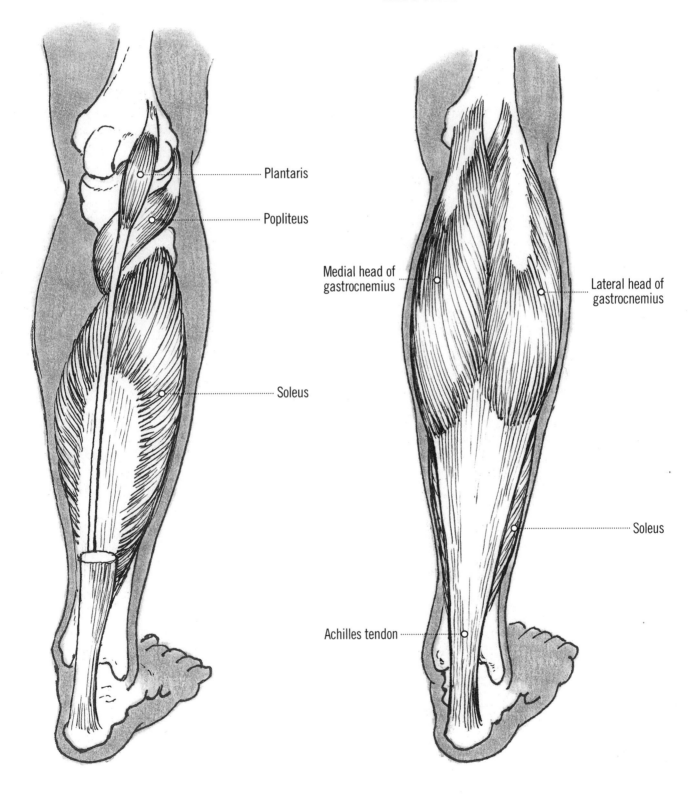

Plantaris

Popliteus

Soleus

Medial head of gastrocnemius

Lateral head of gastrocnemius

Soleus

Achilles tendon

Like the hand, the foot is a complex structure of overlapping bone, muscle and tendons. The foot is less flexible than the hand but stronger, and the area around the ankle and heel has much larger bones than the wrist. Most of the muscles are found underneath the bones of the foot, and the toes are mainly bone and fatty pads.

MUSCLES OF THE FOOT AND HOW THEY WORK

ABDUCTOR HALLUCIS moves big toe outwards.

ABDUCTOR DIGITI MINIMI moves little toe outwards.

ADDUCTOR HALLUCIS moves big toe inwards.

EXTENSOR DIGITORUM BREVIS straightens toes.

EXTENSOR RETINACULUM, SUPERIOR AND INFERIOR enable tendons of the foot to change direction at the ankle.

DORSAL INTEROSSEI Deep-seated muscles that move the toes apart.

FLEXOR DIGITI MINIMI BREVIS flexes little toe.

FLEXOR DIGITORUM BREVIS flexes second to fifth toes.

FLEXOR DIGITORUM LONGUS flexes second to fifth toes.

FLEXOR HALLUCIS BREVIS flexes big toe.

FLEXOR HALLUCIS LONGUS flexes big toe.

LUMBRICALES flex proximal phalanges. Invisible from surface.

OPPONENS DIGITI MINIMI pulls fifth metatarsal bone towards sole.

PLANTAR INTEROSSEI are deep muscles that move third, fourth and fifth toes towards second toe, and flex proximal phalanges.

QUADRATUS PLANTAE (FLEXOR DIGITORUM ACCESSORIUS) helps in flexing toes.

STRUCTURE OF THE FOOT

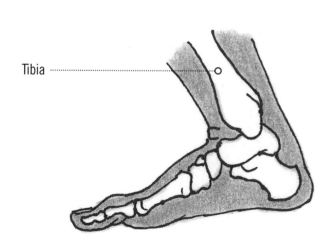
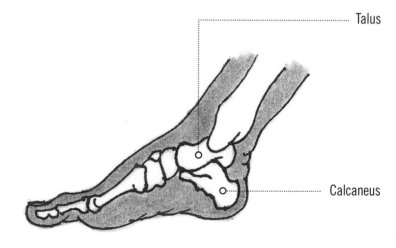

Tibia

Talus

Calcaneus

SIDE VIEW

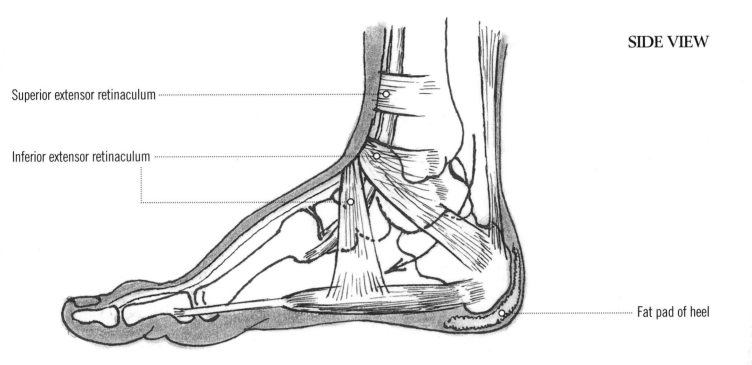

Superior extensor retinaculum

Inferior extensor retinaculum

Fat pad of heel

SIDE VIEW: POINTING TOES

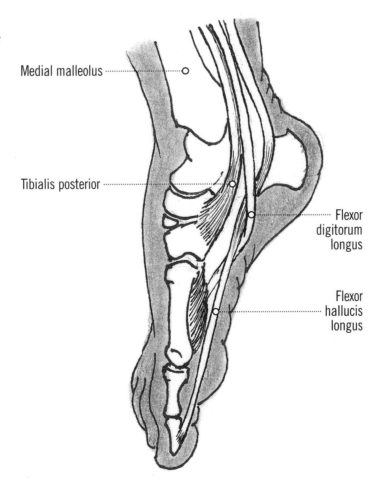

Medial malleolus

Tibialis posterior

Flexor digitorum longus

Flexor hallucis longus

VIEWS FROM BENEATH

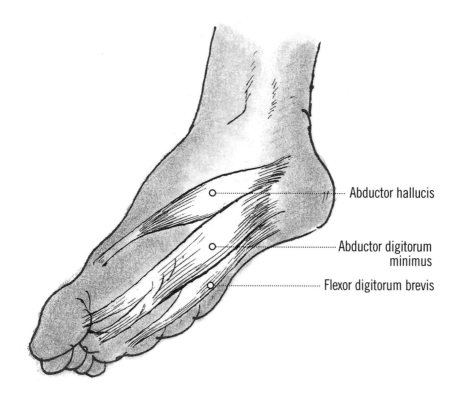

Abductor hallucis

Abductor digitorum minimus

Flexor digitorum brevis

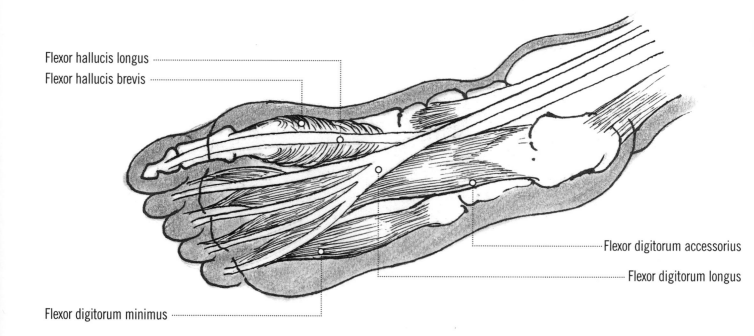

Flexor hallucis longus

Flexor hallucis brevis

Flexor digitorum accessorius

Flexor digitorum longus

Flexor digitorum minimus

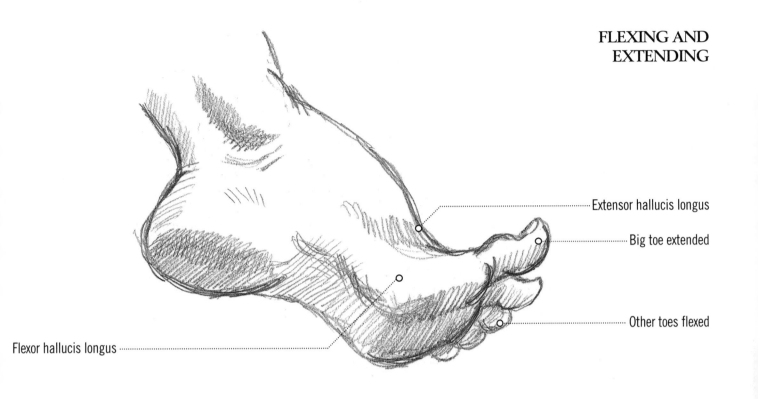

FLEXING AND EXTENDING

Extensor hallucis longus

Big toe extended

Other toes flexed

Flexor hallucis longus

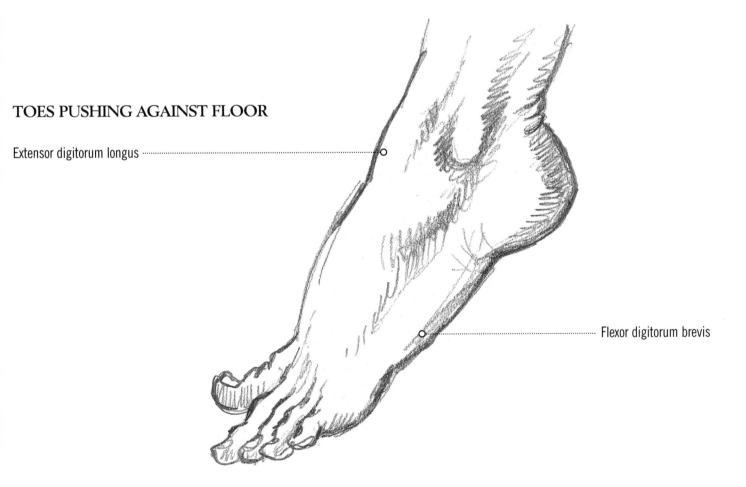

TOES PUSHING AGAINST FLOOR

Extensor digitorum longus

Flexor digitorum brevis

The leg in movement is quite flexible but without the more detailed movements of the arm. The emphasis is on strength and powerful movements that carry the whole body. Over the following pages are various views of legs performing simple movements: note the smoother appearance of the female limb and the clearer musculature of the male.

SIDE VIEW: FLEXED

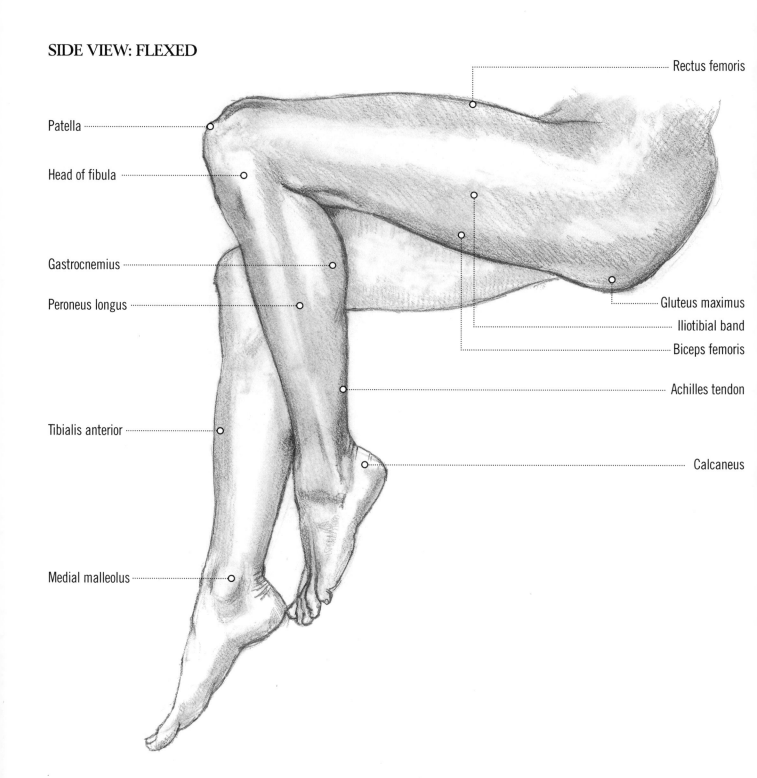

Rectus femoris

Patella

Head of fibula

Gastrocnemius

Peroneus longus

Gluteus maximus

Iliotibial band

Biceps femoris

Achilles tendon

Tibialis anterior

Calcaneus

Medial malleolus

FRONT VIEW: FLEXED

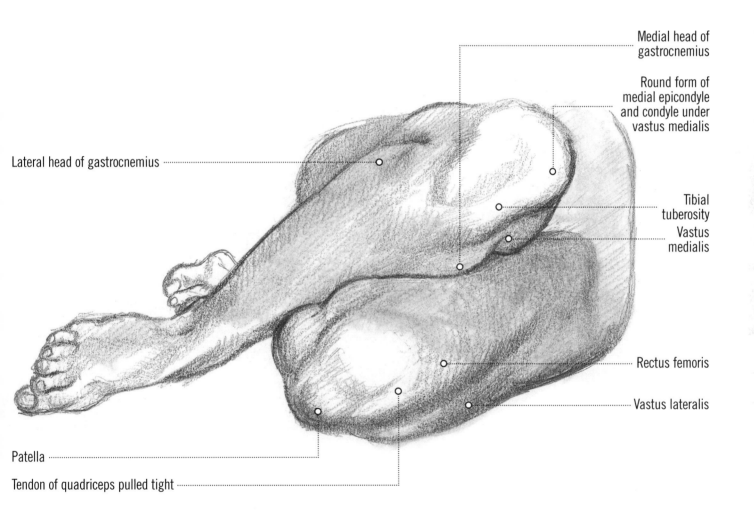

Medial head of gastrocnemius

Round form of medial epicondyle and condyle under vastus medialis

Lateral head of gastrocnemius

Tibial tuberosity

Vastus medialis

Rectus femoris

Vastus lateralis

Patella

Tendon of quadriceps pulled tight

FRONT VIEW: FLEXED

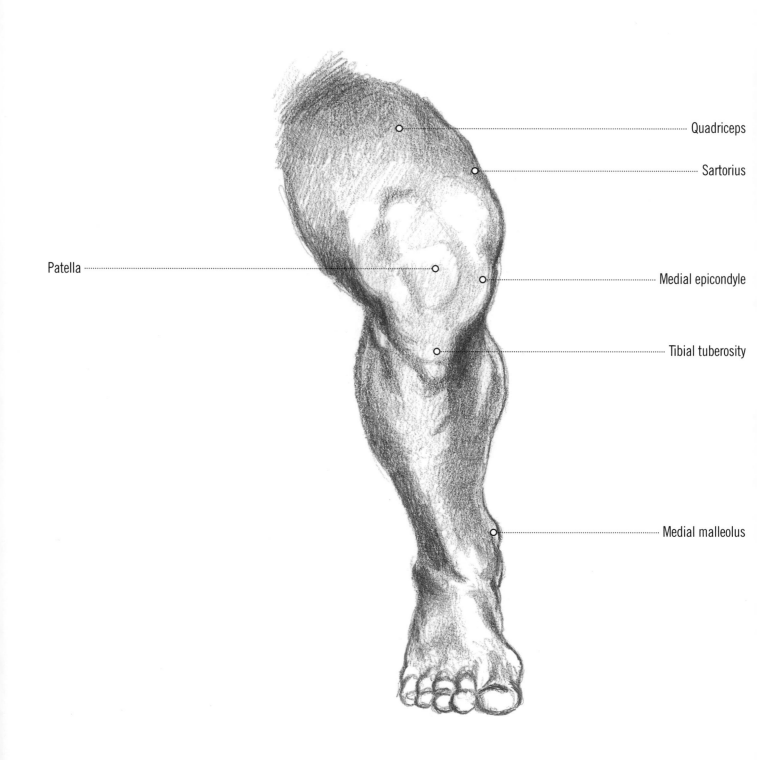

Quadriceps

Sartorius

Patella

Medial epicondyle

Tibial tuberosity

Medial malleolus

SIDE VIEW: FLEXED

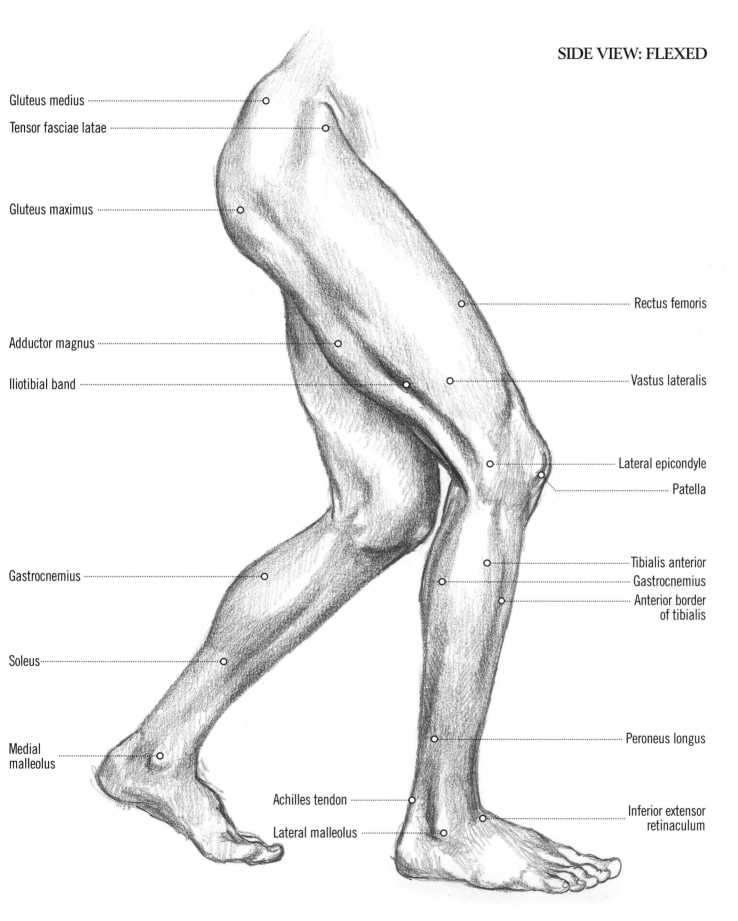

Gluteus medius

Tensor fasciae latae

Gluteus maximus

Adductor magnus

Iliotibial band

Gastrocnemius

Soleus

Medial malleolus

Rectus femoris

Vastus lateralis

Lateral epicondyle

Patella

Tibialis anterior

Gastrocnemius

Anterior border of tibialis

Peroneus longus

Inferior extensor retinaculum

Achilles tendon

Lateral malleolus

SIDE VIEW: TOES TURNED UP

SIDE VIEW: LEG FLEXED

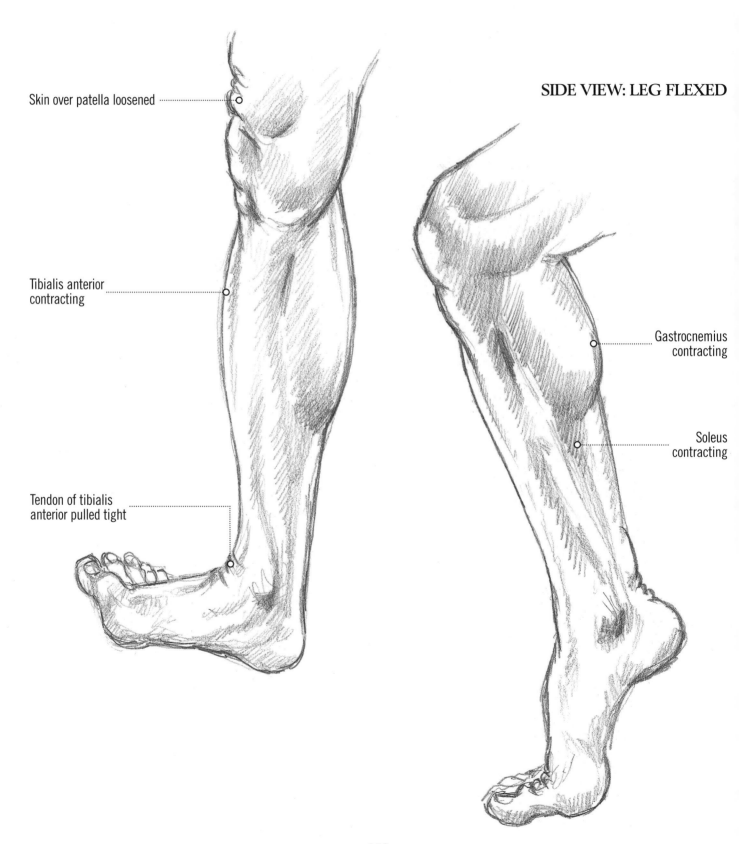

Skin over patella loosened

Tibialis anterior contracting

Tendon of tibialis anterior pulled tight

Gastrocnemius contracting

Soleus contracting

BACK VIEW: LEG FLEXED

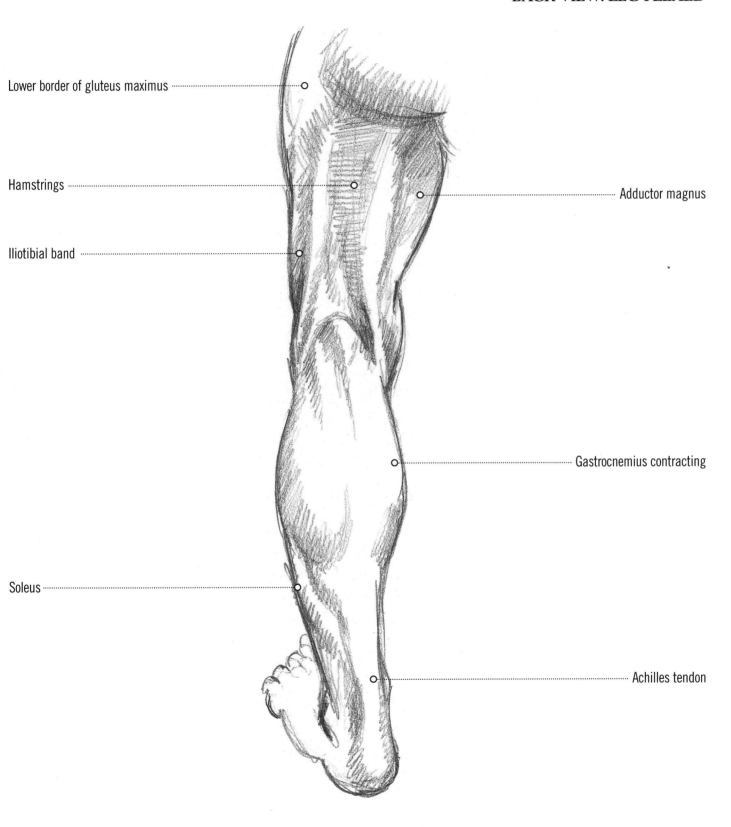

Lower border of gluteus maximus

Hamstrings — Adductor magnus

Iliotibial band

Gastrocnemius contracting

Soleus

Achilles tendon

In these drawings after master artists, I have only given the names of some of the visible muscles and bone structure. It would be a good exercise to see what others you can identify, using the diagrammatic information in the previous pages. This will help you to memorize the terms.

After Charles-Joseph Natoire

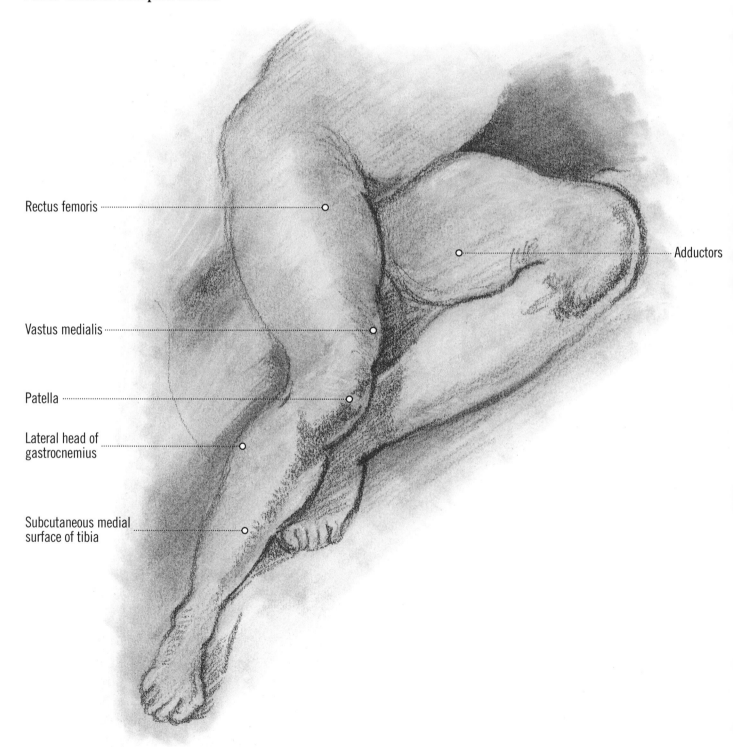

Rectus femoris

Adductors

Vastus medialis

Patella

Lateral head of gastrocnemius

Subcutaneous medial surface of tibia

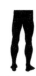

**After Annibale Carracci
(1560–1609)**

Rectus femoris

Iliotibial
band

Gastrocnemius

Achilles
tendon

Lateral
malleolus

After Michelangelo

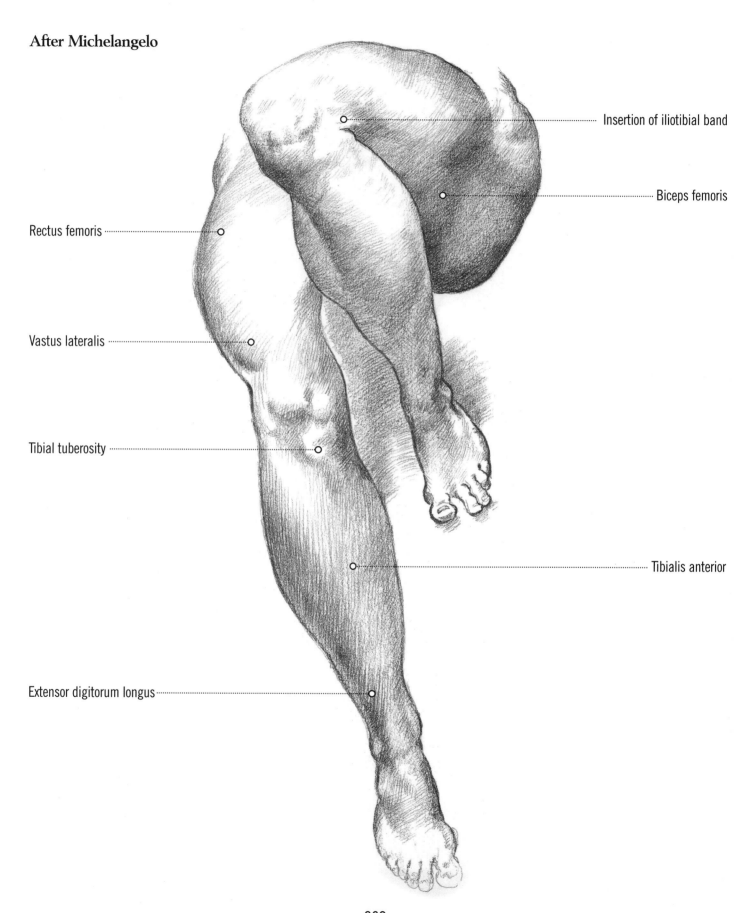

Insertion of iliotibial band

Biceps femoris

Rectus femoris

Vastus lateralis

Tibial tuberosity

Tibialis anterior

Extensor digitorum longus

After Rubens

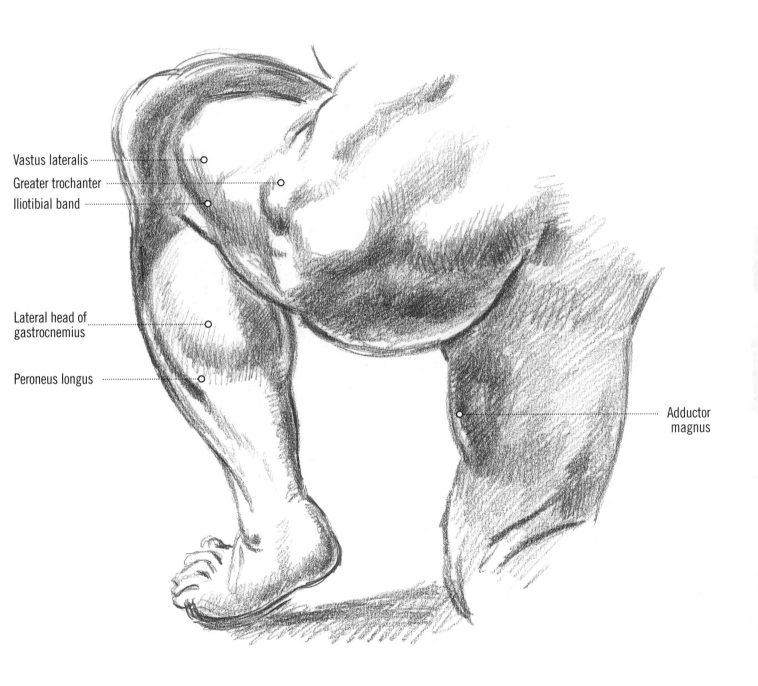

Vastus lateralis

Greater trochanter

Iliotibial band

Lateral head of gastrocnemius

Peroneus longus

Adductor magnus

After Louis de Boulogne (1654–1733)

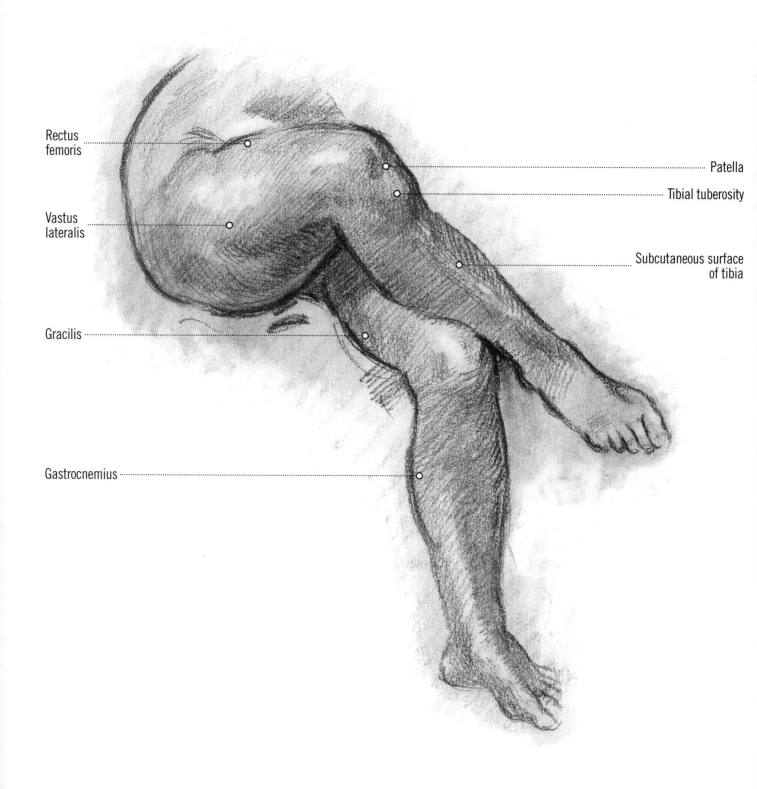

Rectus
femoris

Vastus
lateralis

Gracilis

Gastrocnemius

Patella

Tibial tuberosity

Subcutaneous surface
of tibia

After an unknown Italian master (*c.* 1700)

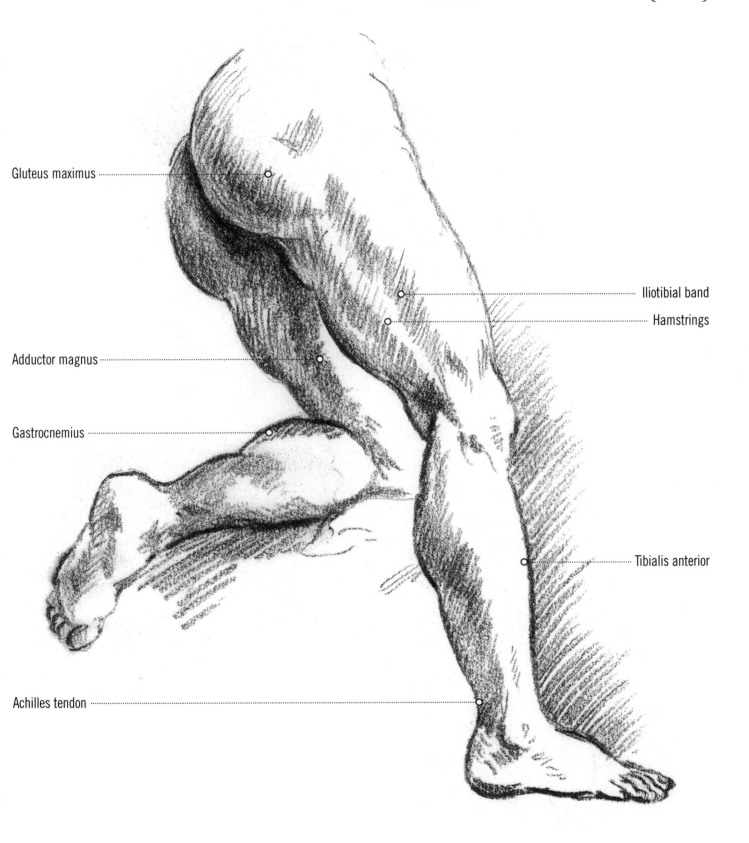

Gluteus maximus

Iliotibial band

Hamstrings

Adductor magnus

Gastrocnemius

Tibialis anterior

Achilles tendon

After Michelangelo

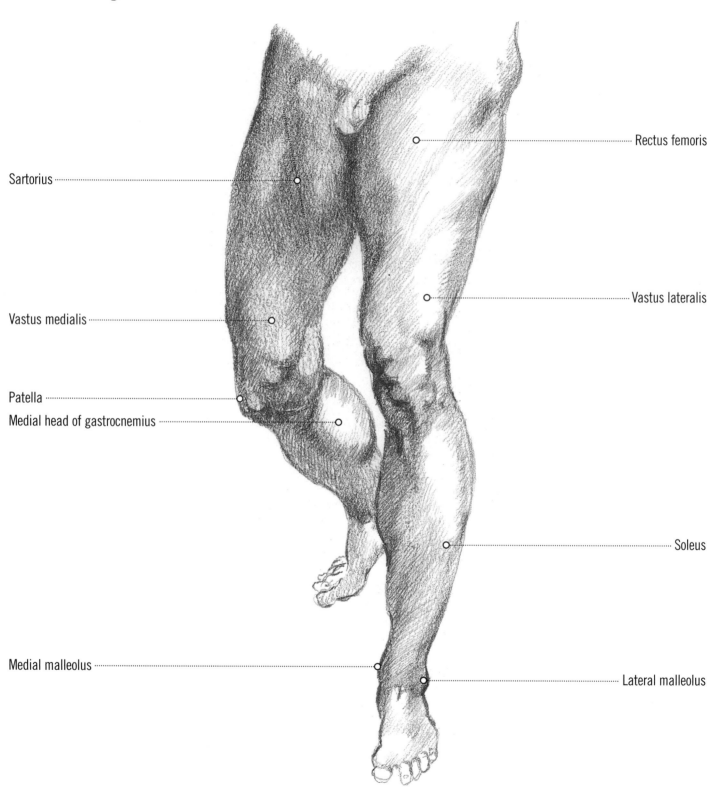

Sartorius

Vastus medialis

Patella

Medial head of gastrocnemius

Medial malleolus

Rectus femoris

Vastus lateralis

Soleus

Lateral malleolus

After Pontormo

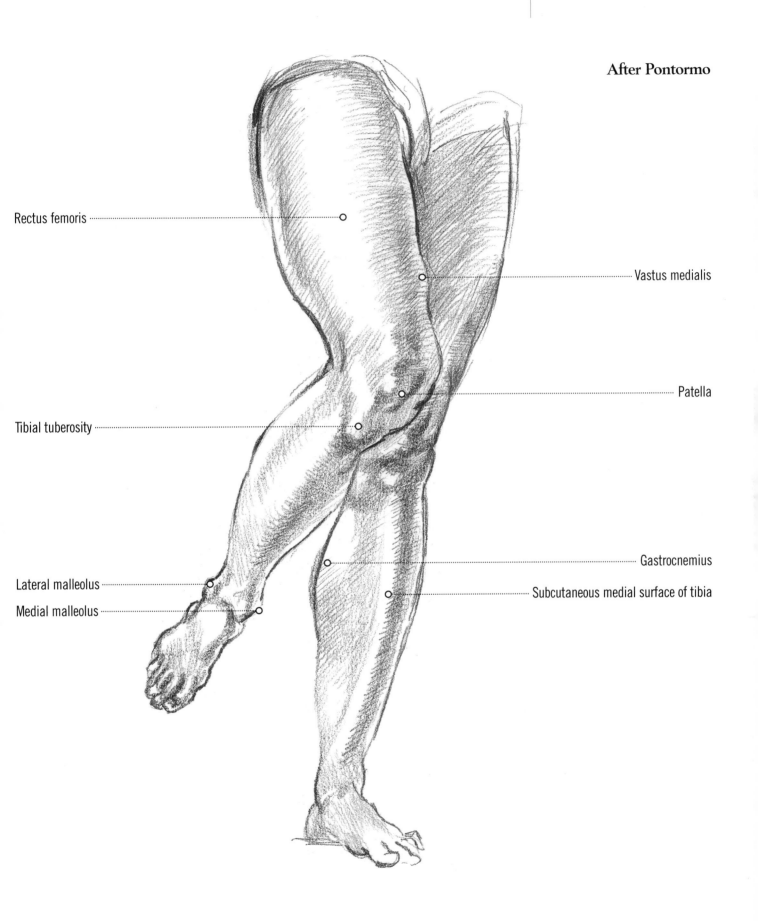

Rectus femoris

Vastus medialis

Patella

Tibial tuberosity

Gastrocnemius

Subcutaneous medial surface of tibia

Lateral malleolus

Medial malleolus

After Michelangelo

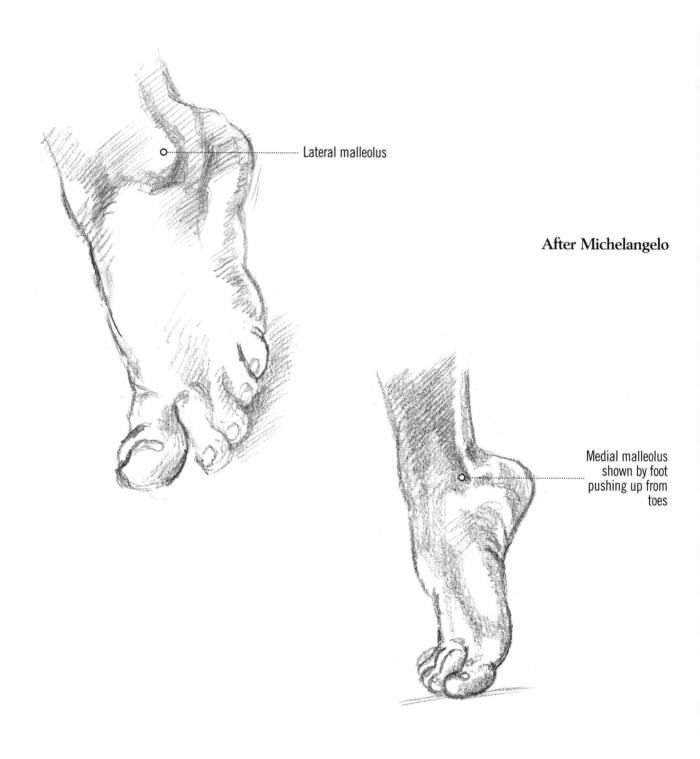

Lateral malleolus

After Michelangelo

Medial malleolus shown by foot pushing up from toes

After Rubens

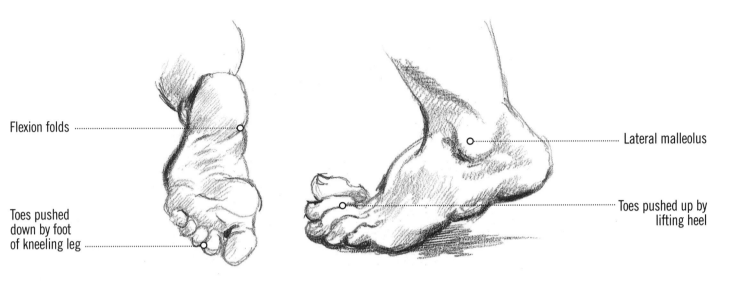

Flexion folds

Toes pushed
down by foot
of kneeling leg

Lateral malleolus

Toes pushed up by
lifting heel

After Domenichino (1581–1641)

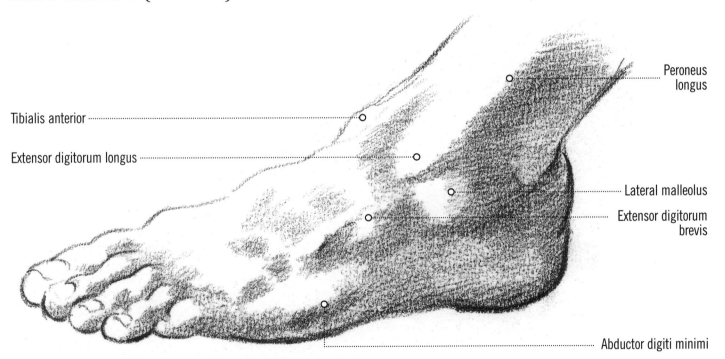

Tibialis anterior

Extensor digitorum longus

Peroneus
longus

Lateral malleolus

Extensor digitorum
brevis

Abductor digiti minimi

THE MOVING BODY

In this section I present the whole body engaged in action, particularly in sporting activities. The figure drawings are taken from several sources, a number of which are photographic because, of course, this is the only way to freeze the movement in mid-action in order to see what happens. Some of the figures are nude, but generally speaking it is possible to see the shape of the body well enough under clothing.

Unlike in the main part of the book, I have not labelled precisely the muscles in play. However, I have given the names of the parts that are obviously being used and you will know where to look up the relevant information. On the whole, we learn quicker when we make the effort to look up the names for ourselves, rather than always finding them attached to the drawings.

I have chosen the type of sports that clearly show the muscles in action, such as running, jumping, climbing, wrestling and weightlifting. It is very interesting for an artist to watch sportspeople and observe what happens to the musculature as they move. This information is doubly valuable when you later study a photograph of the action, because your direct experience does change the way you look at the still image. Your memory can help to give greater verisimilitude to a drawing that is done from a photographic reference, so if you have to use still images, do not neglect to watch the real thing from time to time in order to improve your drawing.

The following group of figures demonstrates how to observe the human form and simultaneously to analyse what is happening to the placing of the body as you draw it.

Start off by visualizing a line from the top of the head to the point between the feet where the weight of the body is resting – this is its centre of gravity. Our system labels this line (from head to ground) as line A.

Next, take the lines across the body that denote the shoulders, hips, knees and feet. The way that these lines lend balance to the form tells you a lot about how to compose the figure. The system labels these as follows: the shoulders, line B; hips, line C; knees, line D; feet, line E.

Then, note the relationship between the elbows and the hands, although these are not always so easy to see. The system here is: the elbows, line F; hands, line G.

So now, as you glance down the length of the figure, your eye automatically notes the distribution of these points of balance. Concentrating your observations in this way, you will find it much easier to render the figure realistically.

The first figure is standing and the distribution of the various levels of balance can be seen quite clearly. The only one that is a bit difficult to relate to, is line F, linking the two elbows. The second figure is also standing, although the shoulders and hips are different from the first. Nevertheless, it is still fairly easy to see how the points relate to one another.

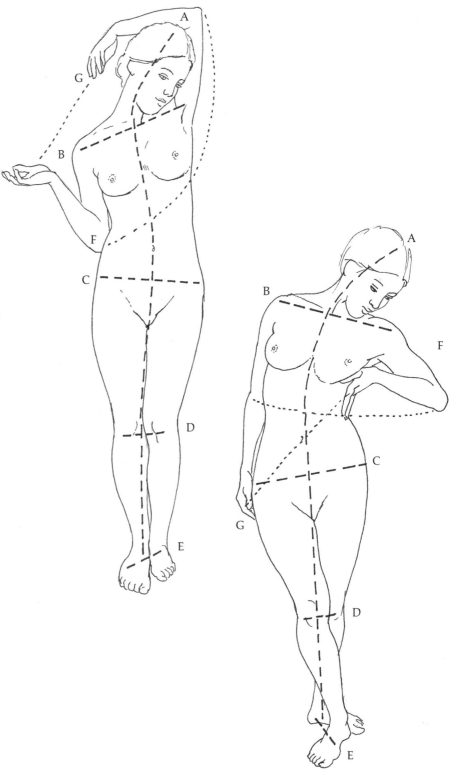

The third figure, still standing but sideways-on this time, makes some of the balancing points less significant. The hips, for example, are one behind the other so they don't register much. The hands are together, so that simplifies that aspect. But the remaining points are important to observe, in order to give the right kind of balance to the figure.

The last standing figure uses all of the points, except for the hands and the knees, which are one behind the other in both cases.

Now, we have a sitting figure in which the main line A is shortened to cover the upper part of the body only, because this is where the balancing line stops. However, the rest are obvious enough, although the lines connecting hands and elbows actually cut across each other in this pose.

273

In the reclining pose, the main balance lies between the line that goes as far as the hip, and a line from shoulder to elbow. I have not indicated the latter in order to avoid overloading the diagram.

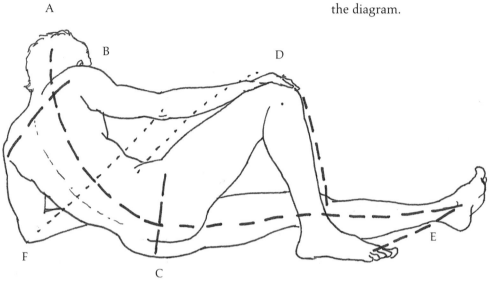

The crouching girl is rather complex because the line passing through the body is not the main balancing point; in this case, it runs straight down from the head, past the knees to the feet and hands. The back foot is also helping to keep the balance, by pushing the lower part of the body upwards.

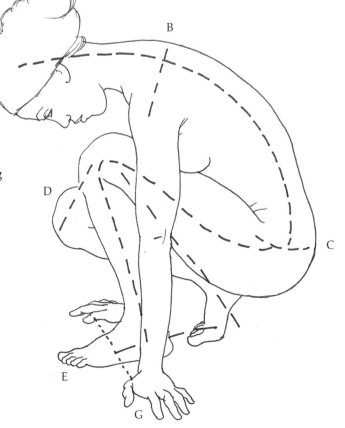

This bending figure illustrates the principle of the cantilever, where the feet planted apart and the position of the arm on the knee, supporting the back, combine to keep the figure upright despite the horizontal angle of the upper body. But to draw the pose convincingly, it is still important to register the balancing points and the positioning of the other pairs of limbs.

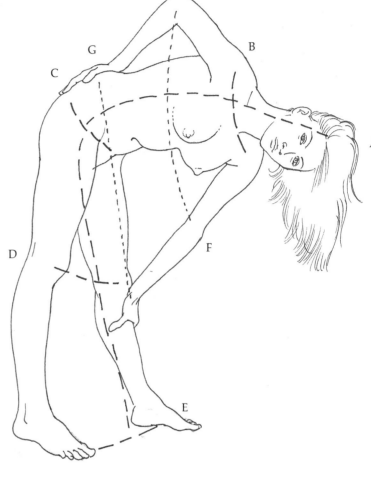

The kneeling man holds a similar position, in which the arm connecting with the floor and the back foot are both part of the balancing system.

275

Now we will look at some more dynamic poses. First, the body leaping through the air, an action which involves all the limbs and the head as well as the torso. Everything is adjusted to keep the balance and make sure that when the body lands back on the ground it will not damage itself.

This girl is leaping in a forward spring and has the grace of a dancer; many of these figures have been drawn from photographs specially taken to help artists and illustrators to render bodies in motion. The muscles most clearly seen in this drawing are those in the upper legs and across the chest and rib cage.

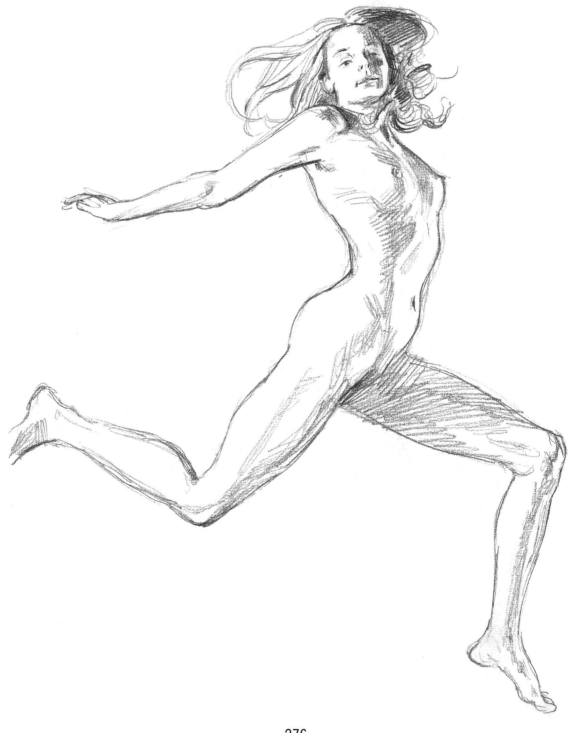

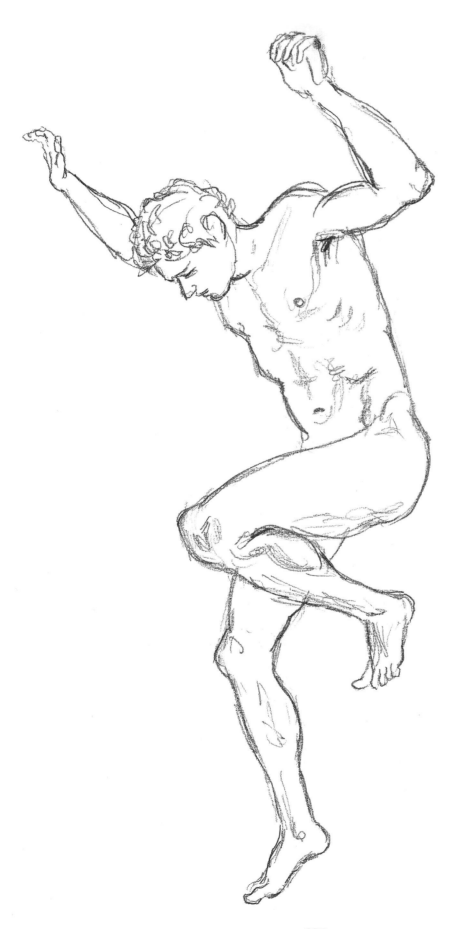

The leaping man is obviously on his way down from a higher level or a very high jump. Note how he is concentrating on his landing place. The muscles most noticeable here are those in the lower legs and along the front and side of the torso.

THE WHOLE BODY IN MOVEMENT
bending and stretching

The next drawings show models bending and stretching, which, although not a very energetic movement, does bring many of the muscles into play. The girl bending sideways is stretching her thigh muscles as well as all the muscles down one side of her torso.

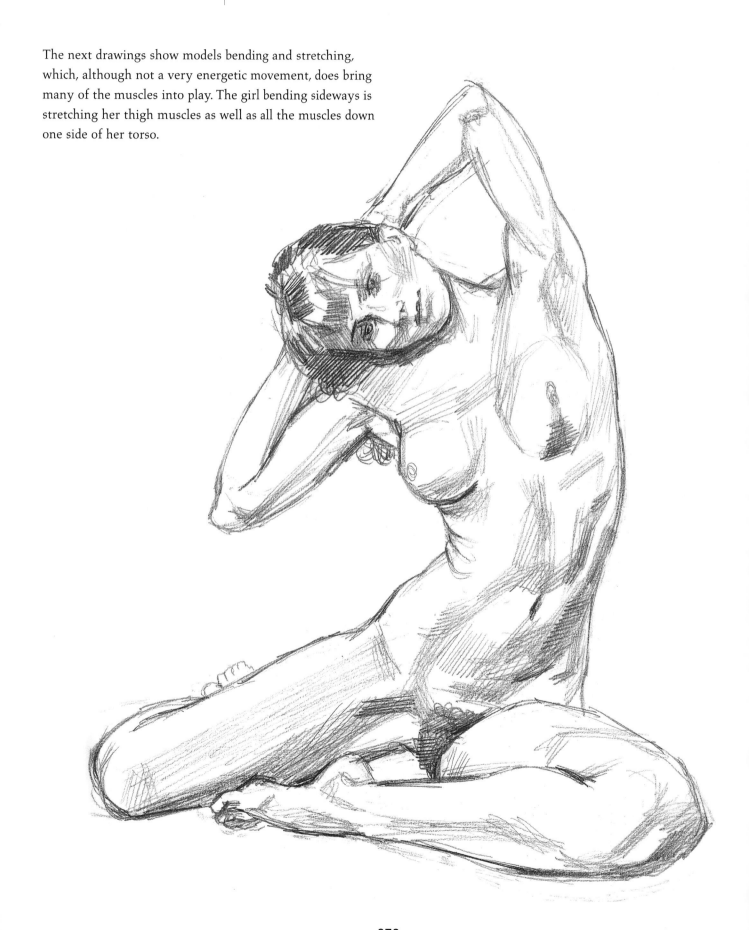

The girl bending over to touch the floor at her feet is both stretching her leg muscles and those of her back.

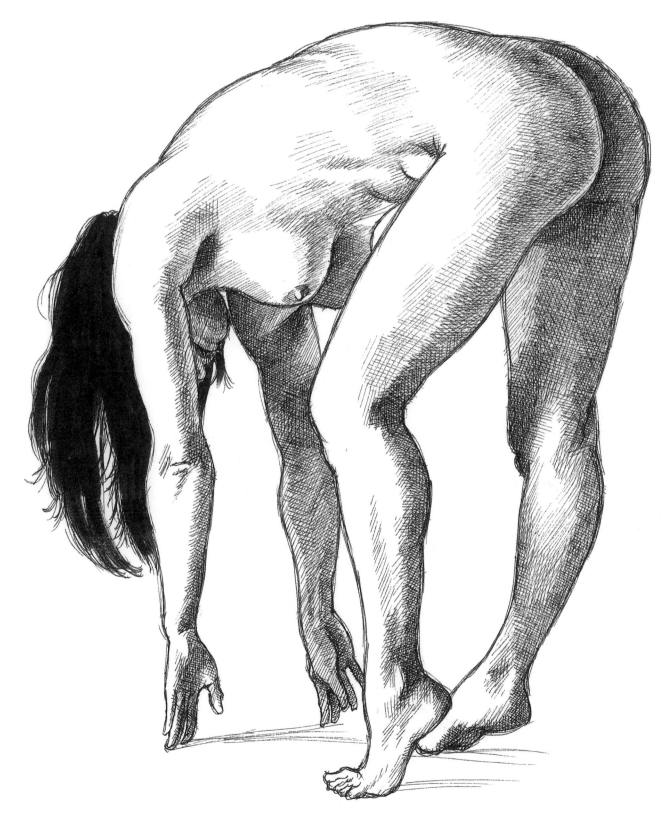

THE WHOLE BODY IN MOVEMENT
bending and stretching

The standing model is stretching her torso down one side and has placed her feet in such a way as to make her legs point in different directions. Note the different muscles being used in the arms.

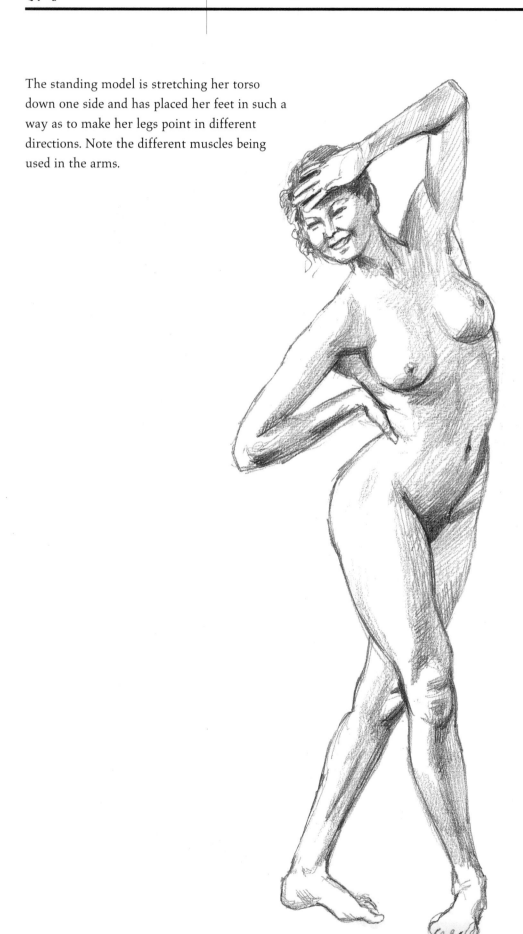

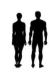
The model sitting cross-legged and stretching her arms above her head is showing very clearly the bony ribcage and her knee joints.

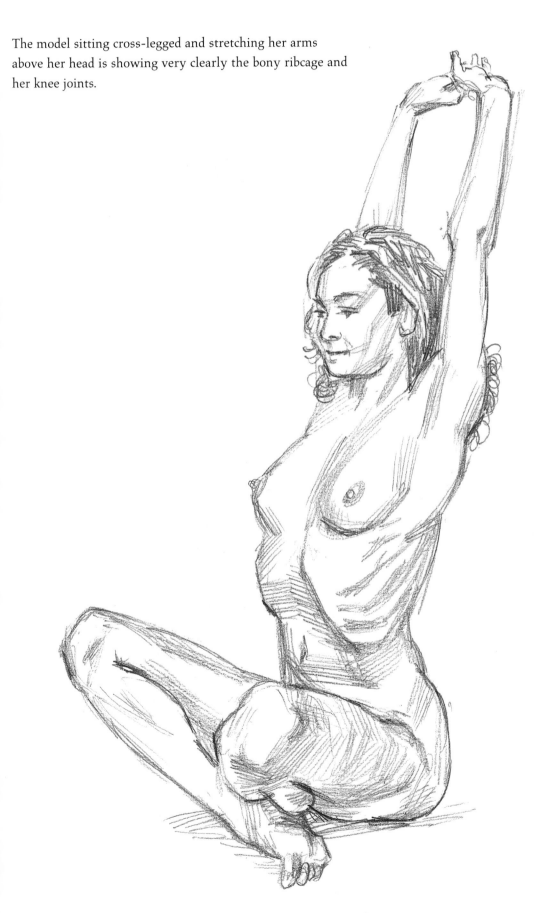

THE WHOLE BODY IN MOVEMENT
dancing and posing

The next three poses make it look as if the models are dancing, using their bodies in a way that makes the most of the opposition of the arms and legs. Their torsos are also turned to show how the muscles are being used. Like sport, dance employs exaggerated movement. Normally the body would not be worked as thoroughly as this.

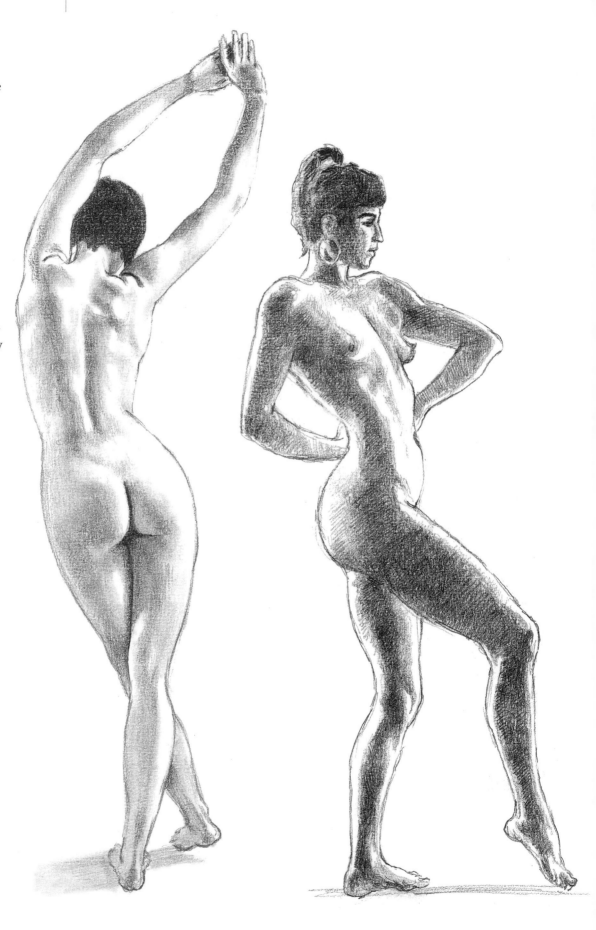

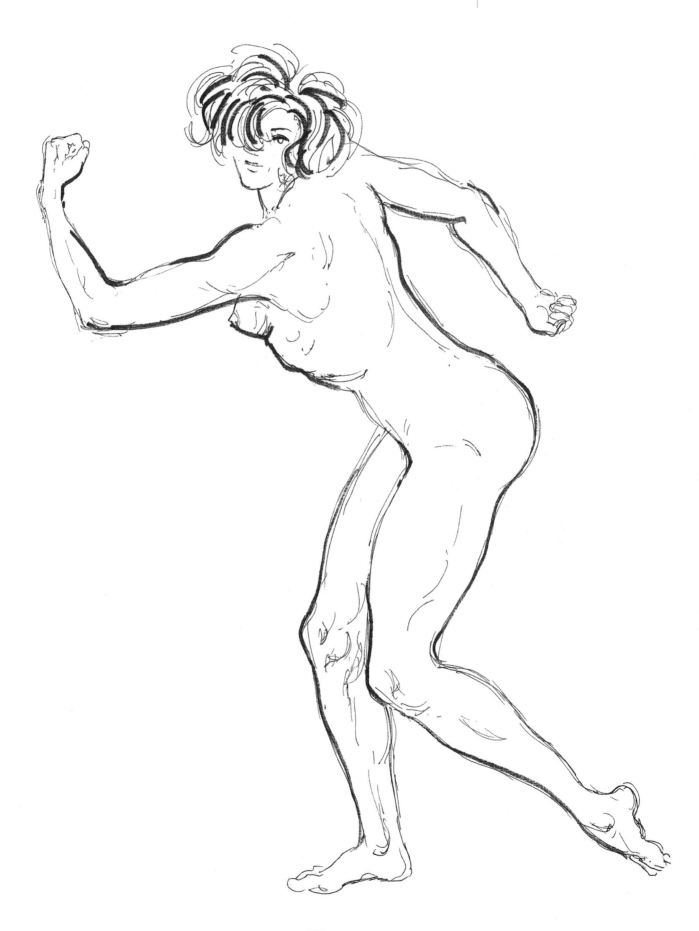

283

THE WHOLE BODY IN MOVEMENT
climbing

Now we come to climbing, one of the more extreme sports, which relies on tremendous muscle co-ordination. It is also the sport which calls most upon your sense of balance and the ability to grip well with your hands and feet. Observe the great tension shown in the body when it is clinging to a difficult rock-face; notice the muscles in the arms and back.

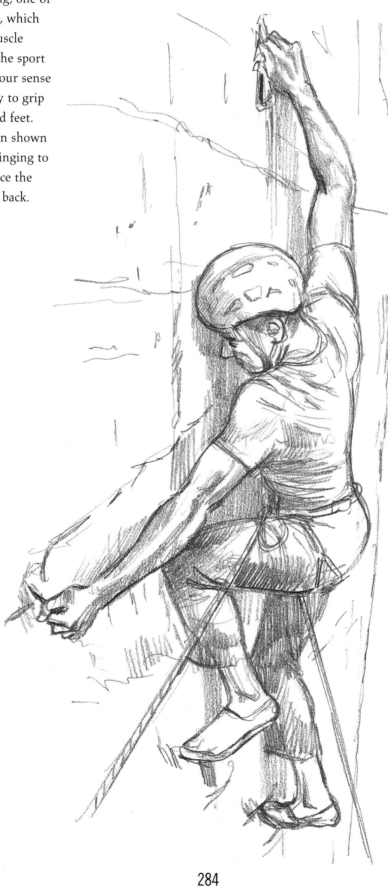

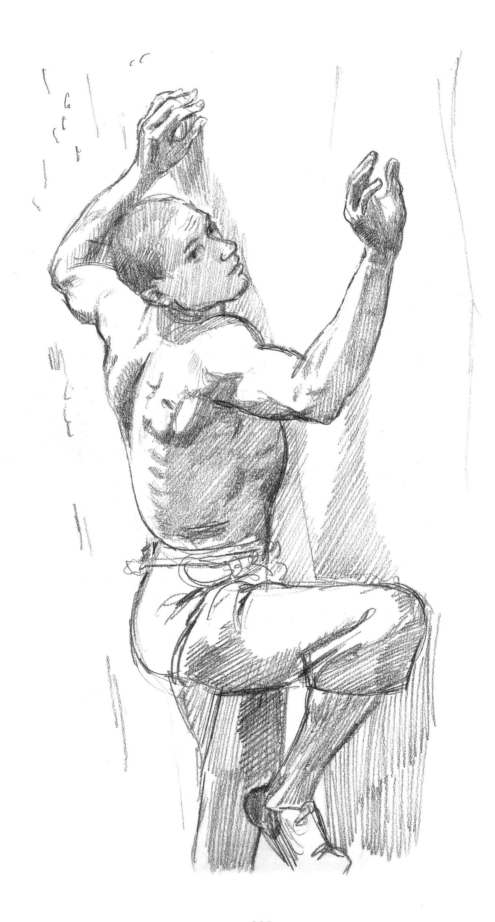

Three more climbers with their legs stretching out to encompass the space between footholds. In the first female climber, it is possible to see how the legs, arms and back muscles are being worked.

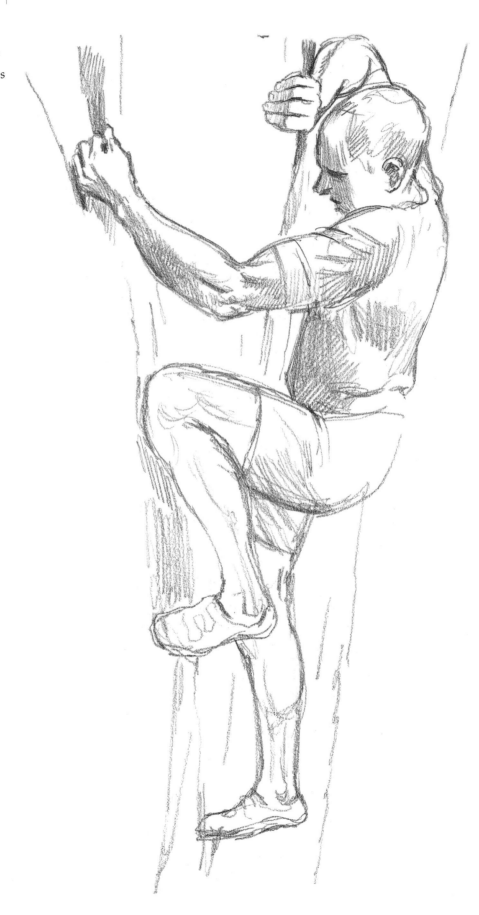

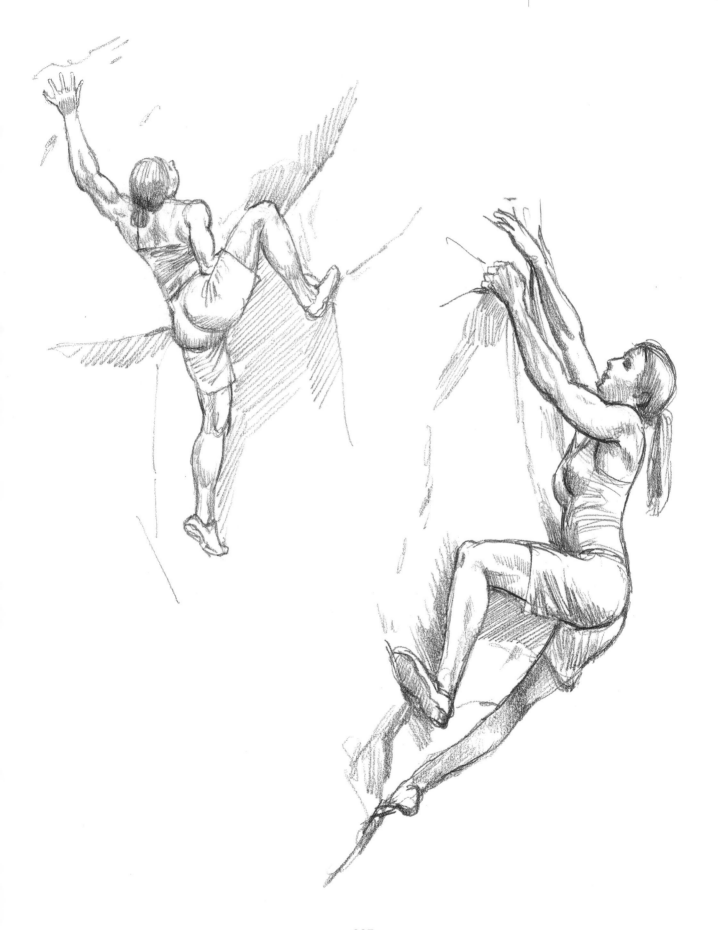

THE WHOLE BODY IN MOVEMENT
football

The popular sport of football provides us with many examples of energetic movement, although the players' sporting strip only reveals the muscles in the legs and arms. The first two players, one tackling the other, demonstrate just how powerful the action can be in competitive sports.

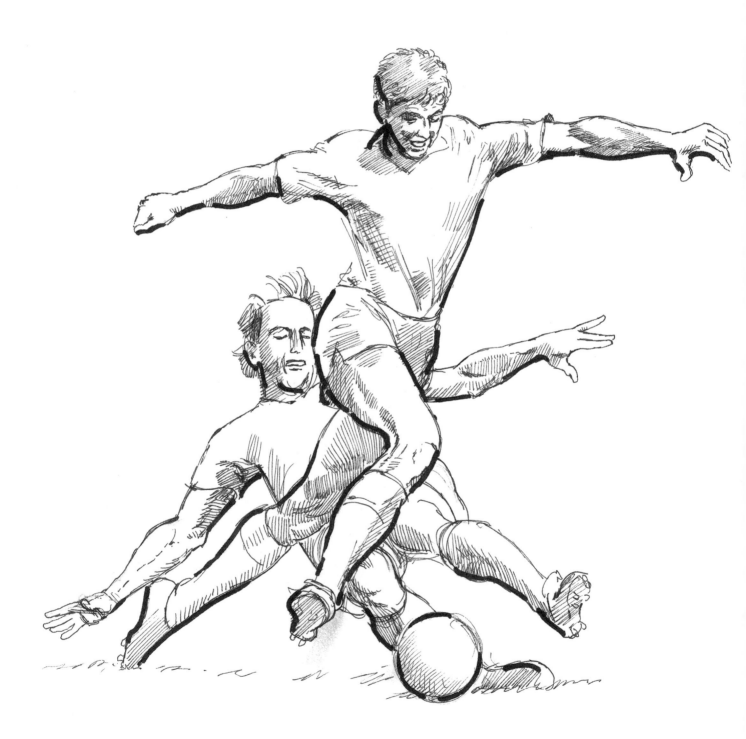

The next three footballers show the movements involved in kicking a ball when in play. The movement of the player at the bottom right is very controlled and almost acrobatic.

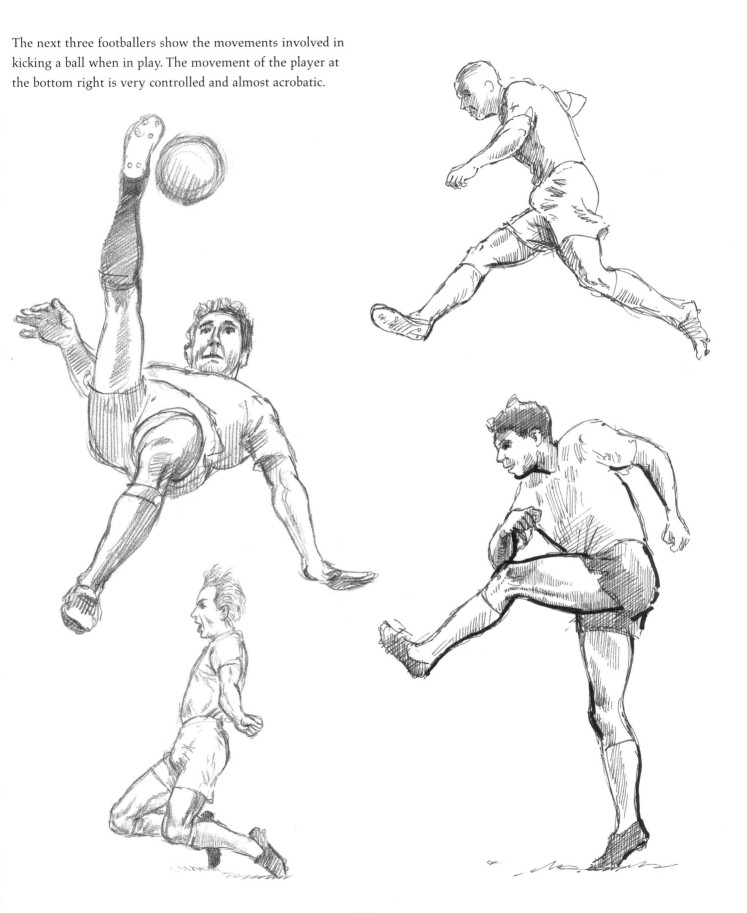

THE WHOLE BODY IN MOVEMENT
football

The next four pictures show the balance and effort required when moving fast and trying to control a ball with your feet at the same time. Notice how, in every case, the players are using their limbs to keep the body in movement and balanced at the same time.

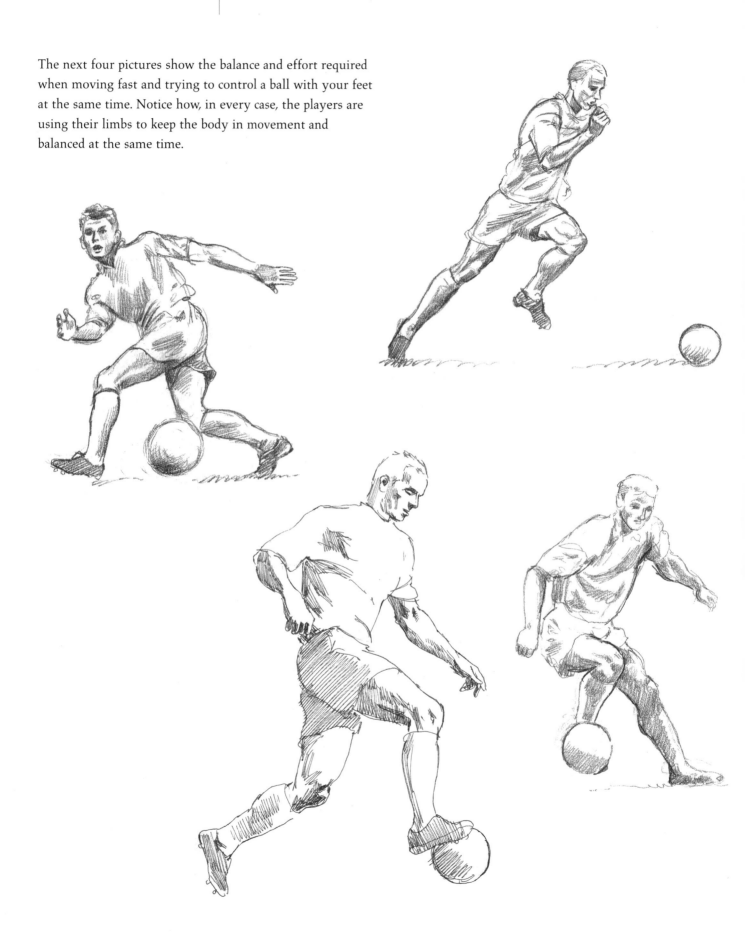

The last football picture is of two players falling after a collision on the field, and it is clear that their balance has gone and their bodies are trying desperately to counter this somehow with the movements of the limbs.

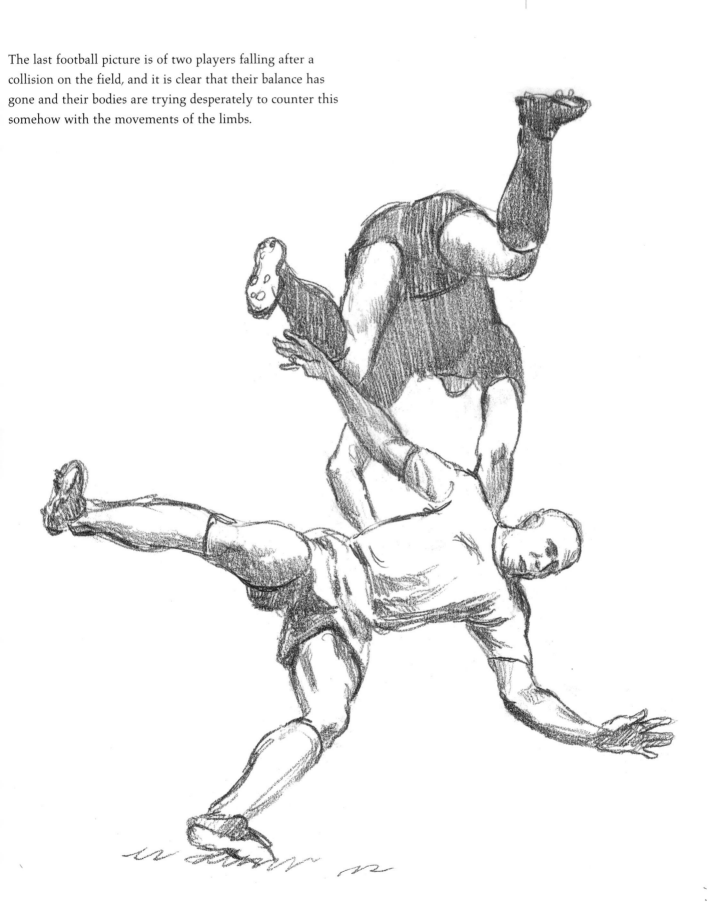

We now examine athletes jumping as high, as far and as fast as they can. Note how the body performs to match and counterbalance the efforts of leaping.

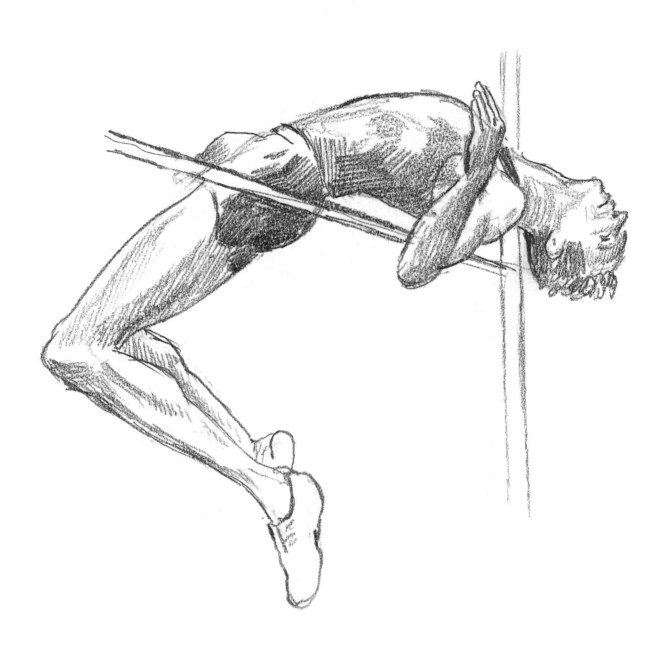

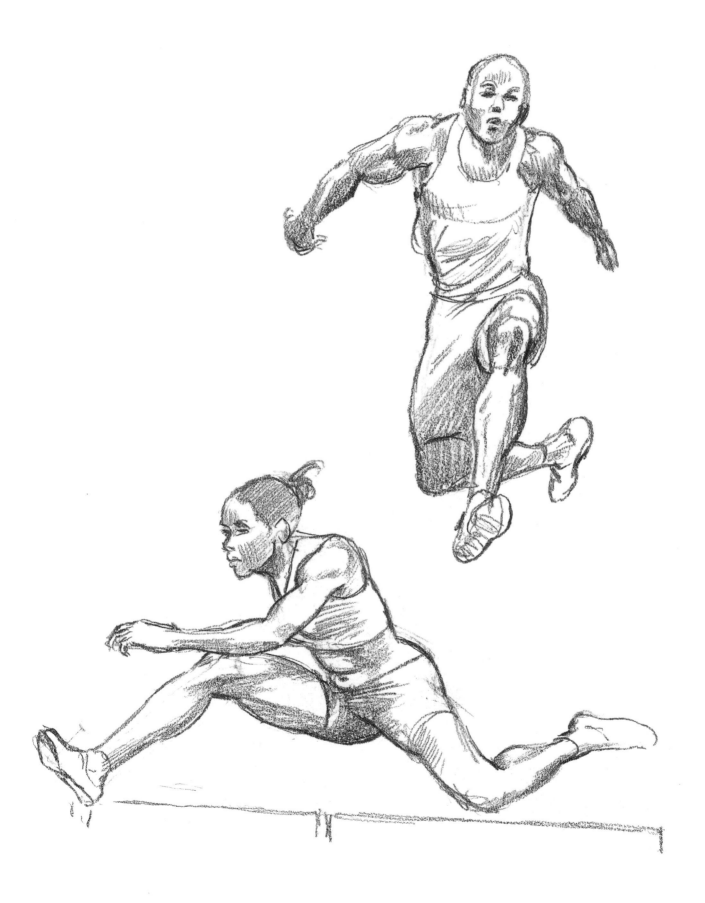

The athlete throwing the discus twists his body and swings his arms in order to get maximum power into his throw.

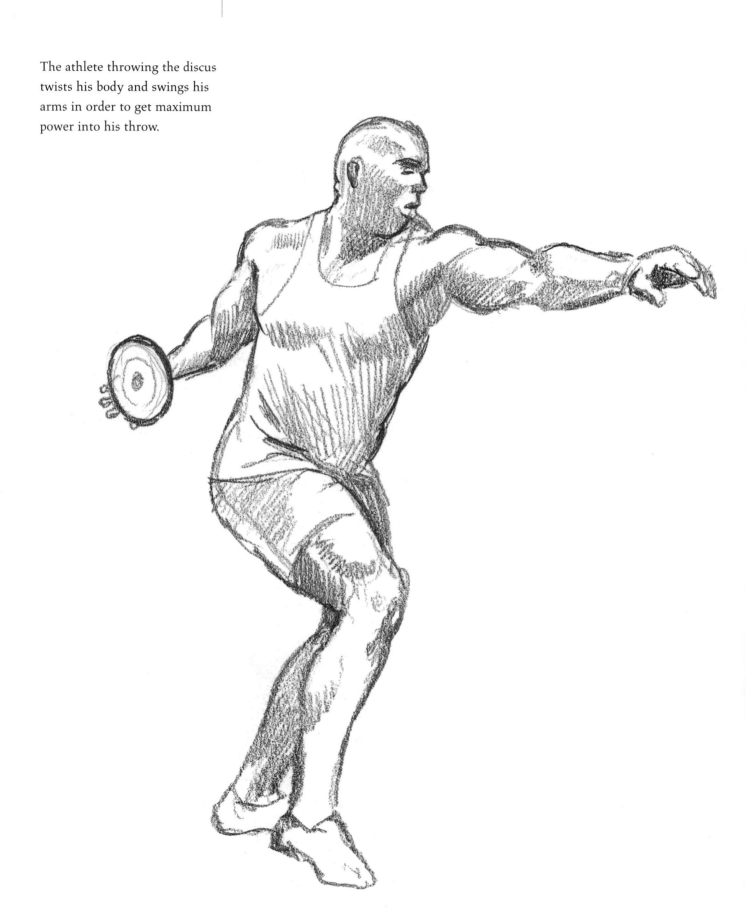

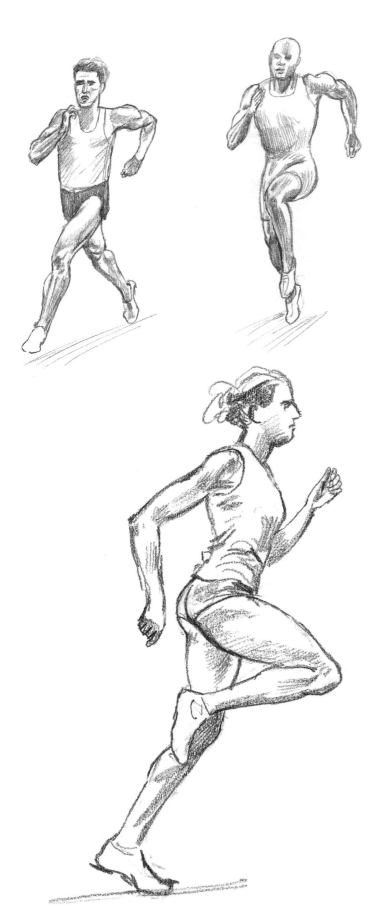

The four runners illustrate the body's efforts to gain speed along a level surface, pumping the arms and legs to keep them moving as fast as possible while remaining balanced and controlled.

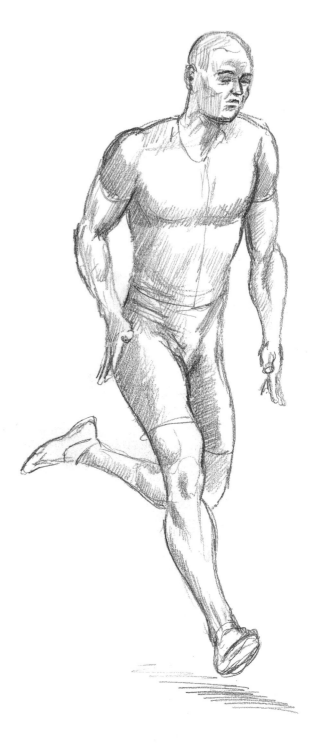

295

Two more jumpers, with a difference, because here they are helped by a pole to leap even higher than normal. The muscles that help the hands to grip, and the rest of the body to swing upwards, are shown under great stress.

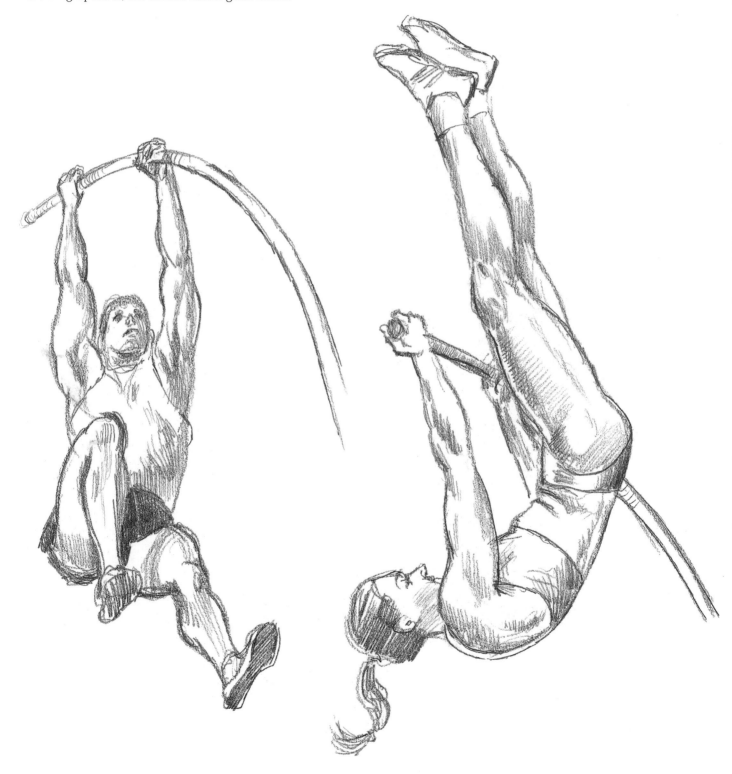

Next we see a couple of wrestling pairs, straining to upset their opponent without losing their own balance.

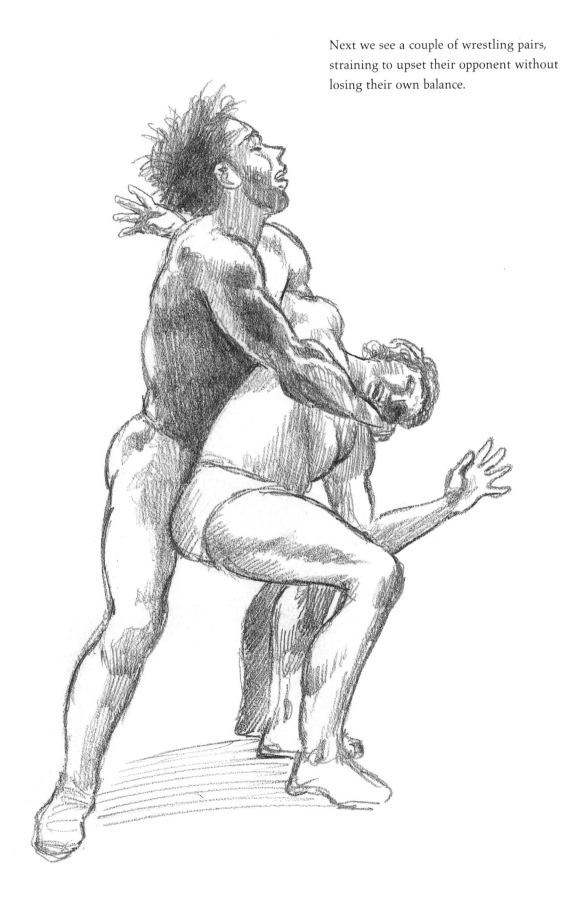

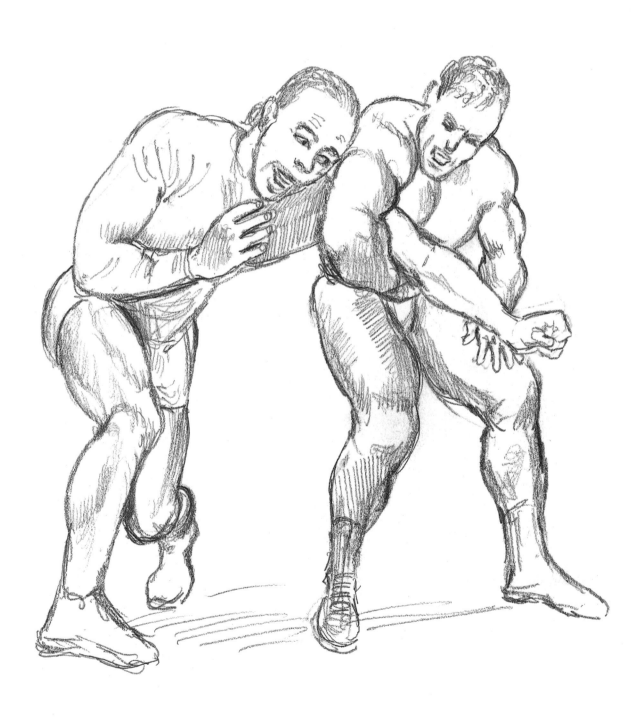

The weightlifters in the next three pictures are good examples of muscle performance under pressure. Note how the facial muscles come into play too. Watching weightlifting is one of the best ways to see clearly how the muscles behave when activated in extreme situations.

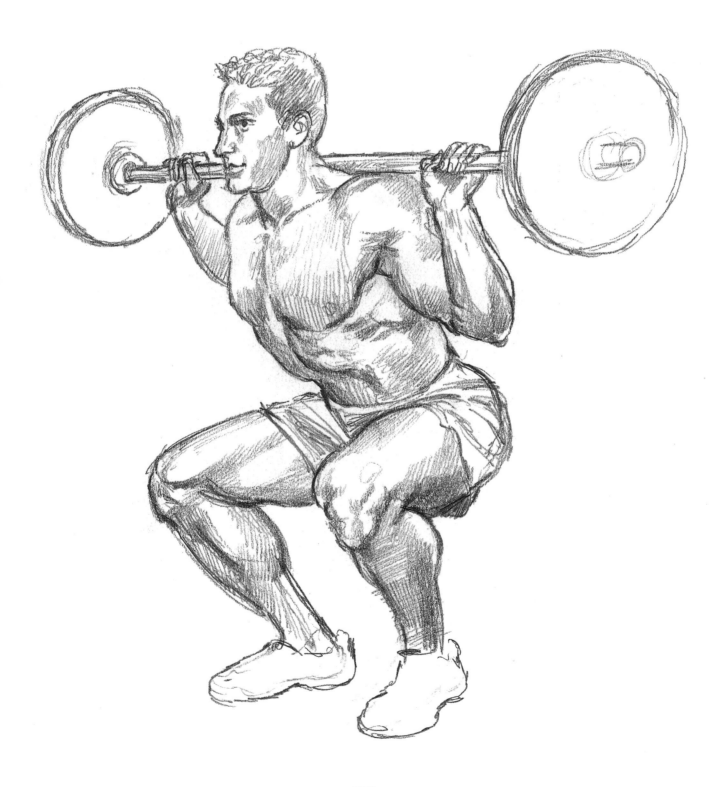

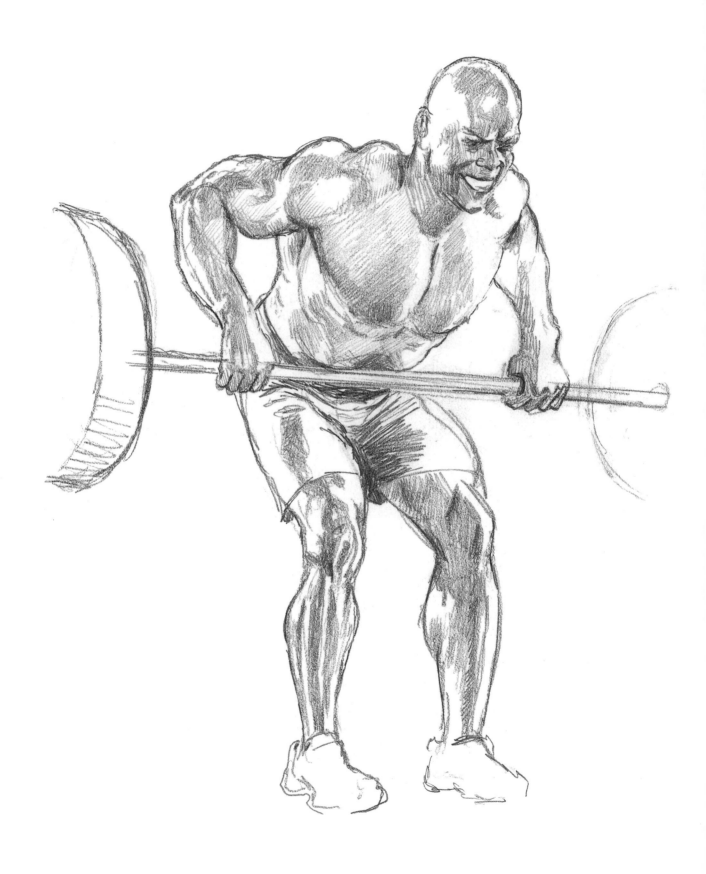

301

This picture of a smith wielding a sledgehammer shows Greiner's thoroughness in informing himself of the muscle movements in the body. A study like this is very informative and would be most useful in producing a finished painting.

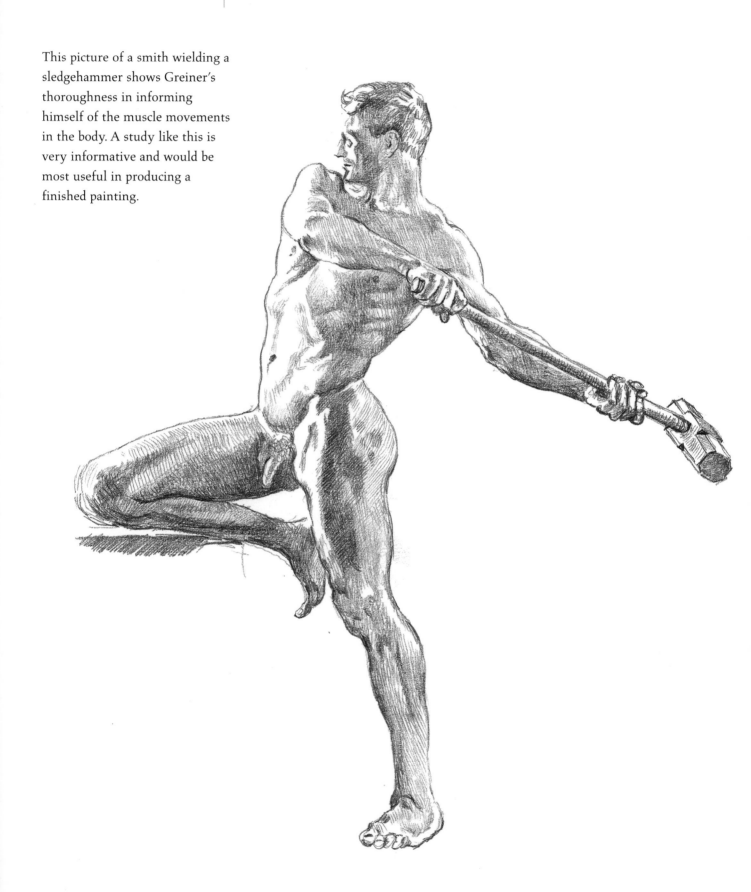

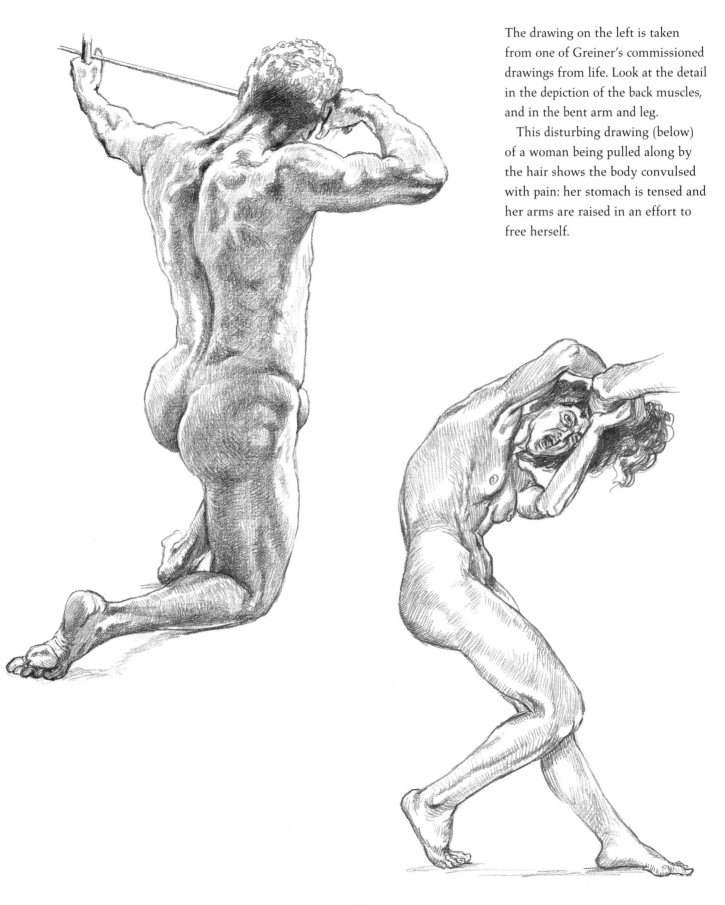

The drawing on the left is taken from one of Greiner's commissioned drawings from life. Look at the detail in the depiction of the back muscles, and in the bent arm and leg.

This disturbing drawing (below) of a woman being pulled along by the hair shows the body convulsed with pain: her stomach is tensed and her arms are raised in an effort to free herself.

The first drawing by Ingres is of a young man bending dramatically down to gather something up, while looking backwards.

The second drawing is of a nymph stretching upwards, showing the tension in her body as she does so. Ingres doesn't define the muscles very sharply, preferring a smoother overall look to his figures. Nevertheless, it is obvious enough which muscles are being indicated in these drawings.

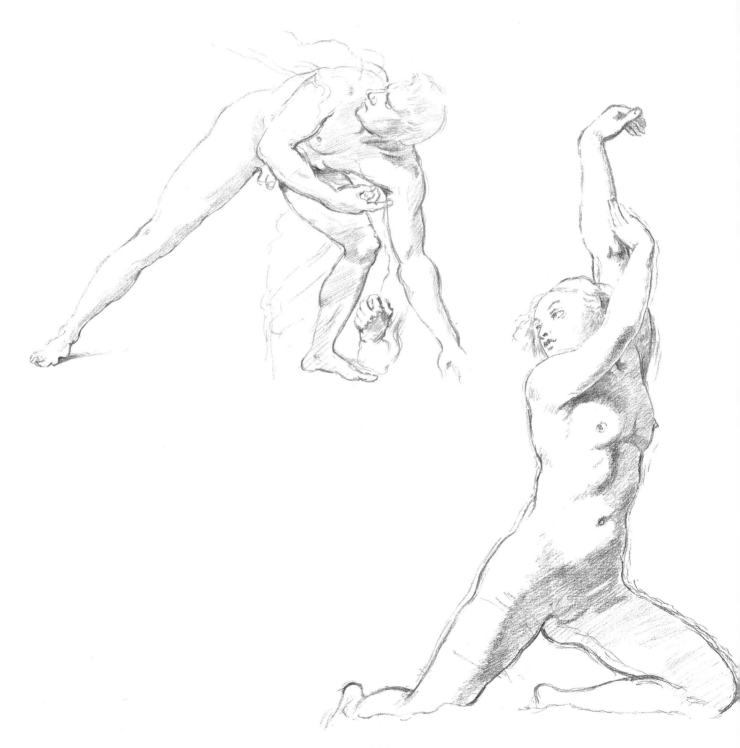

The next drawing shows a man lifting a chair above his shoulder as he walks forward. The arm muscles are particularly obvious.

The final Ingres life study shows a man reaching down to lift something from the ground. The stretching of the legs and arms brings into play all the muscles of the limbs.

As happens in many life drawings by accomplished artists, Ingres has drawn extra definitions of the feet in the standing pose and the stretched arm in the drawing below. These workings help to clarify what is actually happening in a complex part of the pose.

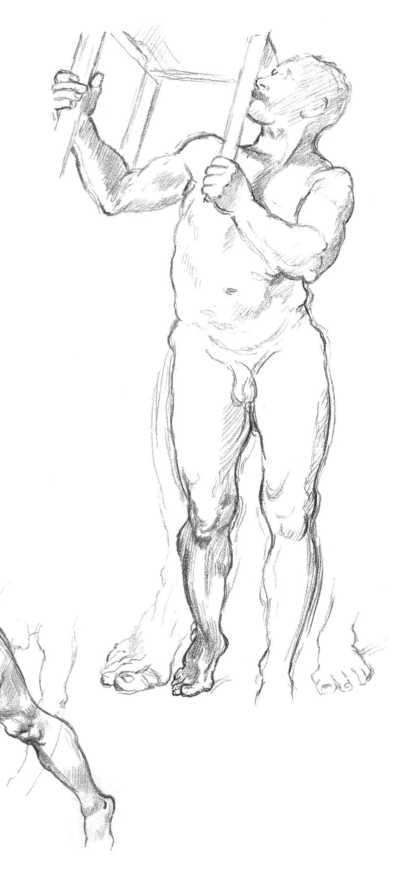

LIFE DRAWING

This chapter points out the benefits of practising life drawing for artists, as well as some of the things to expect and to look out for. As a practising artist myself for many years, I have found frequent stages of drawing from life absolutely necessary to keep improving my own ability. It does not seem to matter how often you practise, the fact remains that it helps you to improve your work, even after years of study.

So although a book like this will give you a lot of information about the human body, it is essential for really good results to draw from life as often as possible, in order to become familiar with what happens to the muscles and bone structure of the body in different circumstances. It used to be possible for artists to attend medical dissections of bodies in order to understand their inner workings, but that is rather difficult now and will not be necessary unless you intend to investigate anatomy in some depth.

If you join a life class at your local art institute or adult education centre, you will have the chance to draw all kinds of models using a variety of techniques. The tutors in such places are generally well qualified to give you an effective course in drawing the human body, so your time will not be wasted. After reading this book, you will be able to identify many of the bony parts and the visible muscles of the body when you see it in its natural state. If you can visualize where a muscle begins and ends, it is much easier to draw what you can see of it – and your knowledge of the structure of the body will also mean that the tutor will be able to describe exactly where you need to look, because you will be talking in the same terms.

The first two examples are both done in a fairly classical style, but whereas one is set in a sort of limbo with no background around it, the other is placed in a real-life setting, which is a London art studio. So, in the first drawing there are no outer marks, no points against which to measure the body shape. In the second, there are the chair, the vertical lines and the shelves in the background, which all help to establish the position of the figure.

A background is an advantage because it convinces us of the space around the model, and makes more sense of the dimensions of the body itself. Many students do not attempt to include the surrounding setting for many weeks when

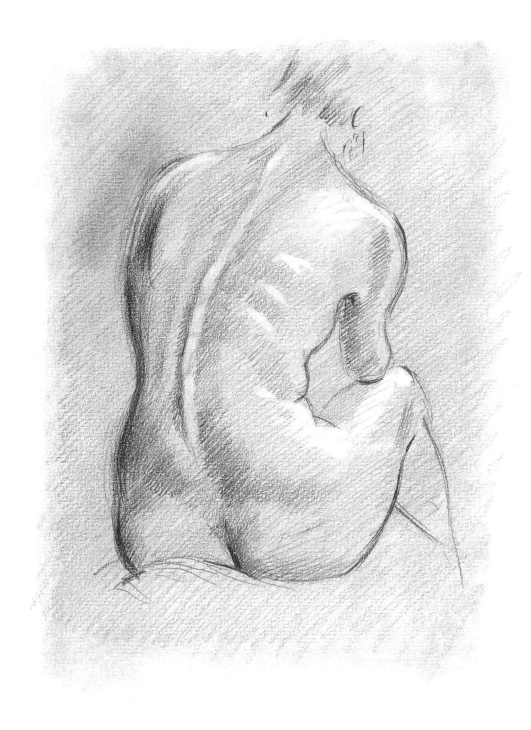

they start life drawing, but if you have the time to put it in, it will help to inform you as to whether the drawing is accurate or not, and that is one thing you need to know if your work is going to improve. It is better to make mistakes and be aware of them than to draw, no matter how beautifully, without some objective understanding of the setting. Of course, the tutor will inform you eventually, but you will need to start noticing what is happening yourself.

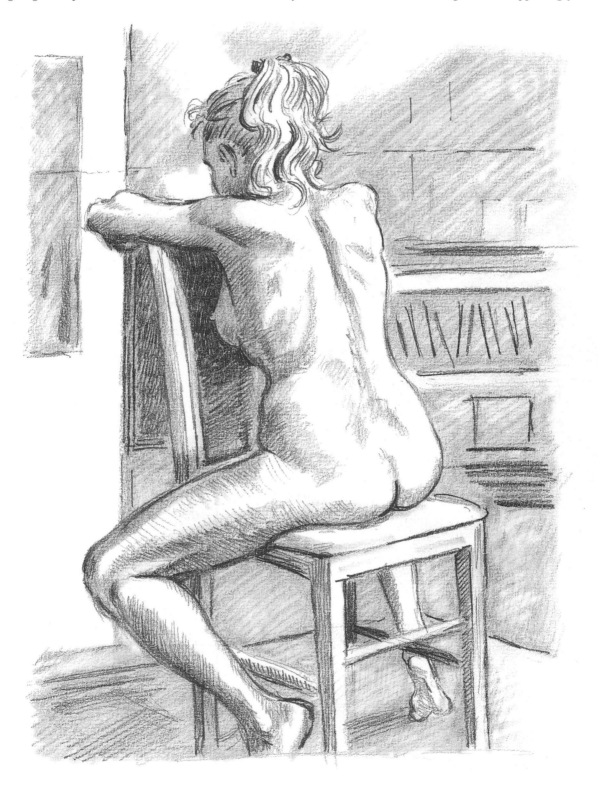

When you begin life classes you may find it difficult to complete a drawing quickly, but the tutor will quite often make you start with several very short poses, taking maybe only a minute or two, to accustom you to drawing instinctively. This can sometimes be a bit damaging to your self-confidence, but do not be downhearted because eventually you will be able to produce a decent result in a surprisingly short time. It does take practice, and the more you do the better you become.

These three poses have all been completed in one to five minutes, and you can see how the approaches are different but effective. You will probably be encouraged by your tutor to use many different mediums, which is all to your eventual advantage. It is in drawing at this speed that your knowledge of the human anatomy starts to help you get it right.

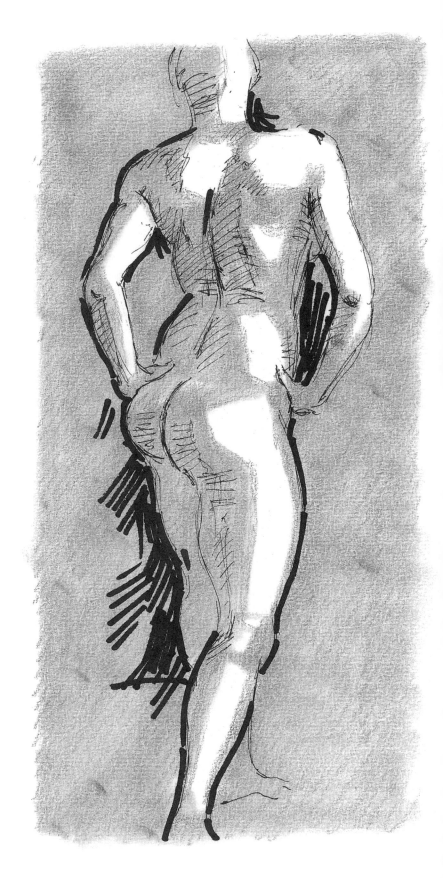

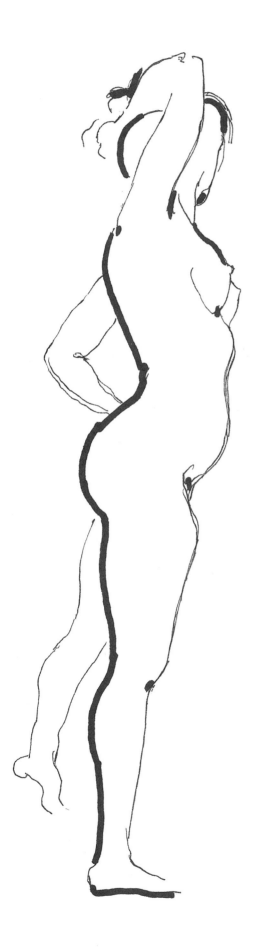

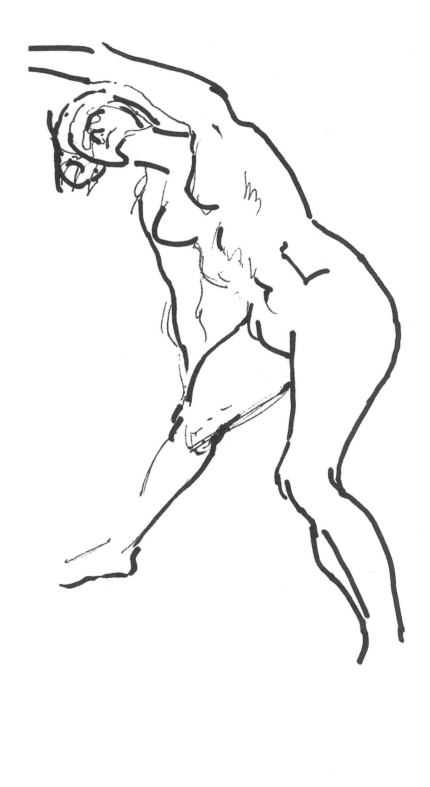

When beginners start life drawing, they often take the slow and painstaking approach of very detailed working, which a professional would not do. So, one method you must learn is how to block in large chunks of the figure, ignoring the detail, in order to get a better idea of the whole solid mass more quickly.

The first example also shows how you may ignore the curves of the body to produce a rather sculptural interpretation of the masses of form. This helps you to produce a much stronger-looking drawing and is easier to measure from point to point.

The second example is not so chunky and some curves are visible, but nevertheless the main point is that it produces an impression of the bulk of the form, using very little in the way of detail.

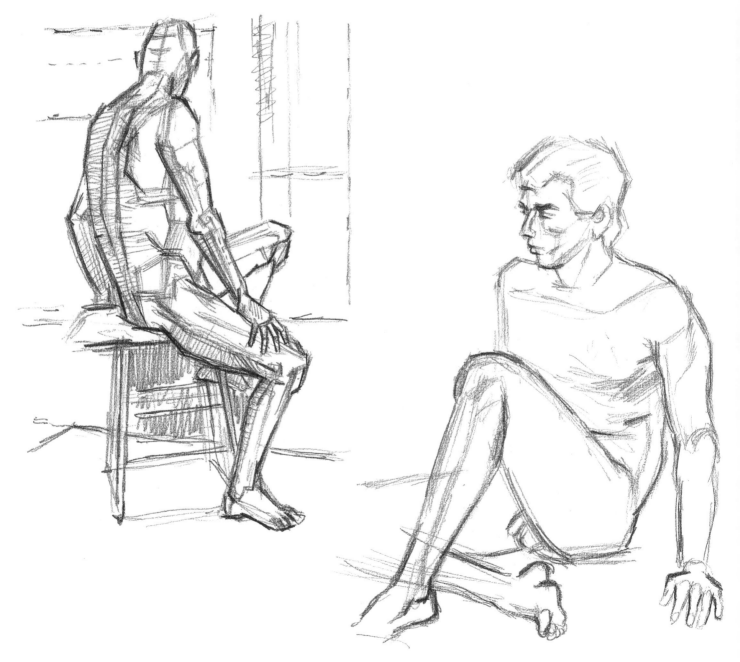

The next study is quite different in technique, executed with a graphic pen fine-liner. This is a daring thing to do if you are a beginner, because every mark you make is obvious, and it is not possible to erase in the normal way. But if you persevere with your studies, it is in fact a very good way to draw, as it makes you more aware of your imperfections and also, as you improve, it gives you the confidence to make mistakes without cringing when others see them. A word of warning, however: it is extremely time-consuming, so you will need a good long pose.

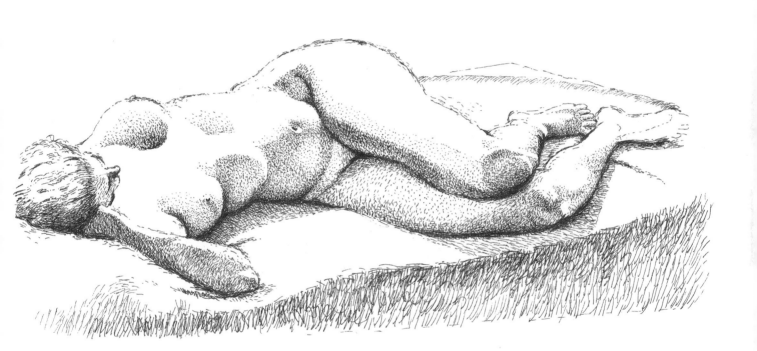

When you draw the same model from different angles at different times you gradually become accustomed to the construction of that particular body. This is very useful, especially if your drawings are all done fairly close together in time. You begin to recognize the particular shapes and proportions of your model, which helps you to identify the different parts of the body more easily.

Here are three studies of one of my favourite models, a Brazilian girl much in demand for life classes. These poses show her from the front sitting in a chair; from the foot end, reclining; and sitting with her back to me but reflected in a mirror. These three drawings and several others have enabled me to get a very clear idea of her body structure, and how the muscles work on the skeleton.

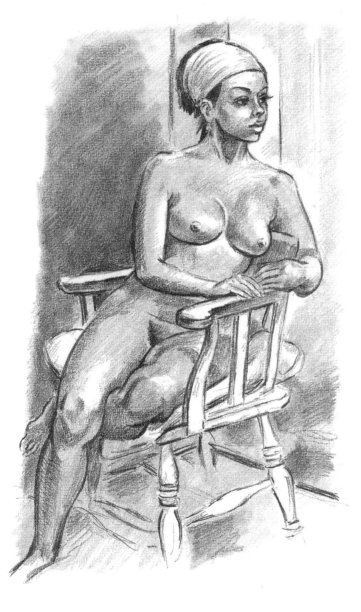

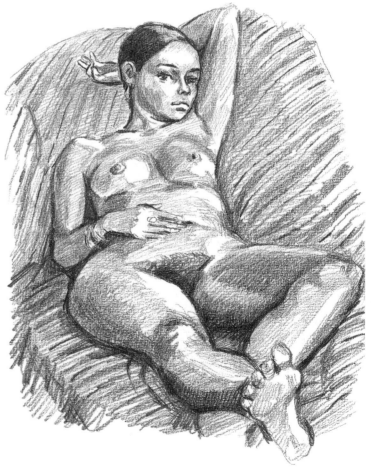

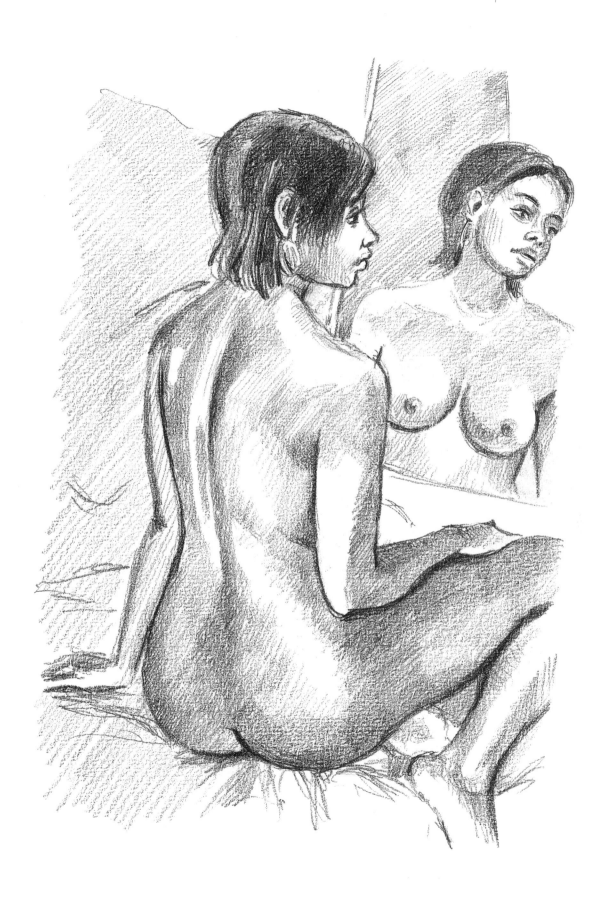

In my drawings for this anatomy book, I have chosen figures of almost perfect proportions in terms of the way that the musculature is distributed over the bone structure, and also of a similar size to the classical norm.

In actual fact, what the model for your life class will look like is anybody's guess, not least because art tutors seem to delight in booking models of as many different shapes and sizes as possible.

As with our first example here, you might get a young man who is skinny and angular, so that the skeleton beneath the muscles is very much more obvious than in an average figure. This means that you get plenty of practice in drawing bone structure but the muscles are harder to make out.

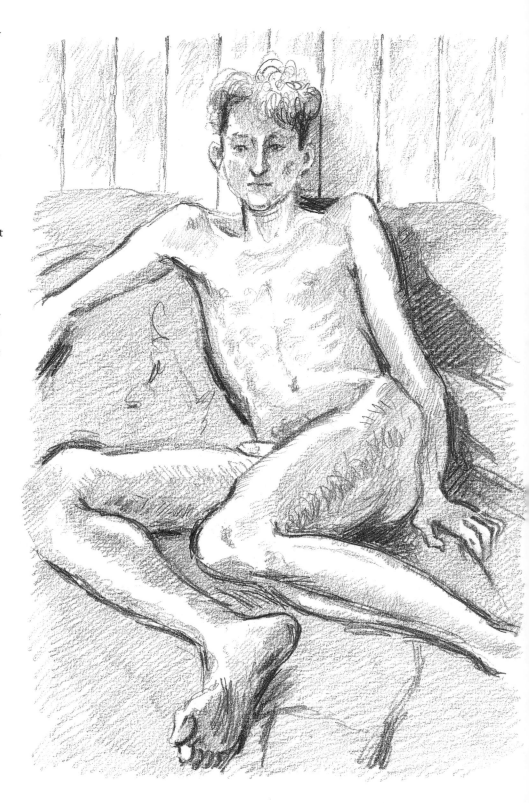

In the second example, the young woman has a rotund build, which presents you with quite a different task when drawing her. Here the bone structure is only noticeable at the wrists, hands and feet. Even the joints of the elbow and knee are fairly well covered, so the principal problem is to ascertain the muscles that lie under the smooth, solid forms.

This variety is all to the good if you are going to learn to draw properly, but it can be difficult at first. Whatever the model is like, the chief concern of the life artist is usually to represent what he or she sees as accurately as possible. However, do not forget that there are different levels of accuracy in drawing, and the main thing from the point of view of anatomy is to discover how well you can identify the structure under the skin.

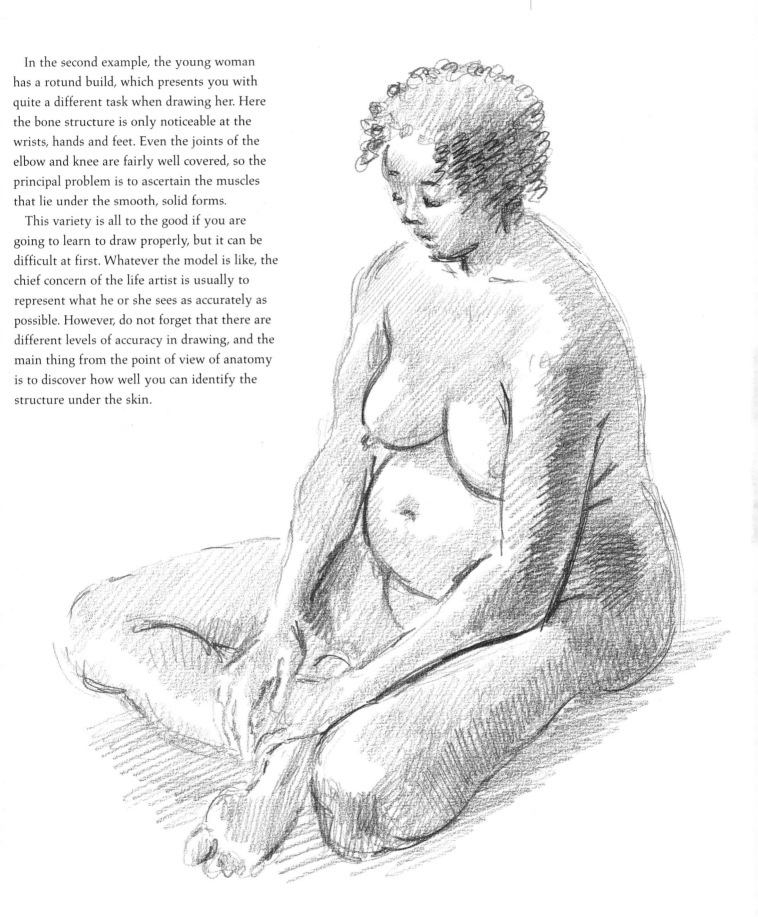

PUTTING IT ALL TOGETHER

Valuable and engrossing though it is to draw the nude human figure from life, observing all the structures of muscle and bone that you have learnt throughout this book, in reality most of the figures you draw will be clothed. Even so, your knowledge of anatomy will inform the way you describe their bodies and the way the clothes adorn them; every drawing you make, whether it be a single portrait or scenes of several figures, will gain in authenticity from the underlying expertise you can contribute.

In this final chapter, we shall look at clothing – the textures of different fabrics and how they drape and flow over the human form. There follows a simple portrait in which you can practise drawing a clothed figure before going on to consider how you will set your subjects within a format before you embark on making a finished picture.

Next, you will be ready to start working on an extended portrait project, from initial rough sketches and studies of your model's individual features to a fully realized drawing, showing the human figure in convincingly three-dimensional form – the kind of project that will teach you how to make portraits that sum up not just the sitter's physical characteristics but their personalities too.

Finally, we shall address the tricky feat of making successful compositions using groups of figures, both formal and informal and interacting in various ways, from ball games to affectionate family gatherings.

The handling of drapery and clothing is not particularly difficult, but it does require some study in order to be clear about how materials behave and what happens when they are covering the body. The results from your study can, of course, be used as a background for still life, but the main purpose of these exercises is to teach you how folds work. How materials behave depends largely on the type of fabric. With practice you will come to understand those differences.

A useful exercise for learning about the behaviour of clothing is to choose an item in a soft fabric – such as wool or silk – and drape it over something so that it falls into various folds. Now try to draw what you see.

1. Draw the main lines of the large folds. When you have got these about right, put in the smaller folds.

2. In order to capture the texture of the material, put in the darkest tones first, and then the less dark. Make sure that the edges of the sharpest folds contrast markedly in tone at the edges. In the softer folds the tone should gradually lighten into nothing.

1.

2.

Try drawing an arm in a sleeve or a leg in trousers and carefully note the main folds and how the bend in the arm or leg affects them. In sleeves, the wrinkles can take on an almost patterned look, like triangles and diamond shapes alternating.

1.

1. Start by very simply putting in the main lines of the creases. Note how on the jacket the folds and creases appear shorter and sharper across the sleeve, whereas on the tracksuit they appear longer and softer down the length of the leg.

2. Shade in where necessary to give the drawing substance.

3. The patterns on these sleeves look almost stylized, partly because the material is a bit stiff.

2.

3.

Next we look at how the movement and actions of the wearer affect the appearance of clothing. Of course, how an item of clothing behaves will depend on the type of material of which it is made, so you need to be aware of different properties and characteristics and how to render them realistically in various situations.

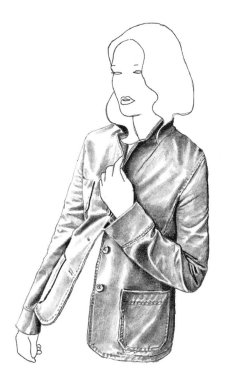

A very simple movement of a girl pulling on her jacket produces all sorts of wrinkles and creases in a rather stiff material. The creases at the bend of the arm are relatively soft, however, which generally indicates an expensive material. As the American Realist painter Ben Shahn remarked, 'There is a big difference between the wrinkles in a $200 suit and a $1,000 suit.' (This was said in the 1950s, so the prices are relative.) What he was remarking on was the fact that more expensive materials fold and crease less markedly and the creases often fall out afterwards, whereas a suit made of cheaper materials has papery-looking creases that remain after the cloth is straightened.

The clothing worn by this figure (right) hangs softly in folds and suggests a lightweight material such as cotton. The shape of the upper body is easily seen but the trousers are thick enough to disguise the shape of the leg.

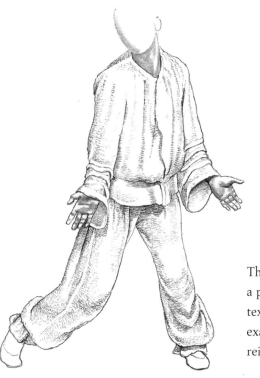

This drawing (left) was made from a picture of a dancer playing a part. The baggy cotton-like material has a slightly bobbly texture and its looseness in the sleeves and legs serves to exaggerate his movements. Both the action and costume reinforce the effect of floppy helplessness.

A bit of clever posing by a fashion photographer was responsible for the original from which the drawing below was made. The model was actually photographed lying on the floor with the dress spread out to make it look as though she was moving in a smooth-flowing dance. The photograph was taken in the 1930s, before the benefits of high-speed cameras and film, and represents an imaginative way round a technical problem. It proves that you can cheat the eye.

The sturdy girl dancer above is swirling a length of thin, light silken material. The movement of the hair and garment tell you quite a bit about her movements and the materiality of the hair and cloth.

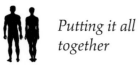

A SIMPLE PORTRAIT

Drawing a simple clothed figure like this will help you to practise what we have learnt about the way material covers the body. Try to keep your drawing loose and simple at first.

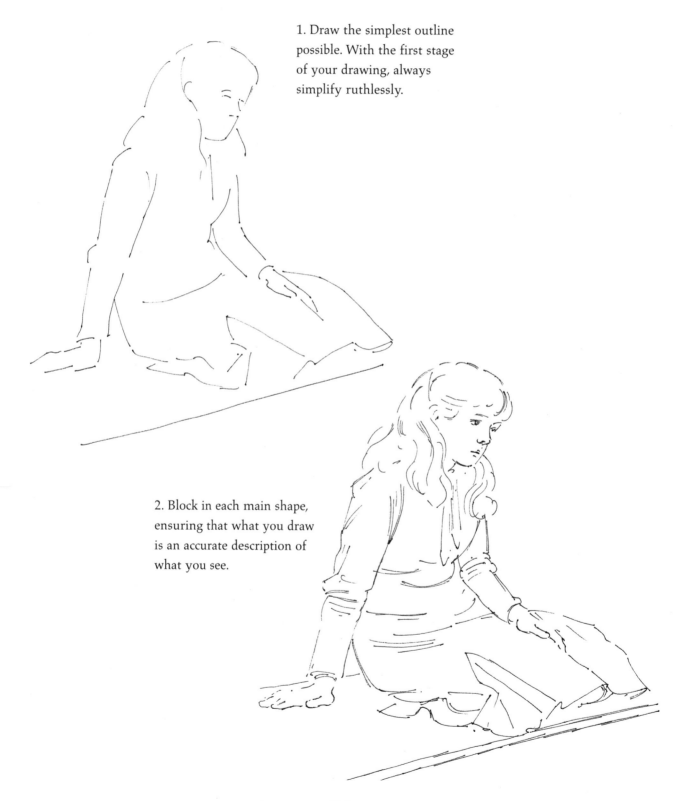

1. Draw the simplest outline possible. With the first stage of your drawing, always simplify ruthlessly.

2. Block in each main shape, ensuring that what you draw is an accurate description of what you see.

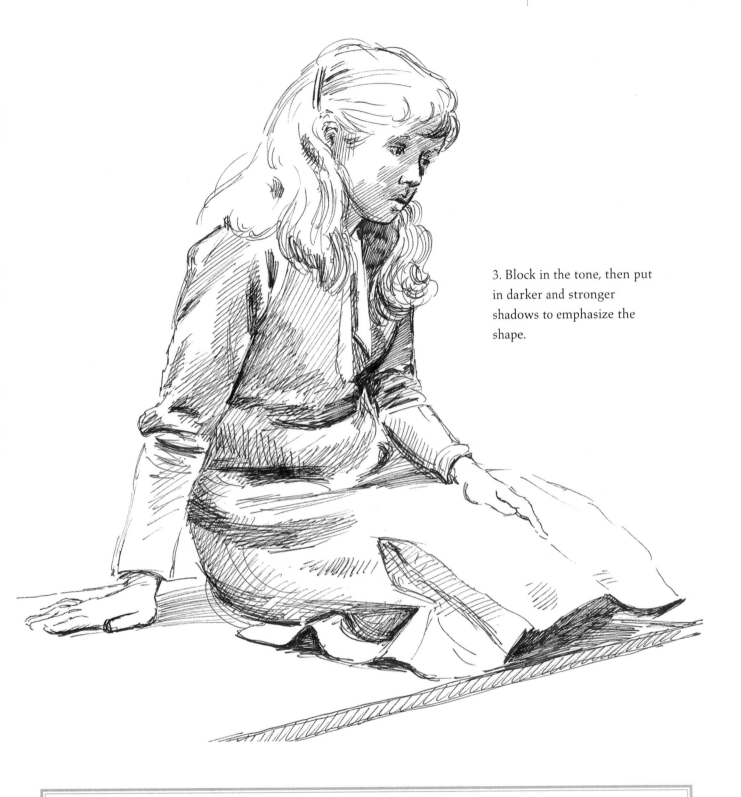

3. Block in the tone, then put in darker and stronger shadows to emphasize the shape.

The best way is to draw from life, but if you see an attractive pose and the model cannot stay put for long, working from a photograph is something to fall back on.

When you are going to draw a portrait, your first consideration is the format of the picture. This is usually the normal portrait shape, taller than its width, but of course this might not always be the case, and you should follow your own ideas. In the examples I have chosen, I've stuck to the upright format in order to simplify the explanation. The idea of these pictures is to give some thought to the way that you use the format to determine the composition. You might choose to draw the head alone or include the entire figure.

The first example shows the most conventional treatment of the sitter, occupying a central position in the picture, showing the top half of the figure with a simple background suggesting the room in which she is sitting. There are probably more portraits showing this proportion of the sitter than any other.

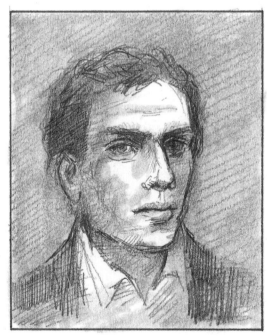

In the second picture, I have gone in close to the face of the sitter and the background is just a dark tone, against which the head is seen. The features are as big as I could get them without losing the whole head, and all the attention is on the face.

The next picture shows the other extreme, the full-figure portrait. In this, the figure is standing, with the surrounding room shown in some detail, although this does not always have to be the case; it could be an empty space or perhaps an outdoor scene. The full-length portrait is often a tour de force for the artist involved.

Here we see a figure, not quite complete, but taking on a more horizontal position. This could be done just as well in a landscape (horizontal) format, but can be most effective in the vertical. In this example, the space above the sitter becomes significant and often features some detail to balance the composition, like the picture shown.

A double portrait – such as a parent and child – creates its own dynamic. All you have to decide is how much of each figure you choose to show, and which person to put in the centre of the composition.

The final example is a portrait of the sitter and his dog. Putting pets into a portrait is always tricky, but the answer is to draw the animal first and then the owner. Before you start you need to decide whether the animal is a mere adjunct or the centrepiece.

There are many ways to approach the drawing of a portrait and this stage of consideration is crucial to the final result.

This exercise entails quite a bit of drawing and you will learn a lot about your model's appearance by spending a whole session drawing and redrawing him or her from as many different angles as you think would be useful.

SKETCHES OF THE HEAD

I chose as my sitter my eldest daughter, who has sat for me often, like all of my family. Not only that, she is an accomplished artist herself, so she knows the problems of drawing from life. This sympathy with your endeavours is useful, as models do get bored with sitting still for too long.

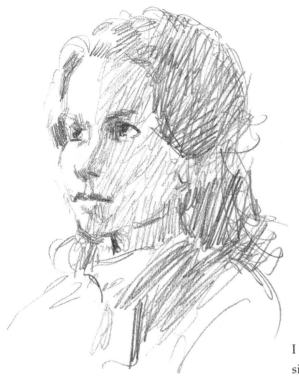

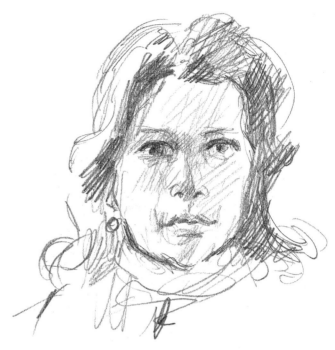

I worked my way round my sitter's head by drawing her first from the side or profile view, then from a more three-quarters view and finally full face. I now had a good idea as to the physiognomy of her face.

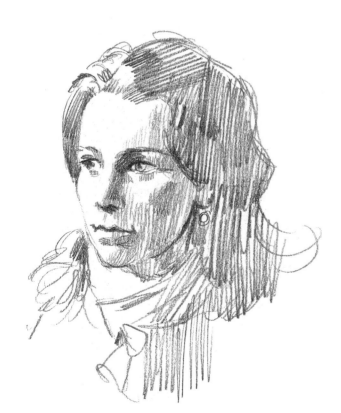

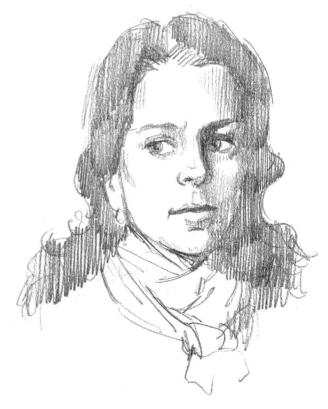

Next I took more account of the lighting, drawing her full-face and three-quarter face, both with strong light cast from the left.

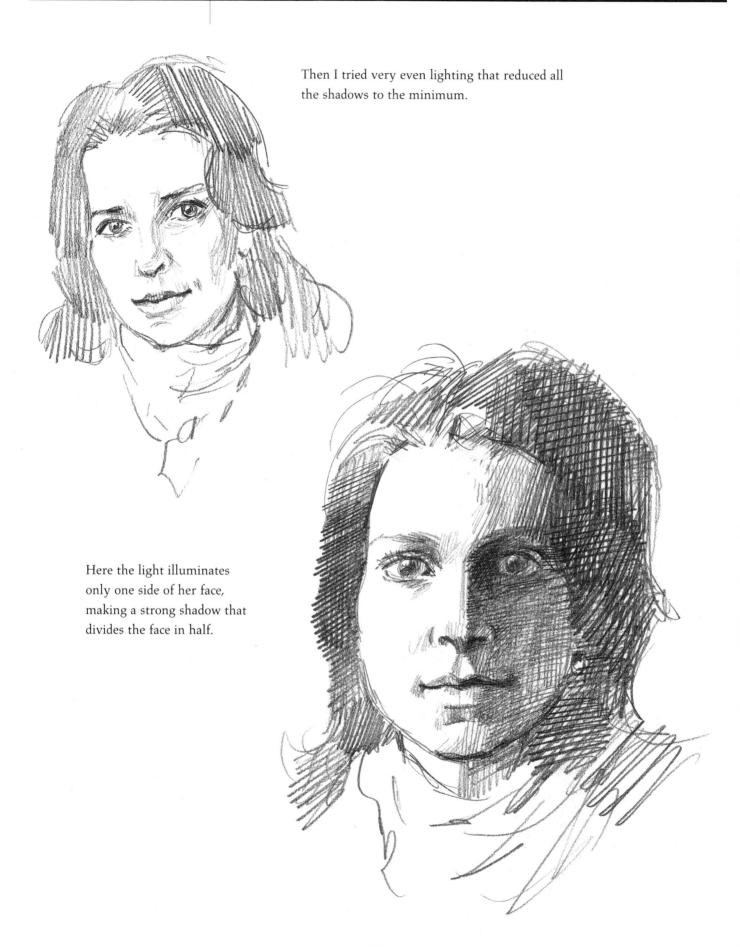

Then I tried very even lighting that reduced all the shadows to the minimum.

Here the light illuminates only one side of her face, making a strong shadow that divides the face in half.

SKETCHING DIFFERENT POSES

Now you need to spend some time drawing the sitter full or three-quarter length in order to decide how much of the pose you might want to draw.

First I drew my daughter standing, with her arm draped across a mantelpiece, which gave me a three-quarter figure.

Next I tried a side view of her kneeling on the rug, which made quite a nice compact shape.

Then I asked her to sit in a big easy chair with her legs crossed. Notice how she is looking out of the picture.

I drew a couple of poses of her sitting on a large sofa, one more or less straight on to my angle of view and one where she leans over on to the armrest.

There followed two more standing poses, one the reverse of the first with her reflection showing in the mirror, and the other of her just leaning on the wall with her hands in her pockets.

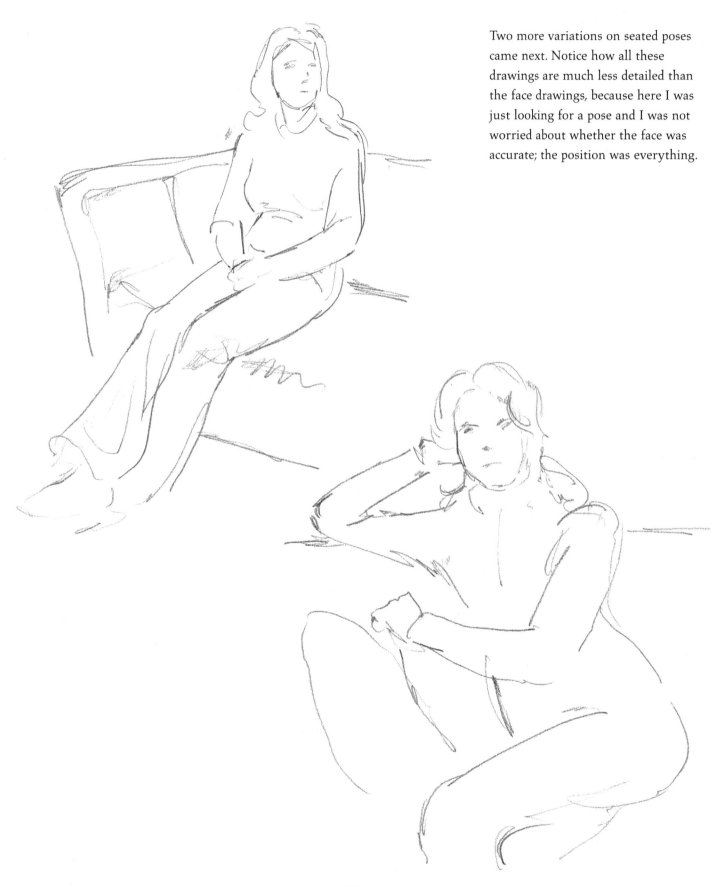

Two more variations on seated poses came next. Notice how all these drawings are much less detailed than the face drawings, because here I was just looking for a pose and I was not worried about whether the face was accurate; the position was everything.

DRAWING THE FEATURES IN DETAIL

Once you have decided upon the pose you need to turn
your attention to the details of the sitter's face, taking
each of the features and making detailed drawings of them.

I started by drawing just one eye. This is a difficult
thing to do, as the model will find your concentrated stare
a little daunting. However, it is also very revealing as to
how carefully you have observed the eye. Having drawn
my daughter's eye directly facing me, I then drew it from
a slight angle so that I got a side view of it. I did this with
both eyes, then drew them as a pair to see how they
looked together, as well as the space between them.

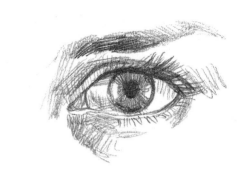

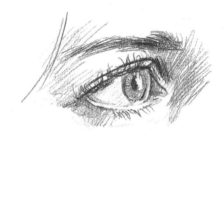

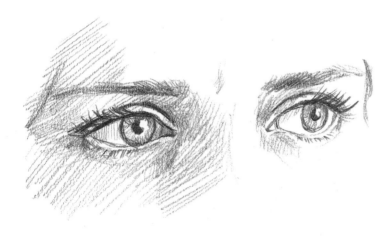

Next I moved on to the mouth and
drew it two or three times,
exploring the front, side and
three-quarter view.

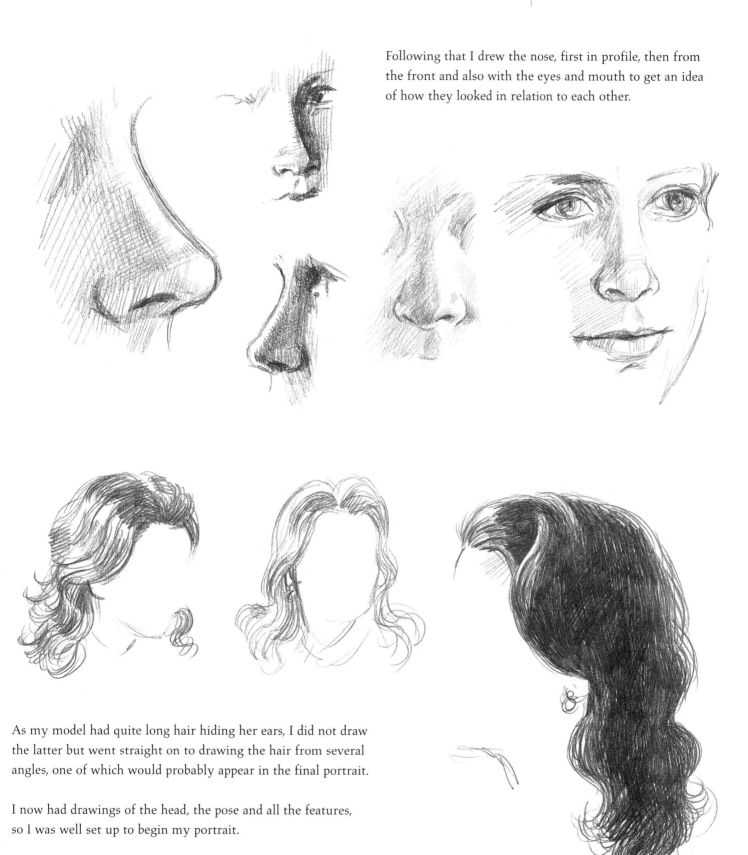

Following that I drew the nose, first in profile, then from the front and also with the eyes and mouth to get an idea of how they looked in relation to each other.

As my model had quite long hair hiding her ears, I did not draw the latter but went straight on to drawing the hair from several angles, one of which would probably appear in the final portrait.

I now had drawings of the head, the pose and all the features, so I was well set up to begin my portrait.

CHOOSE YOUR COMPOSITION

With my drawings gathered together and my model refreshed and ready to sit for me again, I first had to choose the pose and then draw it up in as simple a way as possible but with all the information I needed to proceed to the finished portrait. I decided to place her on a large sofa, legs stretched out and hands in her lap, with her head slightly turned to look directly at me. The light was all derived from the large window to the left and so half of her face was in soft shadow.

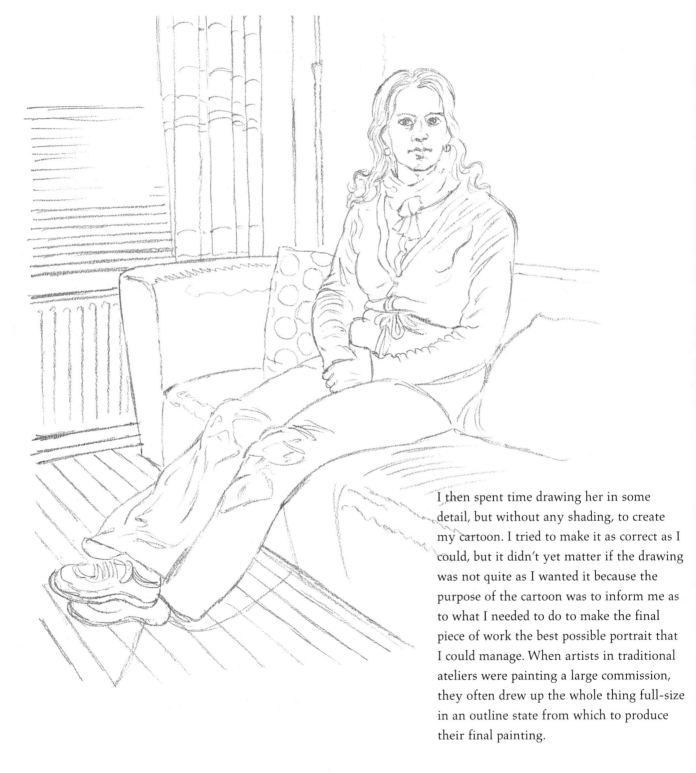

I then spent time drawing her in some detail, but without any shading, to create my cartoon. I tried to make it as correct as I could, but it didn't yet matter if the drawing was not quite as I wanted it because the purpose of the cartoon was to inform me as to what I needed to do to make the final piece of work the best possible portrait that I could manage. When artists in traditional ateliers were painting a large commission, they often drew up the whole thing full-size in an outline state from which to produce their final painting.

336

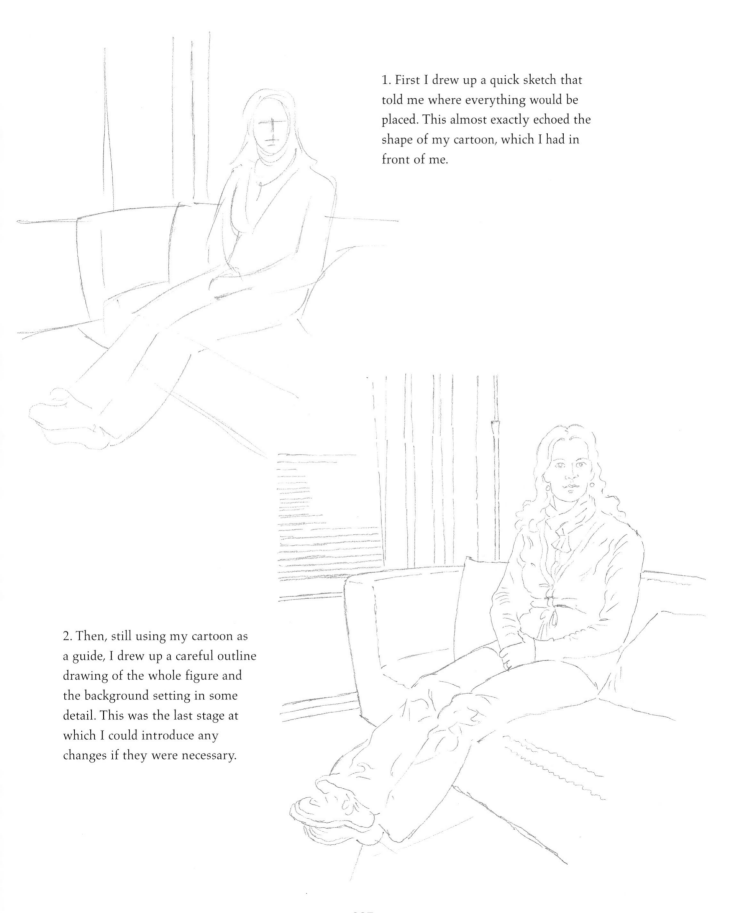

1. First I drew up a quick sketch that told me where everything would be placed. This almost exactly echoed the shape of my cartoon, which I had in front of me.

2. Then, still using my cartoon as a guide, I drew up a careful outline drawing of the whole figure and the background setting in some detail. This was the last stage at which I could introduce any changes if they were necessary.

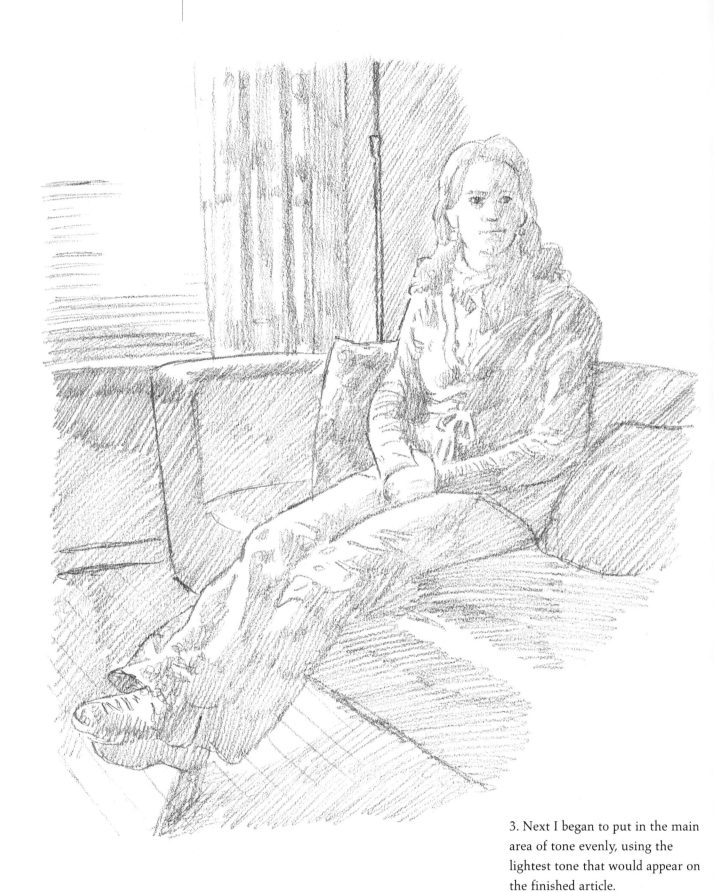

3. Next I began to put in the main area of tone evenly, using the lightest tone that would appear on the finished article.

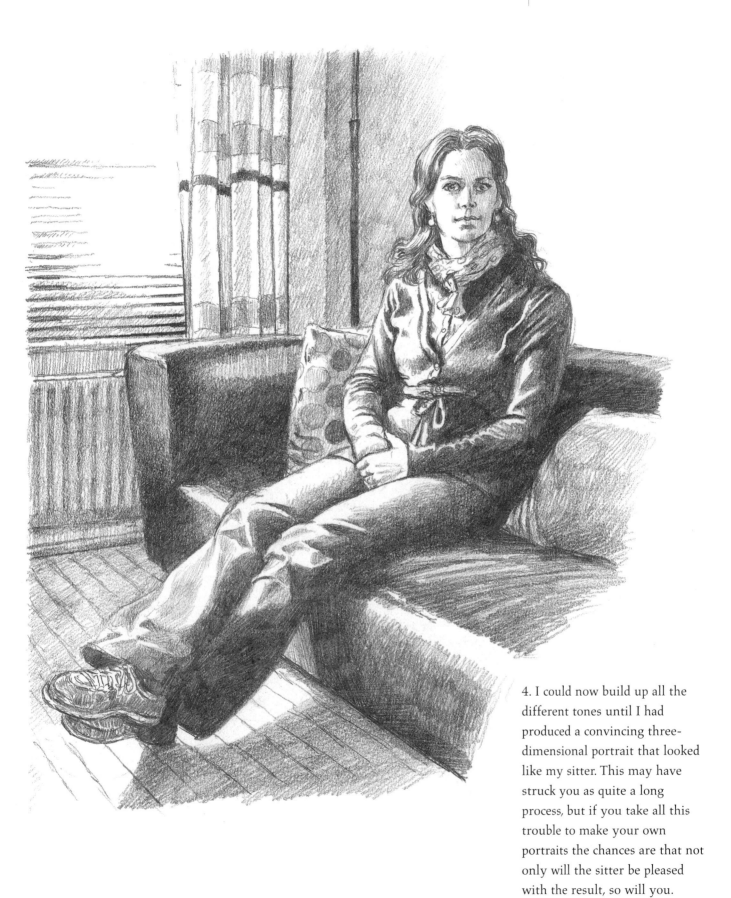

4. I could now build up all the different tones until I had produced a convincing three-dimensional portrait that looked like my sitter. This may have struck you as quite a long process, but if you take all this trouble to make your own portraits the chances are that not only will the sitter be pleased with the result, so will you.

Drawing a figure composition is quite a major task, but if you go about it in a systematic way you will not find it too difficult. The first thing is to determine your format – I decided that mine would either be a short rectangle or a square shape.

As you can see, I had three possible compositions in mind. One had a man lying on the grass with a girl kneeling next to him and another man running towards them.

The second was of two men and a girl in a room talking or arguing.

Finally, I decided that this idea of some young people playing ball on the beach might be the best way of doing my figure composition.

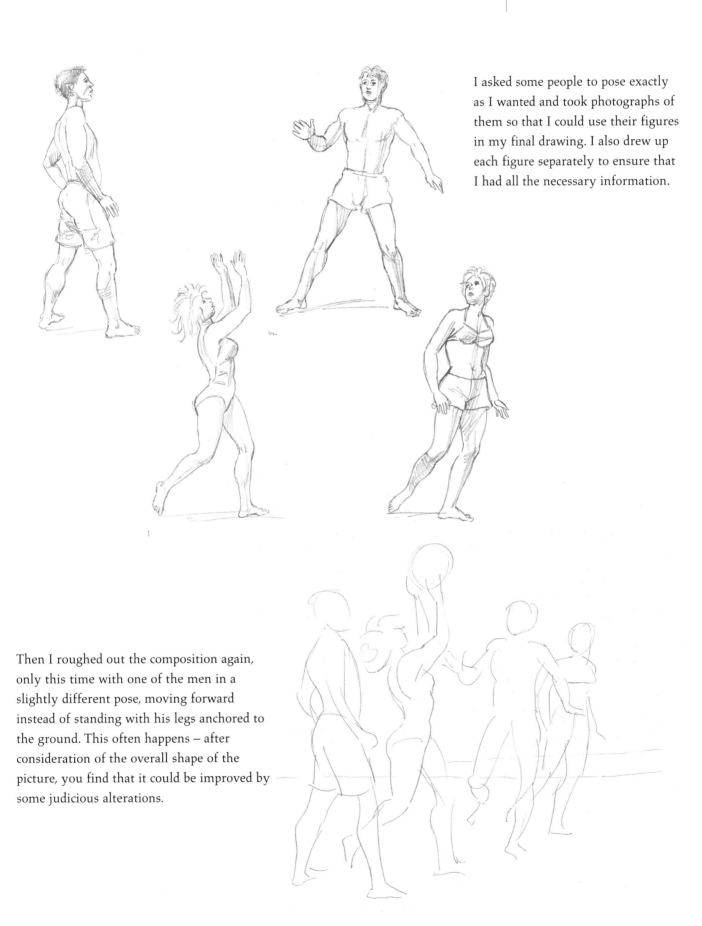

I asked some people to pose exactly as I wanted and took photographs of them so that I could use their figures in my final drawing. I also drew up each figure separately to ensure that I had all the necessary information.

Then I roughed out the composition again, only this time with one of the men in a slightly different pose, moving forward instead of standing with his legs anchored to the ground. This often happens – after consideration of the overall shape of the picture, you find that it could be improved by some judicious alterations.

341

1. With reference to all my extra information, I now began a more careful drawing of the background and the outlines of the figures in the poses I had chosen, correcting any mistakes at this stage.

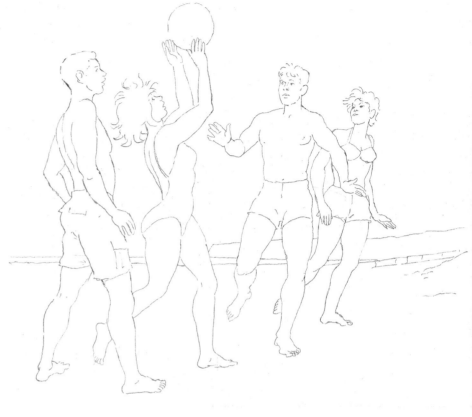

2. Once the picture was clearly drawn up I began to put in tone to show where the sun gave shadows to the figures. I kept the tone as light as possible as I did not want to put in heavy tones until I was sure that the light tone worked as a whole.

3. Now the darker tones could go in, but sparingly, otherwise the whole drawing would get a bit heavy and dark. To avoid overdoing them, I kept stepping back from the drawing to see how the tonal values worked. The long cast shadows on the sand help to anchor the figures to the ground and suggest that the sun is setting and the time is late afternoon.

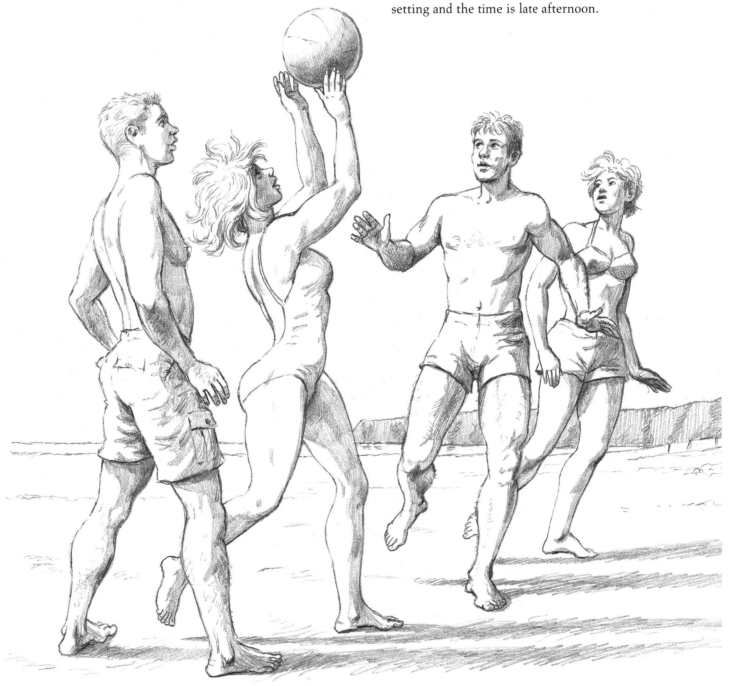

Compositionally, Renoir's *Boating Party* is a masterly grouping of figures in a small space. The scene looks so natural that the eye is almost deceived into believing that the way the figures are grouped is accidental. In fact, it is a very tightly organized piece of work. Notice how the groups are linked within the carefully defined setting – by the awning, the table of food, the balcony – and how one figure in each group links with another, through proximity, gesture or attitude.

Let's look at the various groups in detail.

Group A: In the left foreground is a man standing, leaning against the balcony rail. Sitting by him is a girl talking to her dog and in front of her is a table of bottles, plates, fruit and glasses. It is obviously the end of lunch and people are just sitting around, talking.

Group B: Just behind these two groupings are a girl, leaning on the balcony, and a man and woman, both seated.

Group C: In the right foreground is a threesome of a girl, a man sitting and a man standing who is leaning over the girl, engaging her in conversation.

Group D: In the background, two men are talking earnestly, and to the right of them can be seen the heads and shoulders of two men and a young woman in conversation.

Group A

Group D

Group B

Group C

In the context of portraits, 'group' means anything other than one person, and the group you will most often be asked to draw is just two people, usually with a close relationship with each other.

The first example I show here is a mother with her little girl on her lap, which creates a nice tight composition, and as long as the child will stay still for long enough there's no real problem with such a drawing. Obviously, once you've sketched in the main shapes of the two figures you can then draw the child first as quickly as possible, and when he or she wants to move you can then concentrate on the mother. The other thing about this combination of figures is that you only really have to satisfy the mother; the child usually is pleased with any representation that is even slightly human!

The second type of group, probably lovers or a married couple, is a bit more tricky because you will want a close connection between the two people, but they may find it difficult to sit so close as in my example for any length of time. Entwining figures can make a good composition, but depending on your speed of execution, you may find that they find difficulty in holding the intimate pose.

The next group has progressed to three people. The first trio is the obvious one of a couple and their child. The two adults sit next to each other and the child is in the centre of the composition, linking the two larger figures.

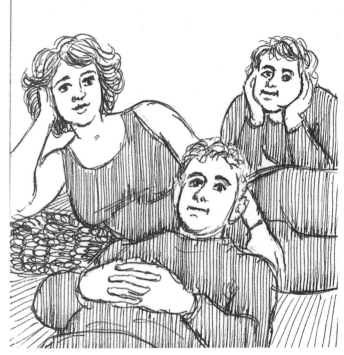

The second trio (above) is two brothers and their sister, arranged in a much less formal composition than those shown so far. This is not usually difficult with siblings under a certain age because of the sort of relationship they tend to have with each other. They probably will not mind a less conventional pose because they will treat it as a sort of game.

The last of these groups (left) is of three female friends, who are drawn as though interrupted out on a jaunt. Posed against a backdrop of trees, they might have been caught on camera as they were on a day out in the country. Quite often a photograph of the composition is a good idea, supplemented with careful drawings of each person which you can do individually later on.

Having decided that I would draw my youngest daughter and her family in a group composition, I first made a quick sketch of them in position. I also took photographs, as the little boy and the baby obviously were not going to pose for long. This is a basic outline of shapes and proportions.

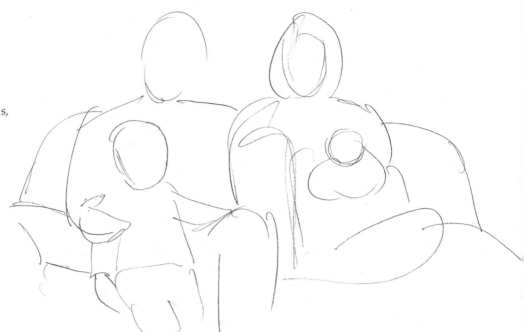

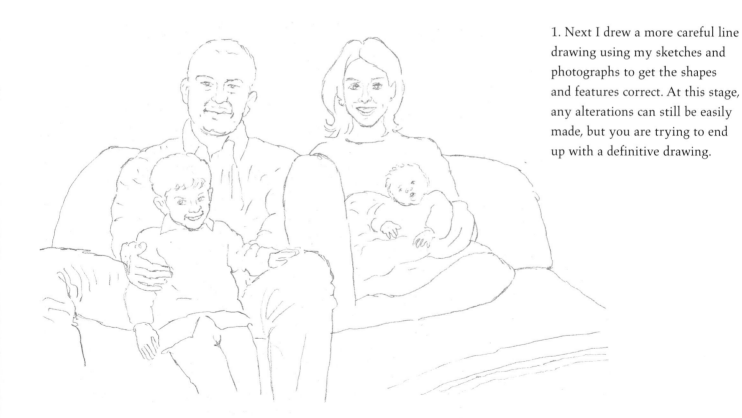

1. Next I drew a more careful line drawing using my sketches and photographs to get the shapes and features correct. At this stage, any alterations can still be easily made, but you are trying to end up with a definitive drawing.

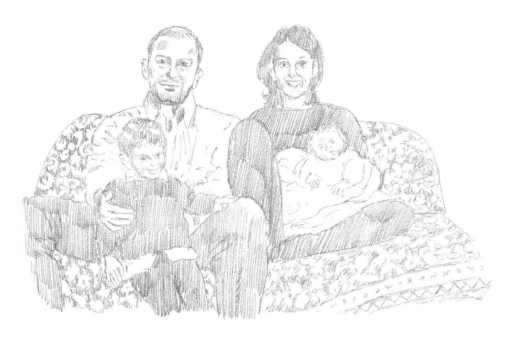

2. Next, I put in all the tone and texture. The texture of the flowery sofa that they are sitting on is important as well as the main tone of the clothing and features.

3. Then, with most of the drawing in place, it is time to build up the tone and texture and define everything for the final work. As you can see, there was no strongly angled light, everything being quite well-lit from in front. The pattern on the sofa is important as it is an attractive setting for the figures and helps to hold the composition together. Most of the stronger tones are based on the local colour of the clothes as there are no very strong shadows. The faces were all drawn separately, when the models could stay still for a while.

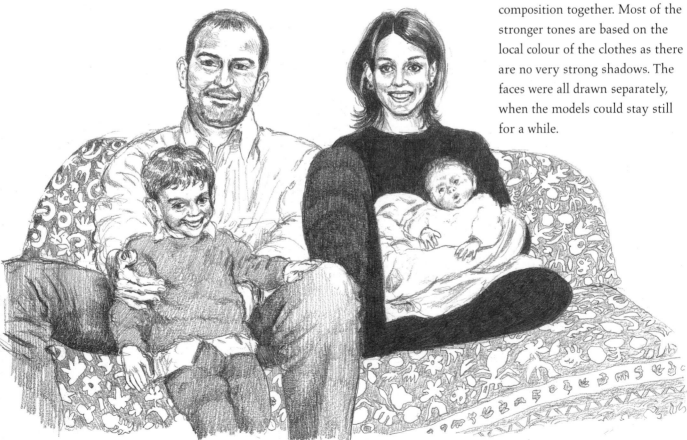

In this informal family group after Dame Laura Knight (1877–1970), the artist Lamorna Birch stands holding on to a tree to help support one of his young daughters, tucked under his arm. His other daughter sits astride another branch of a tree over in the right-hand side of the composition. Behind is a river and more trees. It must have been quite difficult to keep these poses for long, and it may be that Dame Laura relied on photographic reference.

Here is a very complex figure composition after Henri de Toulouse-Lautrec
(1864–1901) that includes many of the habitués of the Moulin Rouge in Paris in
1892. The large balcony edge which cuts across the lower left-hand corner gives a
movement through the picture. Then you see a group of people around what is
probably a small table, which is not visible. In the foreground is a young woman lit
from below, while in the background various people stand around in the larger space.

Index

anatomical terminology 11-13
arms
 female 93
 lower 214-17
 master artists 94-5, 226-31
 movement 210-13, 218-19
 muscles 88-91, 206-9, 214-17
 skeleton 86-7, 206-9
 upper 206-11
back 184-91
Barocci, Federico 94
bending 278-81
body see full figure
body surface 22-7
bones 8, 12 see also skeleton
Boucher, François 231
Boulogne, Louis de 264
Bronzino, Agnolo 83
Carolsfeld, Julius Schnorr von 124
Carracci, Annibale 261
cartilage 10
children 30-1, 34
climbing 284-7
clothing 320-3
Corot, Camille 42
Coypel, Noel-Nicholas 45
dancing 282-3
Delacroix, Eugène 231
Domenichino 269
ears 161
eyes 158-9, 334
face
 details 158-61
 expressions 146-57
fasciae 10
fat 10, 36
feet
 female 131, 132
 male 130, 133
 master artists 134-5, 260-9
 muscles 128-9, 250-2
 skeleton 126-7
 surface views 253
female
 arms 93
 body surface 23, 25, 27
 fat distribution 36
 feet 131, 132
 hands 93, 104-5
 legs 118, 120-1, 254-5
 pelvis 35
 proportions 29
 skeleton 33
 skull 34
 torso 78-9, 179-81, 188, 190-1
framing 326-7
Freud, Lucian 59, 106, 107
full figure
 balance and pose 272-5
 bending and stretching 278-81
 body surface 22-7
 climbing 284-7
 dancing and posing 282-3
 leaping 276-7
 master artists 40-7, 302-5
 muscles 19-21
 perspective 38-9
 practice drawing 48-9
 proportions 28-9
 skeleton 16-18
 sports 288-301

Giorgione 46
gluteal muscles 240-1
Gordon, Louise 143, 144-5, 171, 186-7
Gossaert, Jan 197
Goya, Francisco 47
Greiner, Otto 302-3
group portraits 344-51
hair 335
hands
 female 93, 104-5
 male 92, 102-3
 master artists 106-7
 movement 221-5
 muscles 88-91, 100-1, 214-17, 220
 practice drawing 108-9
 skeleton 86-7, 96-9, 220
head
 different angles 138-42
 master artists 59-61, 143-5
 muscles 56-8
 practice drawing 62-3
 skull 34, 52-4, 66-8
hips 237-9
Ingres, Jean Auguste 41, 106, 124, 304-5
Jacobs, Ted Seth 95, 135
joints 10-11, 244-5
knee-joints 244-5
Knight, Dame Laura 350
leaping 276-7
legs
 female 118, 120-1, 254-5
 gluteal muscles 240-1
 lower 246-9
 male 119, 120-1, 256-9
 master artists 122-5, 260-7
 muscles 114-17, 237, 246-9
 skeleton 112-13, 236-7
 upper 236-7
Leonardo da Vinci 232
life drawing 306-17
ligaments 10
male
 arms 92
 body surface 22, 24, 26
 feet 130, 133
 hands 92, 102-3
 legs 119, 120-1, 256-9
 pelvis 35
 proportions 28
 skeleton 32
 skull 34
 torso 76-7, 178, 180, 189
Manet, Edouard 47
Michelangelo 39, 40, 60, 82, 122, 192, 198, 227, 262, 266, 268
Mignard, Pierre 199
Mola, Pier Francesco 226
mouth 160, 334
muscles
 arms 88-91, 206-9, 214-17
 back 184-5
 feet 128-9, 250-2
 full figure 19-21
 gluteal 240-1
 hands 88-91, 100-1, 214-17, 220
 head 56-8
 hips 238-9
 legs 114-17, 237, 246-9
 neck 57, 71-5, 163-5
 properties of 9
 terminology for 13

 thighs 238-9, 242-3
 torso 71-5, 170-1
 trunk 71-5
Natoire, Charles-Joseph 228, 260
neck
 muscles 57, 71-5, 163-5
 skeleton 162
nose 161, 335
Orpen, William 61
Passarotti, Bartolommeo 200
pelvis 35, 70
perspective 38-9
Peters, Johann Anton de 202
Piombo, Sebastiano del 194
Pontormo, Jacopo da 267
portraits
 composition 336-43
 framing 326-7
 group 344-51
 posing 331-3
 sketches for 328-30
 steps in 324-5
posing 282-3, 331-3
proportions 28-31
Prud'hon, Pierre Paul 196, 226
Raphael 95, 122, 193, 195, 229
rectus abdominis 172-3
Renoir, Pierre-Auguste 344-5
ribcage 174-5
Rubens, Peter Paul 60, 125, 143, 203, 230, 233, 263, 269
Salgado, Antonio 226
Sanzio, Raphael 94
Sheppard, Joseph 134
shoulders 186-7, 206-9
Sickert, Walter 81
Signorelli, Luca 44
skeleton
 arms 86-7, 206-9
 feet 126-7
 female 33
 full figure 16-18
 hands 86-7, 96-9, 220
 legs 112-13, 236-7
 male 32
 neck 162
 torso 66-70, 168-9
skin 10, 37
skull 34, 52-4, 66-8
sports 288-301
stretching 278-81
Stuck, Franz von 201
tendons 9-10
thighs 238-9, 242-3
Tiepolo, Giovanni Battista 80
Titian 46, 107
torso
 female 78-9, 179, 181, 188, 190-1
 male 76-7, 178, 180, 189
 master artists 80-3, 192-203
 moving 176-81
 muscles 71-5, 170-1
 rectus abdominis 172-3
 ribcage 174
 skeleton 66-70, 168-9
Toulouse-Lautrec, Henri de 351
trunk 71-5, 80-3
Velasquez, Diego 48-9
vertebral column 69 see also spine
Volterra, Daniele Ricciarelli da 229
Watteau, Jean-Antoine 228